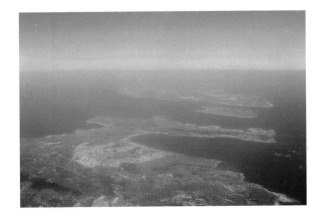

CW00337740

the making of *Malta*

Reuben Grima

photography & design
Daniel Cilia

midsea BOOKS

Acknowledgements:
His Excellency Dr Edward Fenech Adami, President of the Republic.
Casa Rocca Piccola; Cathedral Museum Mdina; Confraternity of the Blessed Sacrament, Curia of Malta, Parish of St Dominic, Valletta; Din l-Art Ħelwa; Fondazzjoni Patrimonju Malti; Fondazzjoni Wirt Artna; l-Għaqda tal-Pawlini, Valletta; Heritage Malta; Micropropagation Centre, Department of Agriculture and Fisheries; Malta Freeport; Munxar Local Council; National Library of Malta; NnG Promotions; Renaissance Productions Ltd; St John's co-Cathedral Foundation; and Ta' Mena estate.
Fr Joe Bezzina, Joseph Borg, Marie Louise Calleja, Fr Victor Camilleri MSSP, John Cremona, Marcia Grima, Charlie Mallia, Giuseppe Mantella, Rosanna Maya, Simon Sultana, Pawlu Mizzi, Louis Scerri, Fr EdgarVella, and Dr Nicholas Vella.

the making of
Malta

First published in Malta in 2008

Midsea Books Ltd

ISBN Hardback 978-99932-7-204-5
ISBN Paperback 978-99932-7-205-2
©2008 Midsea Books Ltd
©2008 Text Reuben Grima
Photography & design:
©2008 Daniel Cilia

Copyright other photos:
p. 7 top: Dr Nicholas Vella,
p. 39 bottom: Dr David Trump

Photo of firing of cannons on pages 304-305 is a timed, multiple exposure.
The artillery fired by Fondazzjoni Wirt Artna are shot individually,
(opposite: sixth photo from top).

All copyrighted images in this publication have been digitally watermarked.

No part of this book may be reproduced or utilized in any form or by any means mechanical or electronic, including photocopying, digital scanning, recording or by any information storage and retrieval system now known or invented in the future, without the prior written permission of the above.

Printed and bound by ALSABA Industrie Grafiche, Siena, Italy

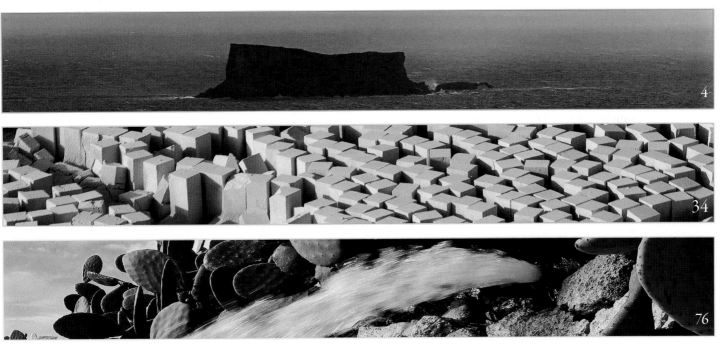

the making of *Malta*

Sea - Rock - Water - Food - Faith - War - Celebration

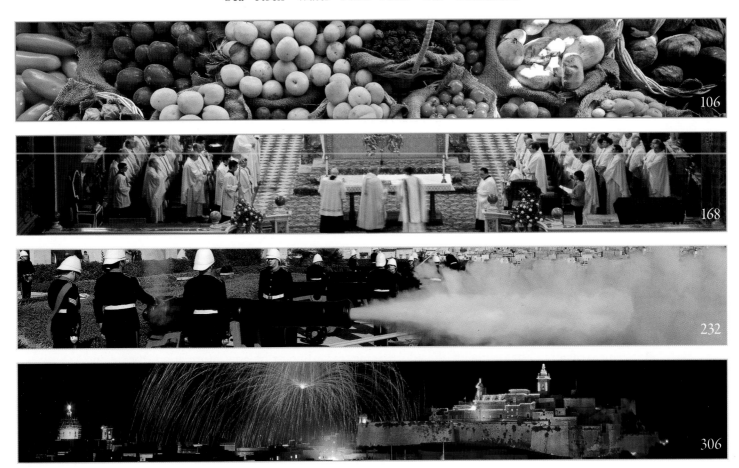

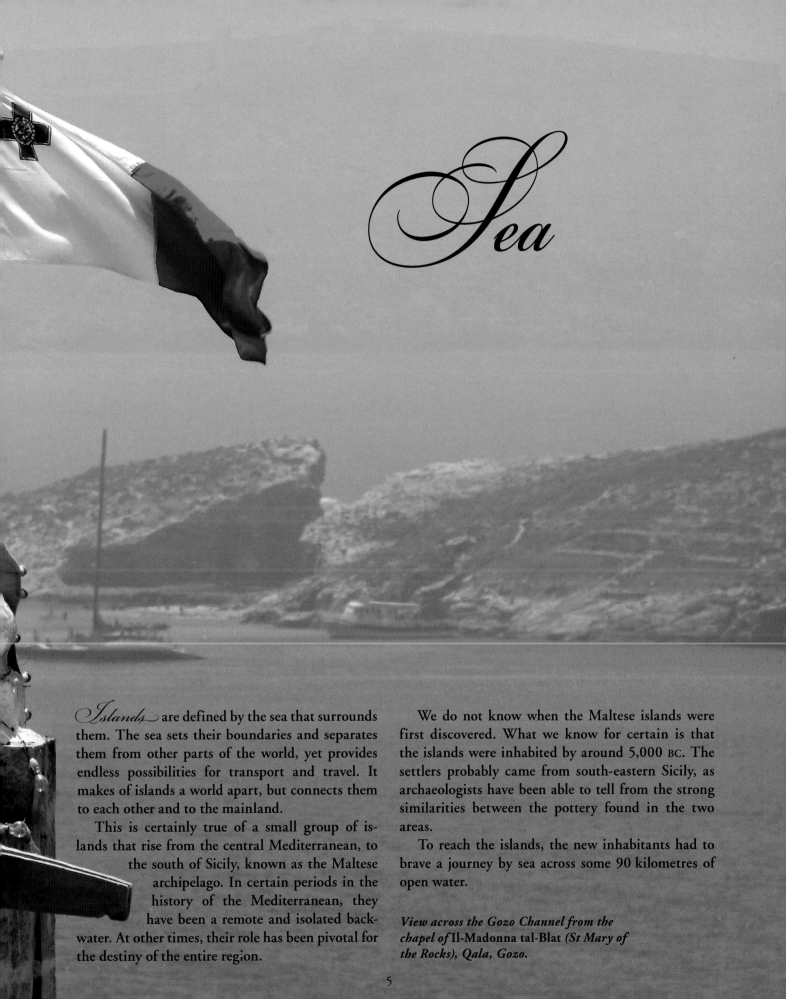

Sea

Islands are defined by the sea that surrounds them. The sea sets their boundaries and separates them from other parts of the world, yet provides endless possibilities for transport and travel. It makes of islands a world apart, but connects them to each other and to the mainland.

This is certainly true of a small group of islands that rise from the central Mediterranean, to the south of Sicily, known as the Maltese archipelago. In certain periods in the history of the Mediterranean, they have been a remote and isolated backwater. At other times, their role has been pivotal for the destiny of the entire region.

We do not know when the Maltese islands were first discovered. What we know for certain is that the islands were inhabited by around 5,000 BC. The settlers probably came from south-eastern Sicily, as archaeologists have been able to tell from the strong similarities between the pottery found in the two areas.

To reach the islands, the new inhabitants had to brave a journey by sea across some 90 kilometres of open water.

View across the Gozo Channel from the chapel of II-Madonna tal-Blat (St Mary of the Rocks), Qala, Gozo.

5

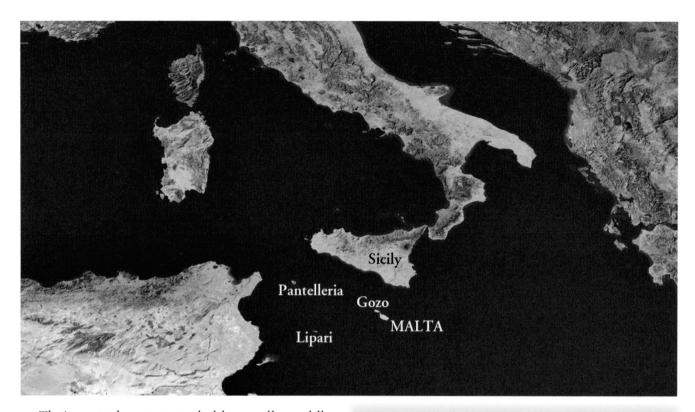

Their vessels were probably small, paddle-driven boats or canoes, perhaps with no sails at all. They may have had to row for the better part of a night and a day, with only short rests. Skilful boatbuilding and stamina were not enough, however. Any vessel that missed the islands on the southbound journey would have been carried by the current into the vast maritime desert of the central Mediterranean, hundreds of kilometres from the nearest landfall, where death was almost inescapable. Accurate navigation was therefore essential, and every sign that could aid orientation had to be carefully studied.

How were the Maltese islands discovered in the first place? The relatively low-lying islands are practically invisible from Sicily. An attentive observer on the Sicilian coast would, however, have noticed the clouds that formed regularly at a specific point on the horizon, even when the rest of the sky was completely cloudless. Islands force air currents upwards, causing the formation of what is known as an orographic cloud. On a windless day, an orographic cloud may stand over the Maltese islands for several hours, practically motionless. Such clouds are, of course, visible from a much greater distance than the islands themselves, and would have been an important tell-tale sign to a would-be explorer in Sicily.

The position of the Maltese archipelago and neighbouring islands in the central Mediterranean.

Although we will never quite know the sequence of events that led up to the daring discovery and settlement, we may allow our imagination to fill in part of the picture. Careful observations from land, and perhaps accidental sightings of the islands by navigators venturing further south

This Coralline Limestone threshold in the temples at Kordin may have served as a quern and may also represent a Neolithic boat.

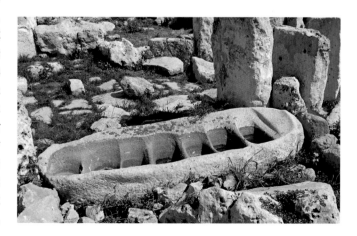

than usual, were probably fed into the collective knowledge of communities on the Sicilian coast over many decades. Under pressure from growing populations fed by thriving agriculture, the prospect of settling a new territory may have become increasingly attractive. At some critical point, the promised benefits would have tipped the scale against the risks of the journey.

Perhaps a reconnaissance expedition was sent out first to confirm the existence of the islands, and to report back on their suitability for settlement. They would have used the stars to set their course if they started the journey in darkness, as the magnetic compass would not be invented until thousands of years later. They would also have taken advantage of the prevailing south-easterly current, aware that it would be against them on the return journey, meaning that they would have to paddle far harder if they were ever to make it back. As the Hyblaean Hills of south-eastern Sicily faded away in a grey blur on the horizon behind them, they would have entered the most dangerous part of the journey, the part completely out of sight of land, where sea met sky to form a flat horizon all around them. Signs such as an orographic cloud would have been extremely helpful at this point. If meteorological conditions became unfavourable, they would have had to proceed by dead reckoning. If they were particularly lucky, they would have sighted the hills of the north coast of Gozo before losing sight of Sicily.

In any event, we know that the navigators did reach the Maltese islands. They would have reported back that there was not just one island, but several, of which two were large enough for many hundreds of people to live on. Once on dry land, they would have found considerable areas covered in forest, and perhaps startled some of the wild deer that roamed the islands. The soil was rich, and springs of fresh water abundant. It had certainly been worth the journey. Many other journeys followed, bringing men, women, sheep, goats, precious seeds of grain and barley, and everything else that could not be found on the islands themselves.

From a distance, an orographic cloud over the Maltese islands is much more visible than the islands themselves.

We must not imagine that the colonizers came across at a single moment, and then severed contact with the outside world. In the centuries that followed, several needs had to be satisfied from outside the archipelago. We know most about the imports made of materials that do not perish over time. However, it is very likely that there were other imports made of organic materials that have not been preserved. Among the imported materials, archaeologists have found obsidian [*left: an obsidian core found at Skorba Temples*], a natural glass formed by the heat of volcanoes. In a world where metals had yet to be discovered, glass is of course a very valuable material, as it makes it possible to create blades with very hard and sharp edges. As a result, obsidian was highly prized across the Mediterranean throughout the Neolithic. In the central Mediterranean, two important sources of obsidian were the volcanic islands of Lipari, off northeast Sicily, and Pantelleria, remotely located between Sicily and Tunisia. Many blades made of obsidian from both these sources have been found in Malta, showing that all these islands were networked in a web of seaborne exchange.

Another material imported for similar purposes was flint from Sicily, a very hard stone that may also be worked into sharp tools [*below: a flint blade from Tarxien Temples*]. Yet another import that is also well

continues on page 10

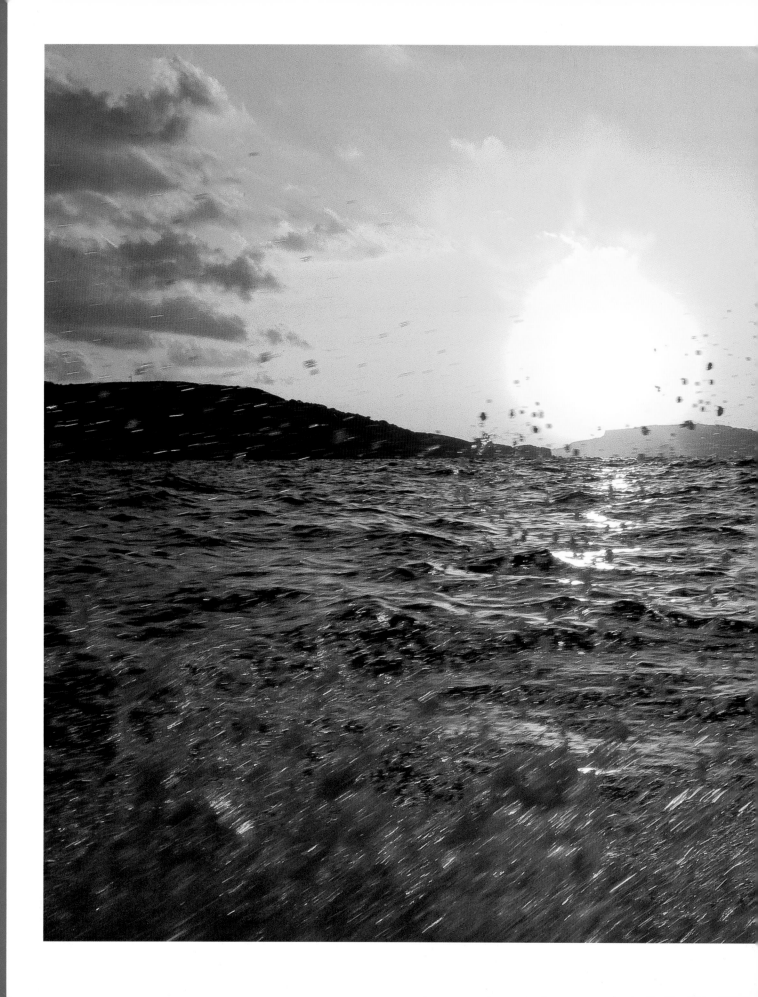

*Approaching Malta's north-eastern coast in a small boat at sunset. Rowing
from Sicily to Malta must have been dangerous and uncertain venture.*

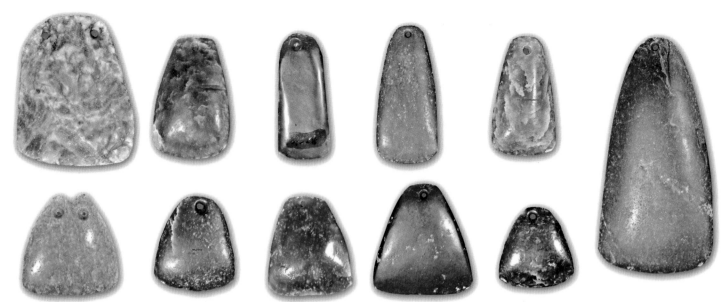

continues from page 7

represented in the archaeological record is that of stones polished into the shape of a small axe. Many of these miniature axes have holes drilled through them, probably to be worn as personal ornaments [*top*]. They are usually made of a dark green stone that is not found in Malta.

It is likely that red ochre [*right*] also had to be imported. This brightly coloured mineral was widely used in the Mediterranean during the Neolithic, particularly during burial rites. In Malta, too, red ochre was abundantly used in the burial of the dead. The earth in which the dead were buried is often found tinted a bright red by the copious amounts of ochre that were deposited with the burials. Perhaps, owing to its resemblance to blood, it was used symbolically to give life to the bones of the dead. So far no source for this material has been identified on the Maltese islands, and the nearest and most likely source is Sicily. If this was the case, many boatloads would have had to be imported to Malta to meet the islanders' needs.

Such imports suggest that the Neolithic inhabitants maintained regular contact with the outside world. Furthermore, the archaeological remains found on Gozo are practically identical to those found on Malta, suggesting that communities in different parts of the archipelago maintained close contact. The fact that they lived on an archipelago encouraged the inhabitants to develop the skills and equipment to travel by sea from one island to another, providing a natural nursery for the skills needed for longer journeys.

In different epochs, the inhabitants have related to the sea and to the coast in very different ways. The Maltese coastline is extremely varied. Several parts of the coastline are composed of precipitous cliffs that drop vertically into the sea. Along the cliffs, it is almost impossible to reach the sea from land. At other points, the forbidding cliffs are interrupted by creeks, beaches, and harbours, providing shelter for boats and access to the shore. These natural gateways between land and sea have been exploited since prehistory.

One example of a very particular relationship with the sea comes from the last part of the Neolithic Age, when the inhabitants developed a new and unique architectural form. Between around 3,600 and 2,500 BC, they built a series of extraordinary megalithic buildings across the archipelago, nowadays referred to as 'temples'. We shall return to these buildings further on. For the

continues on page 14

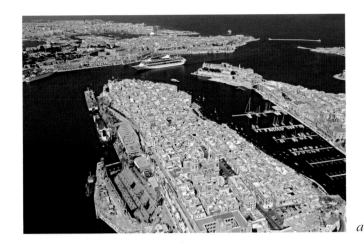

a

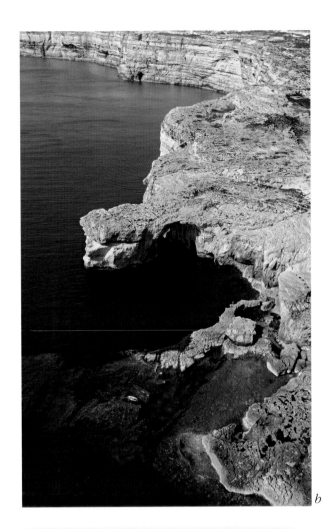

b

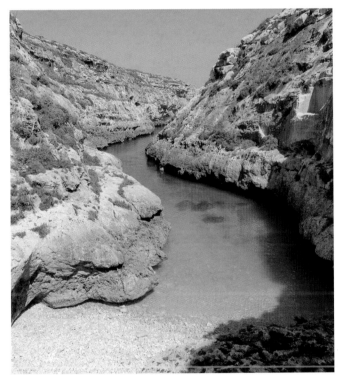

c

The Maltese coastline is extremely varied:
a. Grand Harbour
b. Cliffs at Dwejra, Gozo
c. Wied il-Għasri, Gozo
d. A beach at Mġiebaħ

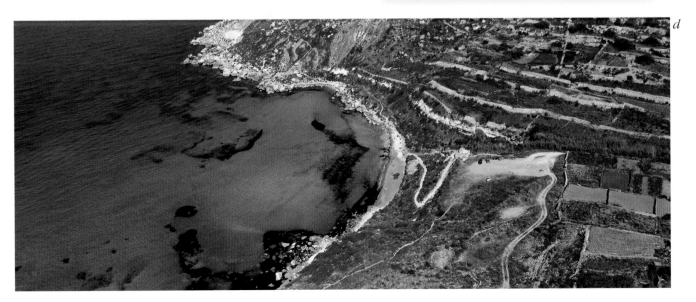

d

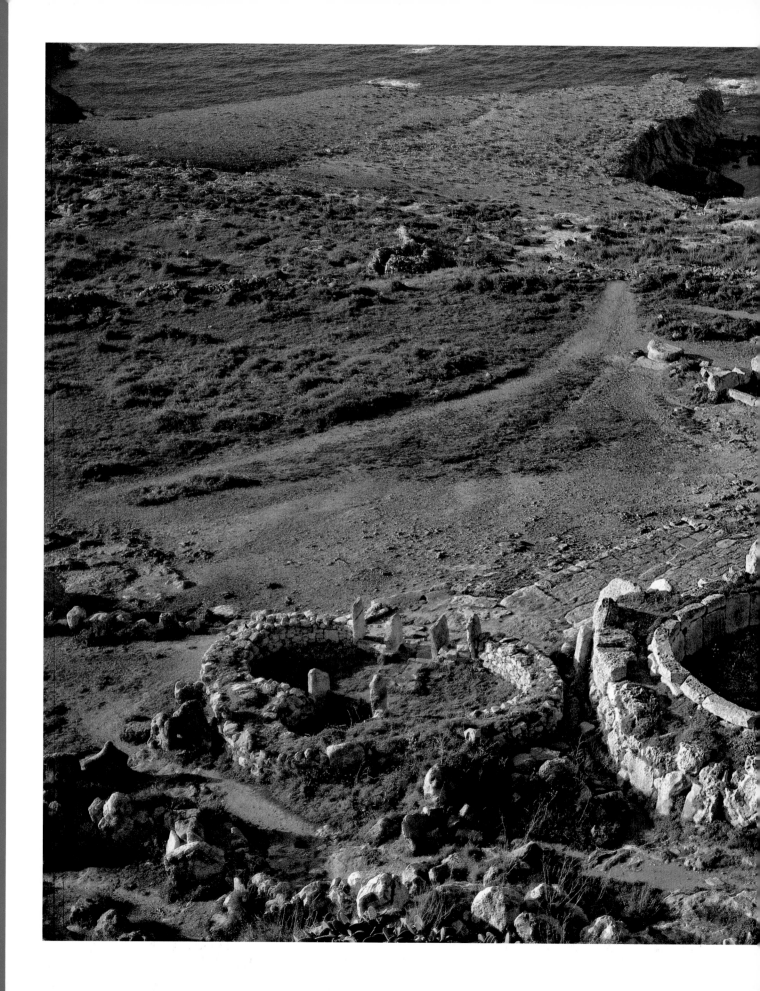

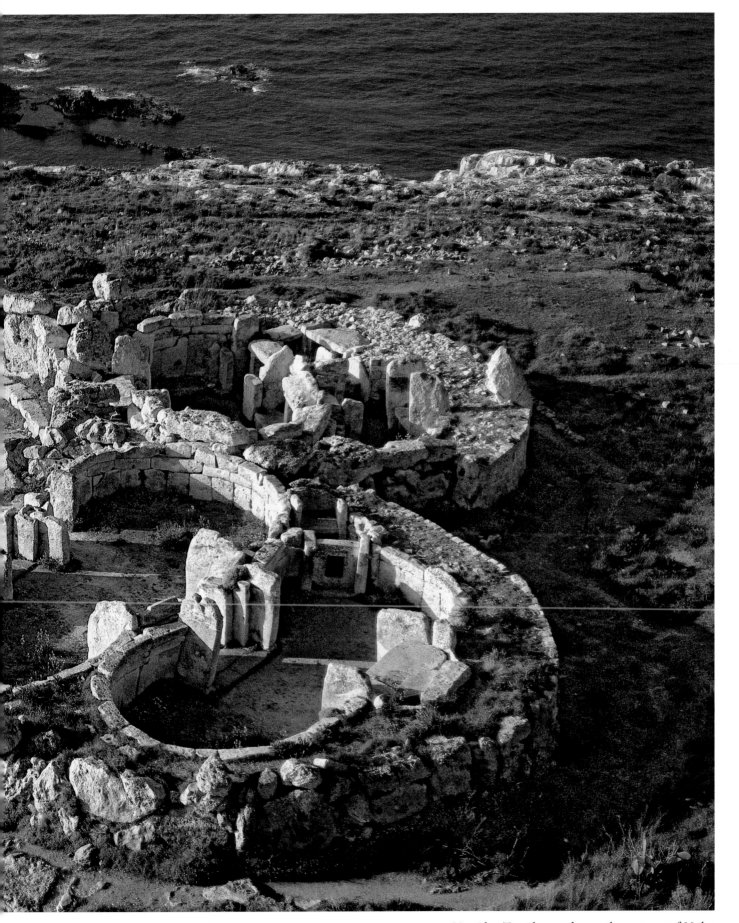

Mnajdra Temples on the southern coast of Malta

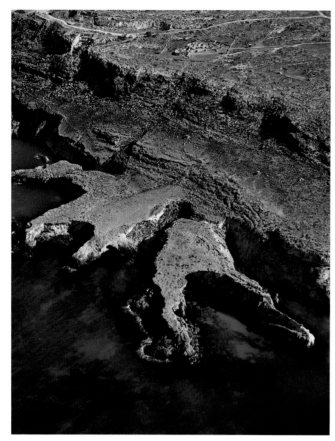

continues from page 10

moment, we are concerned with their location in the landscape. The buildings are positioned in places that allow easy access to the sea, usually near a beach or bay. The position of the buildings strongly suggests that they were in some way tied to seafaring and the sea. Two of the most famous of the megalithic buildings are Ħaġar Qim and Mnajdra, located along the south-western coast of Malta, about half a kilometre apart. What makes this part of the coastline special is the Magħlaq Fault, a geological fault that created a coastal shelf of rock close to sea level, running from Wied

Left: Mnajdra Temples (top centre) are located at one of the few points on the south-western coast that permit access to the sea.

iż-Żurrieq to Għar Lapsi. To north and south, the coast is formed by steep cliffs that continue uninterrupted for about ten kilometres in each direction. Ħaġar Qim and Mnajdra are therefore located in practically the only place along the south-western coast that permits ready access to the sea.

The interplay between land and sea has continued to shape human decisions down to the present. Exploring the coastal landscape around Ħaġar Qim and Mnajdra a little further, we can see how its topography determined human choices in different periods. Apart from the megalithic monuments, the most conspicuous historic buildings in the vicinity are two coastal watchtowers, one overlooking Wied iż-Żurrieq, the other overlooking the Magħlaq Fault. The two towers form part of a series of thirteen such towers built around the mid-seventeenth century by Martin de Redin, grand master of the knights of St John. The towers were built in an age when piracy had once again become common, with the fleets of Christendom and Islam using the pretext of religion to harass the other's shipping and to conduct raids on land. Whole communities were sometimes taken unawares and slaughtered or dragged into slavery. The purpose of de Redin's towers was to help safeguard the coastline against such raids and to give advance warning in case of a major invasion [*below: Ras il-Ħamrija tower near Mnajdra*].

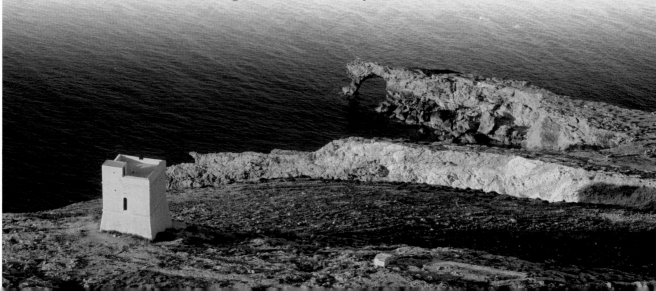

Left: *A rock-cut slipway at the fishing hamlet of Wied iż-Żurrieq.*
Below: *Boats berthed at St Paul's Bay.*

During this period, the topography of the coastline was as important a consideration to the inhabitants of the archipelago as it had been for their predecessors. Only their reasons had changed. The sea had now become a constant source of danger. Areas that were readily accessible from the sea were considered too dangerous to live in. The whole north of Malta, where the coastline is characterized by a series of bays, was very sparsely inhabited during this period. It was not until the nineteenth century that the north became safe enough for sizeable villages to flourish. The present-day villages of Mġarr, Mellieħa, and St Paul's Bay were largely laid out during the nineteenth and early twentieth century, as reflected in their street plan and in the architecture of their churches.

At the time that the de Redin towers were built, however, those parts of the island that could easily be reached from the sea were risky places to live

in. In this respect, the parts of the coastline that were composed of precipitous cliffs provided natural coastal defences. Creeks and bays that provided easy disembarkation points were however breaches in this defensive system, which had to be protected with man-made defences. The coastline between Wied iż-Żurrieq and Għar Lapsi was one such breach, which called not for one tower but for two. To the north and to the south of this part of the coastline, however, the precipitous cliffs were defence enough, and there is not another tower for many kilometres in both directions.

If we continue our exploration of the same area a little further now, moving right down to the shoreline, we will find yet another example of how accessibility from the sea has shaped human activity. At Wied iż-Żurrieq and at Għar Lapsi there are two tiny fishing hamlets, each densely clustered around a little inlet which in summertime is full of little fishing boats bobbing at their moorings. With the approach of the winter storms, the boats are dragged up a network of slipways to the shelter of boatyards and boathouses. Here the accessibility of the sea afforded by this stretch of coastline has been exploited in yet another way, to allow boats to put to sea in order to fish these waters. The forbidding cliffs, of course, render such activity impossible a short distance to the north or south.

continues on page 18

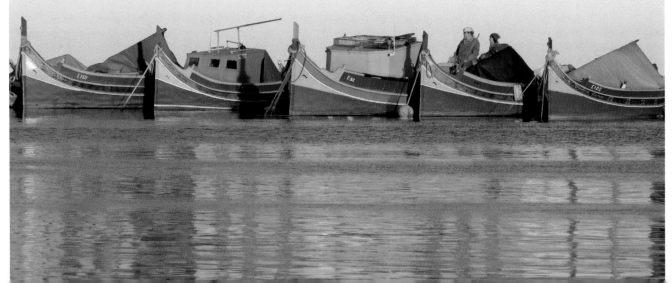

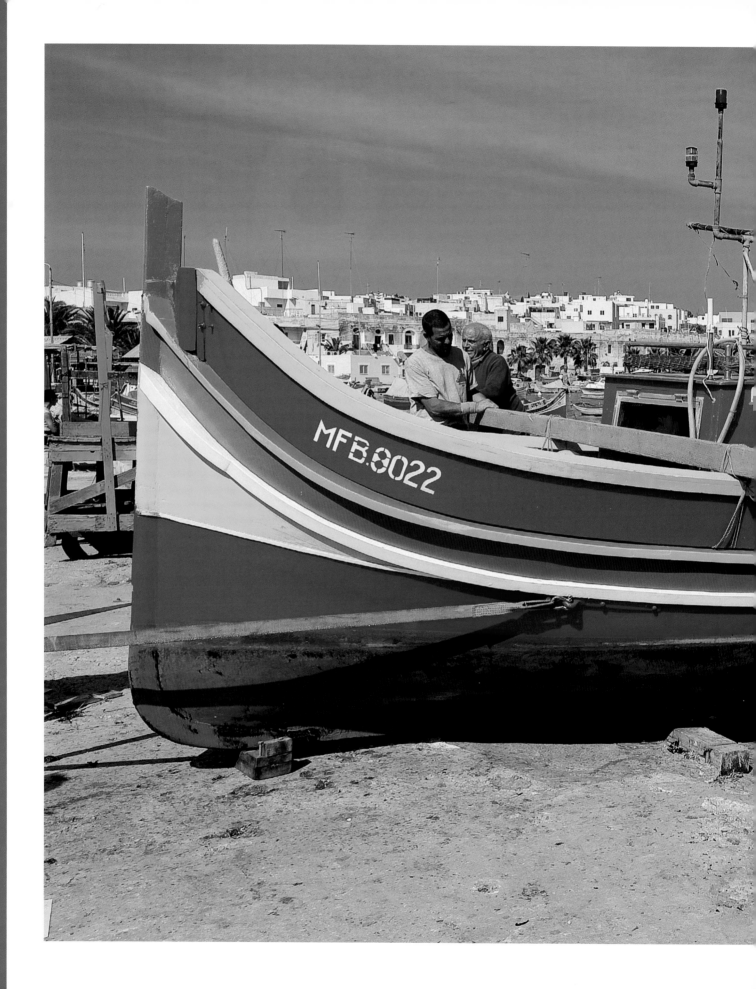

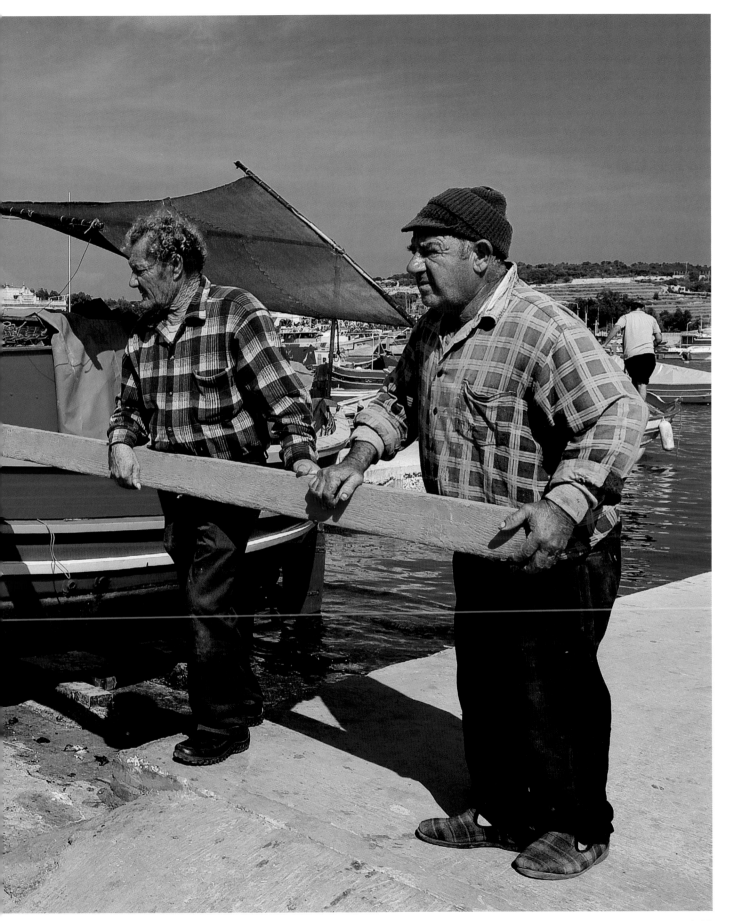

Balancing a luzzu *as it is winched ashore at Marsaxlokk*

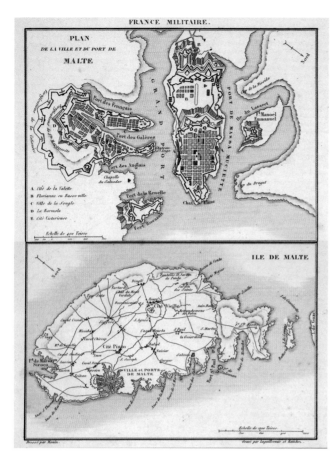

continues from page 15

In a space of a few hundred metres, we have observed three different ways how access to the sea conditioned human decisions in different ages. During the Late Neolithic, monumental public buildings were raised here. In the early modern period, the sea had become a source of danger, and watchtowers were built in the same place. Finally, today we may still observe how the accessibility of the sea also provides opportunities for fishermen to work the sea off this part of the island.

The harbours of Valletta (top) and Malta's principal road network (bottom) in the mid-18th century.

The patterns observed in the short stretch of coastline between Żurrieq and Għar Lapsi may be observed on a grander scale throughout many other bays and harbours around the archipelago. The grandest example of all is the Grand Harbour and the nearby Marsamxett Harbour, which lie on either side of the Valletta peninsula. The existence of these harbours is, perhaps, the most important single factor in the shaping of the destiny of the Maltese islands, setting it apart from other Mediterranean islands of a comparable size, such as Pantelleria, Lampedusa, the Egadi Islands, or the Balearics. The deep and sheltered natural harbours of Valletta are arguably amongst the finest in the world. With the development of larger and larger ships, harbours that were broad and deep enough to shelter them became essential. The value of the harbours was certainly recognized by the Phoenicians. The narrow tongues of land that divide one creek from another within the Grand Harbour, as well as the little island in the middle of Marsamxett Harbour, provided the ideal combination of defensibility from a landward attack and access to sheltered anchorages. Back in their homeland on the seaboard of present-day Lebanon, the Phoenicians had chosen such

Early 18th-century bird's-eye view from the innermost end of the Grand Harbour, showing Valletta, Isla, Birgu, and their harbours.

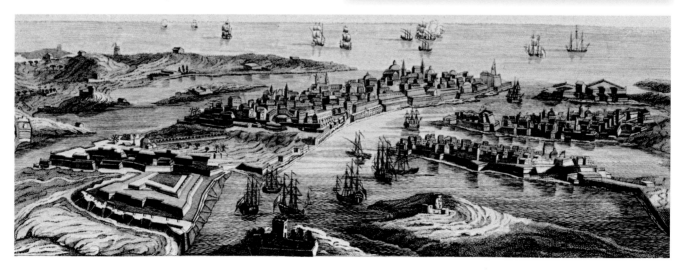

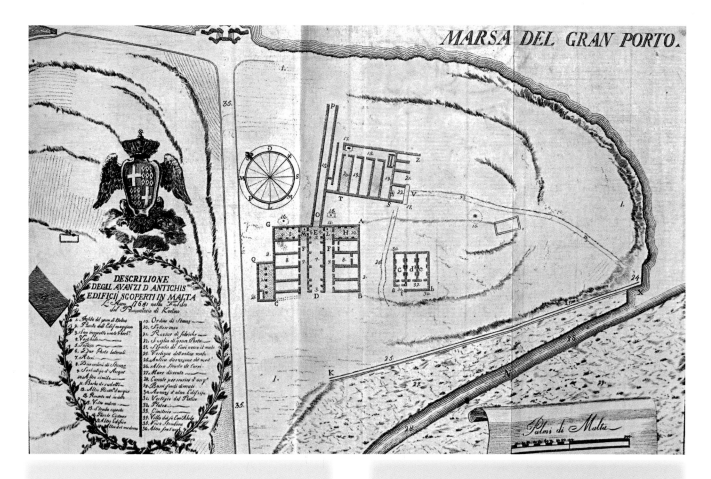

Top: A plan of the ancient Marsa waterfront warehouses published by Marquis Carl Antonio Barbaro in 1794.

Bottom: The harbour region is characterized by ancient tombs such as those discovered during the building of the Marsa Power Station.

locations for their great cities, such as Byblos, Sidon, or Tyre. It is evident that they recognized the potential of the Grand Harbour from the many rock-cut tombs that have been found around it.

More evidence has been found for the use of the Grand Harbour during the Roman period. One of the most spectacular discoveries took place in 1768, during the course of some works at the innermost end of the harbour. At the foot of the promontory where the Marsa power station stands today, a series of ancient waterfront warehouses were discovered. The site was investigated by the Marquis Carl Antonio Barbaro, a keen and erudite antiquarian, who also published an illustrated description of the discoveries in 1794, making it the first published report of an archaeological excavation in Malta. During the 1860s, many works were undertaken in order to improve the harbour in preparation for the increase in shipping that was expected with

the opening of the Suez Canal. As the dredging went on at the innermost end of the harbour, more extensive Roman harbour works were discovered. Similar discoveries have continued sporadically down until the present day.

During the Middle Ages, the inner end of the harbour appears to have become less salubrious, as sediments built up and turned the Marsa basin into marshland.

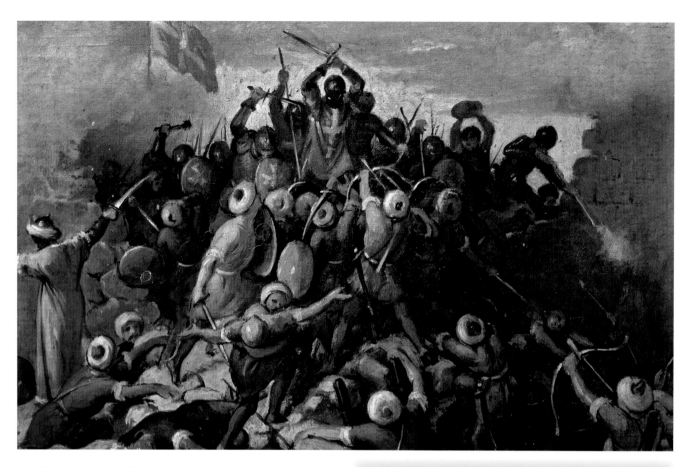

The centre of activity in the harbour now became the promontory where Fort St Angelo stands today, strategically controlling the harbour. Throughout the Middle Ages, mastery of the islands changed hands again and again as one power eclipsed another and different dynasties rose and fell. Throughout this turbulent history, whoever held the stronghold of St Angelo [*bottom right*] effectively held the key to the whole island, as the fort controlled the principal gateway between Malta and the outside world. Battles for control of the island were often centred on the Grand Harbour. In 1283, a sea-battle was fought inside the harbour between the fleets of the Angevins and the Aragonese.

The most momentous conflict, however, was the siege of 1565, when Suleiman the Magnificent, the Turkish Sultan, sent his forces to seize control of the island and to eradicate the knights of St John. The tenacious resistance of the Maltese and the knights has become the stuff of legend. Against all

The siege of 1565 is often romanticized in pictures in history books and paintings in churches, such as this bozzetto by Carlo Ignazio Cortis. Cathedral Museum, Mdina.

odds, the heavily-outnumbered defenders survived a bloody summer of constant bombardment, until the siege crumbled, and the invading forces withdrew in disarray.

As news of the Maltese victory resounded across Europe, it acquired great symbolic importance as a turning point in the power struggle with the Ottoman Sultan. The consequences for Malta

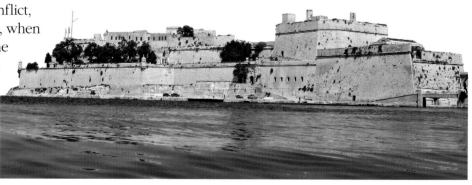

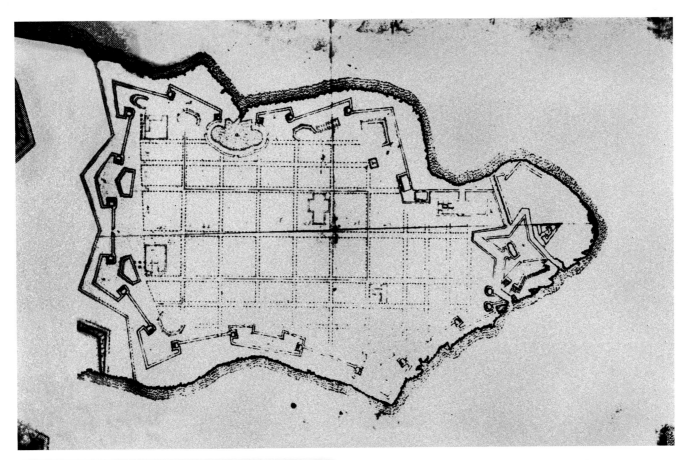

One of a series of alternative proposals for the fortification and layout of the new city of Valletta, prepared by the papal engineer Francesco Laparelli in 1566.

were far-reaching, catapulting the island into the modern world. Money and men poured into the island from across a grateful Europe, keen to consolidate the position of the Knights of St John on Malta. The greater part of these resources went towards the creation of a new fortified city on the peninsula between the Grand Harbour and Marsamxett Harbour. The project was probably the most ambitious ever to be undertaken on the archipelago. It was also one of the most resoundingly successful. The new city of Valletta became Malta's cultural, economic, and administrative centre, and has remained its capital to this day.

The building of the city also brought with it a transformation of the harbours that it overlooked. Vast warehouses [*below*] were built along the waterfront of the Grand Harbour for the storage of merchandise.

continues on page 26

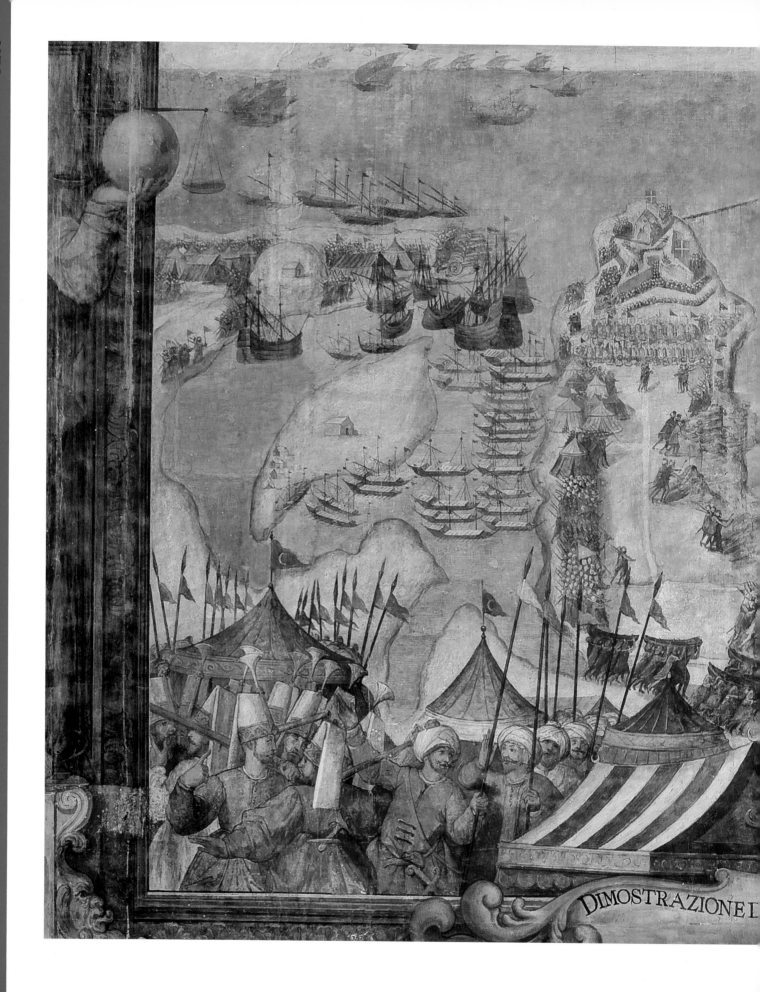

DIMOSTRAZIONE

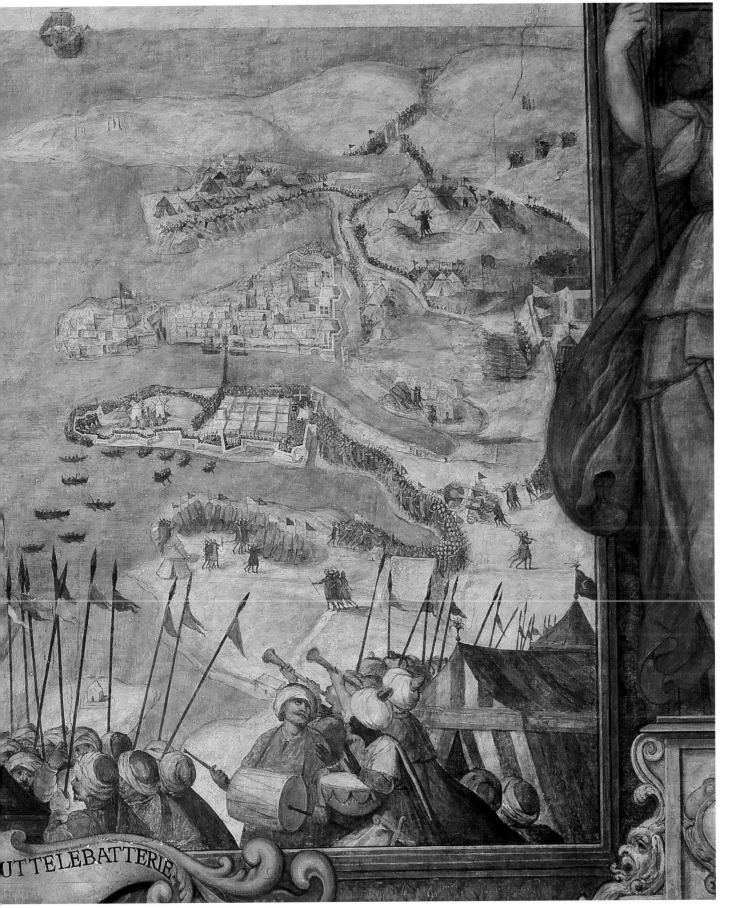

UTTELEBATTERIE

Fresco by Matteo Perez d'Aleccio in the Grand Master's Palace, Valletta showing the Turkish batteries during the siege of 1565

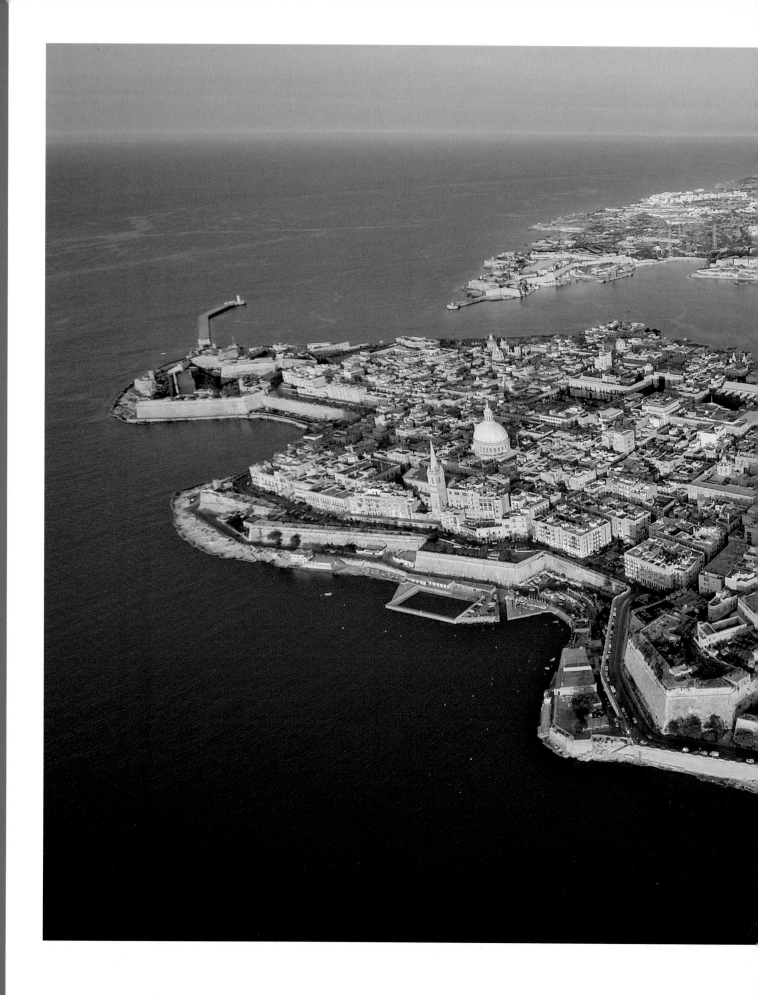

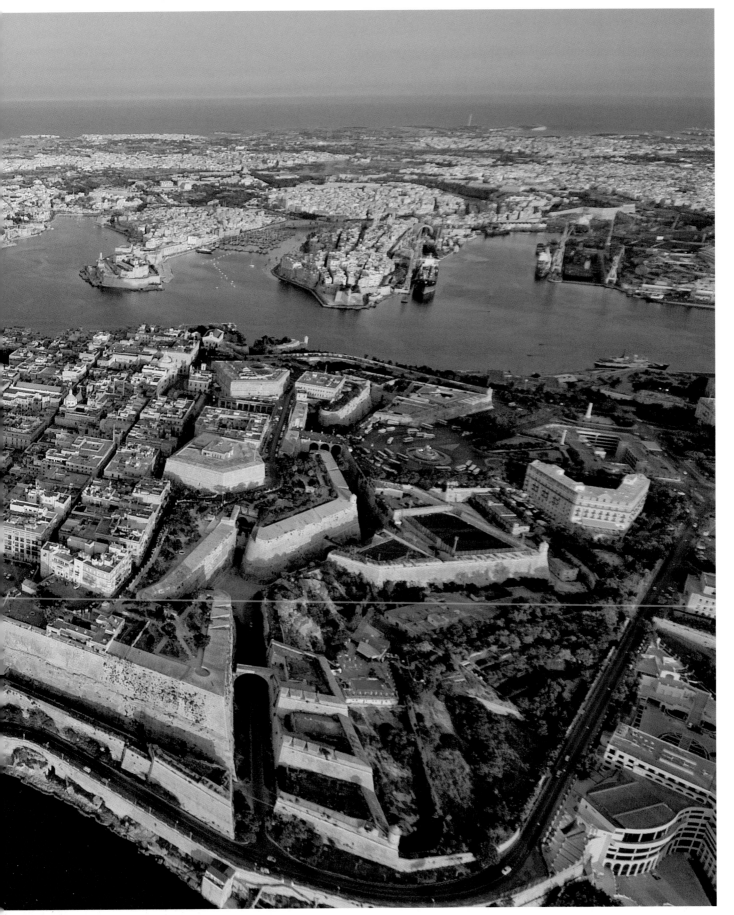

The Valletta peninsula from the west. The city's landward defences are visible on the right

continues from page 26

The island in the middle of Marsamxett Harbour, meanwhile, was used for the development of quarantine facilities [*right:*]. Here shipping and travellers from the eastern Mediterranean could complete the forty-day period of isolation that was required as a precaution against the plague, before proceeding to their destination.

Today, the principal focus of seaborne commerce has shifted once again, this time to the Malta Freeport, a new and extensive container transhipment facility that has been created in Marsaxlokk Harbour, in the south of the island. The waterfronts of the Grand Harbour, meanwhile, are enjoying a new lease of life as they are repristinated for leisure purposes, yacht marinas, and cruise liners.

Meanwhile, a transformation has also been taking place in the bays in other parts of the coastline. Traditional fishing activity is making way for the invasion of Maltese and foreign tourists that flock to the coastline every summer for leisure and relaxation. During the second half of the twentieth century, modest villages like St Paul's Bay, Mellieħa, and Marsascala exploded into coastal holiday towns. Today, tourism has become a mixed blessing for the islands. It is an important

pillar of the Maltese economy, and yet the strain of hosting some 1.2 million tourists annually sometimes threatens the very resources that drew those tourists in the first place. Excessive building development, overcrowding of the shoreline, the heightened demands on the country's water, electricity, and sewage infrastructure, as well as pollution of the sea itself are all very real threats. Only careful regulation and responsible long-term management will safeguard a fragile microcosm from these dangers. After 7,000 years of human endeavour and achievement, today's inhabitants may have to face some of the most daunting challenges the islands have witnessed yet.

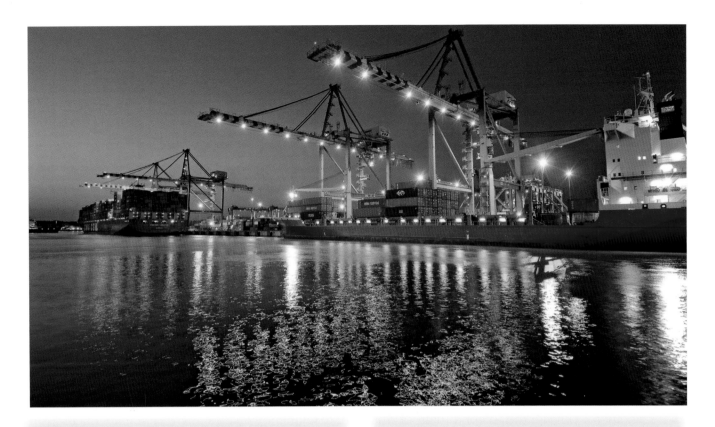

Top: Loading and unloading of containers continues uninterrupted round the clock at the Malta Freeport in Marsaxlokk Harbour.

Bottom: A cruise liner berthed below the bastions of Valletta, where new facilities have been created to meet the needs of the burgeoning number of liners.

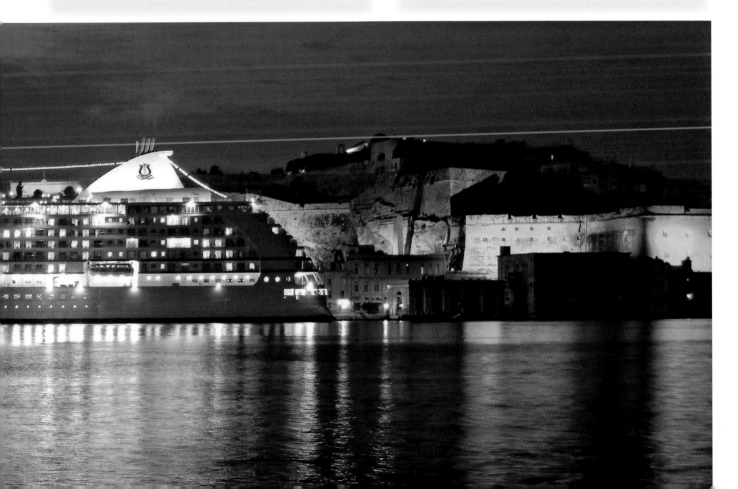

Setting sail from Marsamxett Harbour for the Rolex Middle Sea Race

Exploring the Rożi, a tugboat off Ċirkewwa

Taking a break at the fishing hamlet of Wied iż-Żurrieq

Every summer the Blue Lagoon in Comino becomes a playground for young and old

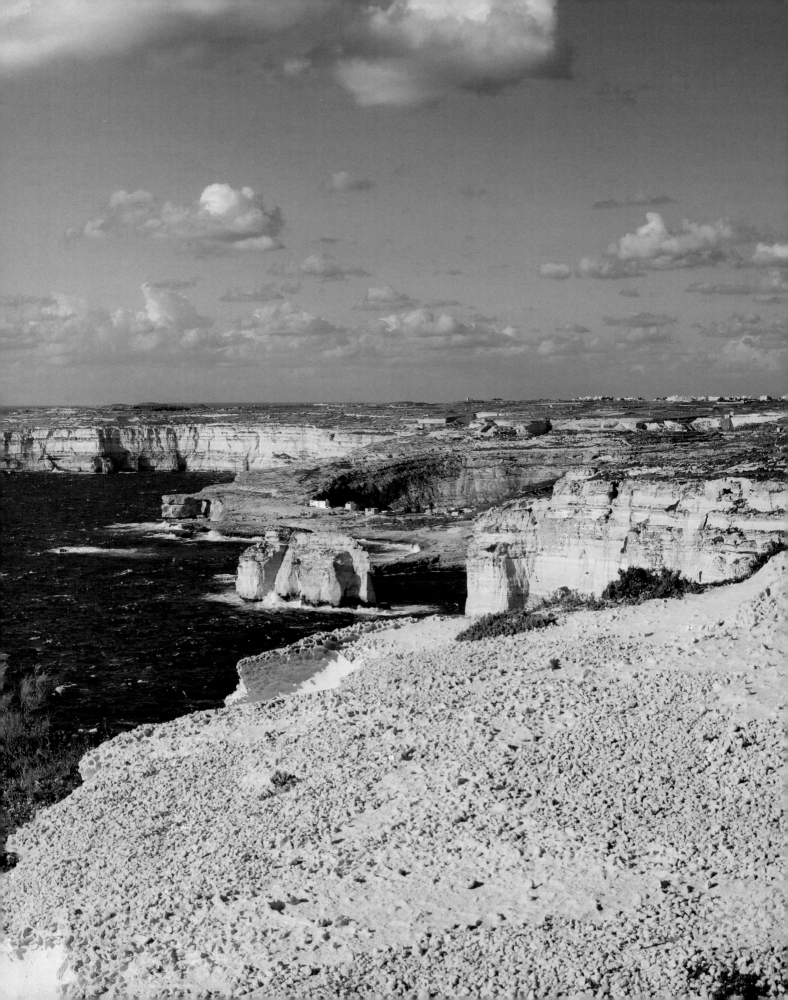

Rock

You will find rock everywhere you turn on the Maltese archipelago. The islands themselves are huge slabs of layered limestone, with a sparse soil cover. Stone is the islands' most abundant material, and the most readily available. For the past 7,000 years, the inhabitants of the archipelago have taken advantage of the opportunities offered by its rock, employing it in a thousand ingenious ways.

They have burrowed into it for shelter, and to create chambers for the burial of the dead. The islands' different stones have been shaped into tools and ornaments, and cut to build houses, temples, and terraced fields for agriculture. Rock has been moulded into jetties and breakwaters to tame the sea in the islands' anchorages, while fortifications have been built up with stone masonry, and carved down into the living rock. Seven millennia of human activity have reshaped the Maltese islandscape, like a vast stone sculpture.

For such a small group of islands, the properties of its rock can be surprisingly varied. The different layers that make up the archipelago are known as sedimentary limestones, composed of sediments that accumulated on the sea-bed over long periods of time. When compared to the age of our planet (around 4,500 million years), the rock that makes up the Maltese islands is very young, as most of it was formed during the Oligocene and Miocene epochs, between 35 million and five million years ago. Just to put that into perspective, dinosaurs became extinct well before the oldest layers that we see today in Malta had come into existence.

Different geological layers erode at different rates. The vertical coastal cliffs in the background are made up of the more resistant Lower Coralline Limestone. The heavily eroded rock in the foreground is the more friable Globigerina Limestone. Ras il-Wardija, Gozo.

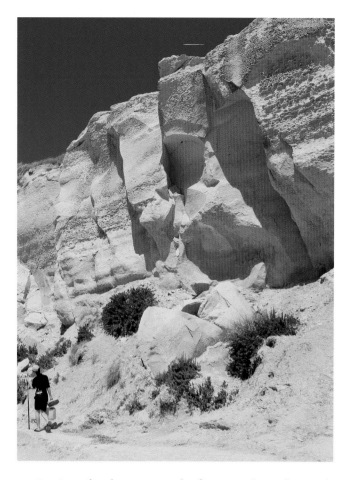

Top left: The upper layers of Globigerina Limestone.
Erosion of softer layers undercuts the layers above.
Top right: Massive Upper Coralline Limestone boulder.

Opposite: This cliff-face at Dwejra, Gozo, is made up
of Lower Coralline Limestone capped by Globigerina
Limestone.

During the long period of time when the rock that makes up the Maltese islands was being created on the sea-bed, the level of the sea rose and fell, and consequently different types of rock were formed at different times. Each one is characterized by the fossilized remains of marine plants and animals that lived in the environment where it was formed [below]. The oldest layer that we can see is known as Lower Coralline Limestone, which is generally hard and crystalline. This originated at a time when the sea was relatively shallow, allowing enough light to reach the seabed for marine algae and corals to grow there, hence the name. The algae and coral built reefs which in turn shaped this geological formation. Over the Lower Coralline Limestone, we

find a layer of stone with very different properties, known as Globigerina Limestone. By studying the structure of this layer and the fossils found within it, geologists have learnt that the sea was much deeper when it was formed. The seabed sediments that were to become Globigerina Limestone were hardly disturbed by wave action, as happens in shallower water. This layer is largely made up of the fossils of microscopic plankton. One of the commonest species is known as Globigerina, which has given this layer of limestone its name.

The small particles of silt and the remains of small micro-organisms that were allowed to settle on the sea-bed in deep, undisturbed water resulted in a stone that is very uniform in composition, and also very workable. These properties make Globigerina Limestone an ideal stone for cutting and carving. A further advantage is that, when exposed to the elements, Globigerina Limestone often develops a hard crust that is more resistant to weathering.

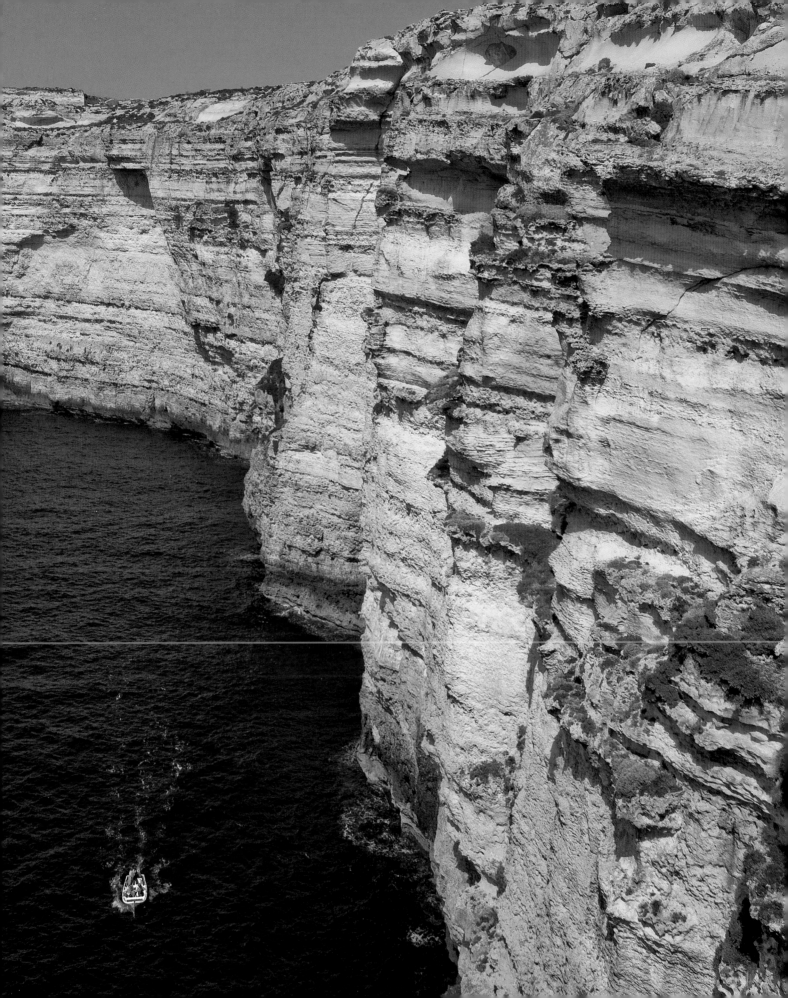

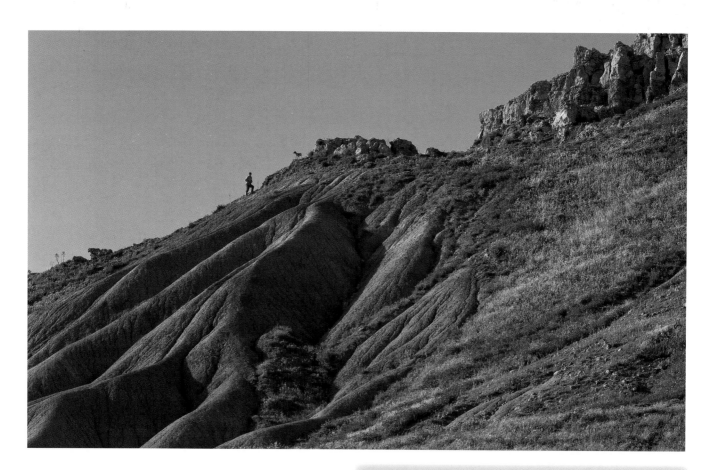

A layer of clay lies over the Globigerina Limestone. The clay is the only layer in the Maltese geological sequence that does not permit water to seep through it. As a result, it holds a reserve of freshwater over it, like a huge underground basin which, as we shall see further on, became a precious resource for the inhabitants of the archipelago.

At the top of the layer-cake that makes up the Maltese geological sequence, we find Upper Coralline Limestone which has properties quite

Where the clay layer is exposed, it erodes to form slopes and gullies. The overlying Upper Coralline Limestone breaks off into boulders as it is undercut by the eroding clay. Tad-Dabrani, Gozo.

similar to those of Lower Coralline Limestone, as it formed during a period when the sea had become relatively shallow once again.

These then were the principal materials that were available in abundance for the islanders to use.

And use them they certainly did. From the earliest known periods of human settlement on the archipelago, we find evidence that the islanders acquired a sophisticated understanding of the materials that it offered. The earliest definite evidence that the islands were inhabited comes from around 5,000 BC. Archaeologists have called this period the Għar Dalam Phase, after the cave where remains dating from this period were first discovered. The remains of a drystone wall built during this early period have been discovered at Skorba, [*left, 1962 excavation photo*] showing that the earliest inhabitants were already using stone for building purposes. The remains of pottery vessels show that clay was also being exploited by the early settlers.

continues on page 45

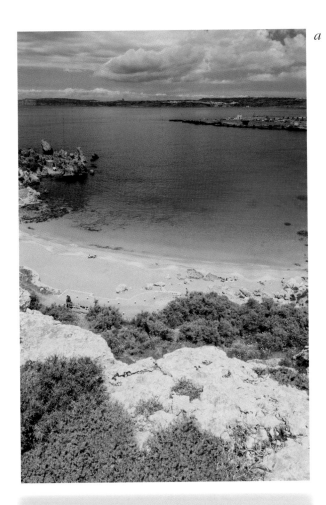

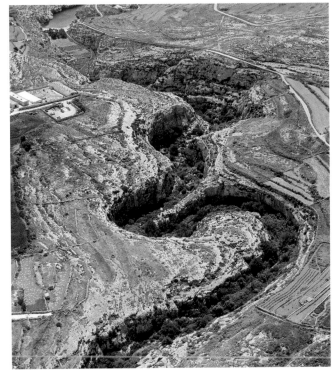

a: A sandy beach at Paradise Bay
b: The sea may erode deep holes and caves into the rock
c: The deeply eroded water-course of Wied Ħanżira, Xewkija, Gozo
d: Globigerina Limestone (lower left) at Il-Prajjet, surmounted by clay slopes, capped by Upper Coralline Limestone

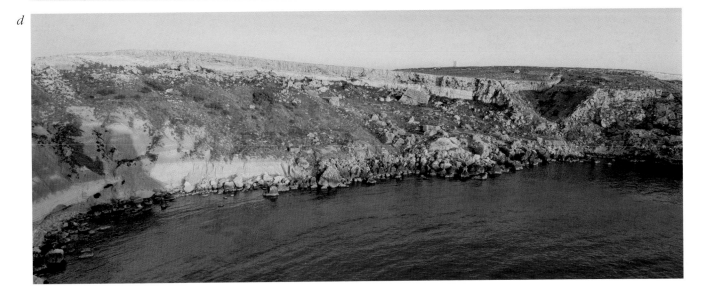

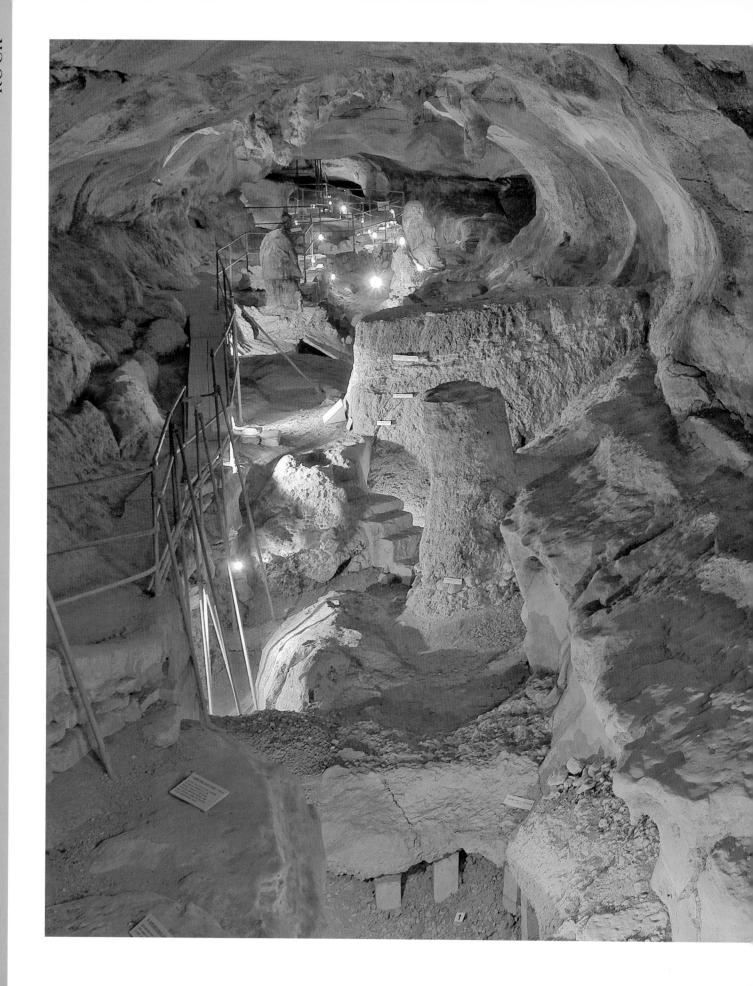

Għar Dalam, Birżebbuġa is a tubular cave formed by the dissolution of the Globigerina Limestone by water. The cave was used by the earliest known inhabitants of the Maltese islands, who had settled the archipelago by around 5,000 BC.

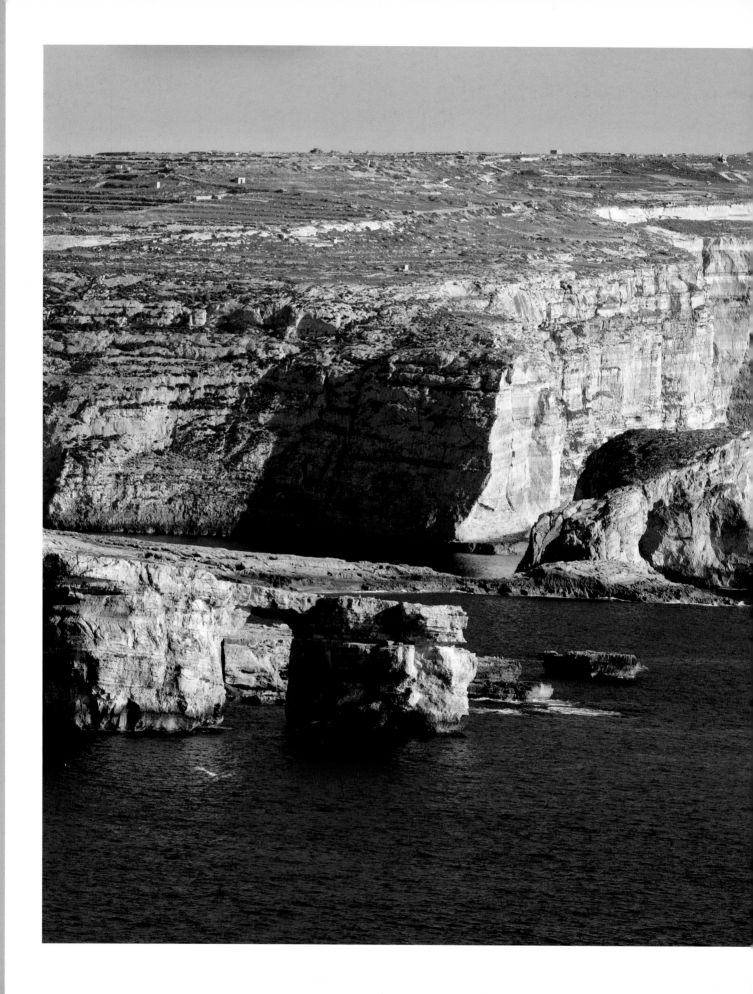

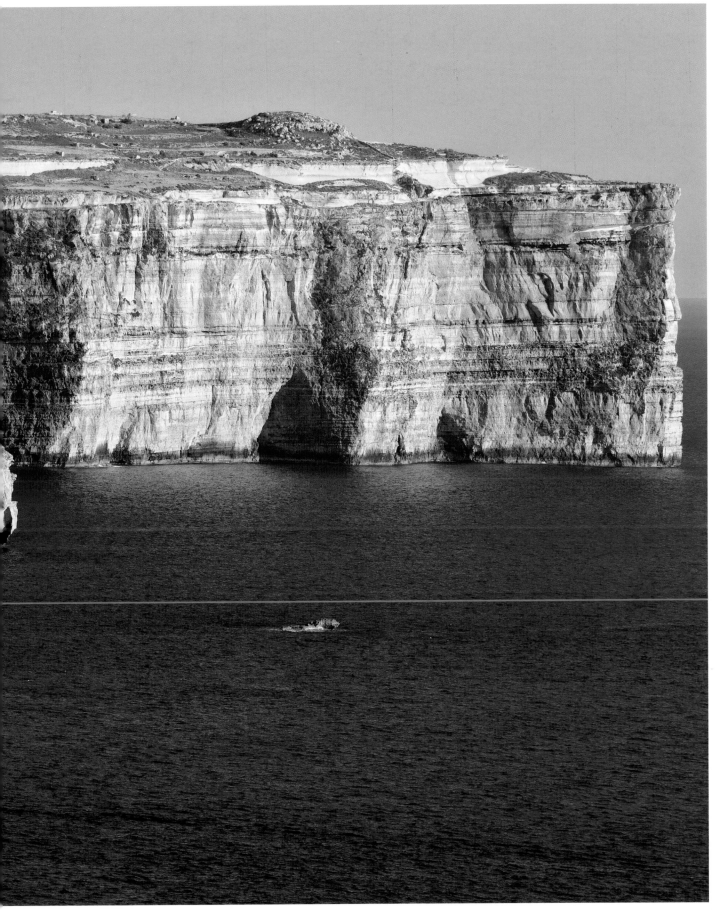

The western coast of Gozo has been sculpted by erosion into a variety of dramatic features

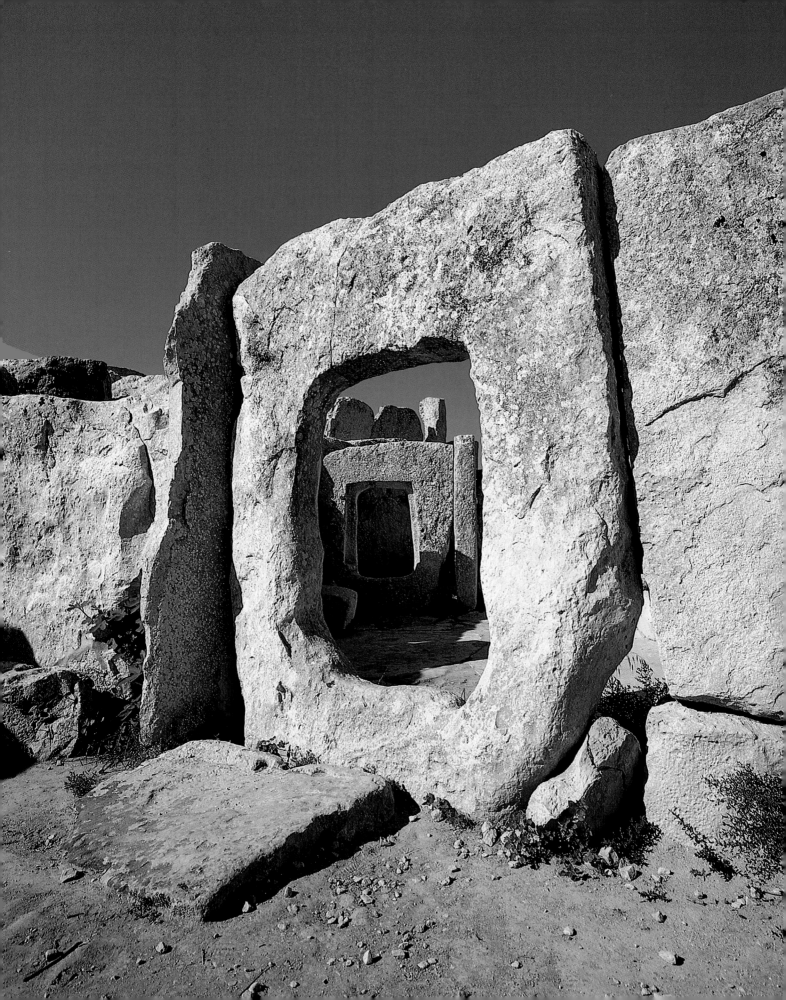

continues from page 38

One of the most remarkable human achievements ever to be seen on the Maltese islands began around a thousand years later. Between around 3,600 BC and around 2,500 BC, the inhabitants developed a new and unique type of monumental building, using megaliths (large blocks of stone). Today, the many examples that have come down to us still astound us with their sheer scale and sophistication. For want of a better label, we call these buildings 'temples', although we are not quite sure what went on inside them originally. In order to create the structures, the builders had to develop a sound understanding of the properties of the different stone materials that the archipelago offered. The builders even developed different building techniques in order to cope with the types of stone that were available across the archipelago. Globigerina Limestone could be cut and shaped into regular blocks, allowing the builders to create coursed masonry. With the harder Coralline Limestone, on the other hand, the builders usually fitted irregularly-shaped lumps of rock together to form their walls.

The raising of these buildings required several technological innovations. The most challenging was probably the creation of corbelled vaults in order to roof over the circular rooms inside the buildings. Each course of stone was laid to over-hang slightly over the one below, so that the walls curved inwards, making it possible to roof over larger spaces. Within the buildings themselves, we find more examples of ingenious uses of stone materials. The soft Globigerina Limestone was carved to make sculpture in the round or in low-relief. Many statues with a human form have been found inside the buildings, as well as large panels of low-relief sculpture carved into the surface of megalithic blocks.

continues on page 50

Opposite: A 'porthole' doorway cut from a single slab of Globigerina Limestone. Ħaġar Qim Temples.

Bottom: The façade of Mnajdra Temples is built of Coralline Limestone, while Globigerina Limestone is used for the interior.

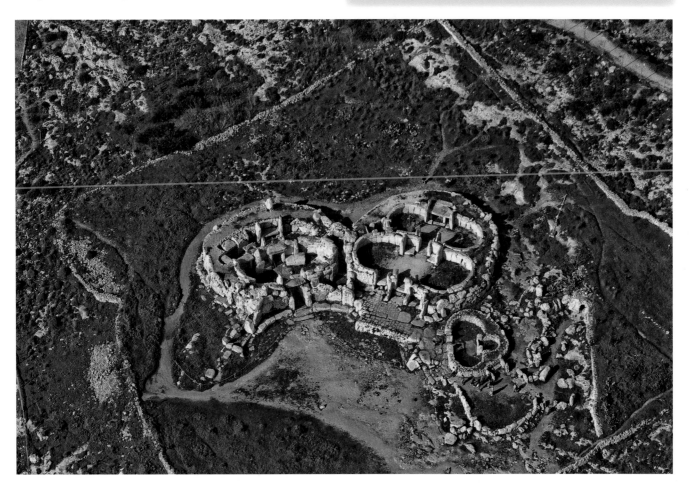

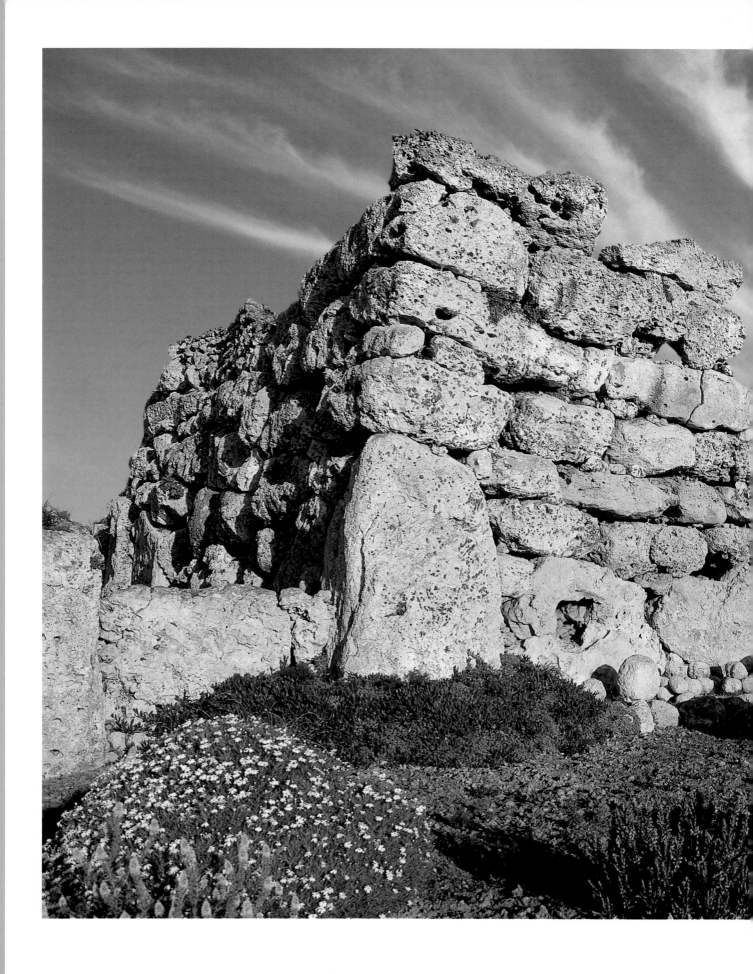

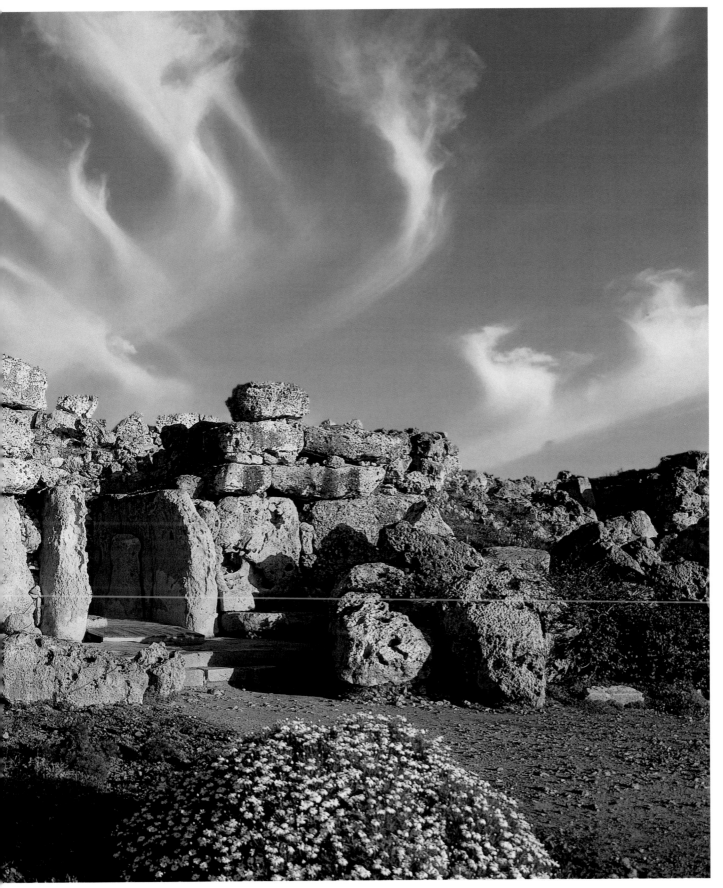

The monumental façade of the Ġgantija Temples in Gozo still towers to a height of over seven metres.
Ġgantija is largely built of the Upper Coralline Limestone that it stands on, but Globigerina Limestone
was transported from several kilometres away to form the smooth doorjambs.

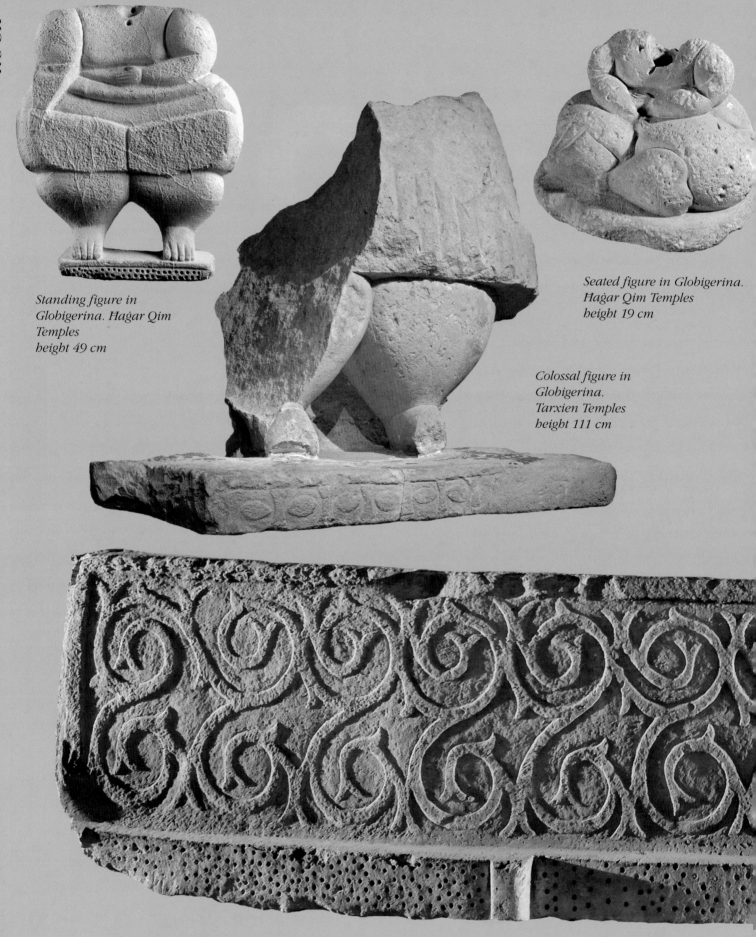

*Standing figure in
Globigerina. Hagar Qim
Temples
height 49 cm*

*Seated figure in Globigerina.
Hagar Qim Temples
height 19 cm*

*Colossal figure in
Globigerina.
Tarxien Temples
height 111 cm*

Chert blade found at the
Xaghra Circle
length 23 cm

Globigerina head.
Tarxien Temples
height 4.5 cm

Globigerina model of a
megalithic building.
Ta' Hagrat
height 3 cm

Stylized standing figure in
Globigerina. Xaghra Circle
height 19 cm

Coralline Limestone
mallet. Hal Saflieni
Hypogeum
length 28 cm

Top: Low relief panel in
Globigerina.
Hagar Qim Temples
width 72 cm

Below: Low relief panel in
Globigerina. Tarxien Temples
width 293 cm

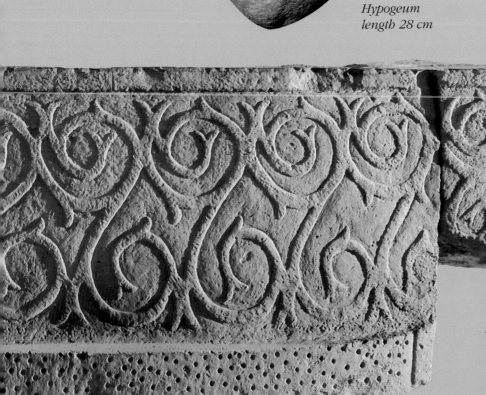

**A selection of artefacts showing the
versatility of Neolithic artists and
craftsmen in the use of local materials.**

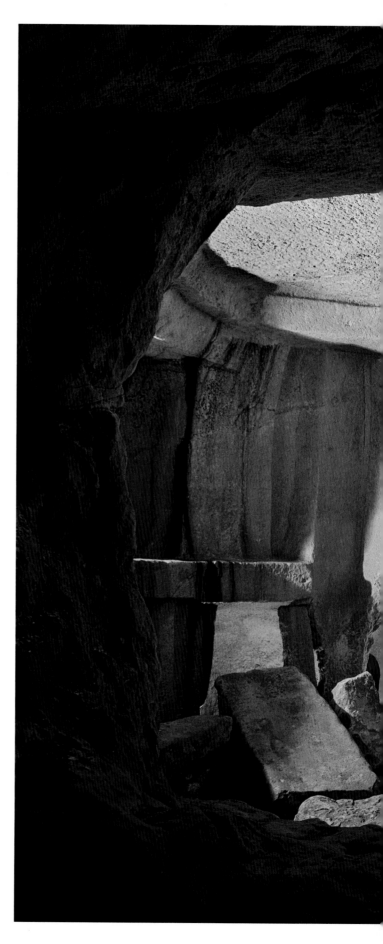

continues from page 45

While the megalithic buildings were being raised above ground, another kind of space was being carved into the rock, deep underground. The builders buried their dead in underground chambers. The older examples of these burial chambers were quite small, just large enough to crouch in, and each had their own separate entrance shaft. The size and layout of these places of burial became progressively more ambitious. The most stunning example that is known at present is the Hypogeum of Ħal Saflieni, in Paola. The underground site lay forgotten for thousands of years. Then in 1902, while a new street of houses was being built, workers cutting into the Globigerina Limestone rock to create cisterns for the storage of rainwater suddenly broke into a series of strange underground chambers. They had made one of the most extraordinary discoveries of the twentieth century. When fully excavated and explored, it was found that the prehistoric burial site was cut on three main levels, one deeper than the other. The underground chambers were so ingeniously executed that, in spite of being 5,000 years old, no part of the complex had collapsed. Some of the walls were found decorated with paintings. The most striking chambers, however, are the ones carved to look like the built interior of a megalithic building, complete with megalithic doorways and corbelled ceilings. The idea of carving a sculpture to look like a building occurs again and again in more recent periods. The example of Ħal Saflieni is, however, the earliest example to be executed with such sophistication and on such a grand scale. It represents an important leap of creative genius, the result of which was astoundingly original.

Up on the surface, a very different kind of sculpture in the rock has created a monument that is no less remarkable, and no less enigmatic. At countless points across the Maltese archipelago, areas where bedrock is visible on the surface are characterized by channels cut into the rock. As the channels are always found in pairs, they have often

The central chamber of the Middle Level of the Ħal Saflieni Hypogeum is a rock-cut representation of the interior of a megalithic building.

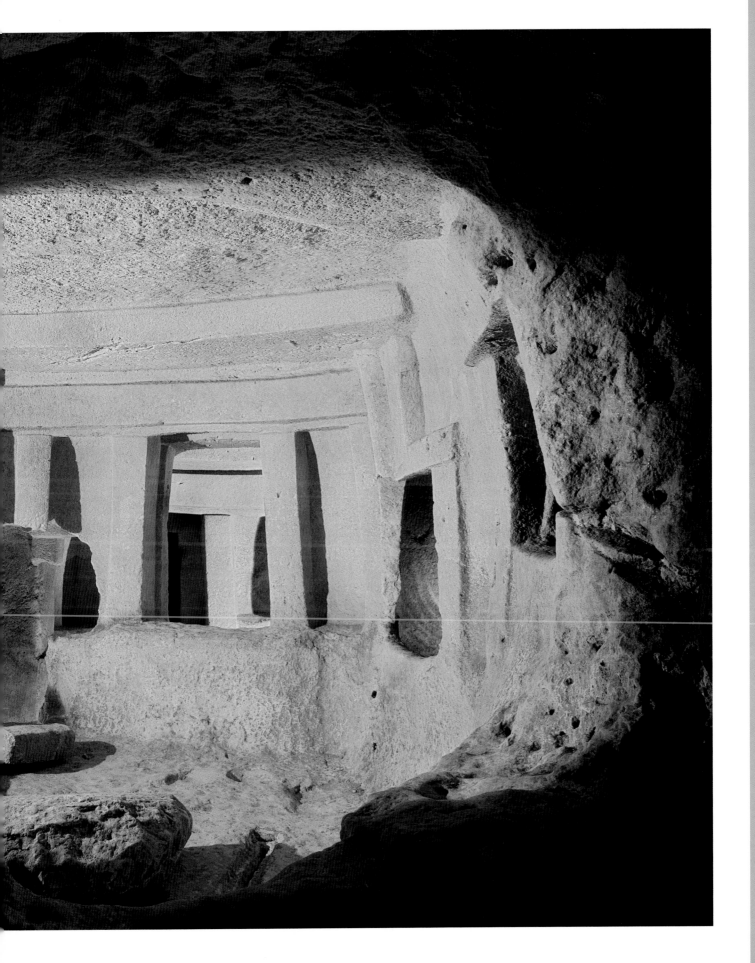

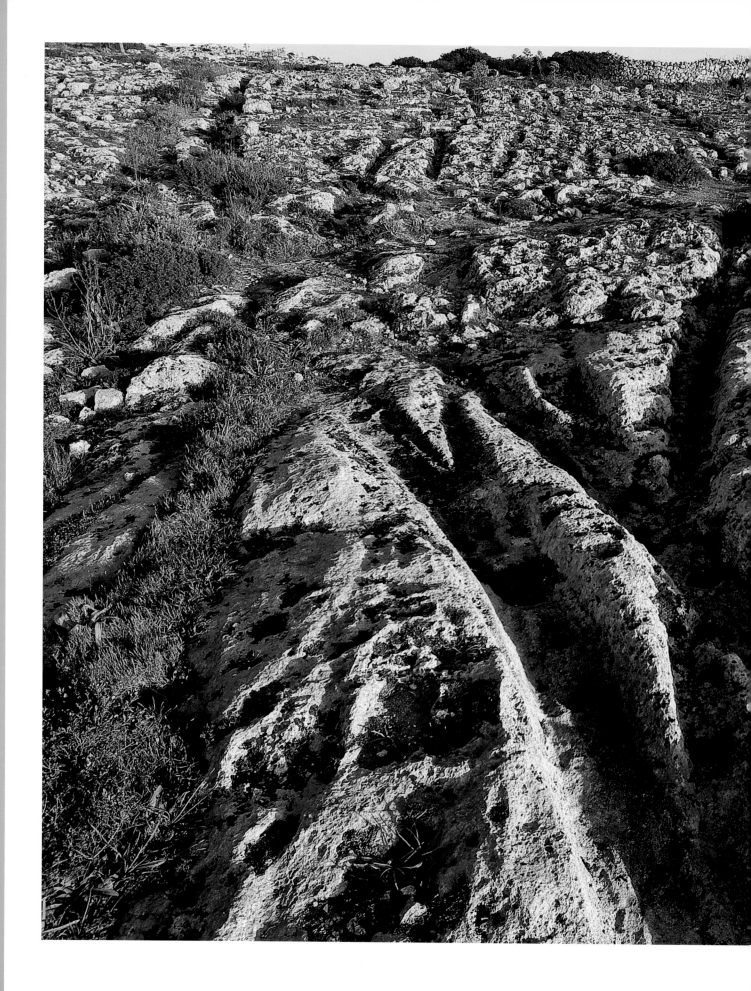

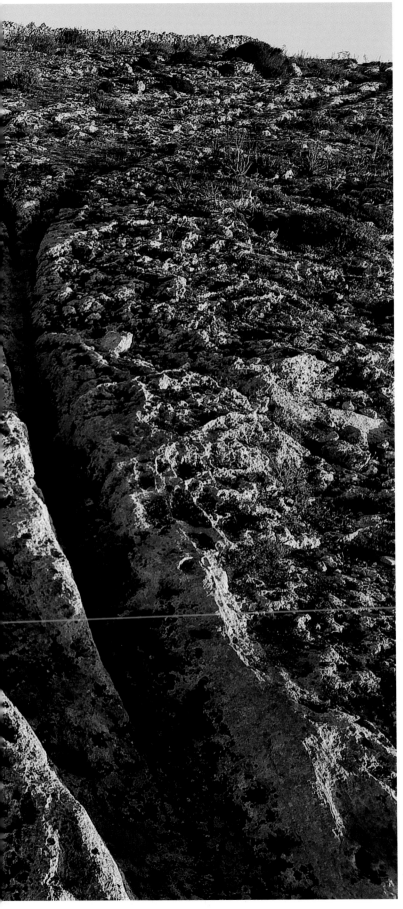

been labelled as 'cart-ruts'. They are known to occur in a wide range of configurations, ranging from a single, isolated pair visible only for a short distance, to dense networks of intersecting and bifurcating pairs. For centuries, they have bewildered antiquarians and archaeologists, who in turn have come up with a bewildering variety of explanations, ranging from water-collection systems to agricultural practices, and from quarrying activity to transport. The dating of these features is also a matter of some debate, as the evidence from different examples has been used to reach contradictory conclusions, sometimes suggesting a Bronze Age origin, and sometimes pointing towards the Phoenician or even Roman period.

One possible explanation for the seemingly contradictory evidence is that the features that are collectively referred to as cart-ruts were created over a very long period of time, perhaps for different purposes. Some form of transportation appears to be the most likely explanation for most examples. One of the more attractive hypotheses is that many of them were created to transport soil for the formation of terraced fields, as the agricultural exploitation of the islands intensified. As rain tends to wash soil down into the valleys, in order to cultivate the slopes it may have been necessary to carry large volumes of soil upslope.

The type of transportation that would have required the ruts has also been much debated. The form of the channels suggests some kind of sledge rather than a wheeled vehicle. The matter however is far from resolved. Each year, more examples are discovered and recorded, permitting researchers to base their arguments on a more complete sample of the evidence. In the meantime, the cart-ruts will continue to be one of the longest-standing enigmas of Maltese archaeology.

The complex network of tracks gouged in the rock near Buskett. This site is widely known as 'Clapham Junction', in a playful reference to a busy railway junction in south London.

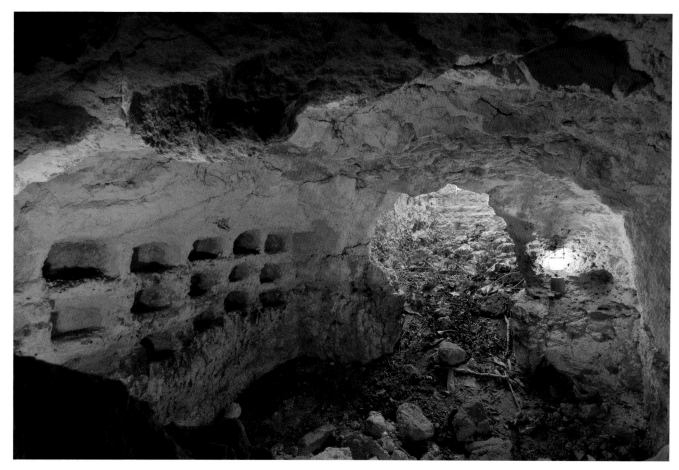

The idea of burying the dead in rock-cut underground chambers was by no means limited to prehistory. Two thousand years after the Hypogeum was created, we find another people exploiting the rock of the Maltese archipelago for the same purpose. These people have gone under several names. Although they probably called themselves Canaanites, the Greeks called them 'Phoenician', which the Romans shortened to 'Punic'. Before the close of the eighth century BC, the Phoenicians had established permanent settlements on Malta. By the fifth century BC, Carthage emerged as the most powerful Phoenician colony, and the Maltese islands fell within its sphere of influence for the next 200 years.

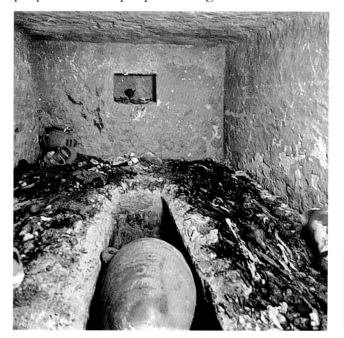

Top: An early Phoenician tomb chamber at Għajn Klieb, Rabat.

Left: Punic tomb chamber showing platforms for the dead on either side, separated by a trench that helped drain away any rainwater that leaked into the tomb. Rabat, Malta.

Opposite top: A typical rock-cut shaft leading into a tomb chamber. The surrounding wall is modern. 'Clapham Junction' near Buskett, Rabat.

Opposite below: Undisturbed Punic tomb chamber in Guardamangia, as it was discovered in 1960.

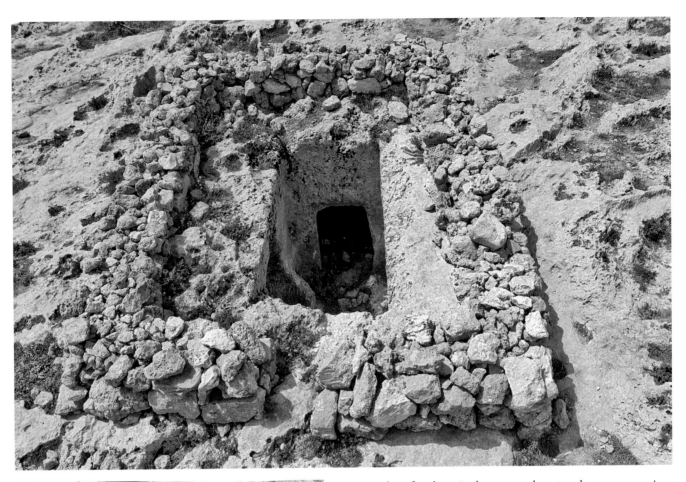

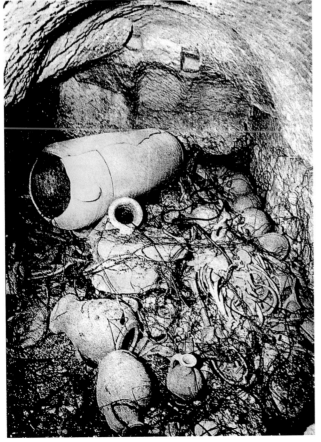

Much of what is known about what was going on in Malta during this period is based on evidence from rock-cut tombs. Tombs were a serious business for the Phoenicians. In their belief system, the tombs were houses for the dead which had to serve their needs during their journey to the underworld. That meant that the burial chamber needed to be rather spacious, and also that it had to be secure from robbers. To make a tomb, the first step was to cut a vertical shaft into the rock, usually between two and three metres deep. A narrow doorway was then cut into one of the walls of the shaft, and a chamber hollowed out behind it. Sometimes more than one chamber was cut around the same shaft. Inside the chamber, platforms made of the living rock were left along the longer sides, usually to the left and right of the entrance. The dead were laid out lengthwise on these platforms, very much like a person lying on a couch. A trench was often cut into the floor of the chamber between the couches, to help drain any water that leaked into the tomb. Here the food and drink needed for the journey was stashed in pottery vessels. Personal ornaments such as bead necklaces or jewellery were often buried with the body.

continues on page 58

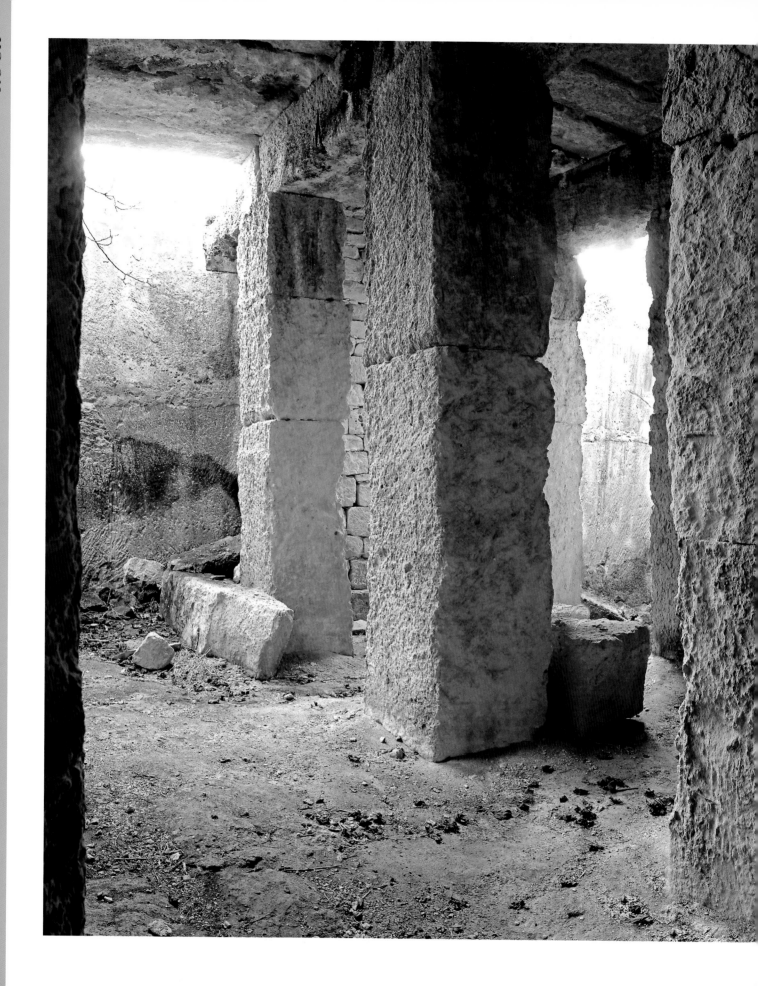

Rock-cut cistern at the Roman villa of Ta' Kaċċatura, roofed with colossal blocks of Globigerina Limestone

57

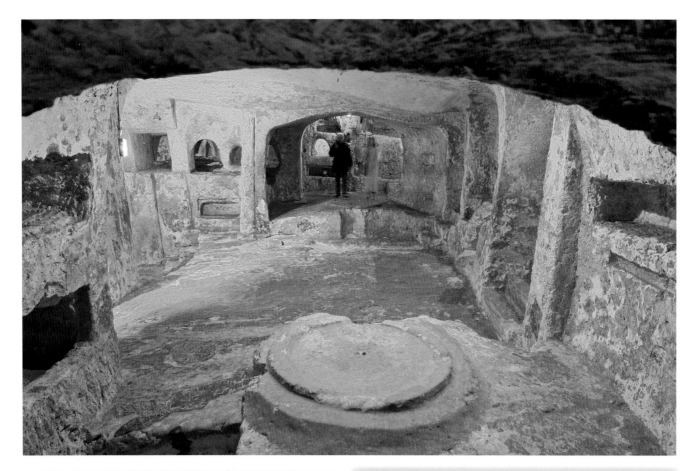

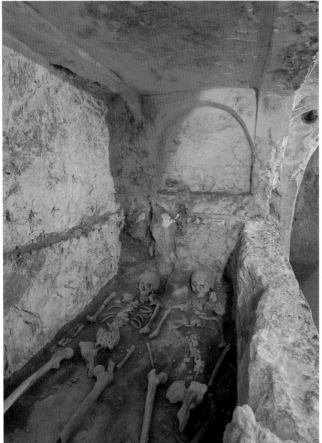

Top: A pair of rock-cut tables with couches to recline on during funerary meals. St Paul's Catacombs, Rabat.
Left: Catacombs of the late Roman period are characterized by paired burials. St Agatha's Catacombs, Rabat.

Century after century, hundreds and hundreds of these tombs were created across the island, wherever settlements existed. Two of the largest concentrations are in the area around Rabat, which was probably the principal settlement, and in the area around the Grand Harbour, which was vital for the shipping interests of the Phoenicians and the Carthaginians.

In 218 BC, Malta was seized by Rome and was to remain under its control for over 600 years. The tradition of rock-cut burials continued to evolve gradually. Most burials were concentrated in the area outside the western walls of the ancient town of *Melite* which has since been built over by the westward extension of Rabat. Century after century, the rocky plateau was turned into a vast graveyard. As space on the surface ran out, people began to burrow deeper into the rock to bury

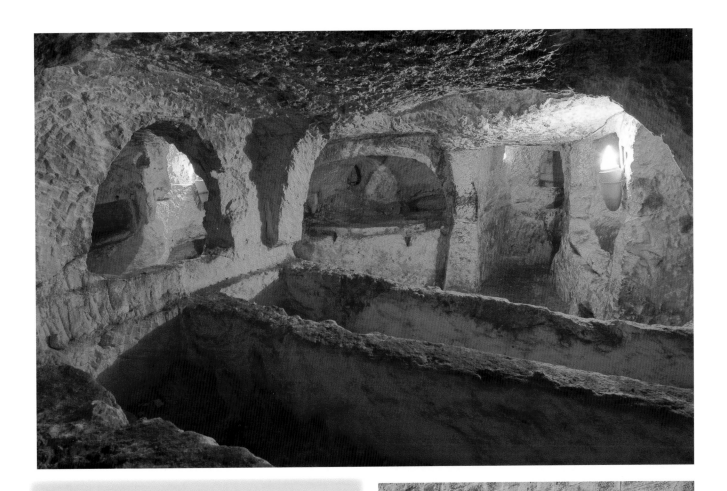

Top: Canopied tombs are very common in Maltese catacombs. The canopies defined the tombs while also supporting the roof. St Agatha's Catacombs, Rabat.

Right: Late medieval windows in the Citadel, Gozo

their dead. Networks of tunnels were hewn into the chalky Upper Coralline Limestone that forms the plateau to create the extensive underground cemeteries that we know as catacombs.

As a result of the dense superposition of successive periods of human activity, the edifices from one age have often been replaced by those of the next. This is especially true of urban areas such as Rabat in Malta as well as Rabat in Gozo, which for millennia have served as the principal settlements of the islands. As the needs of the inhabitants changed over time, buildings had to be modified accordingly. Changing belief systems, fluctuations in population density, and new defence strategies all resulted in new requirements, which had to be accommodated by adapting existing structures or even demolition and total rebuilding.

continues on page 62

A remarkable survivor from the Middle Ages is Palazzo Falson, Mdina

continues from page 59

Gradual erosion by the elements, as well as the occasional earthquake, also took their toll. As a result, the streetscapes that we see today are mostly made up of buildings from the last four or five centuries.

And yet some venerable survivors have come down to us from earlier centuries, as intact buildings that are still in use. In the medieval urban settlements of Birgu, Mdina and Rabat on Malta, as well as the Citadel of Gozo several buildings from the Late Middle Ages may still be seen, often decorated in the distinctive Chiaramonte style that flourished in Sicily during the 14th century. Wandering through the streets, it is difficult to recognize buildings from even earlier centuries. The remains of structures from the early Middle Ages and the Roman period often form a part of the cellars, foundations and lower floors of later buildings.

The most remarkable case of a standing building to survive in a usable state lies hidden in Żurrieq *[right]*. It stands in an orchard, oblivious to the baroque additions that lean against it, and to the hum of traffic from beyond the high garden wall. In the eighteenth century, it was already being recorded as an object of wonder. The remarkable state of preservation of its carefully dressed masonry belies its true age. The distinctive, Egyptian-style cornice that surmounts the structure, however, leaves little doubt that it was raised in the Punic period. The parish priest of Żurrieq is one of the very few men in the world who may boast that the building standing in their back garden dates from before the birth of Christ!

Returning to the streets of Żurrieq, one is immersed in a very different period. As in most of the archipelago's historic village cores, it is the baroque mood of the seventeenth and eighteenth centuries that has left the most enduring imprint on the streetscapes we see today. The period from 1530 to 1798, during which the Order of St John made Malta its home, brought about an unprecedented period of building activity, attracting leading artists and architects from Europe, and nourishing others who were native born. The prosperity generated by the presence of the Order also created the conditions for rapid demographic growth. Even as many smaller, dispersed settlements were abandoned, villages such as Żurrieq,

Qormi, Żebbuġ, Siġġiewi and Birkirkara grew into prosperous towns.

The towns and villages that were remoulded during the baroque period share a number of distinctive characteristics. At the heart of each thriving township, the parish church is its pride and joy, usually towering over the piazza that is the focus of community life. Typically, the baroque steeples and cupola of the parish church dominate the skyline of the village. The houses of the wealthier families jostle for attention around the church piazza, with their sculptured façades, painted shutters and polished brass knockers. The more modest buildings in the backstreets were created with no less pride and care. Surprising displays of the stonemason's craft lie hidden round the corner of every alleyway.

continues on page 69

Opposite: The village piazza is the focus of community life. Siġġiewi. The statue in the centre of the piazza depicts St Nicholas, the village's patron saint.

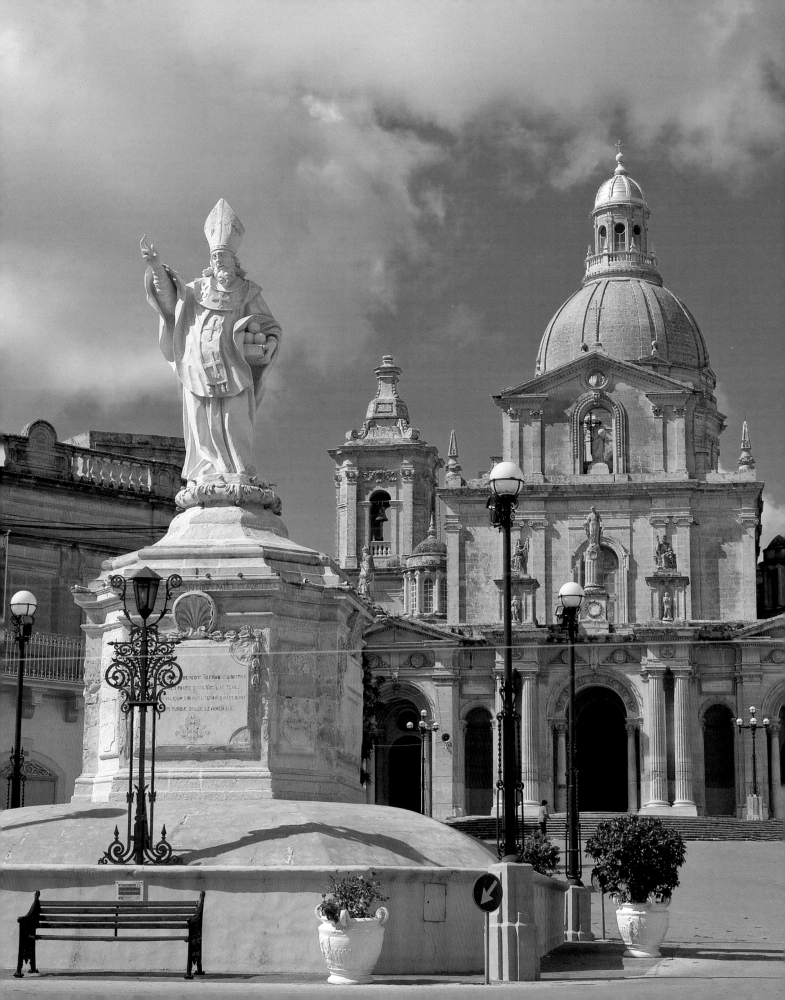

A maze of streets and houses huddled round the parish church of St George. Rabat, Gozo

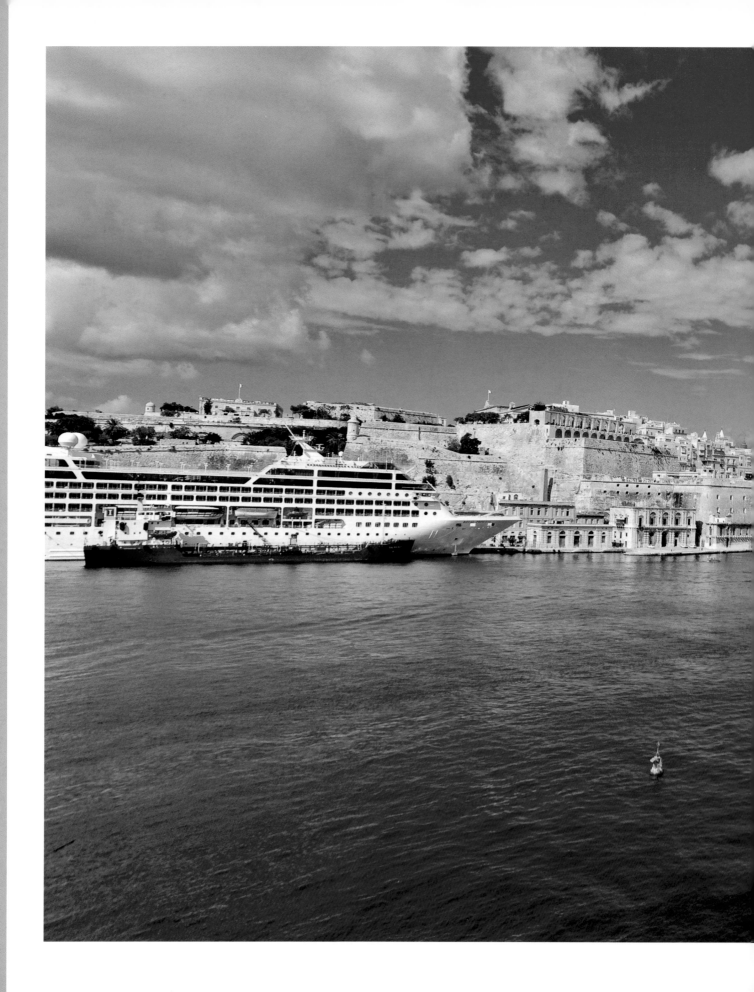

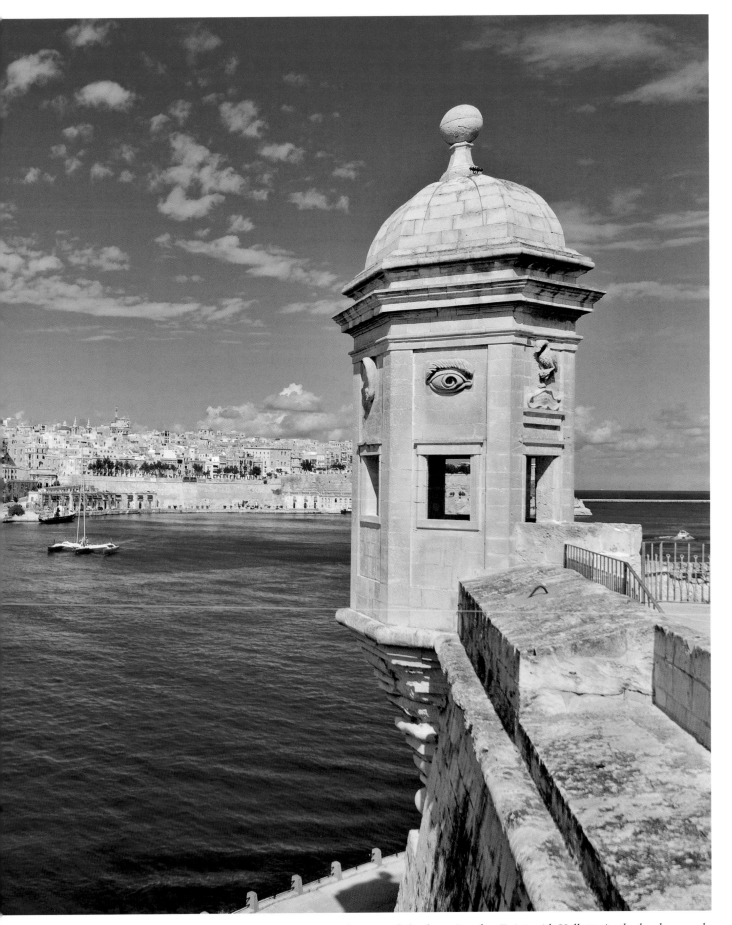

Even fortifications became the setting for baroque architectural displays. Senglea Point with Valletta in the background

b

a

a. Early 17th-century west front of the old parish church, Birkirkara

b. Detail from the 18th-century façade of Għargħur's parish church

c. Detail from early 20th-century façade of Gudja's parish church

d. The historic village core of Attard

c

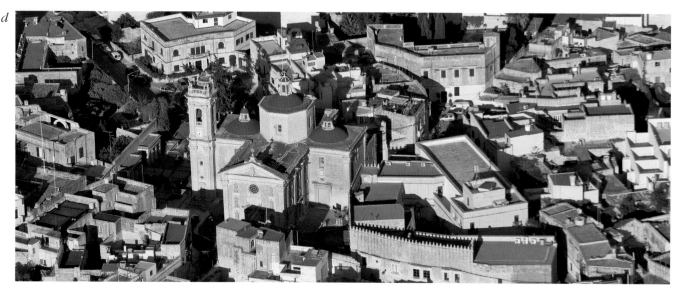

d

continues from page 62

The properties of Globigerina Limestone, eminently suitable for carving, together with the knowledge and experience of local craftsmen, and the influence of baroque taste that swept over the islands from the continent fused happily into a distinctively Maltese mode of expression.

During the nineteenth and early twentieth century, a succession of other styles was effort-lessly adopted by Maltese sculptors as they came into vogue, such as neo-classical, neo-gothic, and nouveau. Meanwhile the population continued to register steady growth, and new neighbourhoods were created to provide more housing, usually in the form of terraced houses on a grid-iron street plan. Following the building booms that began after the World War Two, the development of the islands is reaching a saturation point. A high pro-portion of the surface area of the archipelago is now covered by buildings, in some cases built over some of the better quality stone before it could be quarried. The quarries where the harder grades of

The parish church of Żebbuġ, showing part of the parvis in the foreground.

Coralline Limestone are extracted to make gravel for use in road construction and concrete have taken a considerable toll on the landscape, and the importation of gravel is becoming increasingly recognized as a more sustainable alternative to lo-cal extraction.

These complex pressures require a high level of far-sighted planning. The creation of a plan-ning authority in the early 1990s has gone a long way to address the challenge, and not a moment too soon. At a time when the machinery available has enabled the inhabitants of the islands to pul-verise and manipulate its rock with greater ease than ever before, it has become more important than ever that this power is carefully regulated, to safeguard the quality of life of today's inhabitants as well as those of tomorrow.

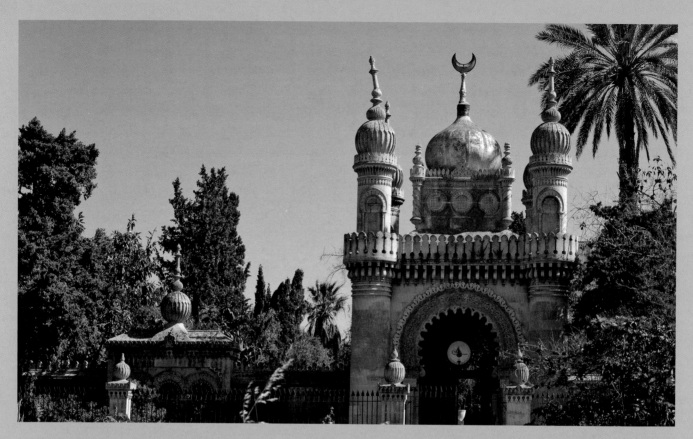

During the 19th century, Maltese limestone
was worked more eclectically than ever,
from the orientalizing fantasy of the Turkish
Cemetery in Marsa...

... to the neo-classical
rotunda of Mosta, based on
the Pantheon in Rome...

... or the austere lines of the
bakery that the Royal Navy
built at Vittoriosa to supply
its Mediterranean fleet.

The 20th century shaped globigerina into the towering art nouveau of Balluta Buildings in St Julian's…

… regimented it into the rather more serious-minded proliferation of military barracks across the island…

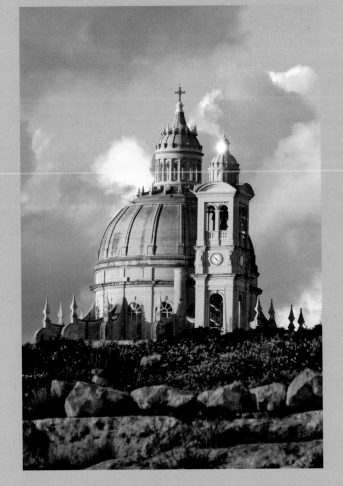

… and even used it to recreate Venice's church of Santa Maria della Salute on the former site of the prehistoric temple of Xewkija!

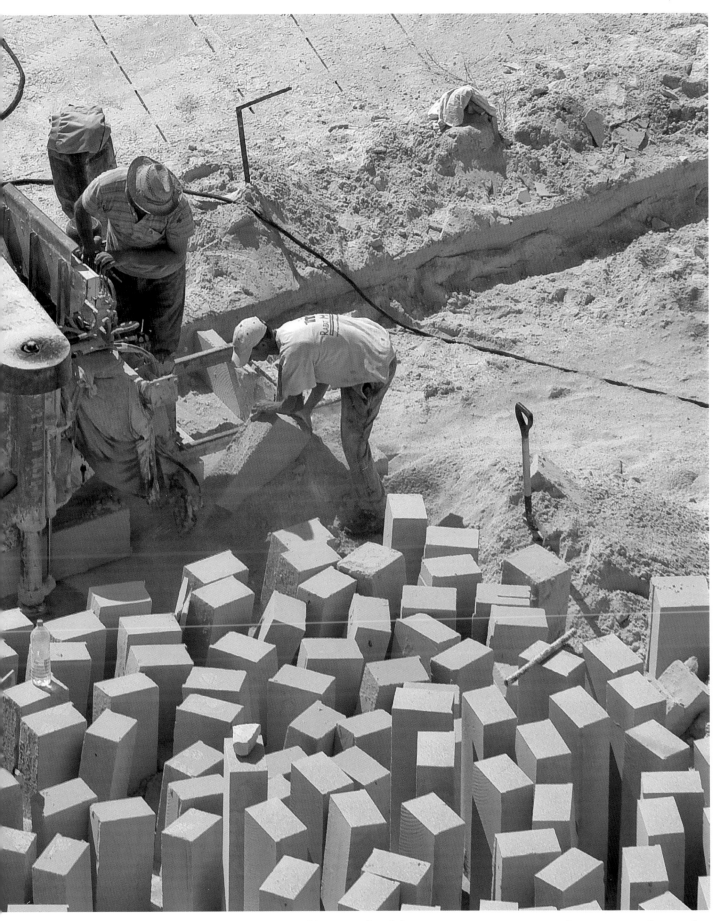

New tools, same old materials. Globigerina Limestone quarry in San Lawrenz, Gozo, today

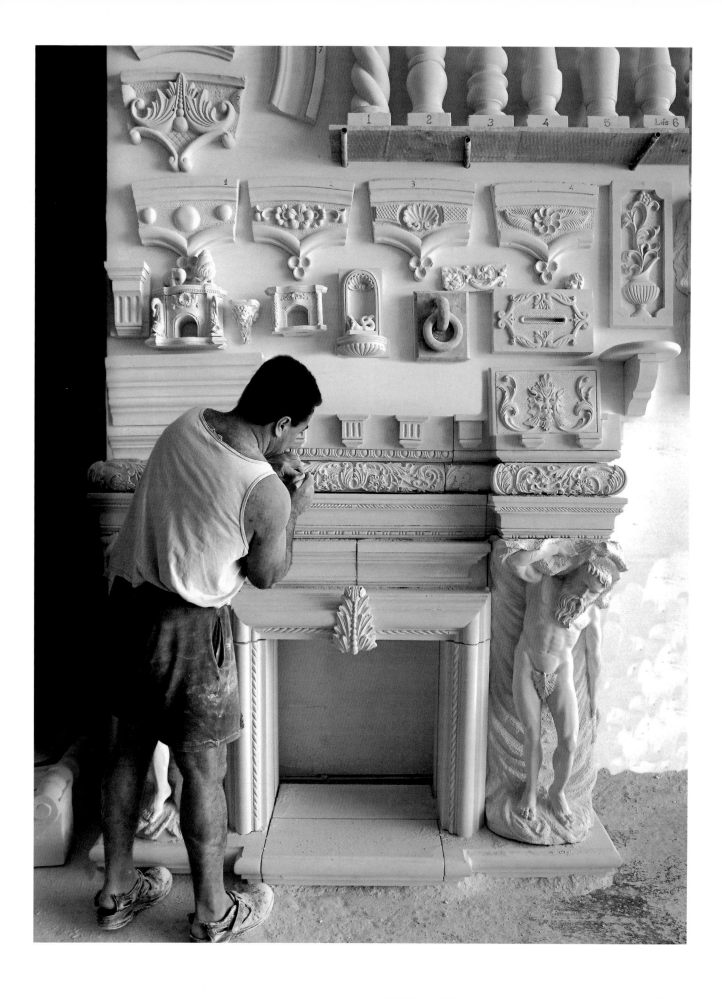

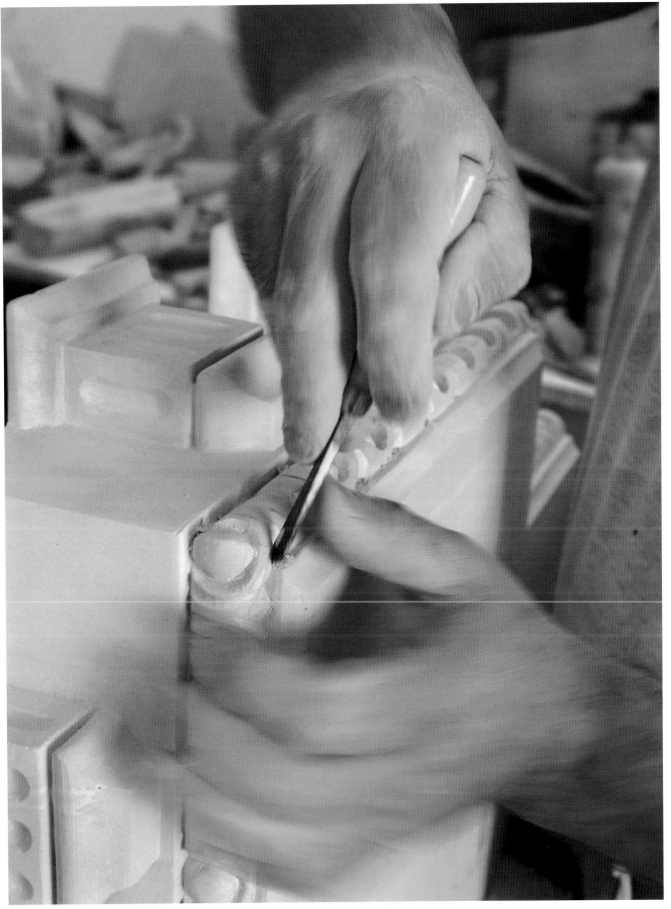

Traditional stone carving is enjoying a revival in popularity

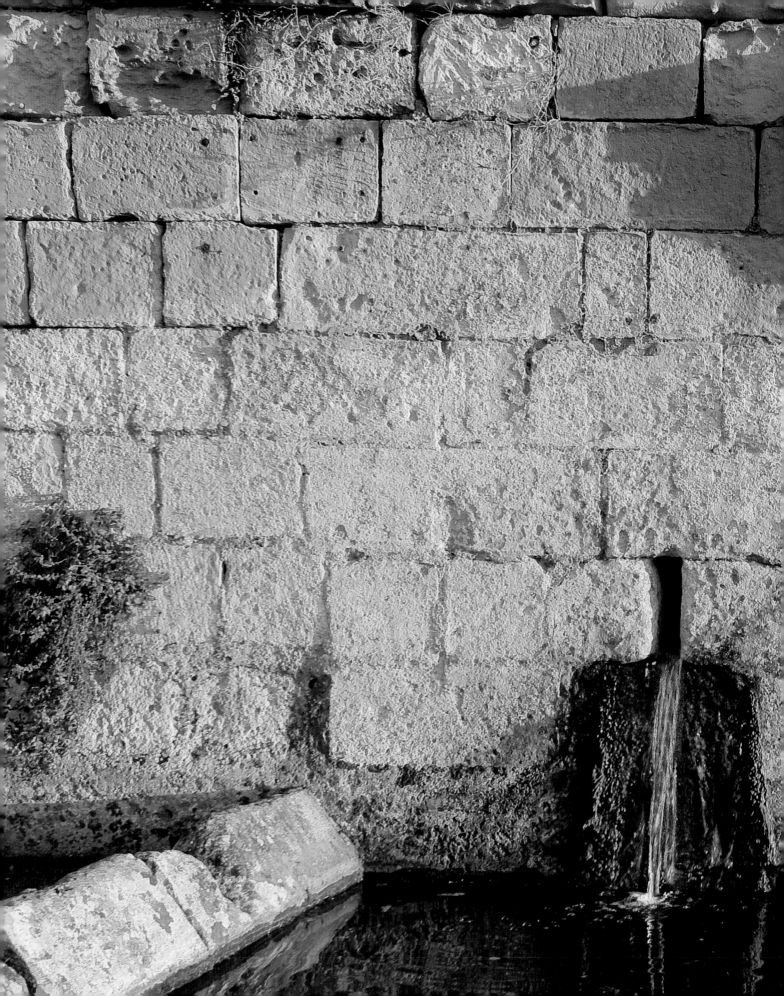

Water

The availability of fresh water is a fundamental prerequisite for human existence. For the inhabitants of the Maltese islands, the scarcity of fresh water has always been a matter of concern, critical to their survival. The layers of porous limestone that make up the geological structure of the islands have sometimes been compared to a giant sponge that can hold a large volume of water within its pores. Rainwater percolates through the rock to gather deep underground, forming a freshwater table at sea level. It will be recalled that one of the geological layers that make up the islands is a layer of impervious clay. Where the clay layer is present, it creates another water table above it, perched high above sea level. Water escaping from the edges of this perched water table supplies a large number of perennial springs. In areas where the clay formation is absent, such as south-eastern Malta, springs are relatively rare. In such areas, people had to depend more on the collection and storage of rainwater from the winter months, for use during the dry summer season.

Although the geological structure of the island had such an important bearing on the storage of freshwater and the formation of springs, these processes were poorly understood until quite recently.

The ancient fresh-water spring of Għajn Għerixem, on the outskirts of Rabat. The coat of arms carved in Globigerina Limestone depicts the Maltese colours, white on the left and red on the right.

Early modern descriptions of the archipelago pay considerable attention to its hydrology, allowing us a glimpse of how this was understood. In the mid-seventeenth century, the pioneer historian and antiquarian Gian Francesco Abela explained the existence of the sea-level water table as the result of water being driven up through the rock by winds blowing over the sea. As late as the last quarter of the eighteenth century, learned people such as the traveller and artist Jean Houel still believed that spring water was formed by condensation in the rock.

Top: The amount of water present in the landscape changes dramatically with the seasons, transforming the lush greenery of the rainy months...

In past centuries, it was also believed that water that collected in certain places was imbued with rare qualities. In the chapel of St Paul the Hermit, near Mosta, water trickles from a rock-face, to collect in a series of small rock-hewn basins. During the seventeenth and eighteenth centuries, water from this source was highly prized as it was believed to help keep those who drank it regularly in good health.

Today we can only try to imagine the awe and wonder that fresh water sources may have inspired centuries ago. The oral and written evidence that has come down to us from medieval and early modern times speaks of a fascination with the source of springs, their origin in time, and the reason that they occur in a particular place. There is a considerable repertoire of Maltese and Gozitan legends that seek to explain the origin or location of various springs. Perhaps the best known is that of Għajn Rasul, in St Paul's Bay [*left*]. This spring was believed to owe its origin to St Paul, who struck the rock and performed a miracle there after his shipwreck, in order to quench the thirst of the survivors. Another story concerns Għajn Abdul, on Gozo. According to the story, the spring was named after a slave or pirate who had been walled up in a cave for his wrongdoings. He desperately

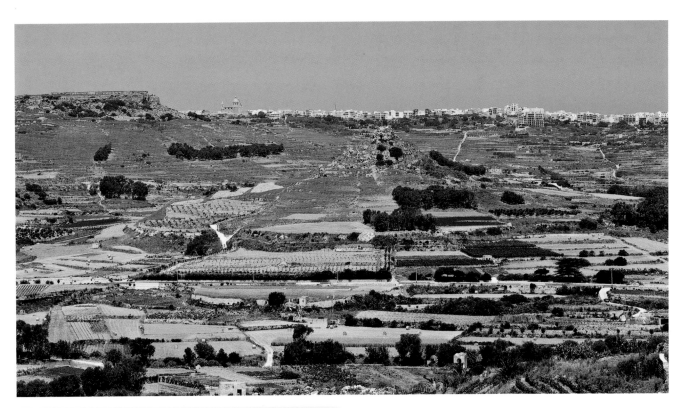

...to the parched shades of summer, broken only where fields are irrigated with carefully nursed water. Marsalforn Valley, Gozo.

dug into the ground until he discovered the spring and promptly drank so much water that it killed him. In yet another story, seven maidens who wandered into a water gallery in the sanctuary of Our Lady in Mellieħa were never seen again. Sacredness and danger are recurrent themes in these stories. The providential presence of a life-sustaining spring inspired association with the sacred, as well as notions about appropriate and inappropriate behaviour.

It is evident from such stories that the presence of springs loomed large in the way the islanders understood their world. The naming of places after springs is another indication of the importance that these held for the islanders across different periods. A large number of place-names still in use today are medieval in origin. Many other medieval place-names have been preserved in late medieval and early modern written documents. Several hundred of these place-names make references to hydrology, allowing us a valuable glimpse of how the hydrological landscape was perceived and organized during the Middle Ages. In parts of the islands where the clay formation is present, toponyms that refer to an *għajn* (spring), are common. Where the clay formation is absent, *għajn* toponyms are exceptional, while *bir* (cistern) toponyms are widespread. In the absence of springs, the inhabitants were obliged to dig rock-cut cisterns for the storage of rain water. The place-name evidence shows how closely these strategies were dictated by the geological structure of the archipelago. This is also borne out by archaeological evidence of these strategies from pre-history to early modern times.

When the position of Neolithic megalithic sites is compared on a map to that of *għajn* toponyms, it becomes clear that there is a preference to locate these buildings near sources of fresh water.

continues on page 82

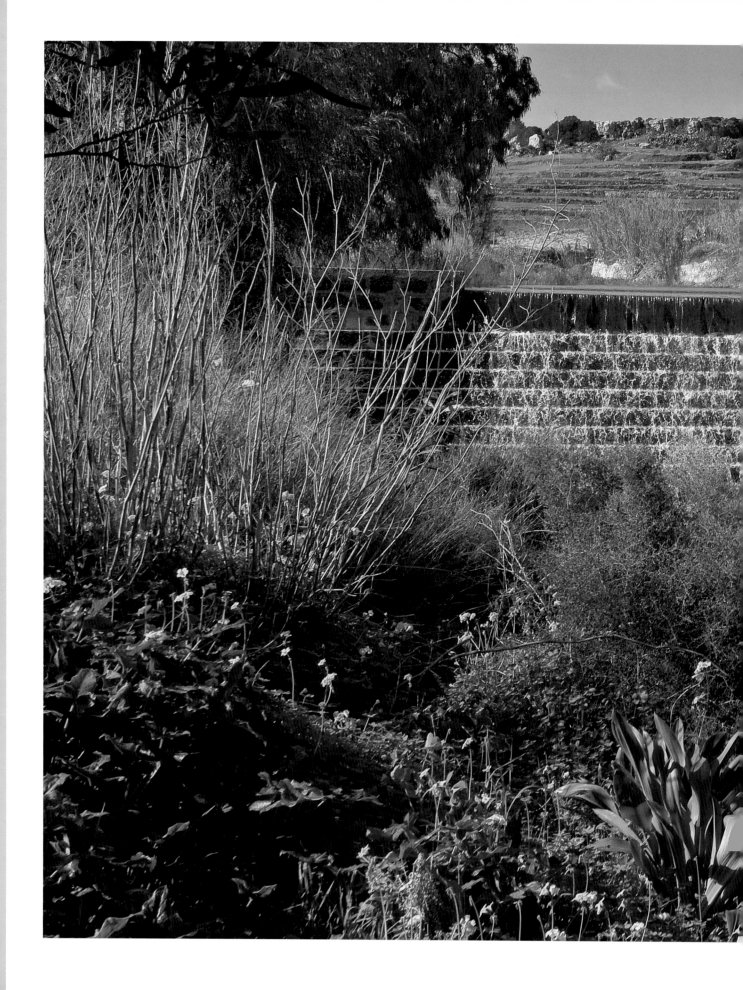

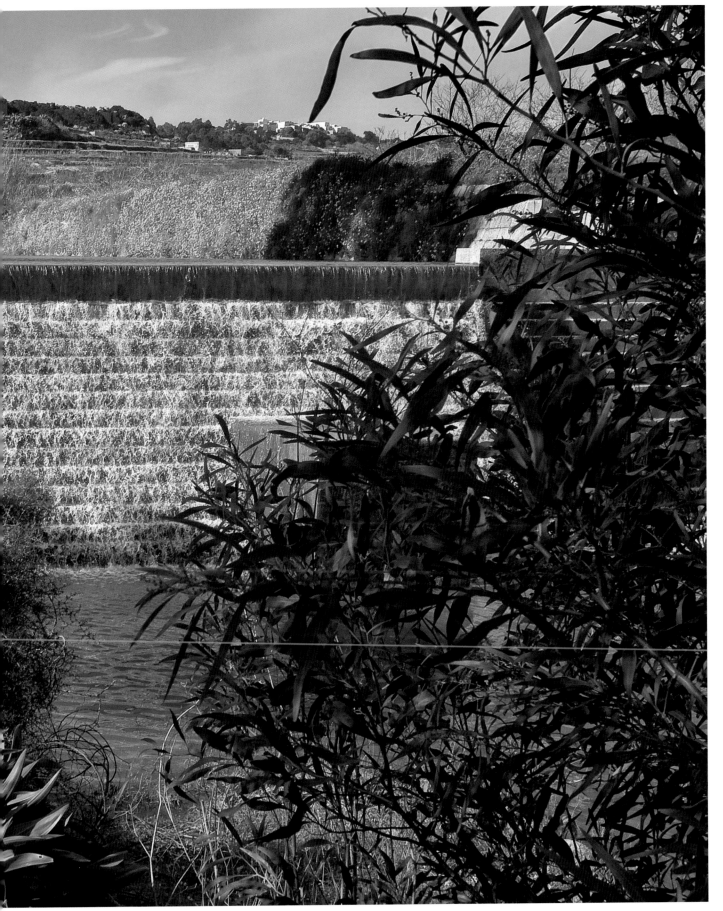

Valleys spring to life during the rainy winter months. Wied tal-Qlejgħa (Chadwick Lakes)

continues from page 79

Sometimes, the position of megalithic sites even coincides with an *għajn* toponym. One megalithic site in northern Malta is located at Għajn Żejtuna (the spring of the olive tree). On Gozo, the district where Ġgantija is located is known as Ta' l-Għejun ([the place] of the springs). The sites of Ta' Ħaġrat and Skorba are located in the district of Mġarr, which also means 'springs', while the area immediately south of Ta' Ħaġrat is known as 'Ta' l-Għajn'.

There are also remains of what may be water storage cisterns from the Neolithic period. The best-known examples are the Misqa Tanks, a group of rock-cut features near the Mnajdra Temples. The tanks are still in use today as water cisterns, and are practically impossible to date with any certainty. Some of the most remarkable water cisterns, however, date from the Phoenician and Roman periods. One of the most breathtaking examples is the large cistern that served the Roman farmstead at ta' Kaċċatura, close to Birżebbuġa. The rectangular cistern is cut into the Globigerina Limestone. Large blocks of the same material were used to raise massive pillars from the floor of the cistern, to support the roof which is still standing today, 2,000 years later.

The Romans were, of course, famous for their plumbing and their baths. Even in Malta, in spite of the general scarcity of water, we find elegant examples of bathing complexes that were fed by fresh water springs, such as the ones at Għajn Tuffieħa. Other remarkable water management systems have been dated to the Middle Ages, such as Ta' Baldu on the western coast of Malta, where a rock-cut chamber was created at the source of a fresh water spring. The most remarkable and extensive water management system, however, was to be created by the knights of St John. The knights built the new city of Valletta in the late-sixteenth century, on a peninsula of land with a harbour on either side. The choice of this location for the city was dictated by two fundamental considerations. As it dominated both harbours, it had easy access to shipping, while providing security to ships in harbour.

continues on page 89

Below: The enigmatic Misqa Tanks from the air

Opposite: The colossal rock-cut cistern at Ta' Kaċċatura was created to meet the needs of a Roman farmstead.

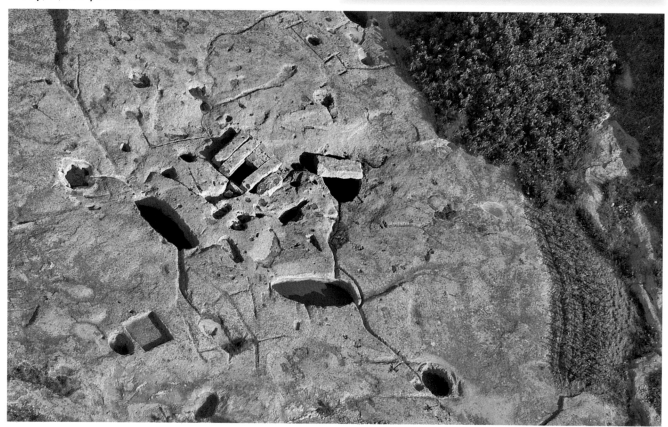

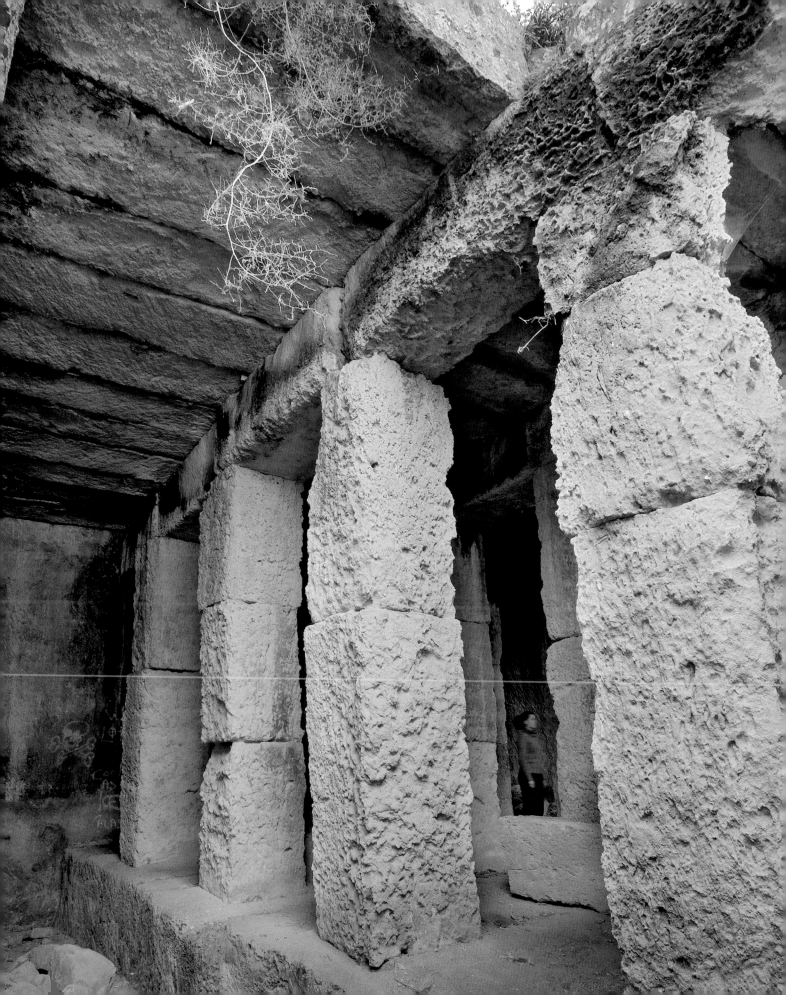

The sumptuous mosaic pavement of this courtyard in the Roman Domus in Rabat also served as a catchment area for rain water that was collected in an underground cistern. Water could be drawn from the well-head in the corner on the left.

A bell-shaped cistern in Casa Rocca Piccola, Valletta, re-used as an air-raid shelter during the World War Two

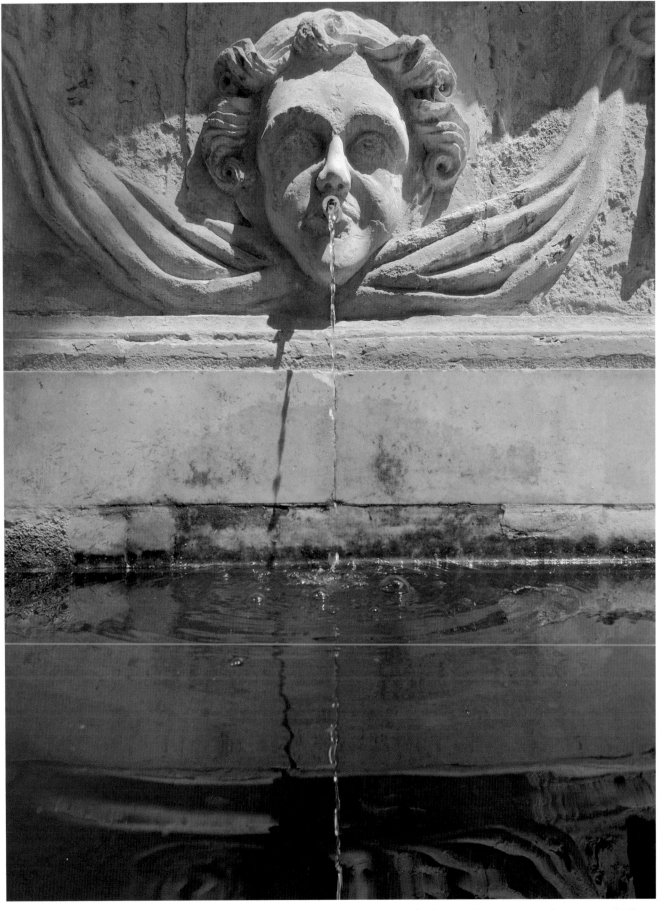

Detail of an early 19-century fountain in Valletta

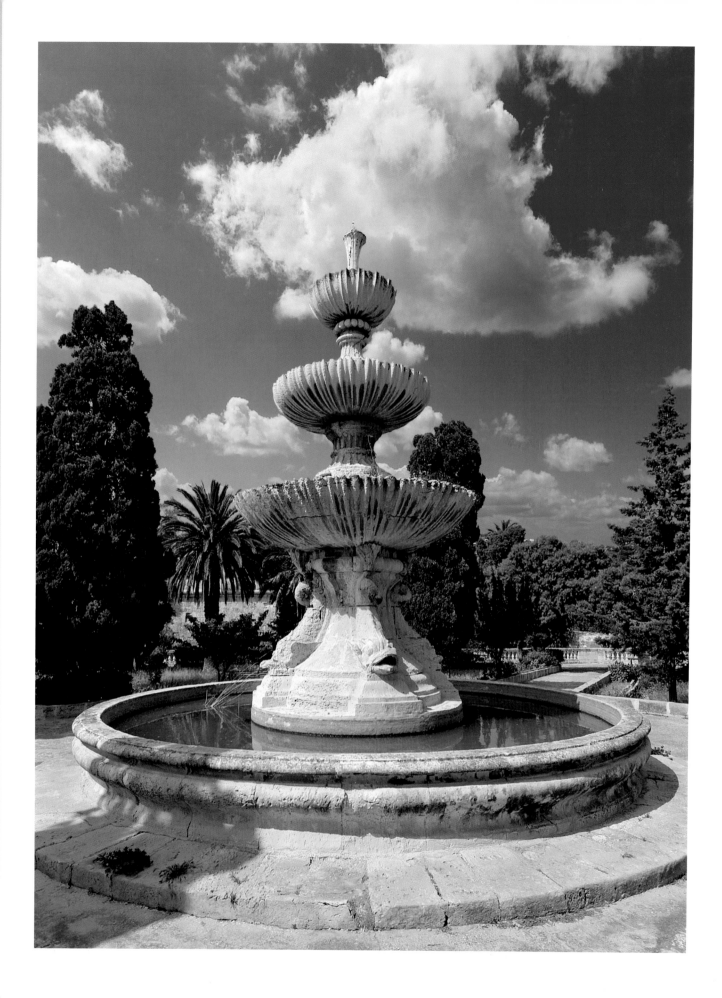

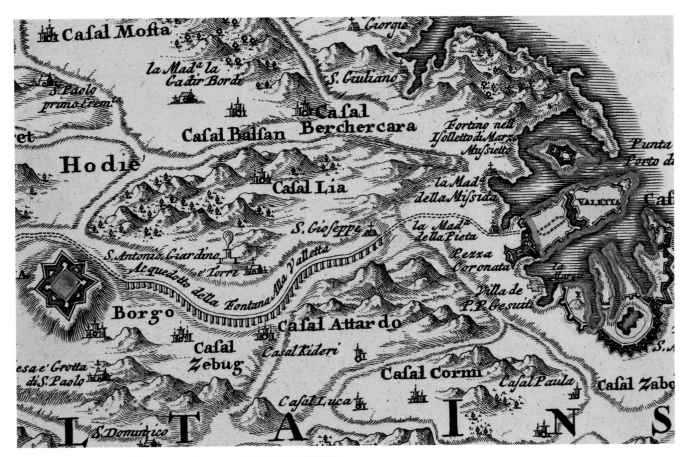

Above: The route of the Wignacourt aqueduct, shown on an 18-century map.

Opposite: This fountain in the Argotti Gardens, Floriana, was originally fed from the Wignacourt aqueduct and stood in front of the Grand Master's Palace in Valletta.

continues from page 82

Furthermore, as the peninsula had a small land-front, it could be more easily defended from a landward invasion. One advantage that this location did not have was the availability of a supply of fresh water. As the harbours were in the low-lying part of Malta, where the clay layer is not present, the city had to depend on the storage of rainwater from the winter months. For this purpose, every house and every public building was obliged to excavate and maintain deep cisterns in the Globigerina Limestone on which the city stands.

The question of the city's water supply was taken extremely seriously. The city had been built in the aftermath of a bloody siege by the forces of the Turkish sultan. While the city was being planned and built, the prospect of another siege was a very real and present one to the builders. In such a scenario, having a reserve of fresh water within the city to outlast a prolonged siege became a matter of life and death. In spite of all the water storage measures that were taken, the problem of water supply to the city remained a chronic one. A generation after the city was first laid out, the problem was finally addressed with an ambitious water management project. The proposed solution was to carry water from the western part of Malta (where the clay layer held a reserve of fresh water that fed natural springs) across the island to the drier, north-eastern coast, where Valletta stood. While the concept sounds simple enough, its implementation required a princely fortune, which came from the generous pockets of the Grand Master of the day, Alof de Wignacourt. It also took considerable ingenuity to carry the water by gravity across the rugged landscape. For a considerable length of the route, an aqueduct was raised on arches, in order to bring the water down at an even and gentle gradient. In the last part of the route, the water was driven under pressure through underground lead pipes, to rise again within the city walls.

continues on page 96

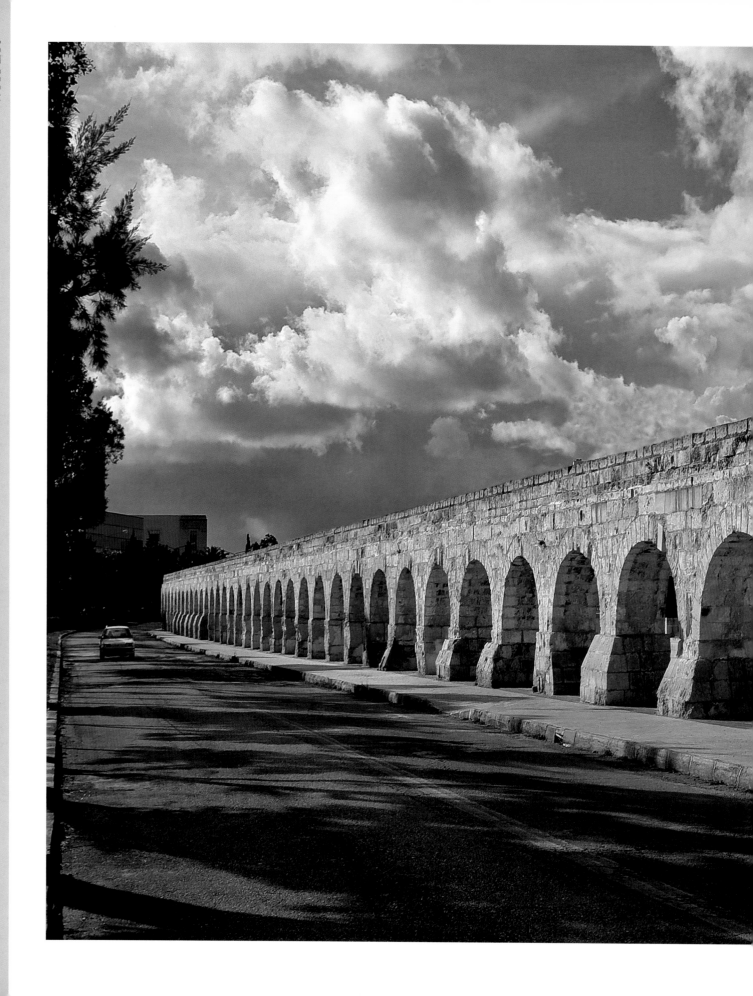

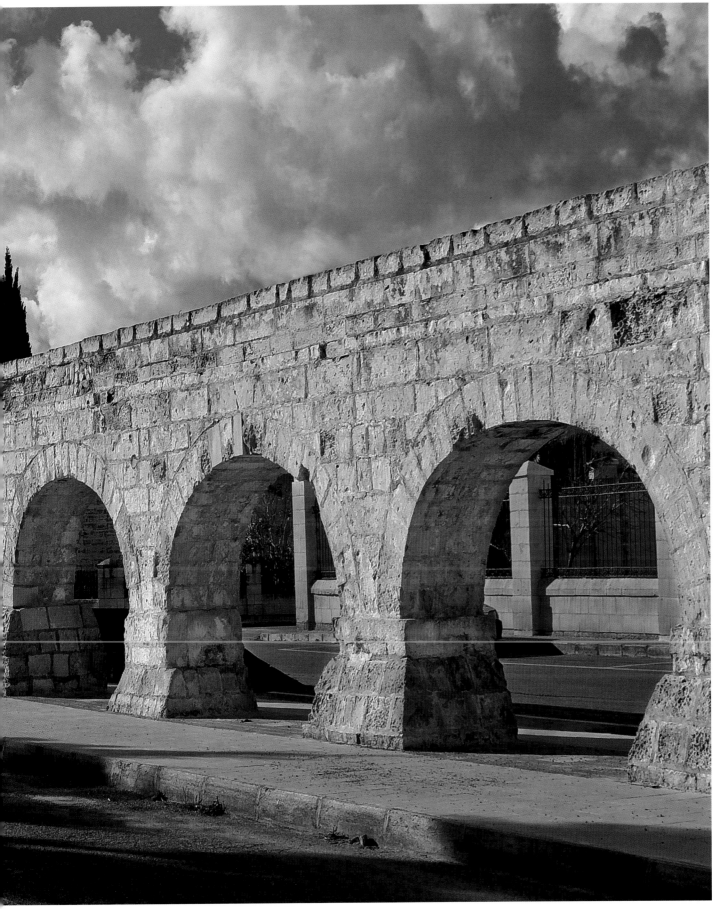

A stretch of the Wignacourt aqueduct today. Santa Venera, Malta

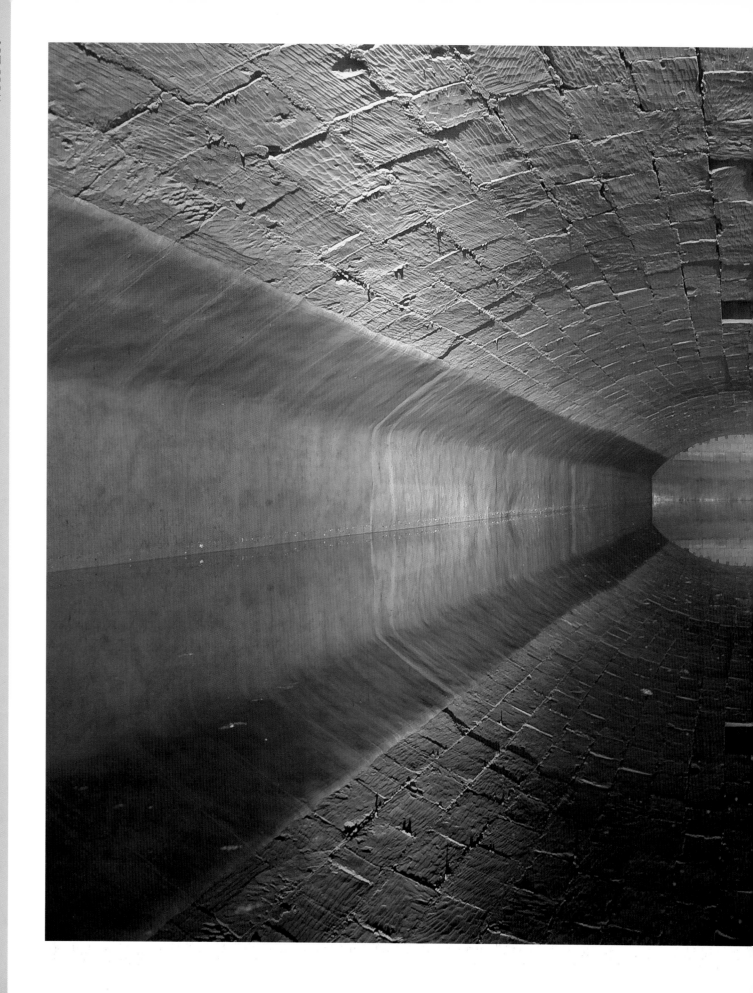

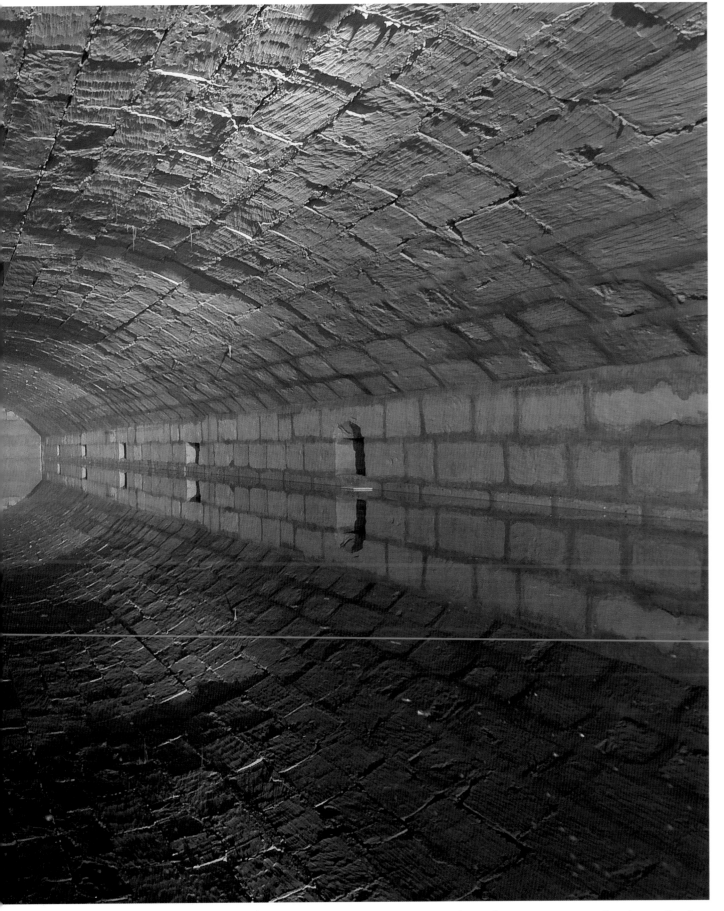

One of three large cisterns, built in 1625 by Grand Master Frà Antoine de Paule at Lija to irrigate San Anton Gardens

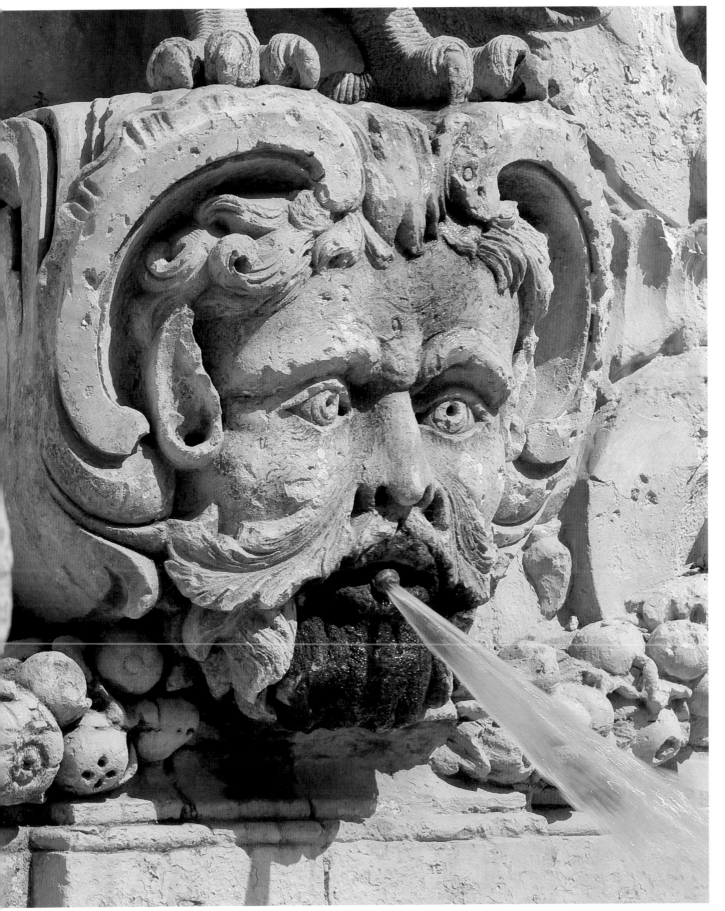

Detail of an 18-century fountain in front of the Grand Master's Palace, Valletta

continues from page 89

With the realization of this project, the inhabitants of the island had finally overcome one of the great constraints that nature had imposed. Until then, spring water had only been available in one half of the island. Now it was being carried across the drier part of the island, right down to the city on the coast. The arrival of fresh spring water gushing into the fountains of the city was a triumph of will and engineering. The time-worn inscriptions that commemorate the event still throb with excitement as they tell the story of how the arrival of water in the parched city gave it new life and confidence.

Above: Some modern irrigation practices are extremely wasteful of water.

Opposite: Concentrated sea water returning to the sea after the reverse osmosis process.

During the nineteenth and early twentieth centuries, the water table at sea level was increasingly exploited in order to meet the archipelago's growing demands for water. Bore-holes were dug into the rock down to sea level, and horizontal galleries were cut for kilometres along the water table to collect the water as it seeped out of the rock, before pumping it to the surface.

Today, the question of fresh water supply remains as topical a concern as ever. The combined effect of the growth in population, changing lifestyles, and the massive influx of tourism has made unprecedented demands on the archipelago's water supply. For the last quarter of a century, demand has outstripped the supply from the islands' water tables. Over-exploitation has led to the contamination of the water tables with sea water. When fresh water was extracted at a rate faster than the rate of replenishment by rain water, seawater moved in to replace it. Faced with this crisis, the islands turned to the sea for a new source of water. A costly process called reverse osmosis uses electric energy to purify sea water into potable water. Today four installations built for this purpose account for the greater part of the country's freshwater supply.

The production of fresh water to meet today's gargantuan demands consumes a colossal proportion of all electricity generated in Malta. Even as the islands' infrastructure strains to meet these demands, new developments are being proposed, such as the creation of new golf courses. The problem that this poses to the islands' meagre water resources is being hotly debated. In such a scenario, today's inhabitants face tough choices between short-term financial goals, and long-term sustainable management of the islands' fragile resources.

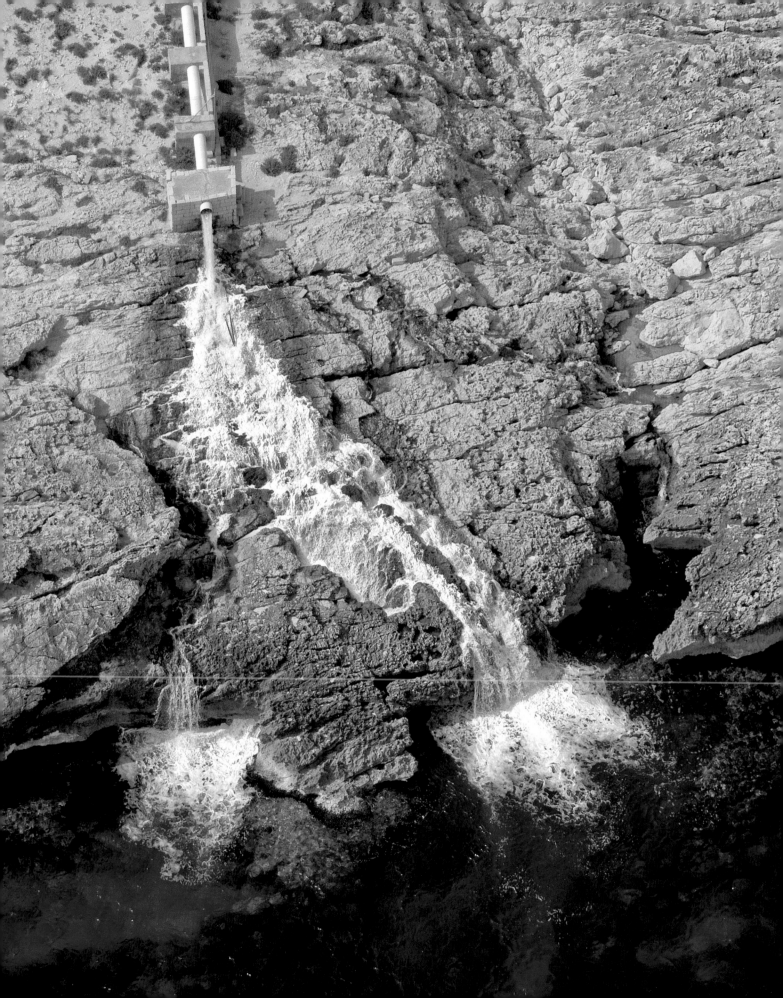

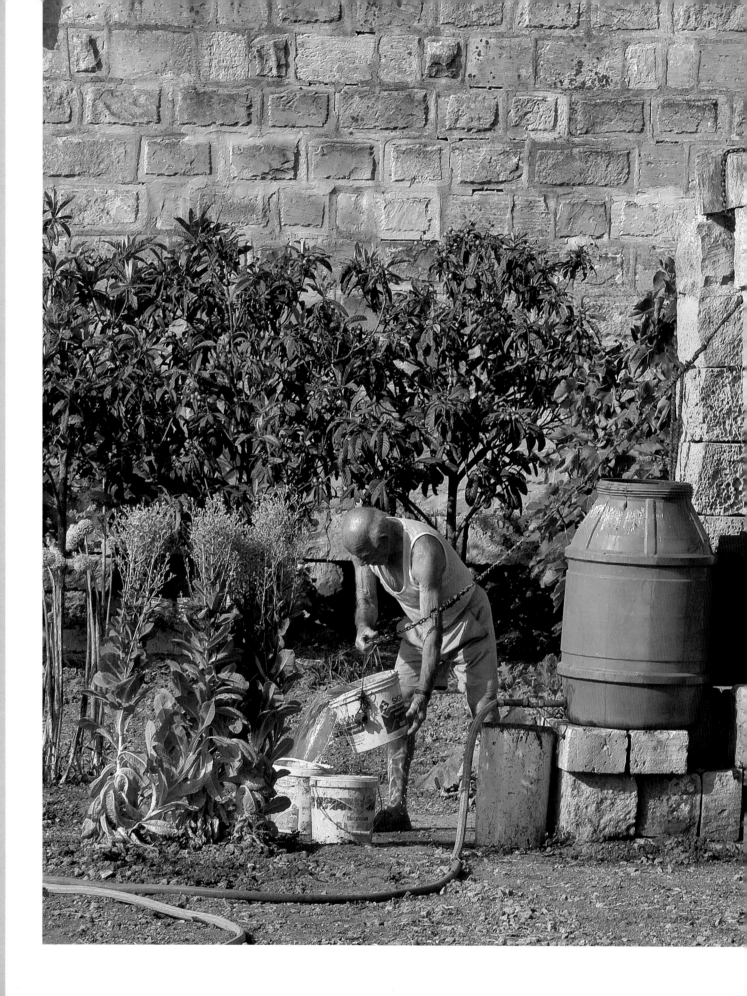

The careful nursing of water remains as important as ever. Drawing water from an old cistern on the outskirts of Żejtun

Field terraces protect slopes from erosion by heavy rain

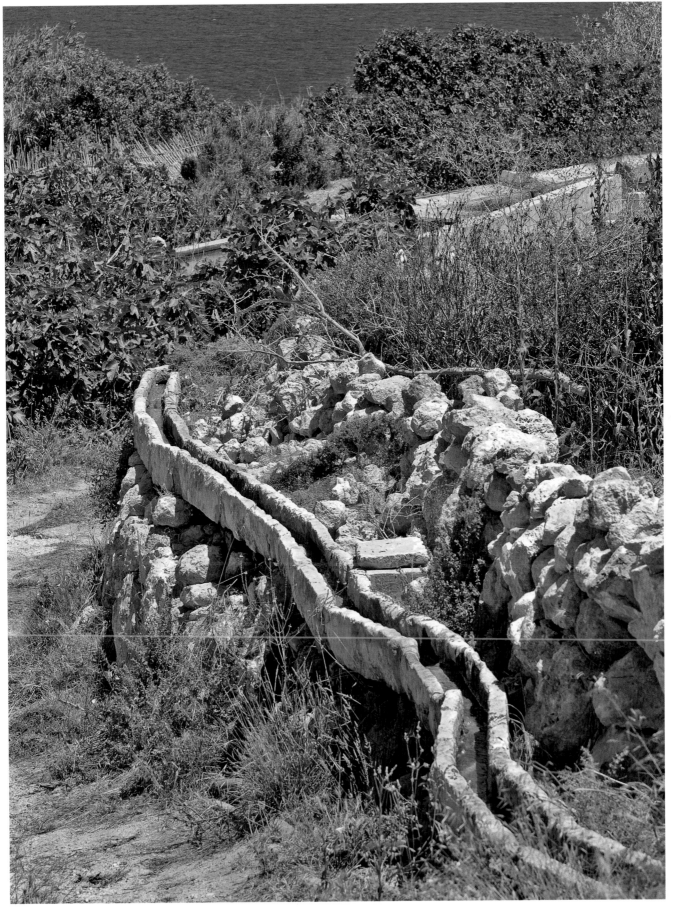

Stone irrigation channels carry water to an orchard

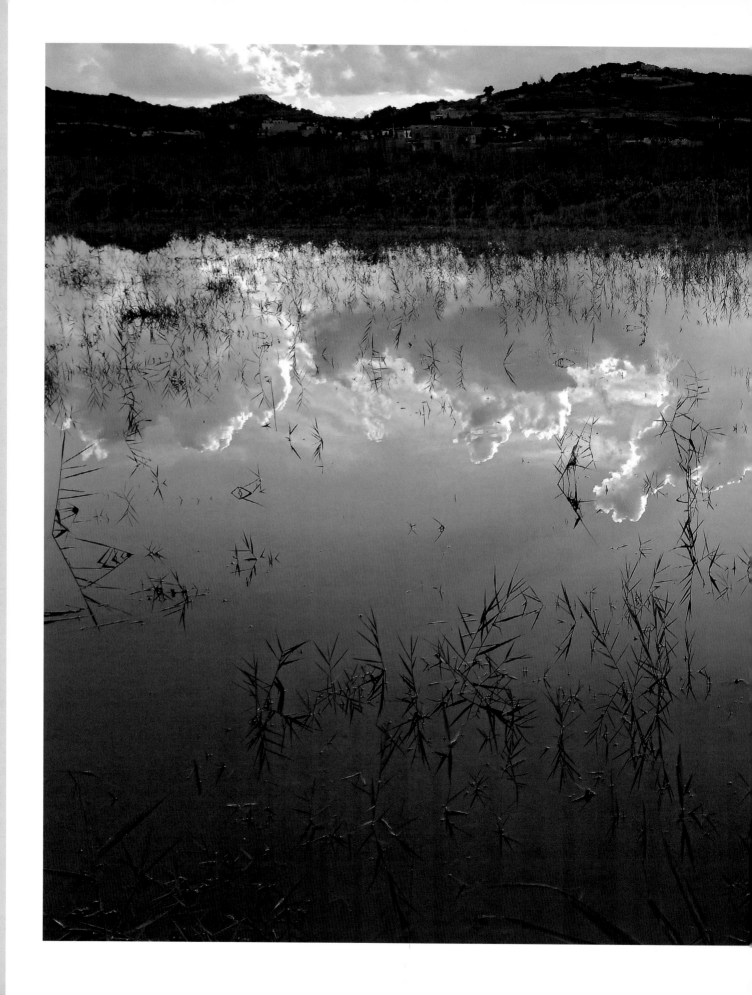

Water-logged fields in the floodplain of Burmarrad after heavy rains

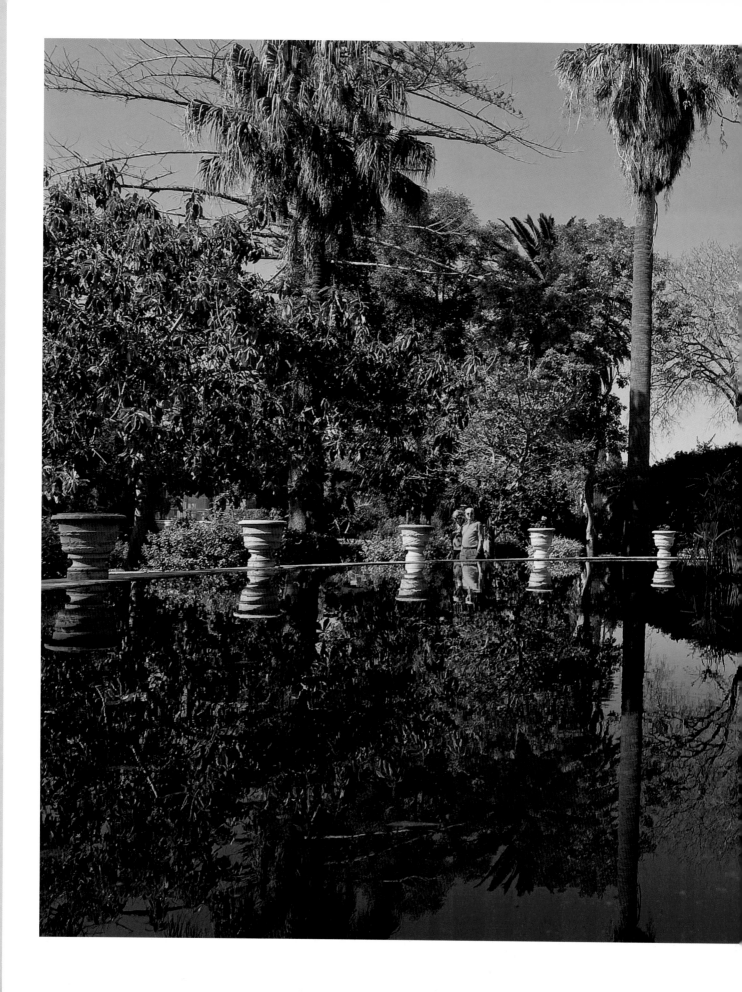

An elegant Baroque fountain on the main axis of San Anton Gardens

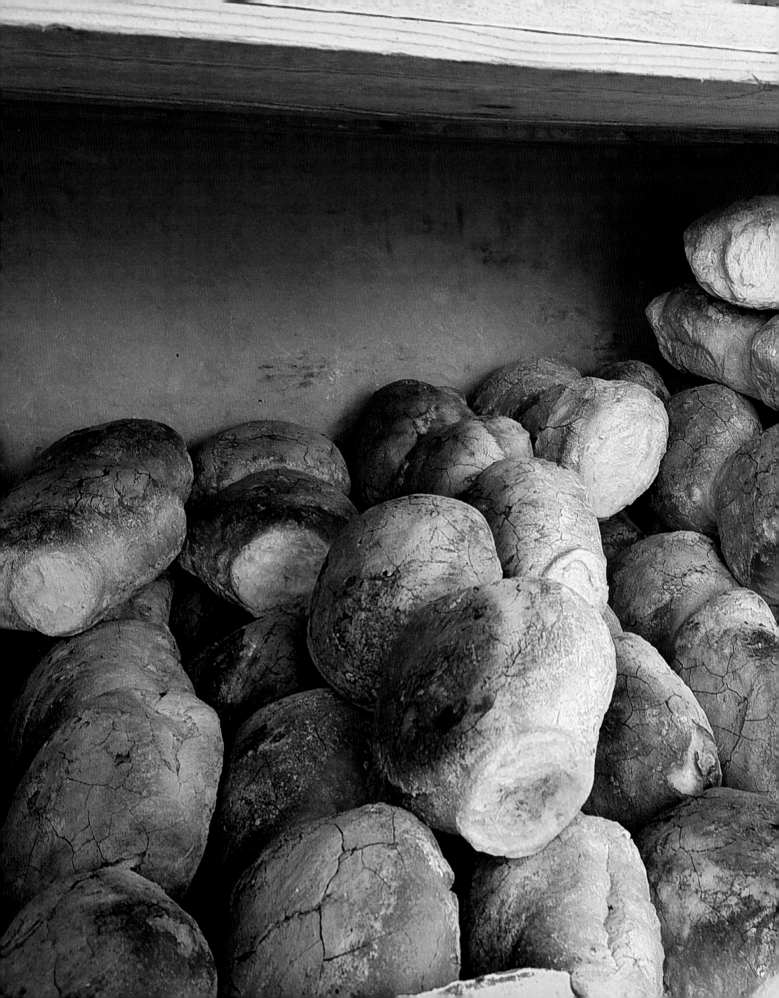

Food

Food is at the centre of Mediterranean life. For thousands of years, up until the recent past, the vast majority of people living around the Mediterranean seaboard eked out an existence very near the subsistence level. The production, storage, preparation, and consumption of food inevitably dominated much of their life as result. A happy consequence is that Mediterranean cooking excels in simple recipes that transform modest and affordable ingredients into wholesome and mouth-watering dishes. Malta is no exception, but before discussing favourite recipes, we should try to start the story from the beginning.

The different strategies that people used to obtain their food have had a direct and decisive bearing on whether they could live on a small island or not. People who depend on hunting and gathering need large territories in order to survive. In a limited territory, such as a small island, the stock of wild animals would be rapidly depleted and hunted out of existence. With animal husbandry and agriculture, however, much more intensive use of the available land became possible, allowing even small territories to feed significant populations. This is the principal reason why the smaller islands of the Mediterranean were settled long after the surrounding mainland. We know that people have been present around the Mediterranean for tens of thousands of years, hunting and gathering, often having to move camp every summer and every winter in order to follow the animals that they hunted.

Delicious, oven-fresh bread is a luxury that everyone in Malta may enjoy daily. Many bakeries use vans to deliver bread straight from the oven to their clients' doorsteps.

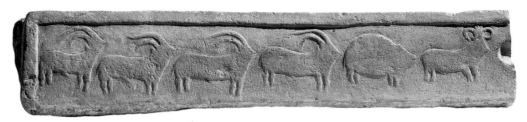

Low-relief panel from Tarxien Temples, showing domesticated animals introduced to Malta by Neolithic settlers.

In this regard, Sicily was far more similar to the mainland than to the smaller islands. Sicily is so large and so near to the Italian mainland that it could support hunter-gatherers for thousands of years. On many of the smaller islands, however, firm evidence of human presence only begins with the emergence and spread of agriculture, roughly around 6,000 BC. The Maltese islands appear to have been successfully colonized by around 5,000 BC.

We still have very little data about where people lived during the Neolithic period. Looking at the meagre evidence that is available, and considering the distribution of the megalithic buildings, human activity appears to have been concentrated in areas of flat, fertile land, where agriculture required far less effort than the steep slopes that characterize the more rugged parts of the archipelago. In order to transform a hillside into fields, a huge investment of labour is required. The slope of the hillside has to be broken into gigantic steps called terraces, each of which can be used as a level field. It therefore appears likely that people chose to exploit the more level land as long as it was available. This would explain why the megalithic 'temples' are mostly located near the edge of a plain, and why the larger of these buildings are located next to the more extensive plains, while smaller examples are found near the smaller plains. It appears that the more extensive plains could support larger communities, which in turn built bigger megalithic buildings.

continues on page 112

Opposite: The creation of stepped terraces to cultivate steep slopes is extremely laborious, Pwales Valley.

Bottom: Ġgantija Temples, Xagħra, overlook the central plain of Gozo.

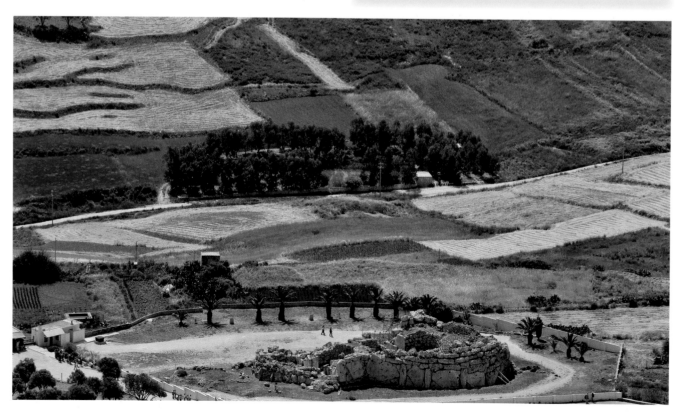

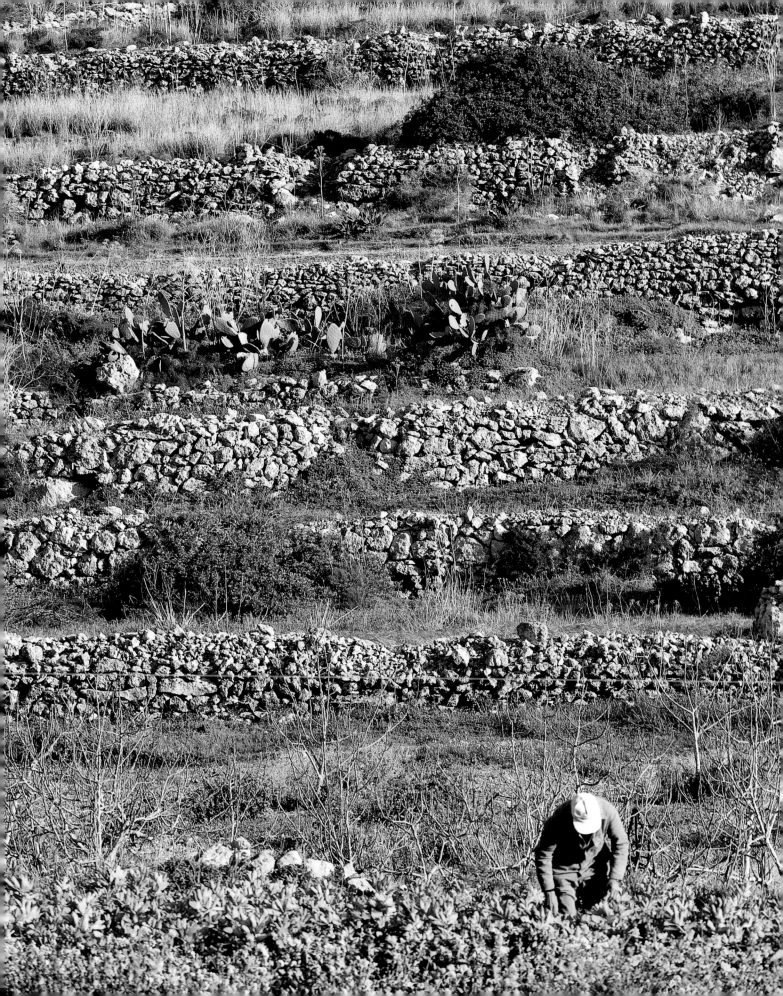

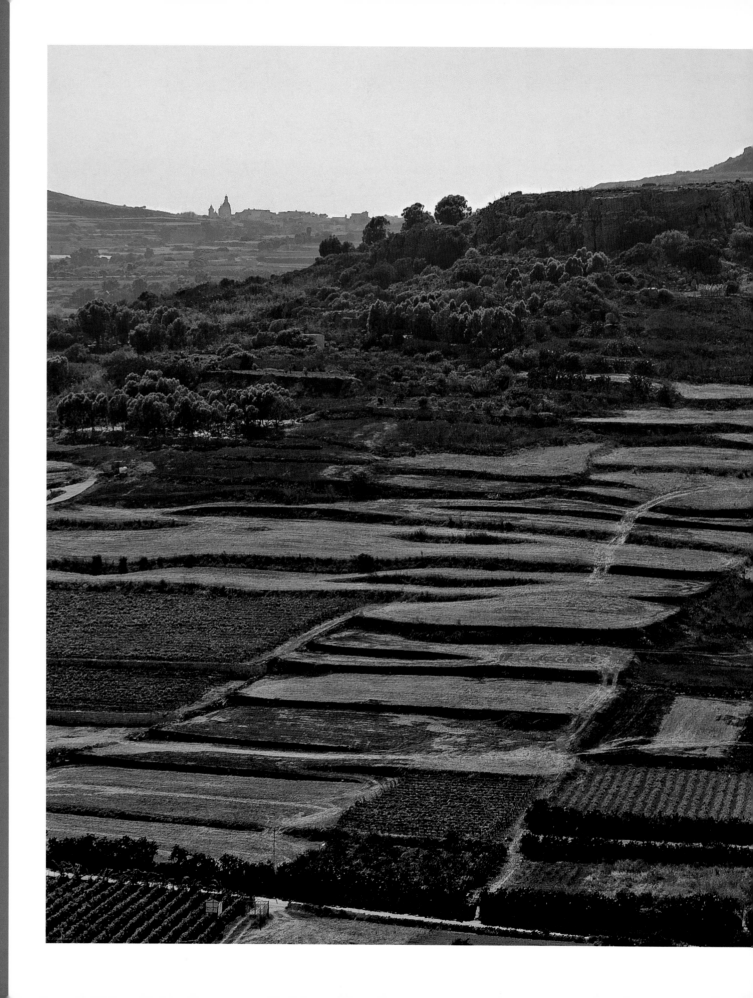

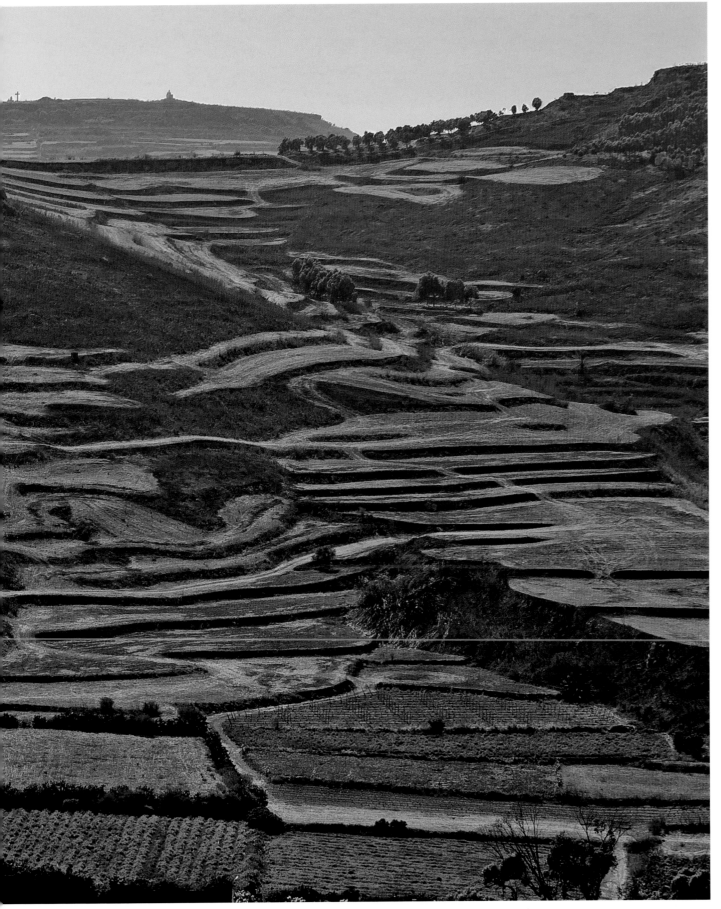

Marsalforn Valley in central Gozo during summer. Note the contrast between the dry zones where cereals and clover have already been harvested, and the intensely irrigated zones where vines and other summer crops are being tended.

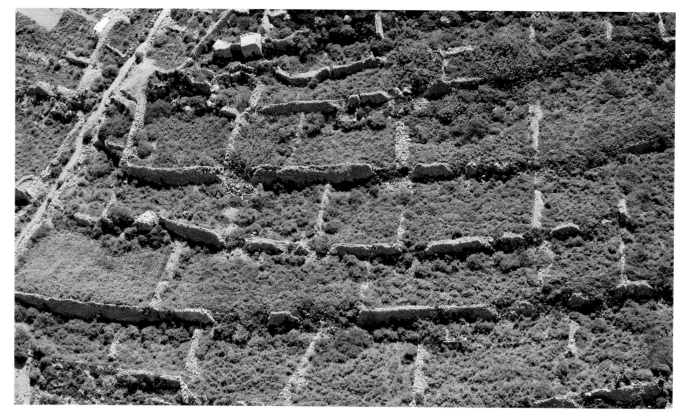

continues from page 108

Looking at the Maltese landscape today, we can see that even the slopes of steep hillsides have at some time or another been cultivated. As the population of the islands grew, the increased demand for food evidently made it necessary to bring the slopes under the plough. It is still unclear when terraced fields started being created on a grand scale. The evidence from other parts of the Mediterranean suggests that agricultural terraces started being built in earnest during the Bronze Age. This may also be true of Malta. The preference for more defensible sites that characterized the Bronze Age led to the creation of settlements on some of the most rugged parts of the island, where terraced fields would have been all the more necessary.

What was grown in these fields in different periods? Archaeologists have found evidence that barley, emmer wheat, and lentils were being cultivated on Malta during the Neolithic period. From the Bronze Age onwards, we may begin to recognize what is known as the Mediterranean triad, consisting of bread, wine, and oil. The three foods became important staples of the Mediterranean diet for a number of reasons. Firstly, the plants that they are produced from all thrive in the Mediterranean climate. Secondly, they ripen at different

Top: A series of abandoned terraced fields on marginal land at Nadur, Gozo.

Opposite: A cane windbreaker shields a vineyard, against a backdrop of bales of hay. Santa Luċija, Gozo.

times of year, so that with a limited labour force, one may move from harvesting wheat and barley in early summer to harvesting grapes in late summer, then olives in the autumn. Thirdly, they permit the storage of surplus food. Properly stored, grain keeps for several years, olive oil can be kept for more than two years, and wine can be kept for even longer periods, depending on its quality. The fact that they could be stored had several important implications. The surpluses produced in a good year could be saved against a year when drought or disease laid the harvests to waste. Such insurance could be extended further. A fourth advantage of the three staples was that they could be transported. The economic implications were far-reaching. If one region suffered drought, while the neighbouring region was spared, surpluses could be transported to the stricken region to save its inhabitants from famine.

continues on page 116

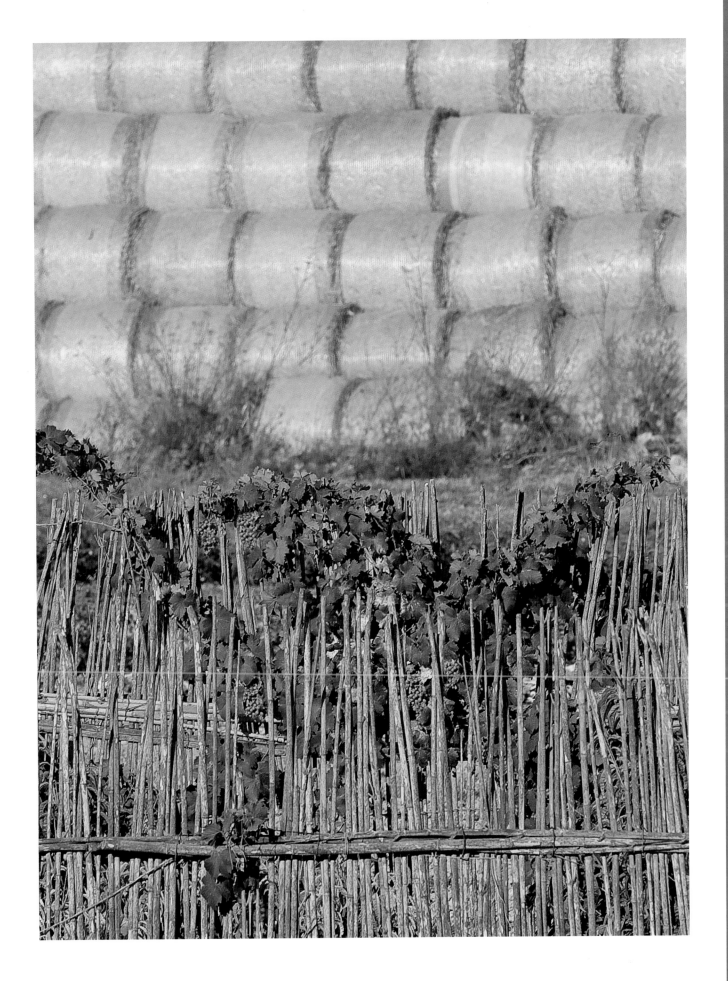

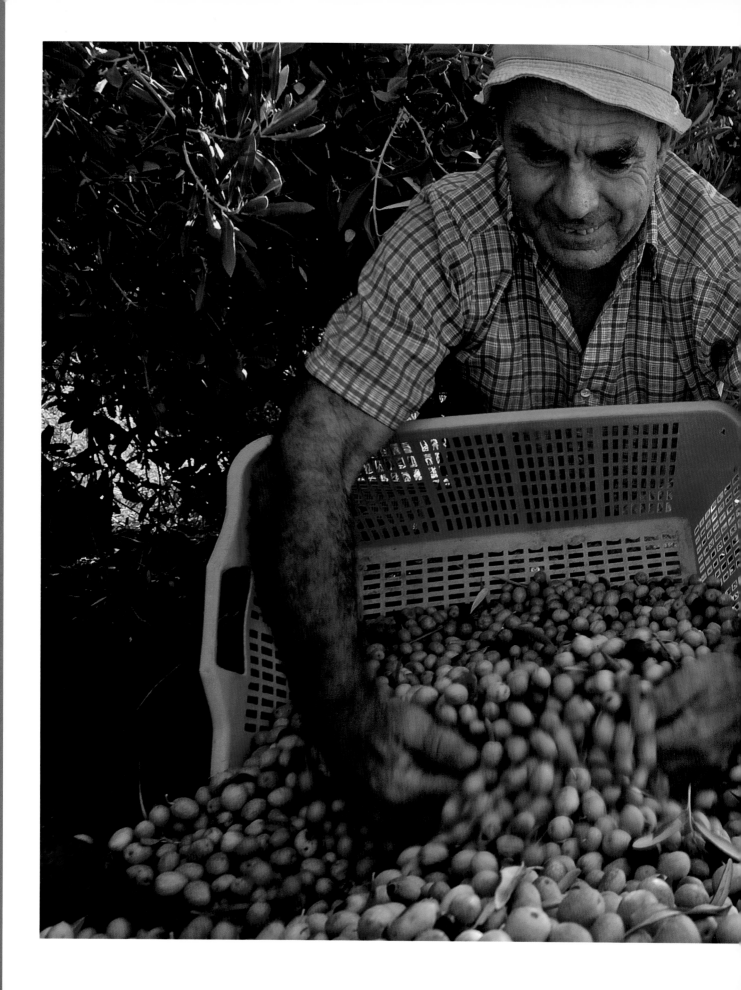

Organic farmer Joseph Borg collects freshly-picked olives, to be taken directly to the press. Fawwara, Siġġiewi

continues from page 112

On another occasion, the region that helped out may itself need the favour to be returned. Of course, such a system could only function in an environment of mutual trust and political stability. It therefore favoured political systems that united larger territories in a single network of redistribution.

The emergence of cities was also closely tied to the storage of foods and their transportability of foods.

Cities consume far more food than they produce and therefore need to bring in food supplies from an agricultural hinterland. With the improvement of transport systems, the sources of food that cities depended upon could be further and further away. The most colossally gargantuan example in the ancient world was that of Rome, whose population probably peaked at over one million inhabitants. In order to feed the urban masses, it was necessary to import vast quantities of food. Grain from Sicily and Egypt, oil from Spain and North Africa, and wine from Greece, Asia Minor, and Italy itself were imported on a grand scale to meet the needs of the city. The transport of staple foods on such a scale brought about a high level of interdependence between the different parts of the Roman empire, where the very survival of a high proportion of the

population depended on the efficiency of transport systems.

Grain can be transported very efficiently because it takes the shape of any container that it is poured into, and it is also hardy enough not to be damaged by handling, as long as it is kept dry. Wine and oil, being liquids, had to be transported in containers. The material that was most commonly used for the containers was fired clay. Since pottery is virtually indestructible, it is one of the common finds encountered by archaeologists. As a result, the remains of the pottery vessels that were used to transport foodstuffs are one of the best indicators of how and where foods were being transported. The most common type of vessel used was the amphora, or two-handled jar. Amphorae [*top, from Xlendi wrecks*] were produced in many different shapes, depending on their area of origin, content, and the date when they were produced. As a result, archaeologists may learn much even from a single fragment of an amphora, if the type is recognizable. For many centuries, the size of an amphora was dictated by the maximum weight that a man could carry, as the amphorae had to be loaded onto ships by hand. Many amphora shapes taper down to end in a solid foot or peg. As the peg makes it impossible for an

amphora to stand up on its own, it may look rather strange to us today. The reasons for this peg were very practical, however. It served as a third handle that made it easier to manoeuvre the heavy amphorae when carrying them or when pouring out the contents. It also made it easier to stack amphorae together in a ship's hold, layer over layer, with the pegs fitting between the necks of the amphorae in the layer below. Over the centuries, more efficient shapes were developed, with thinner walls that could hold more contents in a lighter amphora.

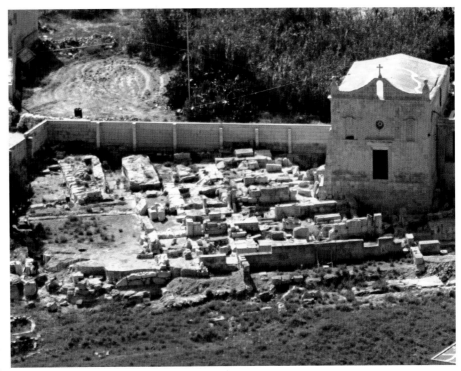

A colossal volume of shipping was involved in the transport of foodstuffs across the Mediterranean, and inevitably, the sea claimed its toll of shipwrecks. Perhaps the most famous is the Alexandrian grain carrier that was carrying St Paul to Rome, which many believe was wrecked near Malta. Thousands of wrecks from the ancient world have been discovered around the Mediterranean, from which much has been learnt about ancient trade and exchange systems. Many wrecks have been discovered around the Maltese islands, carrying cargoes of food from other parts of the Mediterranean as well as exports from the Maltese islands themselves.

During the Roman period, olive oil appears to have been one of Malta's principal products. The remains of farmsteads equipped for oil-pressing have been found across the island. Two of the best examples are the *villa rustica*, or farmstead, at San Pawl Milqi [*top: aerial photo*] and the one at Ta' Kaċċatura. Both have yielded remains of the equipment for the different stages of olive oil production, from the removal of the pips, to the pressing of the olives, and the settling and storage of the oil. Fragments of similar equipment have been found in other parts of the archipelago, suggesting that olive oil production was very widespread.

continues on page 124

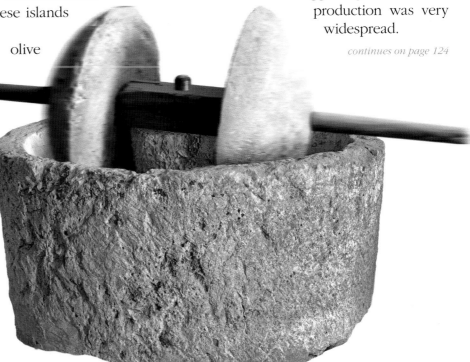

Opposite: Reconstruction in miniature of an Alexandrian grain carrier. Maritime Museum, Birgu.

Right: A reconstructed Roman hand-driven olive pipper, made of Coralline Limestone, found at Tad-Dawl, Ħal Kirkop.

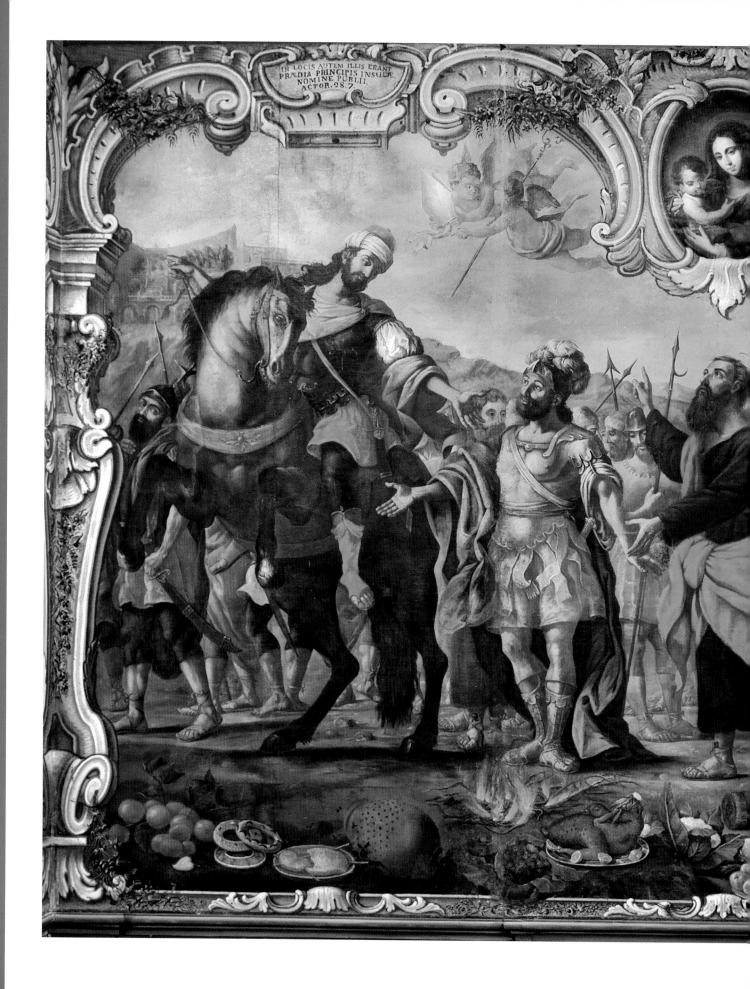

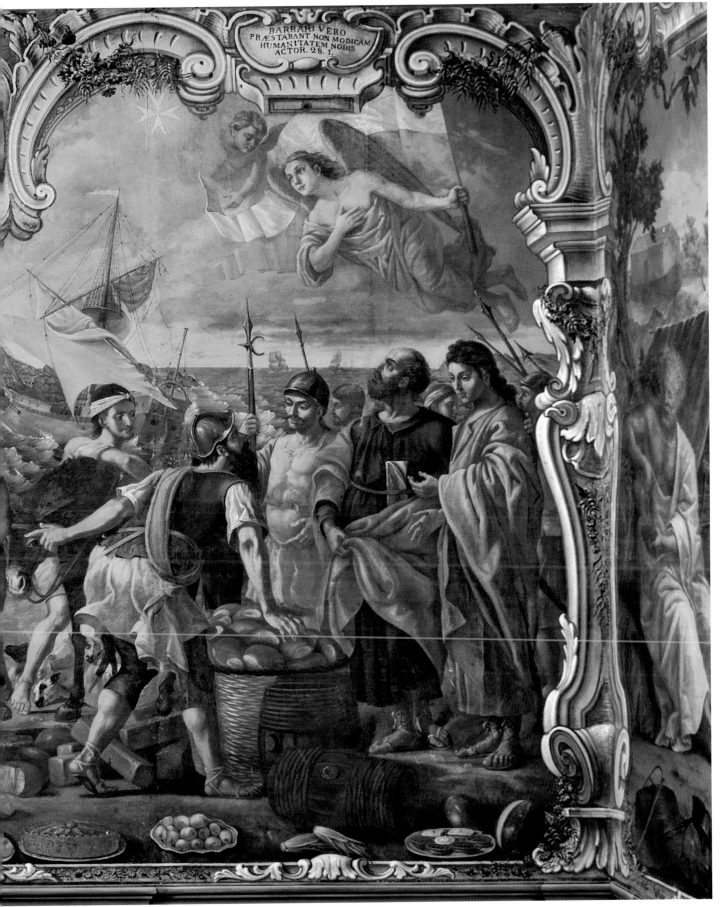

BARBARI VERO
PRÆSTABANT NON MODICAM
HUMANITATEM NOBIS
ACTOR. 28. 1.

The welcome of St Paul on Malta. From a fresco cycle painted in 1762 by Leonetti on the refectory walls at the Curia, Floriana.
The theme of food and hospitality is continued in the cornucopia of local dishes and delicacies depicted below the main scene.

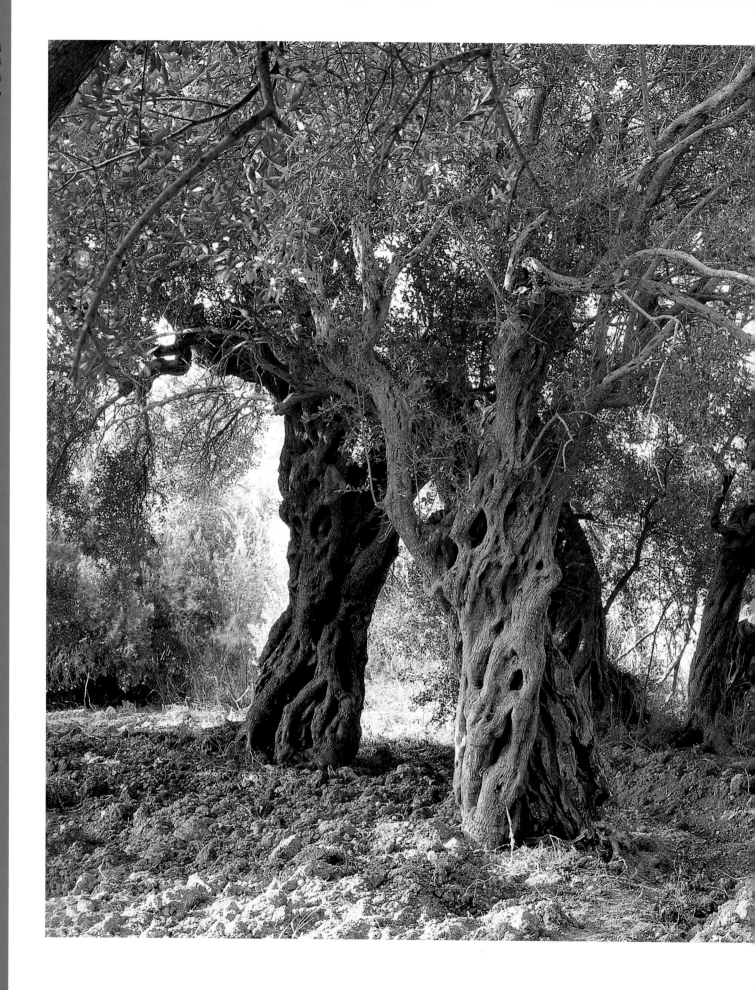

An ancient olive grove at Bidnija preserves some of the oldest living trees in Malta

Caper, olive, garlic, and onion. Preservation in vinegar, oil, or brine allows a seasonal harvest to be enjoyed all year

FOOD

continues from page 117

During the centuries following the disintegration of the political and economic systems of the Roman empire, it is very likely that olive cultivation declined. Another activity, which may have been introduced by the Arabs, began to transform the Maltese agricultural landscape. This was the cultivation of citrus trees, which thrive on the Maltese islands. Even today, many parts of the Maltese landscape are characterized by large irrigated orchards with high walls or windbreakers, full of trees bearing oranges, lemons, and tangerines. During the seventeenth and eighteenth centuries, the 'blood-oranges' [*left*] produced in Malta, so named on account of their distinctive ruby tint, were highly prized across Europe.

Top: A lemon tree at San Blas, Nadur, Gozo peeps through a cane windbreaker.

Opposite: The cotton crop in a field at Qala, Gozo

Another very important agricultural product during the same period was cotton, much of which was processed for export. The cotton crop had the attraction of being rather more profitable than staple foods such as grain. From the fifteenth century onwards, the documentary evidence shows that the Maltese islands depended on grain imported from Sicily in order to feed the population. The availability of imported grain made it possible to experiment with other more profitable crops. The dependence on imported foods increased progressively with the growth of the population, down until the present.

During the seventeenth and eighteenth centuries, the Maltese population grew dramatically. The more marginal parts of the island, which had not been previously cultivated, were transformed into terraced fields to allow the cultivation of more crops.

continues on page 129

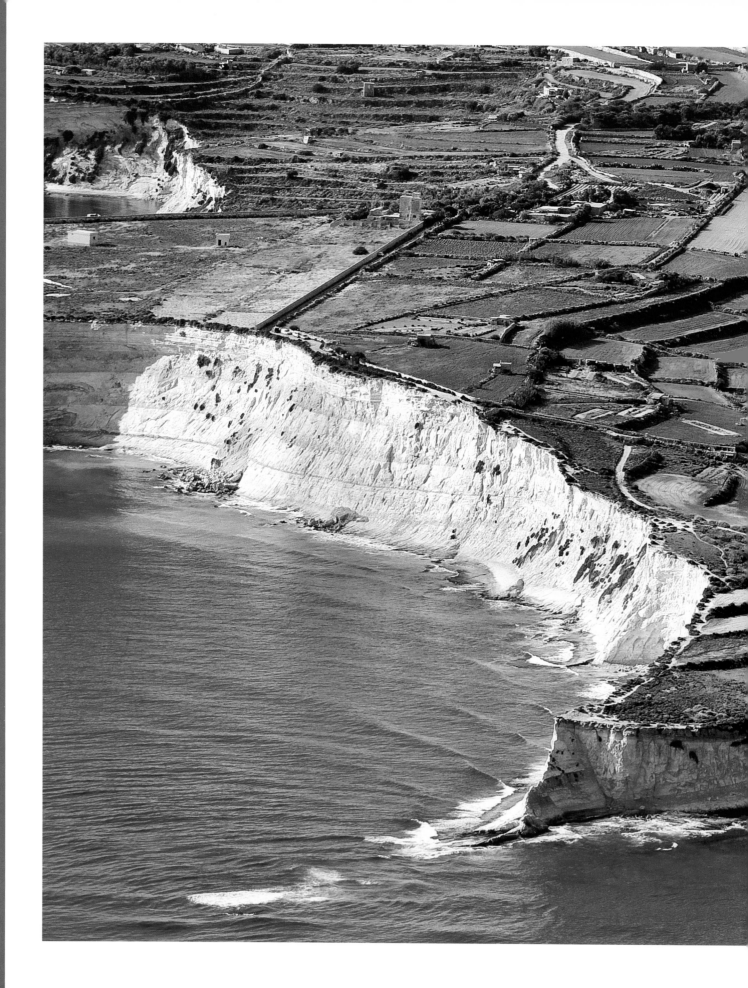

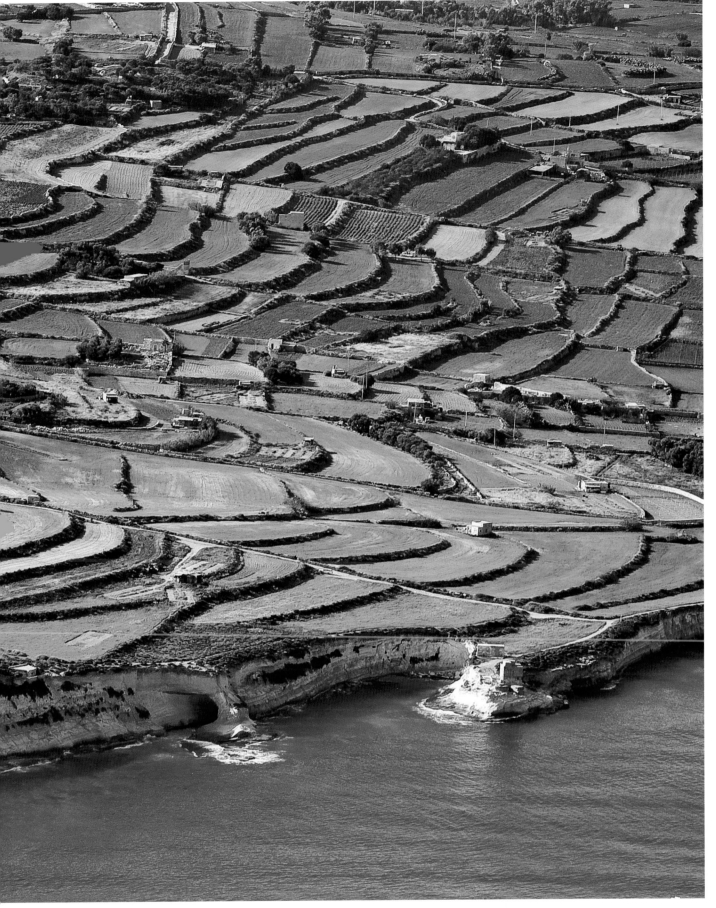

During the eighteenth and nineteenth centuries, even marginal land was brought under the plough. Munxar, Marsascala

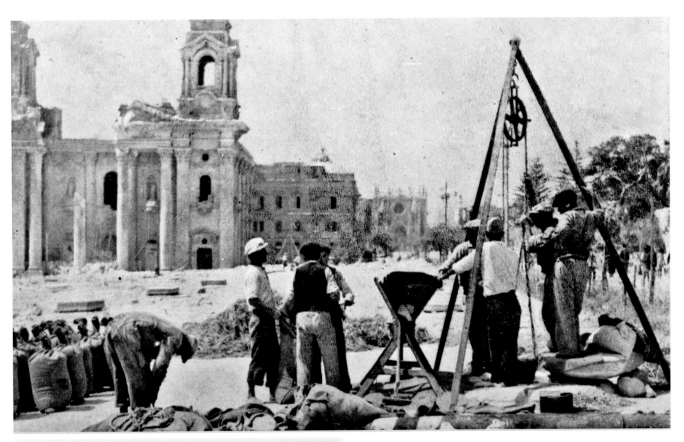

Grain being hoisted out of the centuries-old granaries of Floriana during the World War Two.

continues from page 124

Contemporary chroniclers have recorded the laborious process that was required to transform rocky wasteland into arable fields. The rock was pounded and crushed to create a layer of chips and boulders that was needed to provide adequate drainage. Soil was painstakingly scraped together from the little pockets in the rock where it gathered, to be mixed with manure and domestic waste in order to create a meagre mantle of soil. Meanwhile, more grandiose projects were undertaken by the state, draining the marshlands of Marsa and Burmarrad, to reclaim them for agriculture.

A high proportion of the burgeoning population lived in the fortified cities around the Grand Harbour. This urban population lived under the perpetual threat of another siege. In order to ensure a secure supply of food in such an eventuality, deep granaries were cut into the rock within the walls of the cities themselves. The vastest of these are the granaries of Floriana, which still form the largest square on the islands. Many of these rock-cut silos continued to serve the needs of the population into the 1980s, when a new grain terminal was built on the Kordin promontory, along the shore-line of the Grand Harbour.

Today the dependence on imported foods has reached unprecedented proportions, as the area of agricultural land under cultivation continues to diminish and the population continues to rise. A very high proportion of agricultural activity on the islands is now directed towards the cultivation of fresh fruits and vegetables. Practically all cereals for human consumption are imported, as well as a growing volume of fresh fruit and vegetables that is needed to complement local supplies. The well-drained soils and long hours of sunshine enjoyed by the Maltese islands, together with the traditional methods still used by many farmers, give many of the Maltese products a richness of flavour that is absent in the imported substitutes. The pleated and squat tomatoes that are grown outdoors in early summer are simply the best for making *ħobż biż-żejt u t-tadam* [*opposite*], a traditional and healthy snack similar to *pane consato* in Sicily or *pan tomaka* in Spain. The Maltese version is made of traditional crusty bread smeared with freshly-cut tomatoes,

continues on page 130

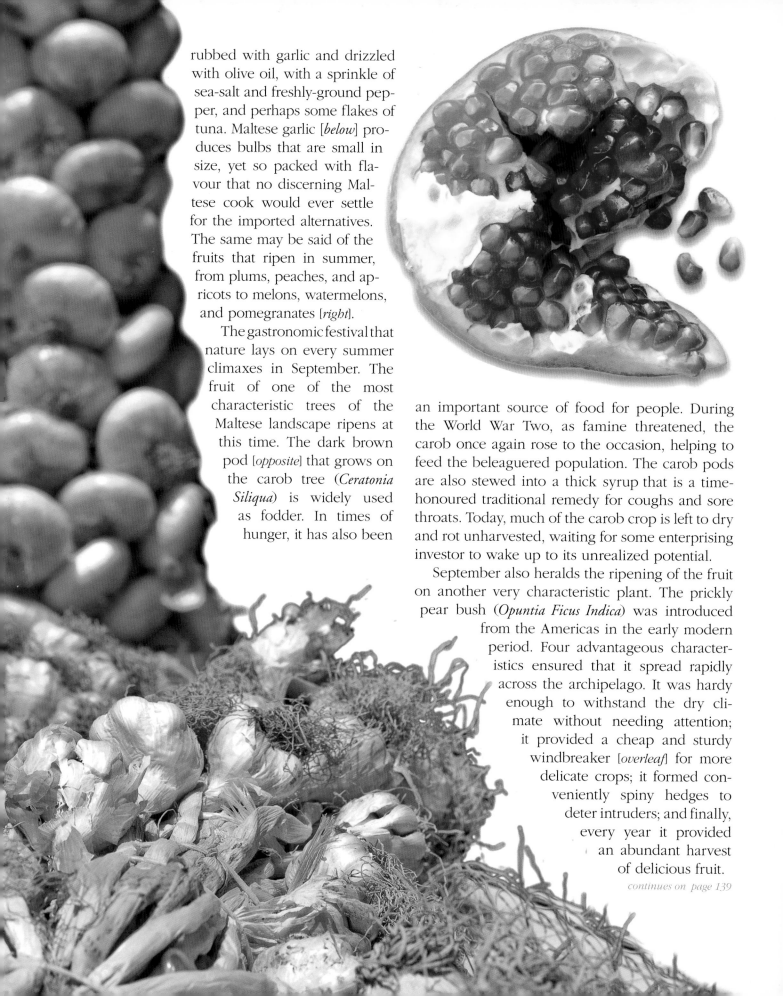

rubbed with garlic and drizzled with olive oil, with a sprinkle of sea-salt and freshly-ground pepper, and perhaps some flakes of tuna. Maltese garlic [*below*] produces bulbs that are small in size, yet so packed with flavour that no discerning Maltese cook would ever settle for the imported alternatives. The same may be said of the fruits that ripen in summer, from plums, peaches, and apricots to melons, watermelons, and pomegranates [*right*].

The gastronomic festival that nature lays on every summer climaxes in September. The fruit of one of the most characteristic trees of the Maltese landscape ripens at this time. The dark brown pod [*opposite*] that grows on the carob tree (*Ceratonia Siliqua*) is widely used as fodder. In times of hunger, it has also been an important source of food for people. During the World War Two, as famine threatened, the carob once again rose to the occasion, helping to feed the beleaguered population. The carob pods are also stewed into a thick syrup that is a time-honoured traditional remedy for coughs and sore throats. Today, much of the carob crop is left to dry and rot unharvested, waiting for some enterprising investor to wake up to its unrealized potential.

September also heralds the ripening of the fruit on another very characteristic plant. The prickly pear bush (*Opuntia Ficus Indica*) was introduced from the Americas in the early modern period. Four advantageous characteristics ensured that it spread rapidly across the archipelago. It was hardy enough to withstand the dry climate without needing attention; it provided a cheap and sturdy windbreaker [*overleaf*] for more delicate crops; it formed conveniently spiny hedges to deter intruders; and finally, every year it provided an abundant harvest of delicious fruit.

continues on page 139

The prickly pear works as windbreaker, fruit-tree, and a thorny deterrent to intruders without needing attention

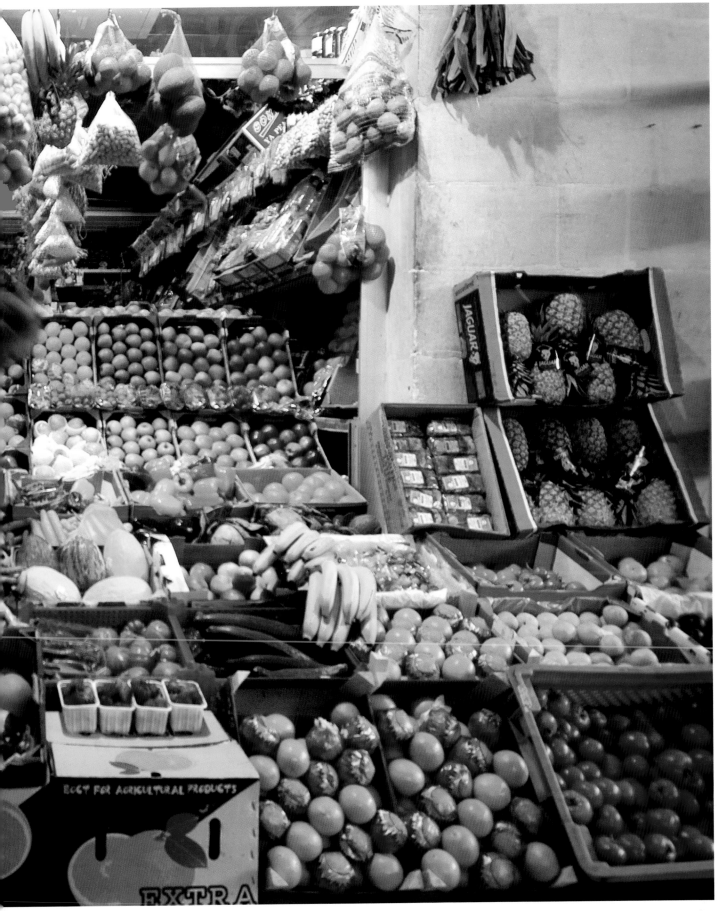

Imported fruit jostles for attention with local produce. Valletta Market

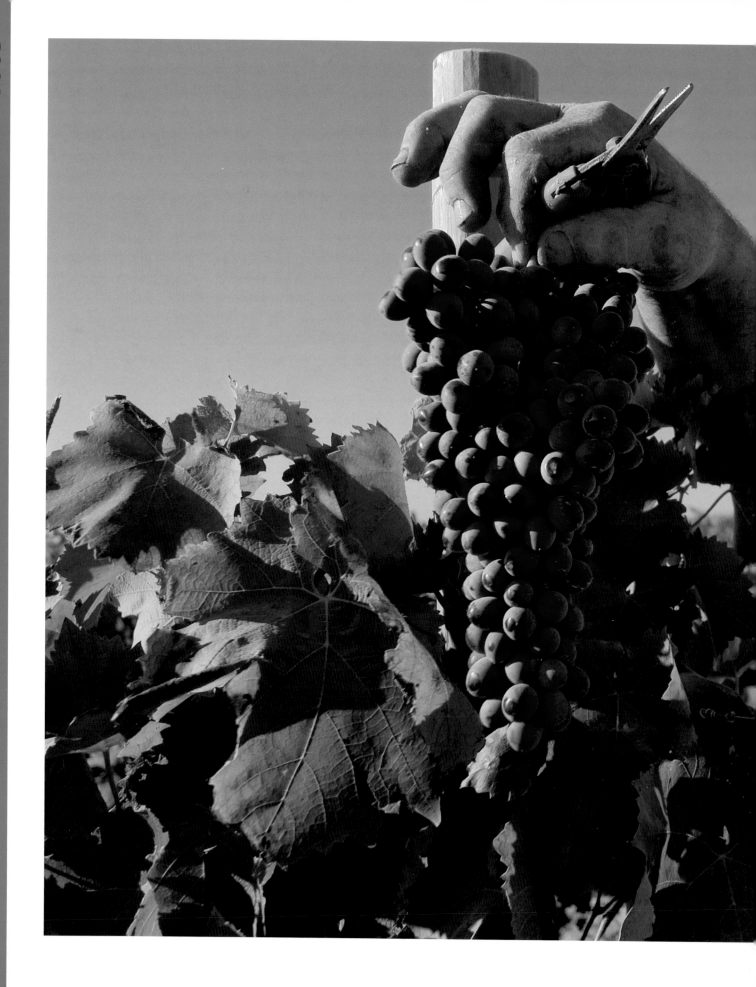

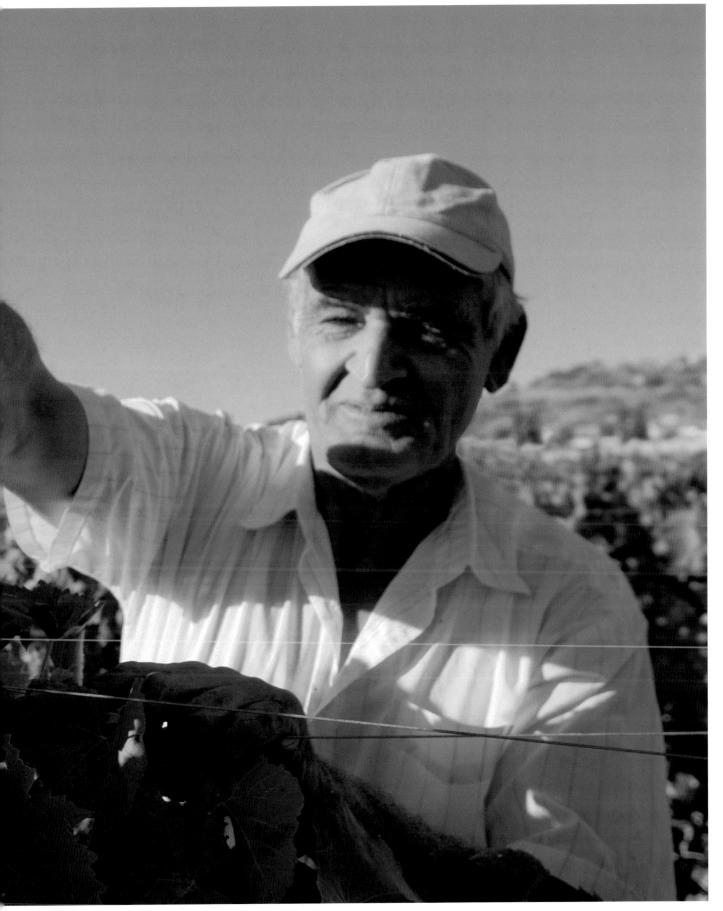

The best-loved fruit to ripen in the latter days of summer is incontestably the grape

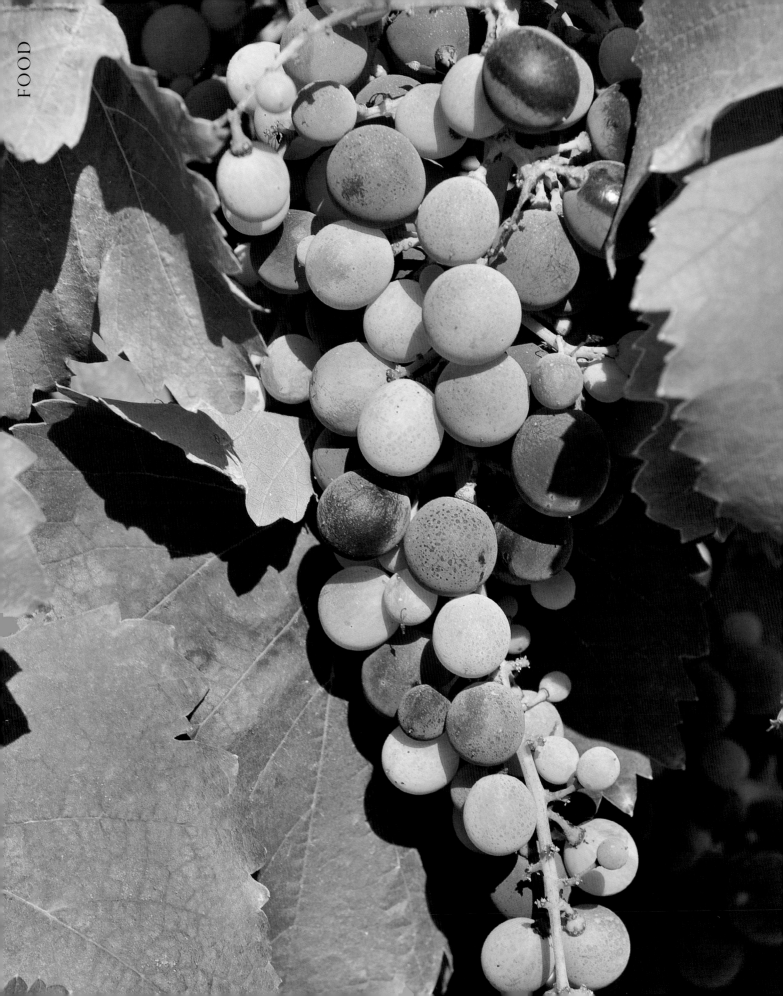

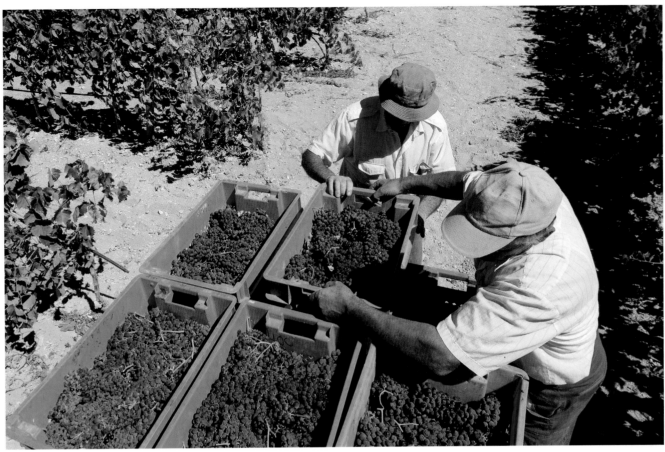

continues from page 130

The best-loved fruit that ripens in the latter days of summer is incontestably the grape. After having to put up with rather insipid imports for the rest of the year, for one glorious month, from the feast of Santa Marija in mid-August through the first half of September, grape-lovers may gorge themselves on the smaller but incomparably more delicious

The grape harvest is gathered by hand in late August and September.

harvest of the traditional Maltese varieties. In houses and farm buildings across the islands, the summer sunlight is filtered by vines grown on trellises over yards and terraces, sagging lower and lower under the weight of the ripening grapes. After Santa Marija, they are relieved of their bounteous load, to be sent to the table or to the wine-press. The Maltese wine industry, which until only a couple of decades ago was the butt of many jokes, has come of age. Expert viniculture together with incentives for farmers to plant new vineyards has generated a formidable array of native wines suitable for a range of pockets, from exquisite world-class artisanal wines to a wide range of very affordable and friendly labels, alongside many unlabelled but respectable home-made varieties that are often served as house-wines in local taverns.

The latter days of summer are also the time for another bounteous harvest, this time from the sea. From late August until December, shoals of a migratory species of fish swim past the Maltese islands. The species is present in tropical and sub-tropical waters around the world. In the English-speaking world, from America to Australia, it is known as the 'dolphin fish'. Rather more appropriately, Spanish speakers know it as the *dorado* (golden or gilded) on account of its colour. In the Pacific, it is known as *mahi mahi* (strong strong). In the Mediterranean, the most widely used name is *lambuga*, and to the Maltese, it is the *lampuka* [*opposite*]. In order to harvest this off-shore fish as it migrates past Malta, fishermen here have developed a remarkable technique. Large floating shades built of cork and palm fronds are left floating in open sea, moored in place by Globigerina Limestone blocks that are allowed to sink to the bottom of the sea. The predatory *lampuki* congregate around the floats to feed upon the smaller fish that are attracted by the shade. The fishermen's task is then to visit the floats at regular intervals, netting the *lampuki* gathered around each

float. Catches are so bounteous that this remains the most affordable fish in Malta when in season. It is also one of the most delicious, especially when grilled.

The *lampuka* is not the only seasonal fish to visits Maltese waters. Another important migratory fish is tuna [*below*]. During May and June, these handsome giants of the deep swim through the channel between Africa and Sicily. Along the nearby Sicilian coast, the fishing and processing of this fish has been attested for thousands of years. The traditional method that is still used there is to funnel the tuna shoal through a series of nets into more and more confined spaces, until they are forced to the surface and slaughtered. A similar technique is known to have been practiced on a much smaller scale in Malta during the early modern period, particularly at Għadira and Ġnejna. Today Maltese fishermen use offshore line fishing to harvest this fish. During the period when it migrates past Malta, the tuna is at an optimal stage in its growth cycle, so much so that a high proportion of the Maltese catch is airlifted to Japan to supply the sushi restaurants there.

continues on page 152

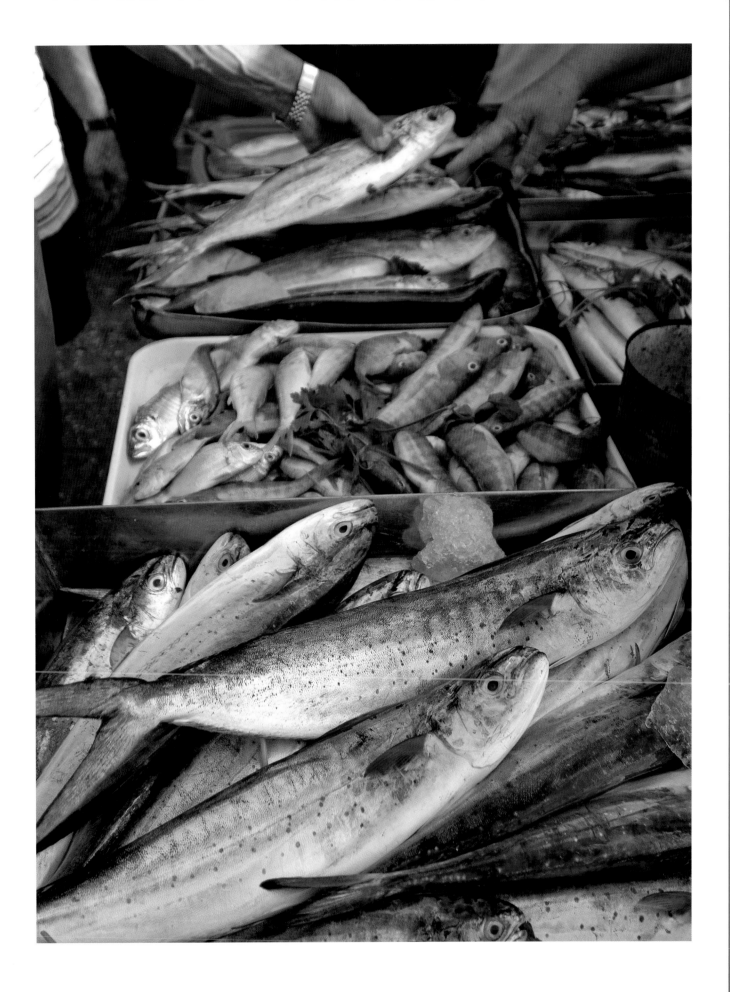

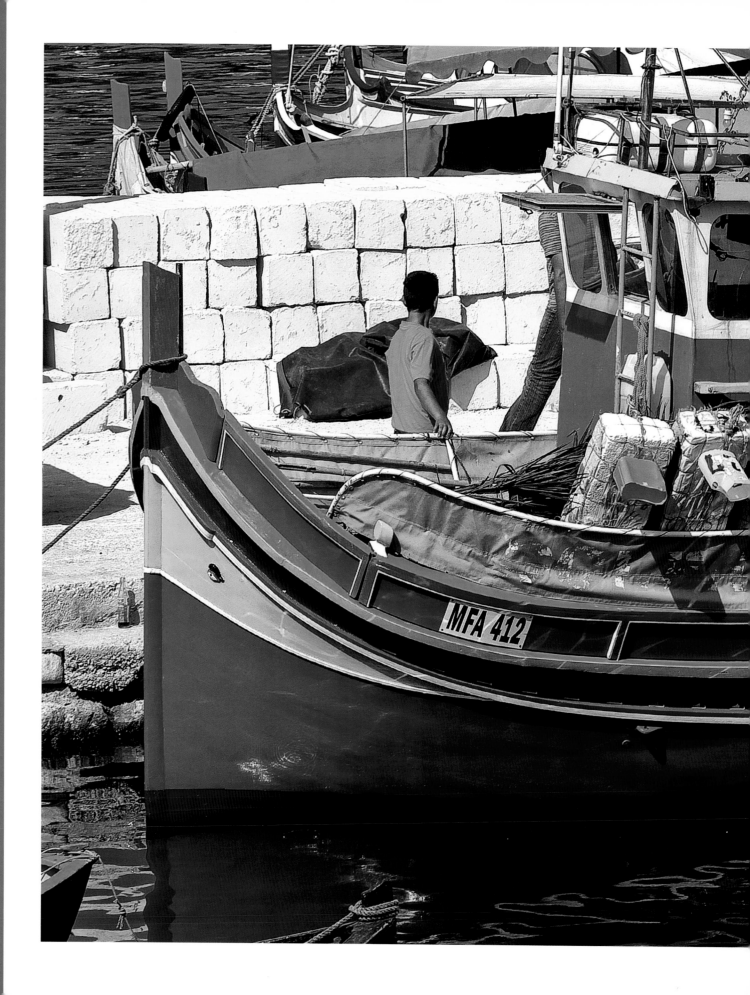

Globigerina Limestone sinker blocks ready for loading onto a luzzu *along with floating shades built of cork and palm fronds. Mgarr, Gozo*

143

Yellow-fin tuna at the Valletta fish market

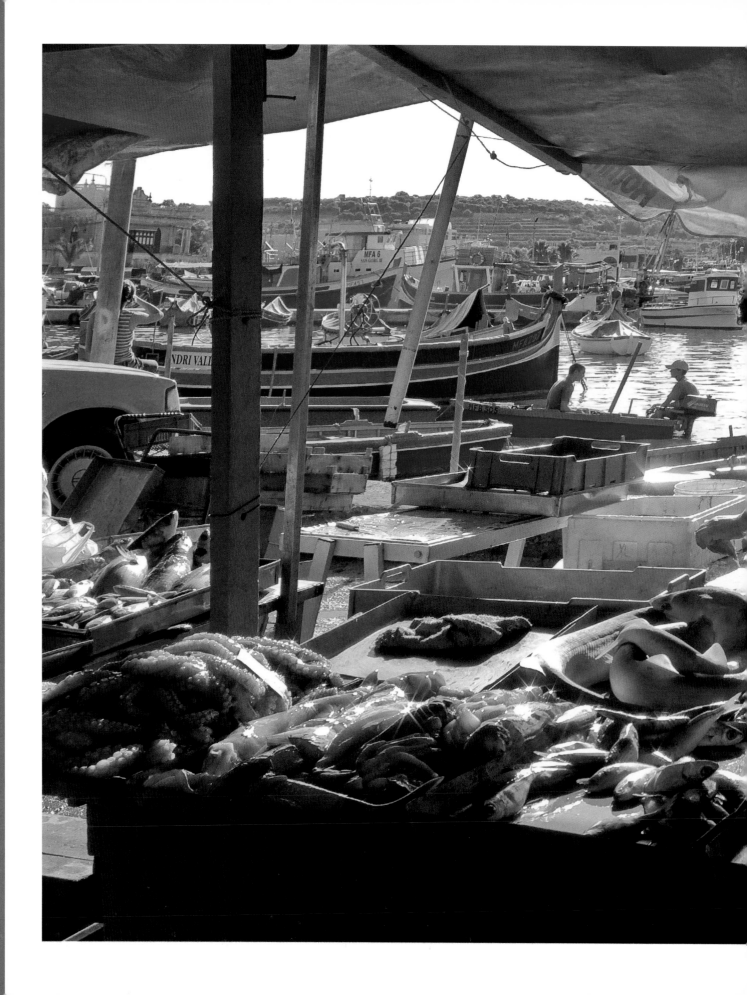

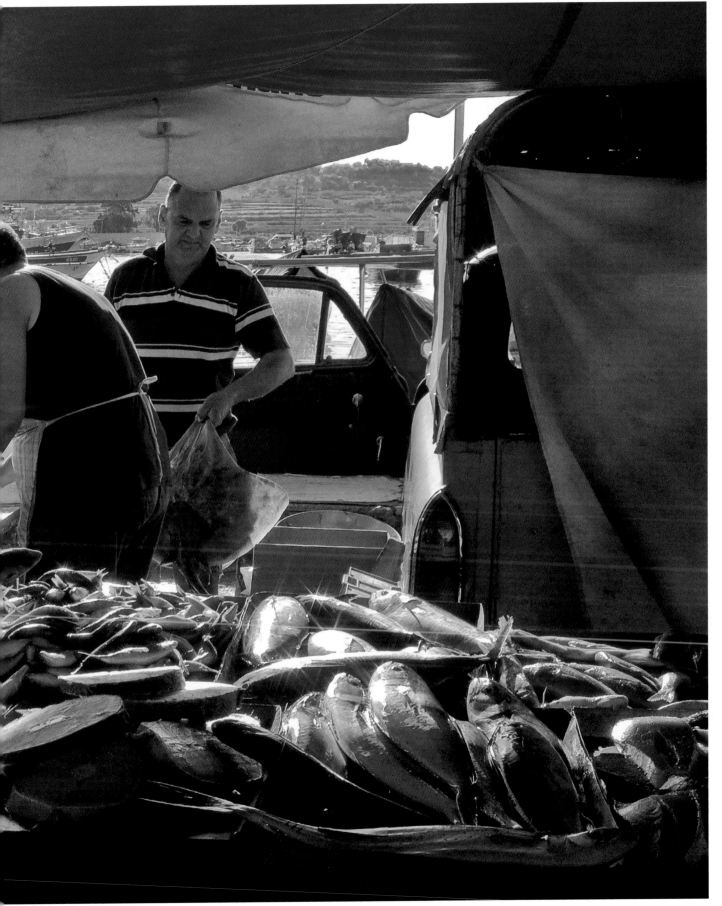

The stalls of fishmongers at Marsaxlokk present a bewildering variety of fish species

From the sea to the table. One of the many restaurants along the Valletta Waterfront

Don't try this at home. Sea-urchin roe is an exquisite snack for the initiated

151

continues from page 140

Lampuki and tuna are, of course, only two of the most spectacular species that the sea offers up to the Maltese table. There are numerous other species, several of which are fished all year round. Some of the inshore species have probably been known and exploited since the earliest occupation of the islands. One of the earliest records of an interest in such fish comes from a prehistoric megalithic building on the Buġibba peninsula. One of the megalithic blocks [*top*] in this 5,000-year-old building carries two panels of low-relief sculpture, one showing three fish, the other showing a single fish. It has been suggested that the reliefs may repre-

sent *sargu* [*left*], a common species around the Maltese coast, which is still a very popular choice on our tables today.

Another precious harvest that has probably been gathered from the sea for as long as the islands have been inhabited is salt. Seawater trapped in natural rock-pools on the shoreline evaporates, leaving behind a crunchy layer of snow-white salt, packed with the flavour of the sea. The most remarkable example must be the Clockmaker's Saltpans, near Wied il-Għasri on the north coast of Gozo [*below*].

An extraordinary tale has been recorded by Jean Houel, the traveller and artist who visited Malta in the late the eighteenth century. Houel recorded [*opposite*] how an ingenious clockmaker drilled a shaft into the roof of a sea-cave in order to let the force of the waves fill his saltpans. The method proved to be disastrously effective. When the first storm came, the might of the open sea

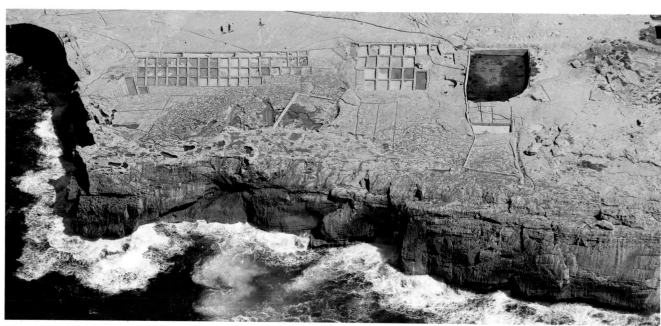

Cases de la Saline de l'Orloger.

Vue de la Gerbe

qu'a produit le Puit de la Saline de l'Orloger, dans l'Isle du Goze.

was funnelled through the cave and up the shaft, sending a column of sea water high into the sky. The wind carried the water across large swathes of countryside, ruining crops and damaging the soil. The clockmaker was reduced to ruin. Today, when a northern wind is blowing, if you stand over the blocked-up shaft, you may hear the wind heaving and the sea churning in the cave deep beneath your feet.

It is easy to imagine how, when demand for salt outstripped the supply provided by natural rock-pools, people starting making artificial rock-pools to increase production. This process is well documented from the Late Middle Ages onwards. Sixteenth-century maps refer to Għadira as the *Saline Vecchie* or old saltpans. A series of colossal saltpans were built by the Knights of St John across the width of what is still known as Salina Bay. More modest rock-cut pans may be seen along various parts of the coastline, particularly where there is a shelf of Globigerina Limestone close to the waterline.

continues on page 158

The Knights of St John's largest complex of saltpans spans Salina Bay in the north of Malta

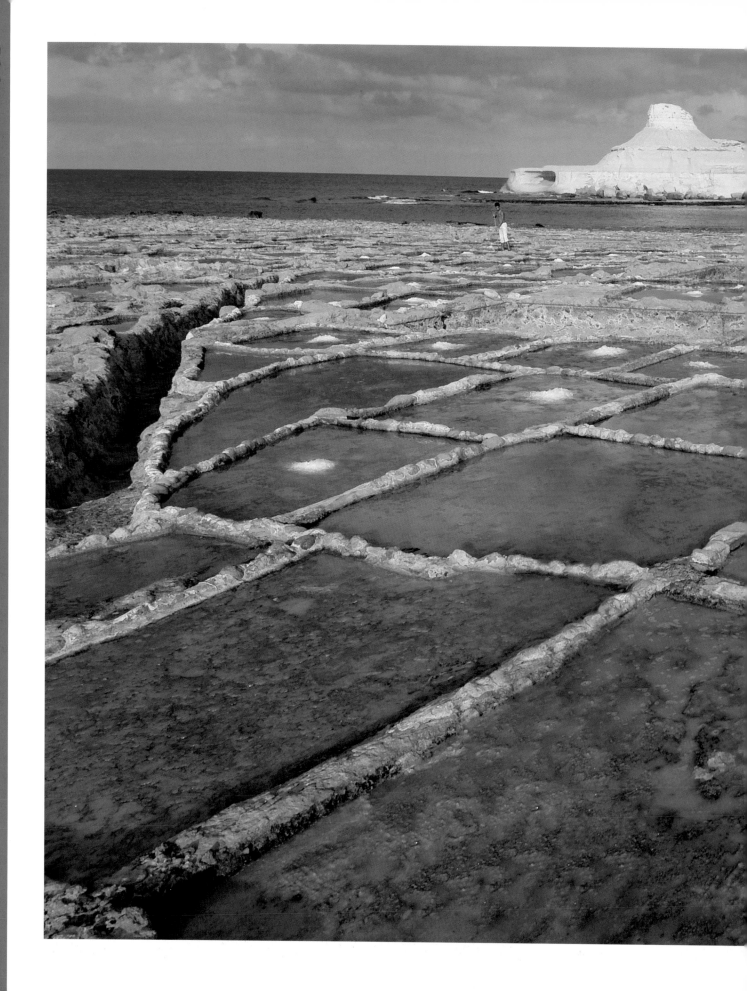

Salt is still harvested from some of the saltpans at Qbajjar in Gozo

continues from page 153

Another important component in the islands' subsistence strategies is animal husbandry. The Neolithic settlers introduced domesticated sheep, goat and cattle to the islands, where they have been reared since. Today, fresh Maltese lamb is highly sought after for its tenderness and flavour. Until the mid-twentieth century, herds of goats were a common sight in the streets of Malta's towns and villages, a milk distribution system on the hoof. The goatherd would milk his goats on demand, at the doorstep of the households buying the milk. In spite of the attraction of delivering milk of guaranteed freshness, which must have been all the more welcome in the absence of refrigerated trucks, this system had one serious flaw. Unpasteurized goats' milk could carry and transmit the bacteria that cause brucellosis, or undulant fever, and the practice was eventually discontinued as a result.

Sheep's milk and goats' milk, safely pasteurized, is used to produce Malta's only cheese, the Ġbejna, or 'cheeselet'. Ġbejniet may be eaten in three forms. When freshly made, they are large, soft and creamy. For medium-term preservation, they may be dried by natural ventilation, shrinking and hardening in the process. For longer-term

Freshly-made cheeselets being placed in a well-ventilated cupboard to dry and harden, on a roof on one of the old houses on the Citadel of Gozo.

preservation, they may be kept in hermetically sealed jars with pepper and vinegar, which gives them such a pungent taste that they are generally consumed in small quantities.

Before leaving the subject of food, we should not fail to mention some of the sweets that are made at specific times of the year, partly inspired by Sicilian sweets, but with a local twist. Carnival brings the *prinjolata*, a rich medley of trifle, cream, marzipan and candied fruit. Although traditionally intended to mop up all the ingredients prohibited during the impending period of Lent, in practice it has become an excuse to indulge in a cholesterol bombshell of calories. Lent itself brings the much more restrained *quaresimal*, which takes its name from *Quaresima*, the Italian term for Lent, or forty-day period of fasting preceding Easter, is an almond biscuit flavoured with cocoa, cinnamon and lemon

Food may be enjoyed outdoors during more than half the year. Many restaurants line the bay of St Julian's.

peel. Another sweet traditionally tolerated during Lent is the *karamelli tal-ħarrub*, or carob caramels, which may be allowed to melt gradually in the mouth rather than chewed. Come Easter Sunday, every child must receive a *figolla*, a flat, colourfully decorated almond pastry, traditionally in the form of a lamb, but nowadays also found in an endless range of other shapes. From the Italian mainland comes the tradition of *zeppoli* or *sfineġ*, deep-fried dough-balls that may be sweet or savoury, which are particularly associated with the feast of St Joseph on the 19 of March.

The parish *festas* are irremediably implicated in the sale of *qubbajt* from handsome wooden stalls sporting portable vetrines and shining weighing scales. *Qubbajt* is a nougat that may be found in a variety of colours, flavours and textures, all frowned upon by dentists. The festa season over,

the onset of November, the month of the dead, is the time for *għadam tal-mejtin*. Literally 'bones of the dead', these are almond-filled pastries shaped like a long-bone, covered in white icing to complete the ossuary effect. The eleventh of November, St Martin's Day, is marked with the *borża ta' San Martin*, or St Martin's bag, a long-awaited bagful of assorted nuts, sweet bread, dried figs and tangerines which is traditionally given to every child. Christmas brings the inevitable onslaught of imported recipes and mass-produced sweets, but not to the extent of obliterating the well-loved *qagħaq tal-għasel*, pastry rings with a core of treacle or molasses flavoured with cinnamon and orange peel.

Of course, apart from the sweets there are also several savoury dishes associated with specific times of the year, largely because of the seasonal availability of certain ingredients in the past. Even as globalisation permits instant access to any ingredient practically all year round, and any recipe at the touch of a button, traditional sweets and dishes are acquiring renewed significance as cherished cultural markers, which are likely to be with us for some time to come.

One of the most traditional meals is the fenkata, *where the central dish is rabbit fried in garlic, herbs and wine.*

Braġjoli, *or beef olives, traditionally stewed with onions, tomatoes, peas, and potatoes in a ceramic casserole or* pagna.

Pasta is the commonest yet most varied staple. Here it is served with shellfish, olive oil, dry white wine, herbs, and garlic.

A grilled sargu... *only one example of the variety of fish dishes that may be enjoyed all year round.*

The ftira, *or unleavened bread, can be used as a base for tomatoes,* ġbejniet, *and endless other toppings. A favourite midday meal for labourers.*

Baked pies are a staple of Maltese cooking. Around autumn, lampuka is the favourite filling. Other possibilities include rabbit, chicken, rice, spinach, and pumpkin.

A baking tray, or tilar, *of* qassatat, *small pies that may be stuffed with meat, tuna, cheese, spinach or peas.*

Pastizzi *may be stuffed with cheese (*ricotta *or* ġbejniet*) or mushy peas.*

Qagħaq ta' l-għasel, *pastry rings with a core of treacle or molasses flavoured with cinnamon and orange peel.*

Prinjolata *is a traditional Maltese sweet eaten during carnival. It takes its name from the Maltese for pine nuts.*

Maltese quaresimal *is an almond biscuit flavoured with cocoa, cinnamon and lemon peel. Peanuts are sometimes grated on top.*

Qubbajt *is a nougat that may be found in a variety of colours, flavours and textures and is traditional sold from stalls during the village feasts.*

A figolla, *a flat, colourfully decorated almond pastry, traditionally in the form of a lamb is given to children on Easter Sunday.*

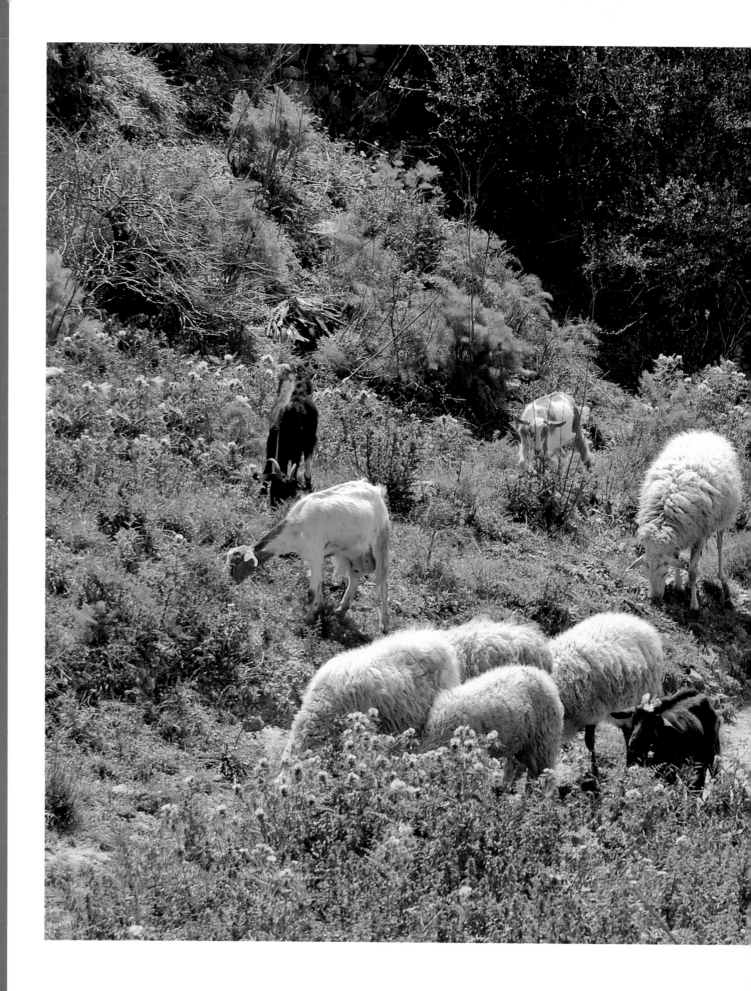

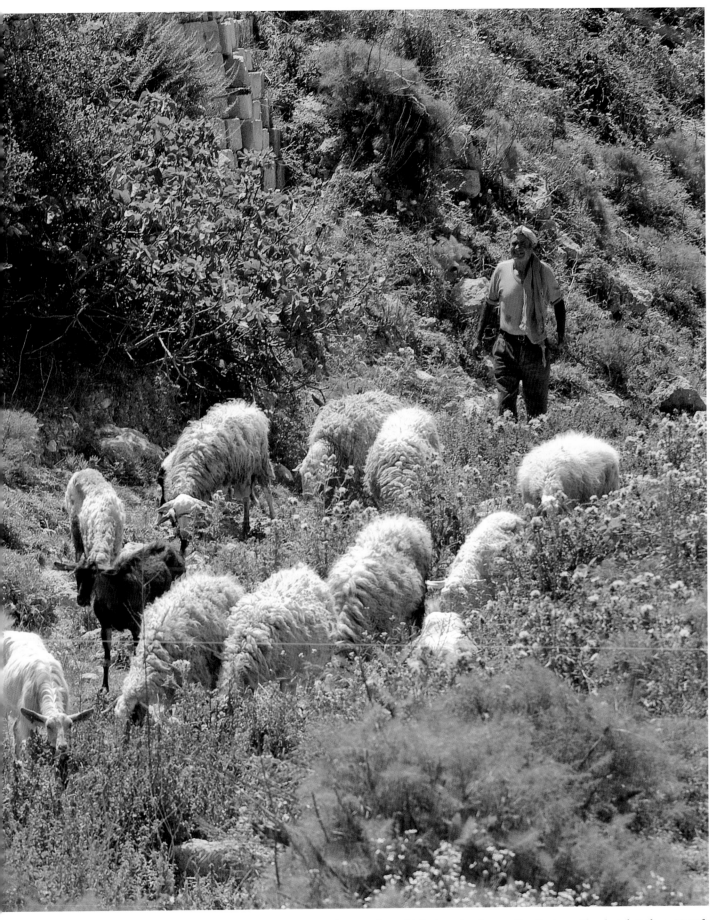

Sheep's milk and goats' milk, safely pasteurized, is used to produce Malta's only cheese, the ġbejna. Chadwick Lakes, Mtarfa

Imqaret *are deep-fried pastries filled with dates... an irresistible cholesterol bomb*

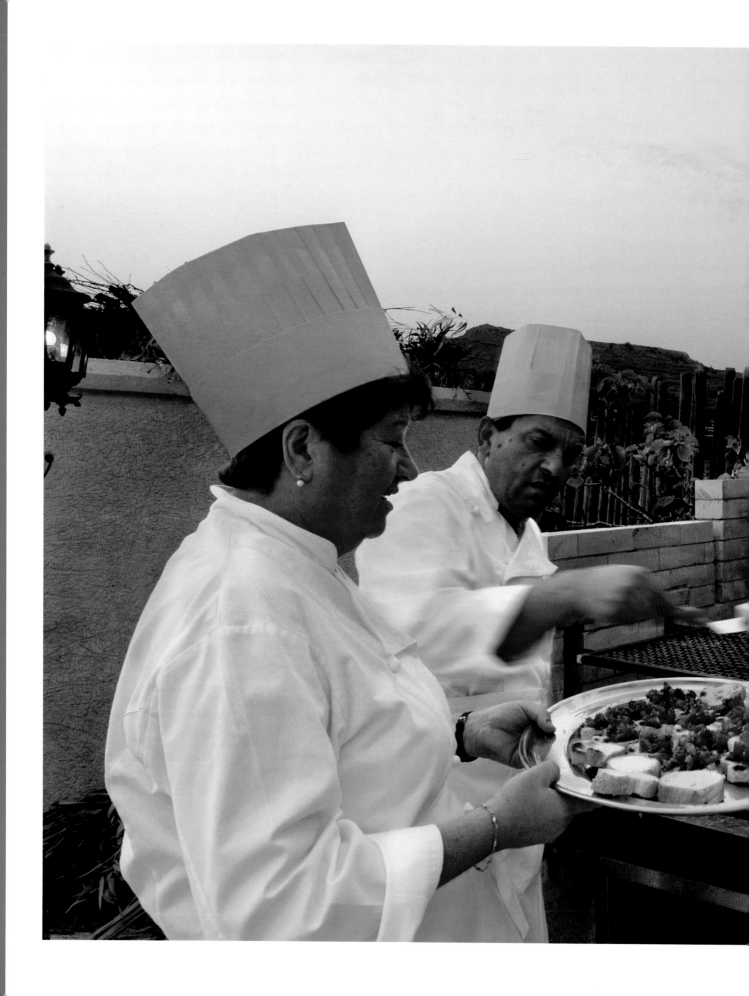

A thriving hospitality sector caters for the tastes of visitors and natives alike

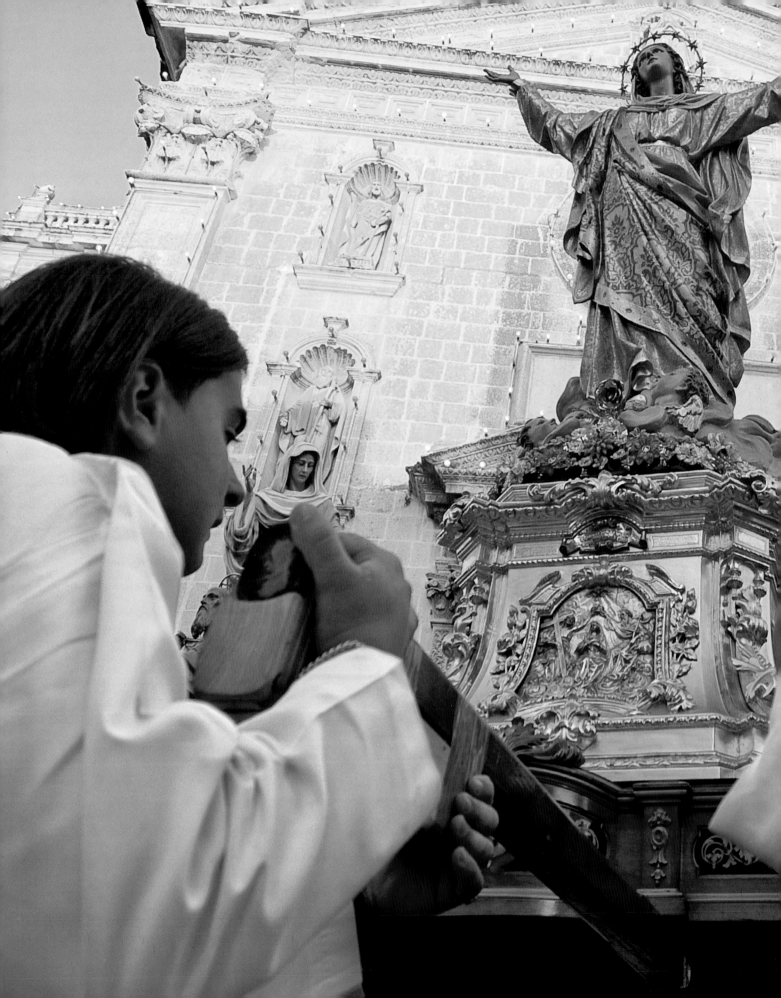

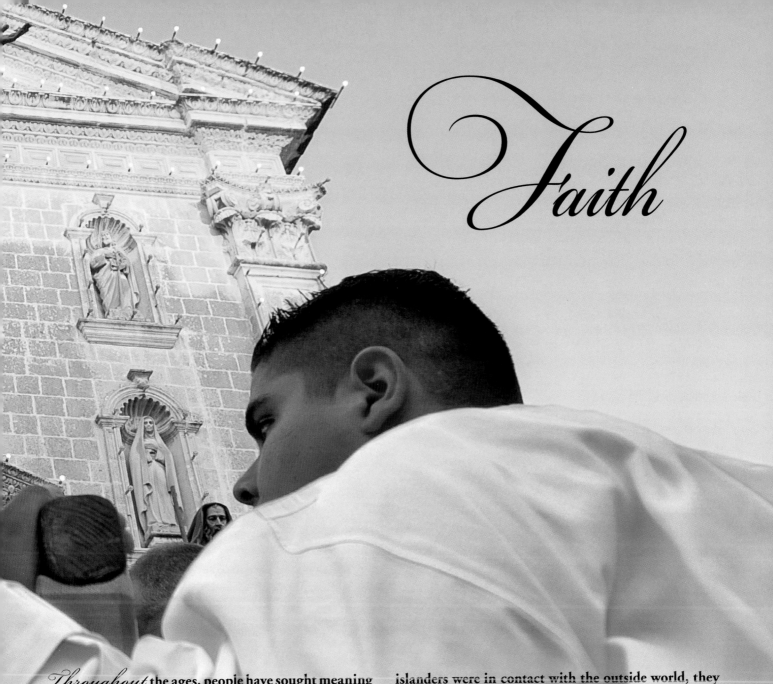

Faith

Throughout the ages, people have sought meaning and order in their world, and to this end many different systems of belief have been assembled. The myths and beliefs that have developed in different parts of the world are often inextricably bound to the climatic and geographic context in which they emerged. Such a relationship may be observed again and again in the beliefs of the islanders that have inhabited the Maltese archipelago in different periods.

One of the earliest belief systems to flourish on the Maltese islands is still the most remarkable. During the last part of the Neolithic, for over a thousand years, the islanders developed a distinctive and unique way of life. Although we know from their imports that the islanders were in contact with the outside world, they chose to do things differently from their neighbours in Sicily. We can only tell how different they were from the fragmentary remains that have come down to us. Between around 3,600 BC and around 2,500 BC, the way that they decorated pottery became more and more distinctive and different from what was being produced in Sicily at the same time. The greatest difference during this period, however, was in the extraordinary monumental buildings created on the archipelago.

The parish church of Attard is one of many dedicated to the ascension of Mary into heaven, commemorated on 15 August.

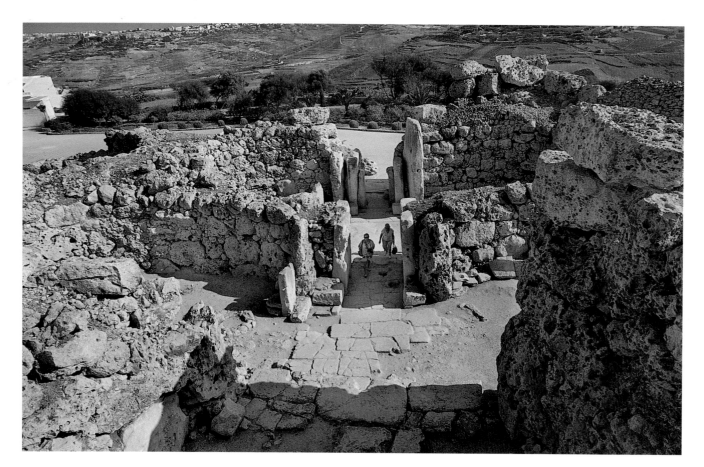

Top: View down the central axis of the South Temple, Ġgantija.

Opposite: Detail of a statuette found at the Temple Period burial site of the Xagħra Circle, Gozo. Enlarged four times actual size.

Although five thousand years have gone by, their ruins are still conspicuous features of the Maltese landscape today, silent and enigmatic. In the case of Ġgantija on Gozo, part of the façade still towers some seven metres above the ground. Although silent, the ruins are eloquent witnesses of the sophisticated system of beliefs that must have driven such a colossal effort for more than a thousand years.

We have far more questions than answers about this belief system, and about what went on inside and around the buildings. One enigma is posed by the statues with a human form that are found within them. We do not know if they represented gods, ancestors, or leaders. The same is true of the panels of low-relief sculpture that are found on many megalithic blocks. Although the significance of these panels often escapes us, it is clear that they played an important part in the rituals that went on inside the buildings. One possibility is that the panels were meant to represent the island environment during the rituals that took place inside the buildings. As noted earlier, the megalithic buildings are generally built in places that permit access to the sea. They also tend to be located at the edges of plains that would have been very favourable for agriculture. One possible interpretation is that such places were natural gateways between the land and the sea. The buildings may have been the setting for rituals and ceremonies related to the boundary between the two, and between the island and the outside world. Representations of boats in some of the buildings suggest a link with seafaring. People setting off on a journey may have visited the buildings to invoke protection during the voyage, while those returning from a successful journey may have visited in thanksgiving. The megalithic buildings with their carved panels, statues, and painted decoration were symbolically powerful places. Within, the islanders could perform rituals that helped them make sense of their world.

continues on page 178

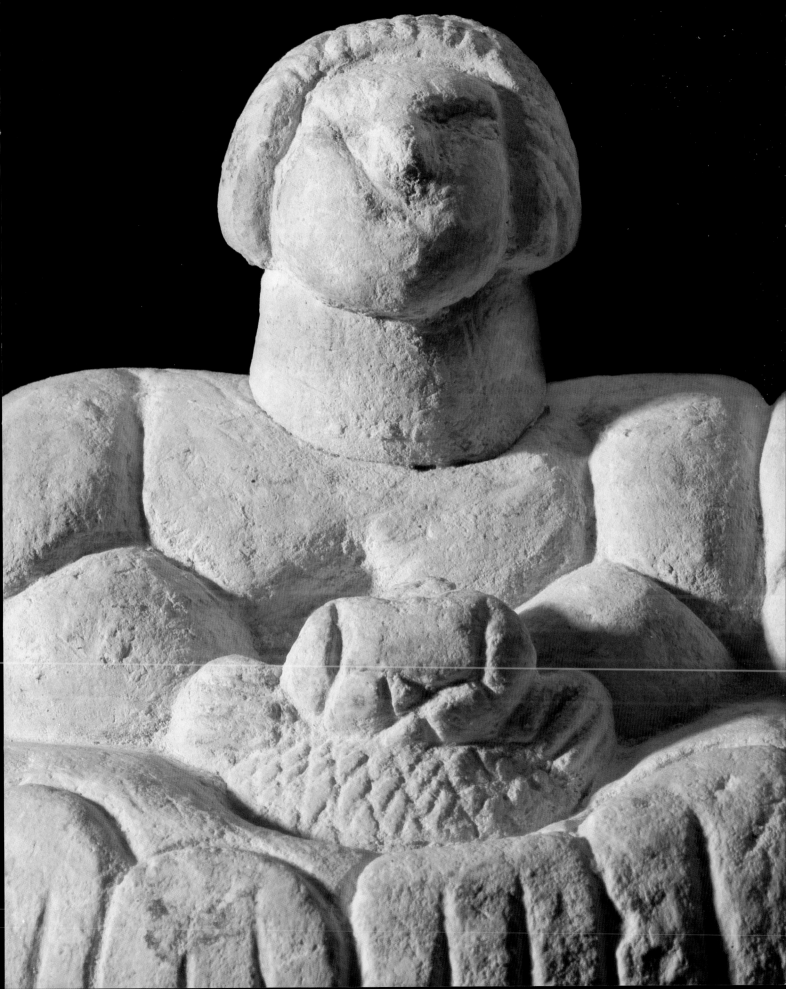

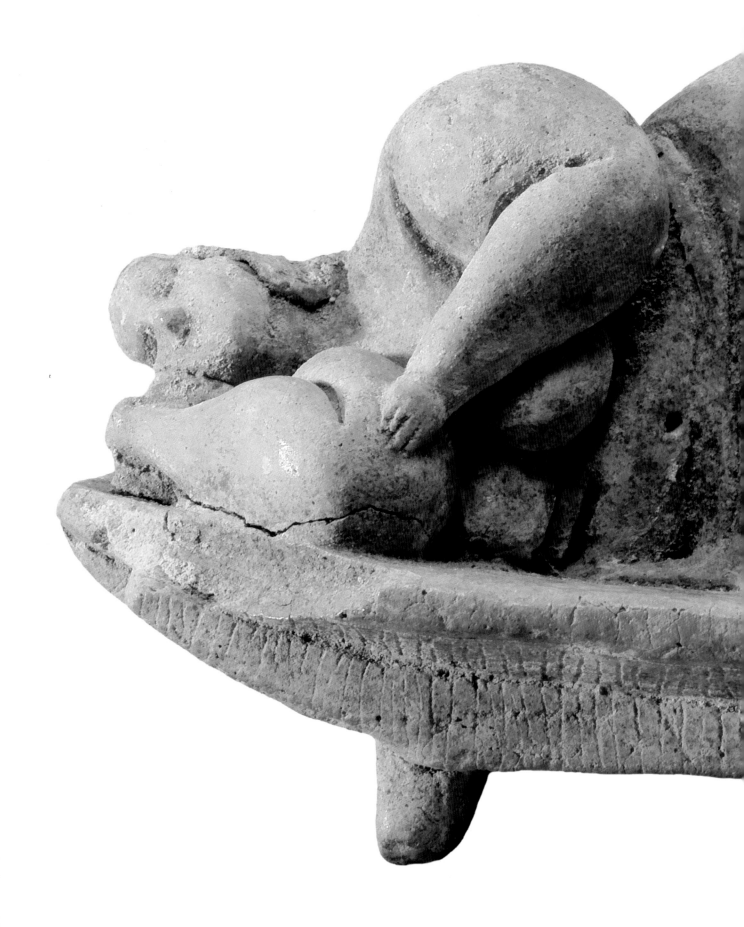

The Sleeping Lady from the Temple Period burial site of Ħal Saflieni. Enlarged four times actual size

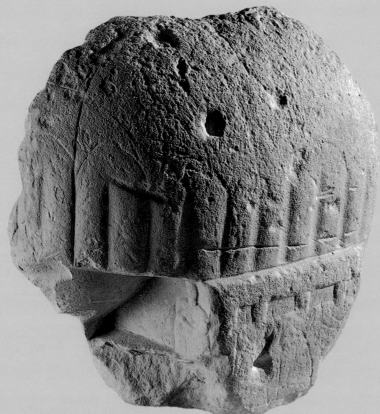

Figure incised on pottery after firing. Tarxien.
Height 5 cm.

Lower part of a statue from Tarxien. Notice the smaller representations carved under the dress. Height 20 cm.

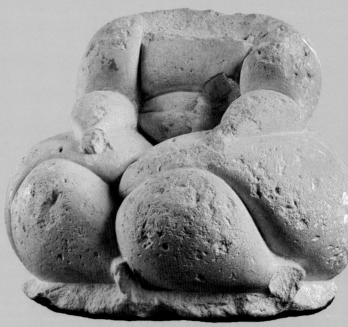

Seated figure from Hagar Qim. Height 21 cm.

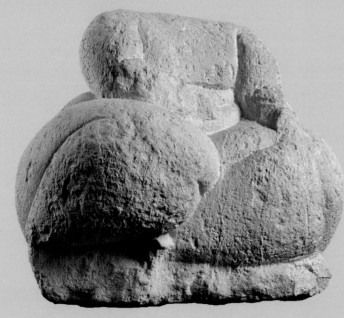

Seated figure from Hagar Qim. Height 24 cm.

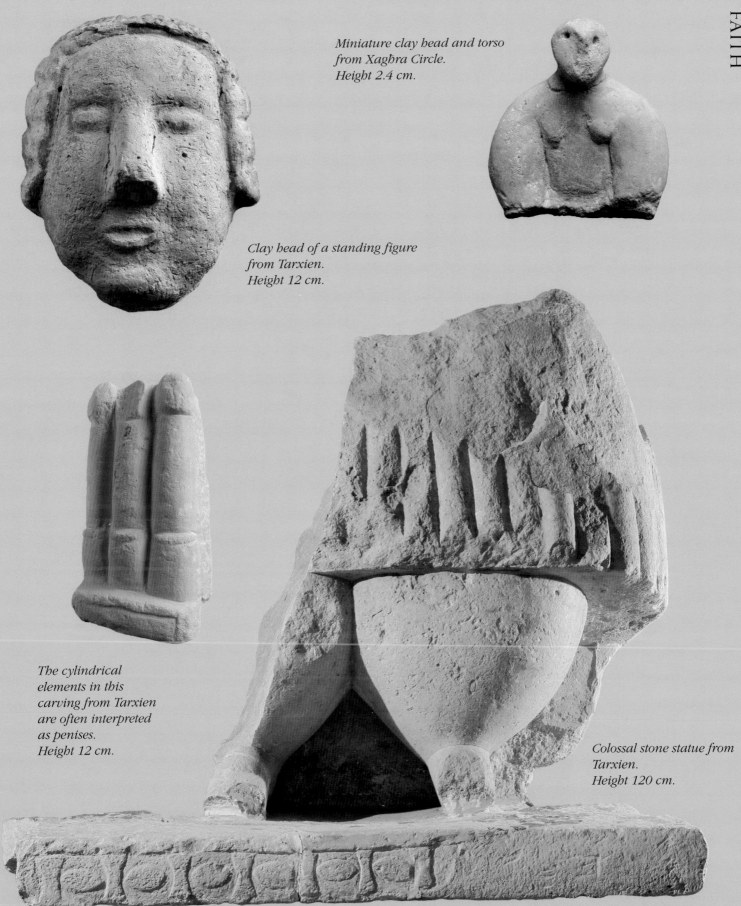

*Miniature clay head and torso
from Xagħra Circle.
Height 2.4 cm.*

*Clay head of a standing figure
from Tarxien.
Height 12 cm.*

*The cylindrical
elements in this
carving from Tarxien
are often interpreted
as penises.
Height 12 cm.*

*Colossal stone statue from
Tarxien.
Height 120 cm.*

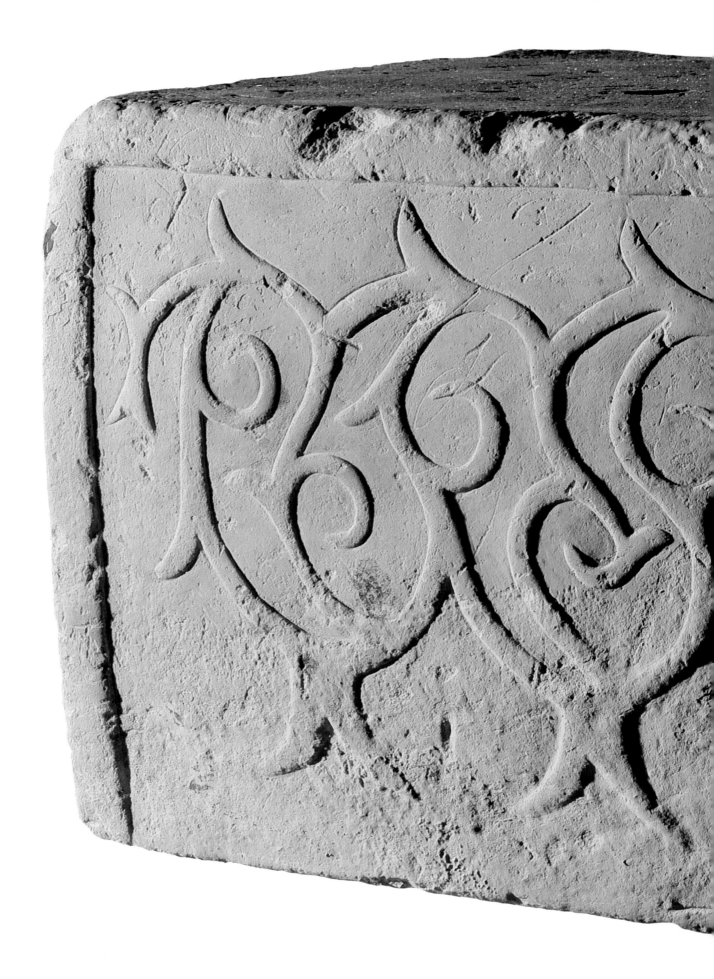

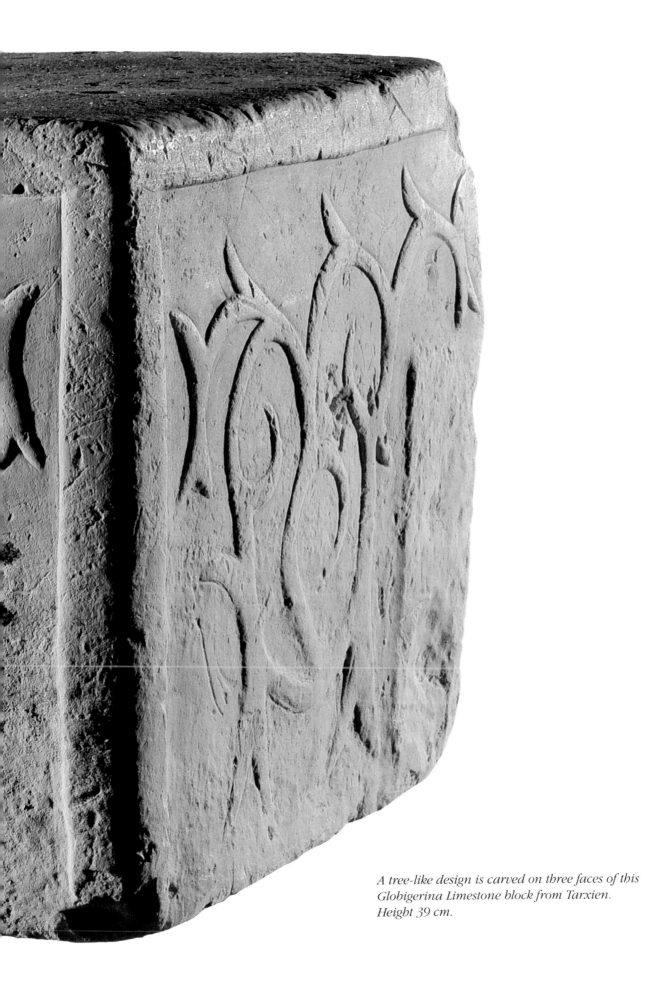

*A tree-like design is carved on three faces of this
Globigerina Limestone block from Tarxien.
Height 39 cm.*

continues from page 170

One of the megalithic buildings stood on a hilltop at Tas-Silġ, overlooking Marsaxlokk Bay. Perhaps the most remarkable thing about this site is that centuries later, the Phoenicians appear to have adopted the remains of the megalithic building, raising a larger temple around it and dedicating to Astarte (Hera to the Greeks, Juno to the Romans). The complex continued to be extended and embellished in the Roman period. The glistening mass of the temple towered over the surrounding landscape. To a sailor approaching Marsaxlokk Bay or the nearby creek of Marsascala, it would have been the most conspicuous landmark, which would even have helped him navigate to safety.

Elsewhere on the Maltese coastline, there are more Phoenician sites where cults were practiced. Two examples must be mentioned here, both of which are in carefully selected locations. Ras ir-Raħeb, on the west coast of Malta, is a flat-topped promontory

Top: A photo of the multi-period site of Tas-Silġ, Marsaxlokk, during the 1960s excavations. The original prehistoric core of the complex is in the top right corner.

Bottom left: Limestone head from Tas-Silġ

[*opposite, seen from the air*] that extends out into the sea. On its seaward sides, it is bound by cliffs of Lower Coralline Limestone that drop vertically into the sea. At the seaward extremity of the promontory, there stood a building that remained in use from Punic through Roman times. It has been suggested that the building was related to the cult of Hercules, and may even be the temple dedicated to this god recorded by Ptolemy, the second-century AD geographer. On the south-west corner of Gozo, another Phoenician sanctuary site is located at Ras il-Wardija, in a position that is perhaps even more vertiginously breath-taking.

The two sites are at once remote from the sea, and in intimate contact with it. While the cliffs make it practically impossible to embark or disembark in the vicinity, they command views of the sea that stretch to the horizon on three sides, the way a ship does.

continues on page 188

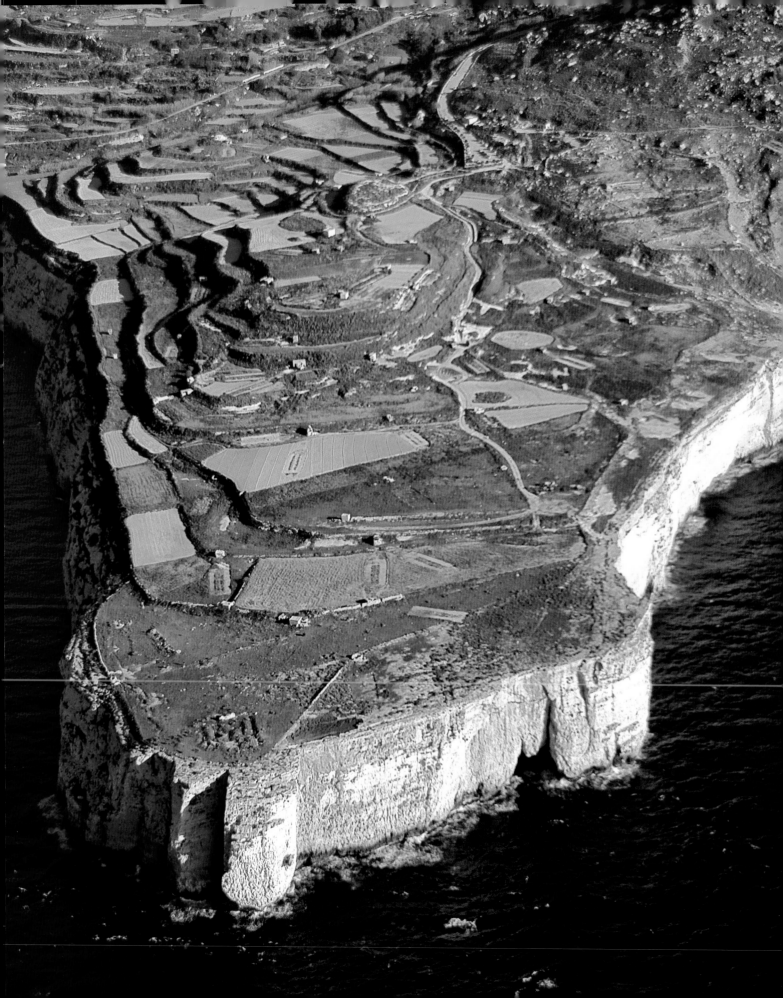

One of the enigmatic finds at Ras ir-Raheb was a small ivory plaque showing a boar, which may be a reference to one of the labours of Hercules.

An aerial photo of the site of Ras ir-Raheb during its excavation in the 1960s.

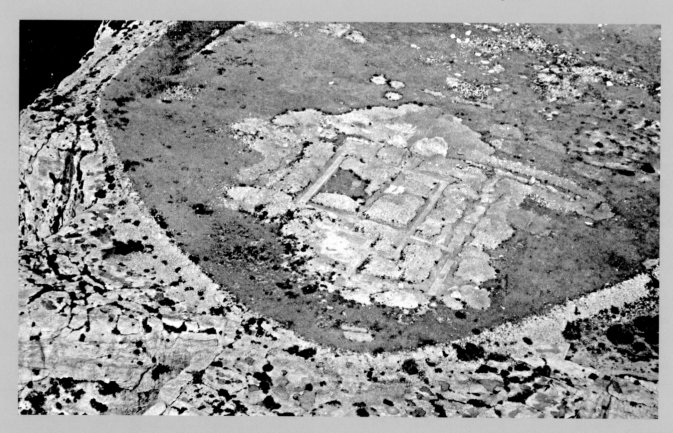

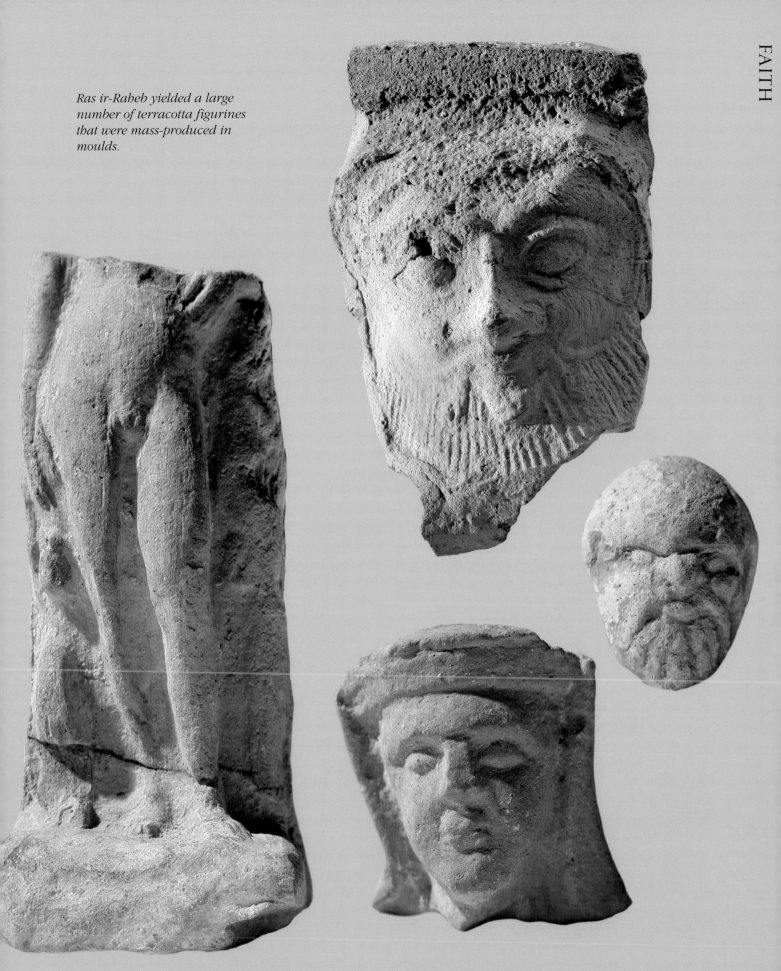

Ras ir-Raheb yielded a large number of terracotta figurines that were mass-produced in moulds.

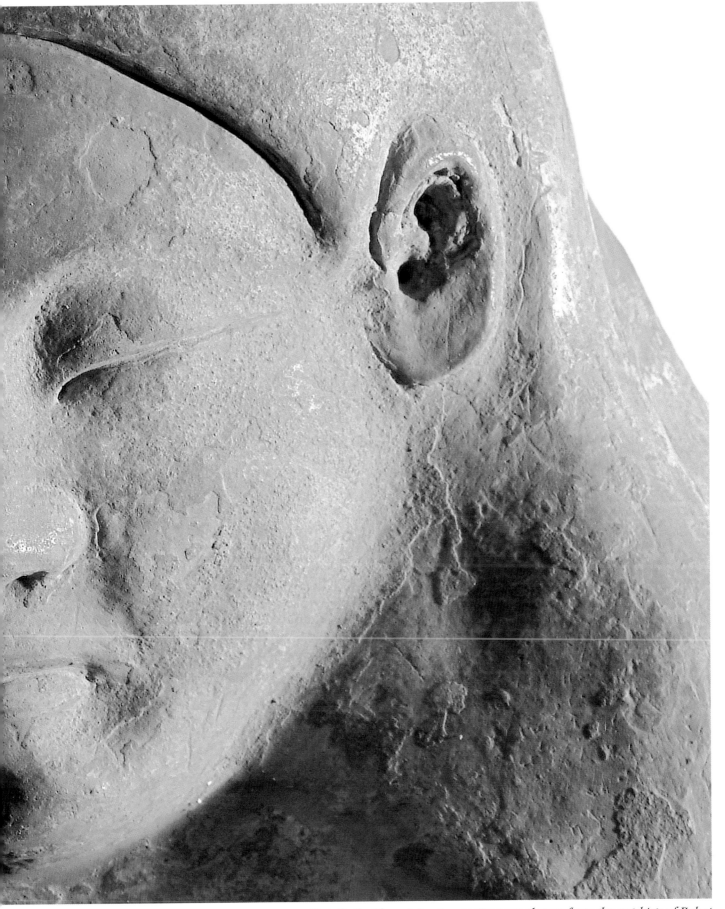

Detail of a Phoenician terracotta sarcophagus from the outskirts of Rabat

View from the rock-cut chamber of the sanctuary at Ras il-Wardija

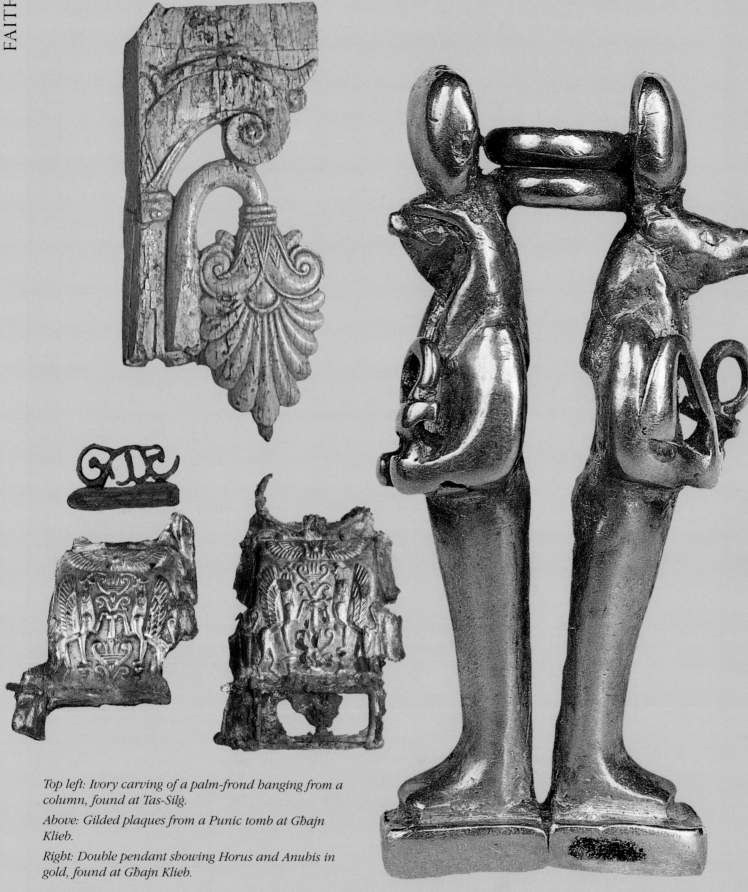

Top left: Ivory carving of a palm-frond hanging from a column, found at Tas-Silġ.

Above: Gilded plaques from a Punic tomb at Għajn Klieb.

Right: Double pendant showing Horus and Anubis in gold, found at Għajn Klieb.

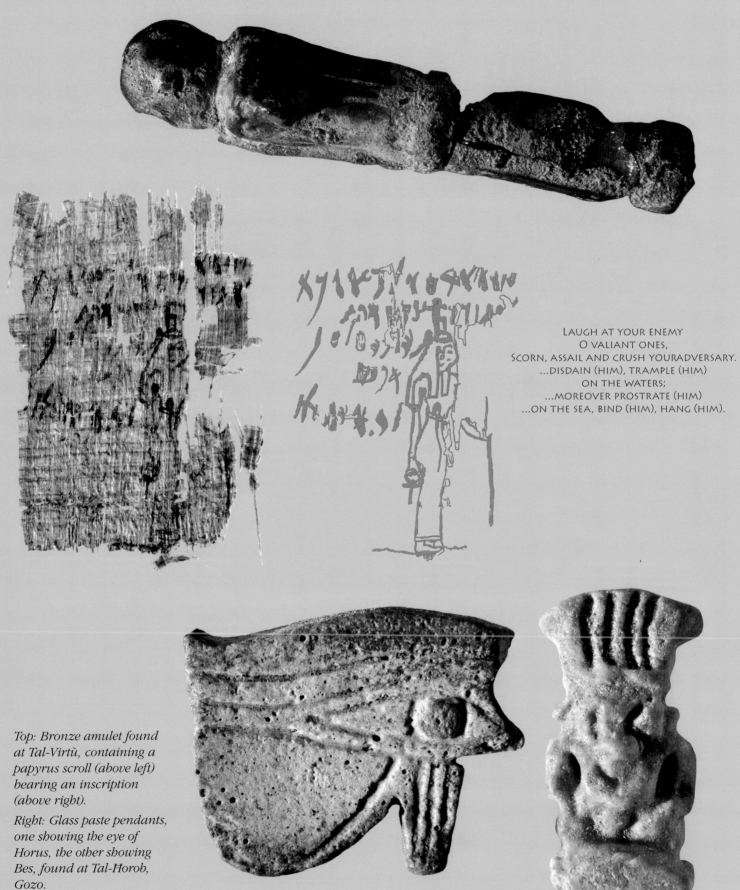

LAUGH AT YOUR ENEMY
O VALIANT ONES,
SCORN, ASSAIL AND CRUSH YOURADVERSARY.
...DISDAIN (HIM), TRAMPLE (HIM)
ON THE WATERS;
...MOREOVER PROSTRATE (HIM)
...ON THE SEA, BIND (HIM), HANG (HIM).

Top: Bronze amulet found at Tal-Virtù, containing a papyrus scroll (above left) bearing an inscription (above right).

Right: Glass paste pendants, one showing the eye of Horus, the other showing Bes, found at Tal-Horob, Gozo.

continues from page 178

Ras ir-Raheb and Ras il Wardija are also conspicuous to a sailor navigating along this hostile coast. The choice of these locations speaks eloquently of the Phoenicians' passionate relationship with the sea and of their confident mastery of the Mediterranean from end to end. Whoever chose these sites must have often looked out to the horizon, knowing that beyond it lay Carthage, the thriving megalopolis of their people.

The titanic power struggle between Carthage and Rome is something we shall come to shortly. For the moment, let us recall that Malta was taken by Rome in 218 BC, at the start of the second war between the two powers. The change in regime did not bring about a sudden change in religious practices. Phoenician divinities were equated with those in the Greek and Roman pantheon. Melqart, for instance, was equated with Hercules, as we learn from the inscriptions on a pair of pillars [*photo opposite*] found in Malta, written in Phoenician and Greek. The natural consequence was that the sanctuaries and temples created by the Phoenicians continued to be venerated. The most famous record of this enduring veneration is a speech written by Cicero, attacking Verres for despoiling the temple of Juno while serving as governor of Malta.

Above: Maltese coins of the early Roman period reveal a strong undercurrent of Punic culture.

Right: These two remarkable candelabra each bear a dedicatory inscription in two languages, to Melqart in Phoenician, and to Hercules in Greek. The one on the left is the marble original, while the one on the right is a cast of the original held in the Louvre.

By the close of the first century BC, Roman power was being consolidated around the entire Mediterranean seaboard. The ensuing *Pax Romana* allowed even more interaction between the peoples of the Mediterranean, making urban centres more cosmopolitan than ever before. Several exotic and strange cults started spreading out of the eastern provinces. One of the strangest of these cults emerged in Palestine in the first century AD. Its followers were suspected of practising cannibalism and were at times tolerated, but at others vigorously persecuted. In spite of all the persecutions, the cult continued to flourish or fester, depending whose side you look at it from. By the fourth century AD, Christianity had become the dominant religion in the Roman empire.

In Malta, archaeological evidence of Christianity begins from around this time, in the traces of Christian burial practices that are found in the rock-cut catacombs.

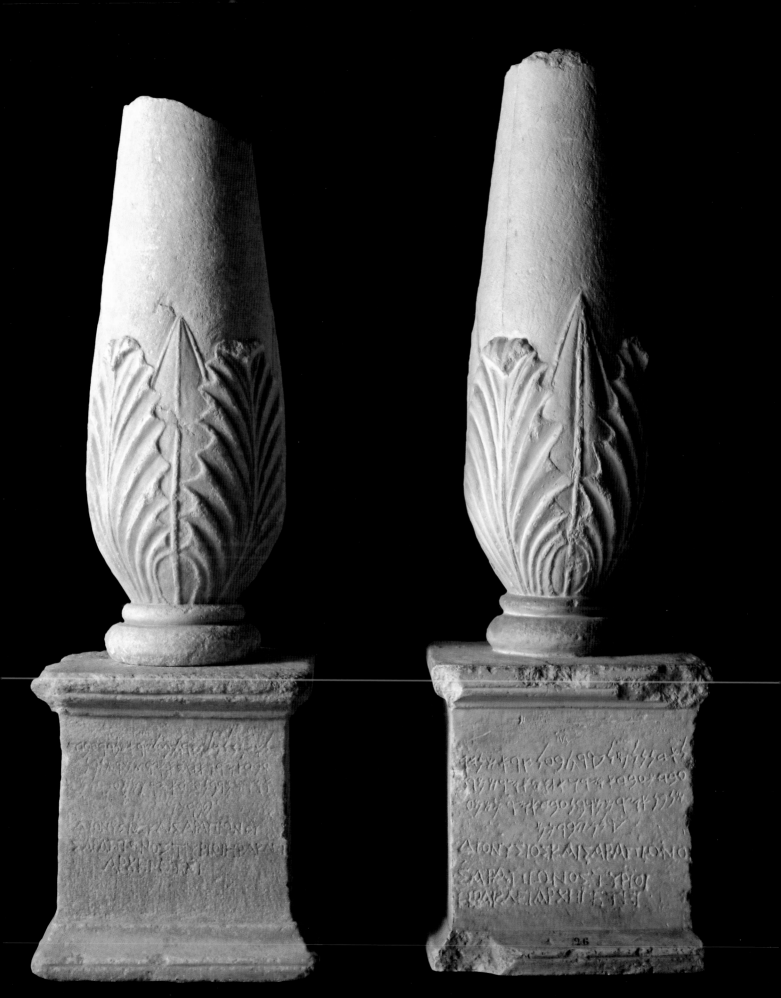

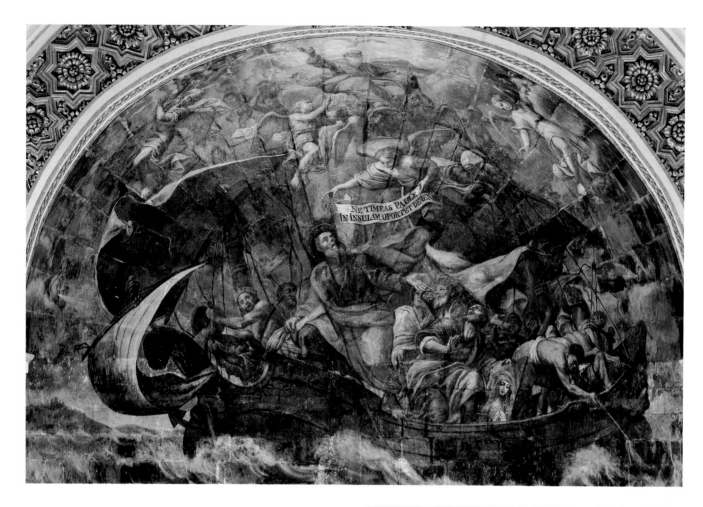

If popular traditions are to be believed, however, the conversion of the archipelago to Christianity took place rather earlier.

Sometime around 60 AD, a ship carrying grain from Alexandria to Rome was caught in a storm and shipwrecked on an island called Malta. On board was a prisoner on his way to trial in Rome. The prisoner's name was Paul and the reason he was in trouble was that he was one of the most zealous activists of the new cult. According to Maltese traditions that may be traced back to the Middle Ages, Paul was responsible for the mass conversion

Above: St Paul before the shipwreck. St Paul's cathedral, Mdina.

Opposite: A tradition of pious devotion holds this rock-cut chamber in Rabat to be the place where the prisoner Paul was held while on Malta.

Left: Graffiti of a male figure and ship from San Pawl Milqi have sometimes been interpreted as the earliest pictorial reference to Paul's shipwreck.

of the Maltese population to Christianity. Popular tradition would also have it that the islands remained Christian without interruption, right until the present. The available evidence suggests otherwise. The Muslim conquest of much of the Mediterranean world reached Malta in the ninth century AD, when the Arabs wrested the islands from the Byzantines. During the Arab period, from around 870 to around 1091 AD, the Maltese population appears to have converted to Islam. As had happened in many other urban settlements during the decline of the Roman empire, the population had declined

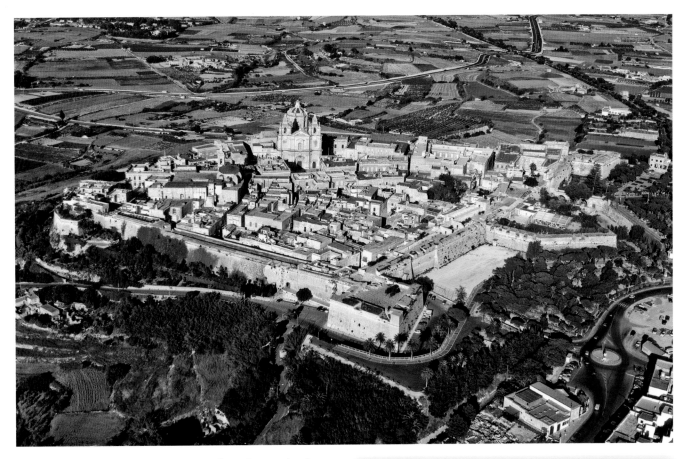

drastically. The walled town of Melite, which in Roman times had taken in the present day area of Mdina and much of Rabat, had shrunk to the area of Mdina by the Arab period. The oscillating size of the city is reflected in the distribution of burial sites, which could only be located outside the city walls. Phoenician tombs and rock-cut catacombs of the Roman period are found west of the line joining the churches of St Dominic and St Paul. Just outside Mdina, on the other hand, a Muslim cemetery dating from the twelfth century AD was found overlying the remains of a sumptuous Roman townhouse, known today as the Domus Romana.

Above: The Roman town of Rabat must have shrunk to present-day Mdina by the Arab period, because an extensive Muslim cemetery was found just outside it, in the area in bottom right of picture.

Opposite: Seated figure and inscription painted on a late Roman grave in St Paul's Catacombs, Rabat.

Bottom left: Examples of 12-century Islamic tombstones from Rabat.

Several of the Islamic tombstones may still be seen today in the archaeological museum on the same site. By the late Middle Ages, the town was expanding once again into the thriving suburb of Rabat.

When Malta became the new home of the Knights of St John in 1530, the old town of Rabat presented them with an unusual opportunity.

The tradition that St Paul was shipwrecked in Malta and imprisoned in Rabat was a public relations vehicle of the first order. Here was a story no less dramatic than that of the Order of St John itself.

continues on page 202

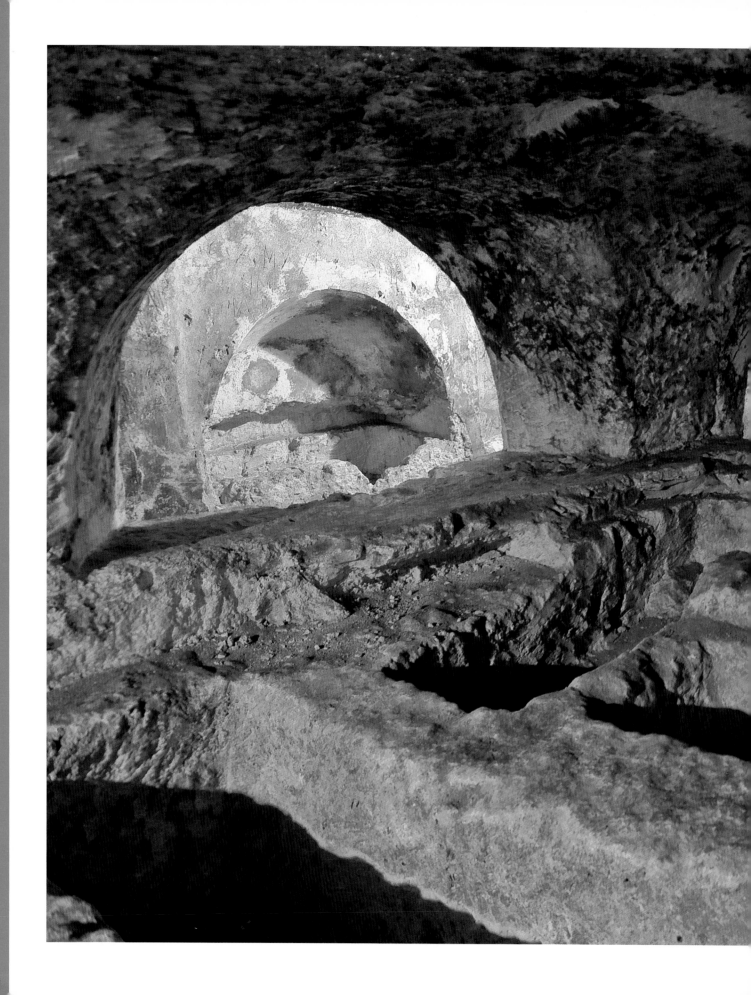

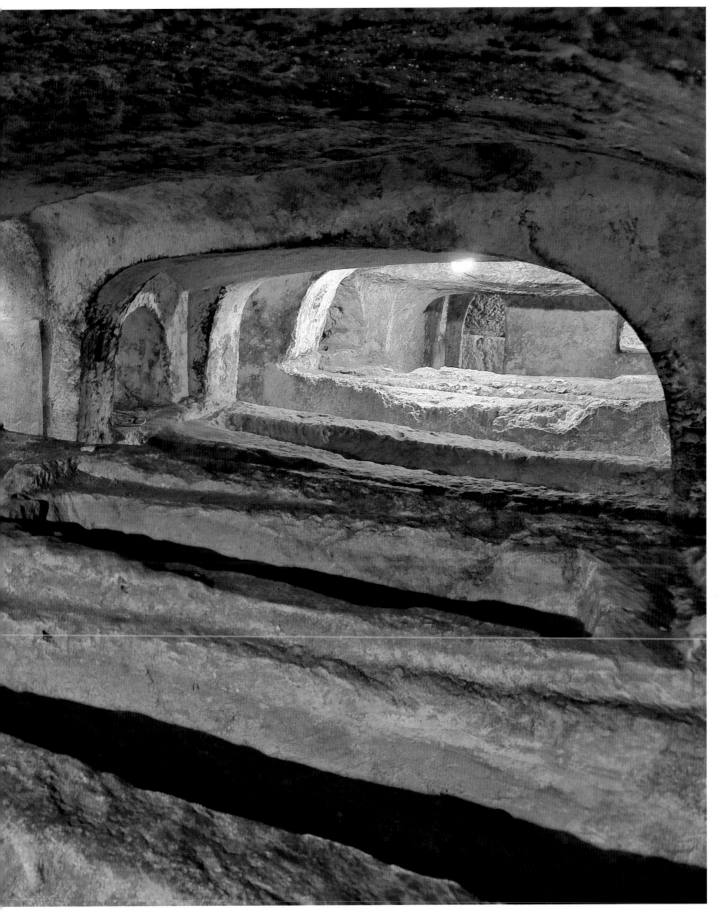

Canopied graves were the most widely-used type of graves at St Paul's Catacombs

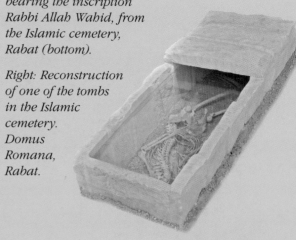

Left: Silver signet ring bearing the inscription Rabbi Allah Wahid, from the Islamic cemetery, Rabat (bottom).

Right: Reconstruction of one of the tombs in the Islamic cemetery. Domus Romana, Rabat.

In the name of God the Compassionate and Merciful. God look kindly upon the Prophet Muhammad and his family, and grant them eternal well being. To God belongs power and everlasting life, and his creatures are destined for death: And you have a fine example in the Prophet of God.

This is the tomb of Maimūna, daughter of Hassan, son of Ali ᶜal-Hudali called Ibn as-Sūsī;; she died, may the mercy of God be with her, on the fifth day, the sixteenth of the month of Shaᶜban of the year 569, witnessing that there is no God but the only God, who has no equal.

Look around with your eyes. Is there anything in the world which can stay or repel death, or cast a spell upon it? Death took me away from my palace and, alas, neither doors nor bars could save me from it. I have become a pledge, carrying my past deeds with me for my redemption, and that which I have achieved remains.

You who look upon this grave. I am already decayed within it; the dust has covered the lids and sockets of my eyes. In my resting place and in my position in death there is a warning, and at my resurrection when I shall come before my Creator. Oh brother, be excellent and repent.

The 12th-century funerary inscription of Maimūna (Museum of Archaeology, Gozo), translated above.
Source: Luttrell 1975.

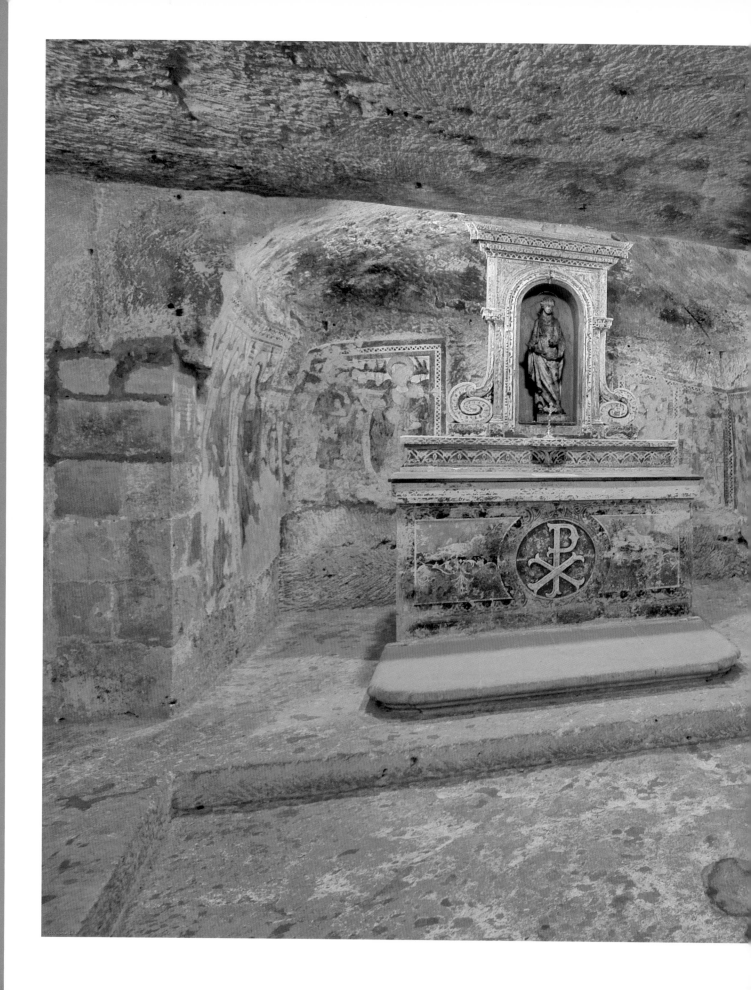

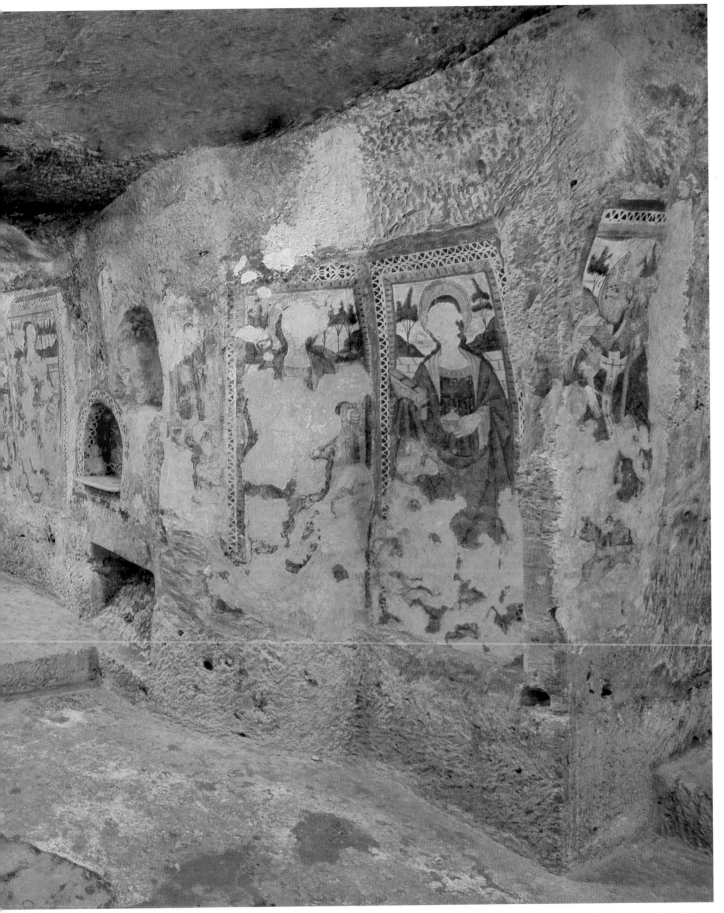

The medieval underground rock-cut church of St Agatha, Rabat

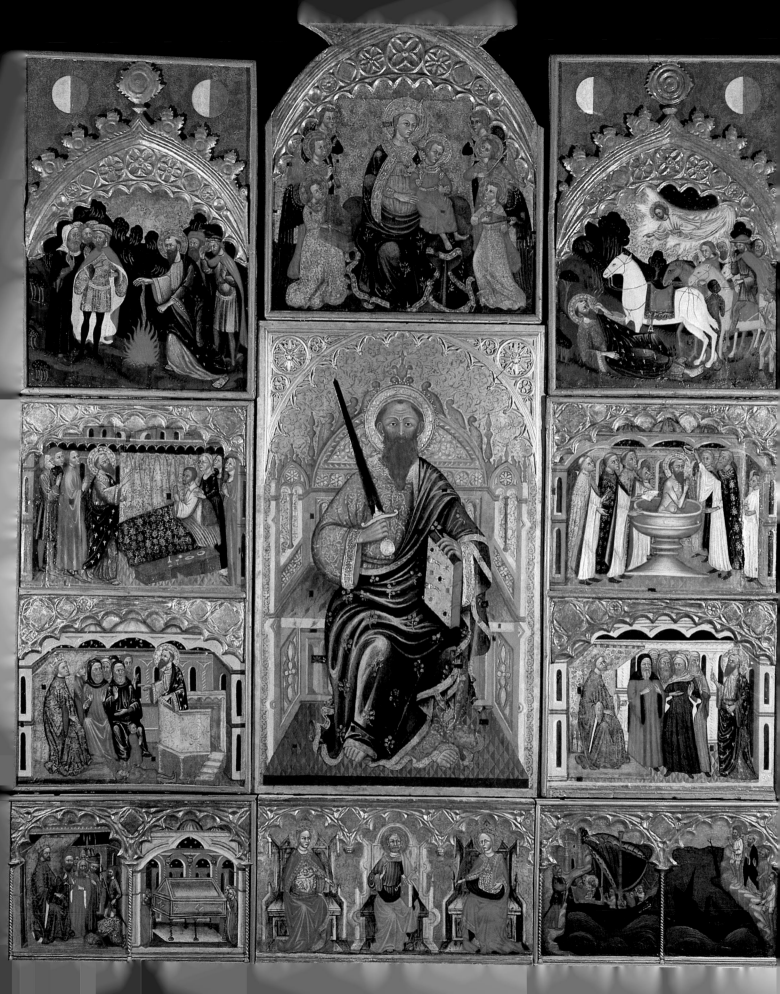

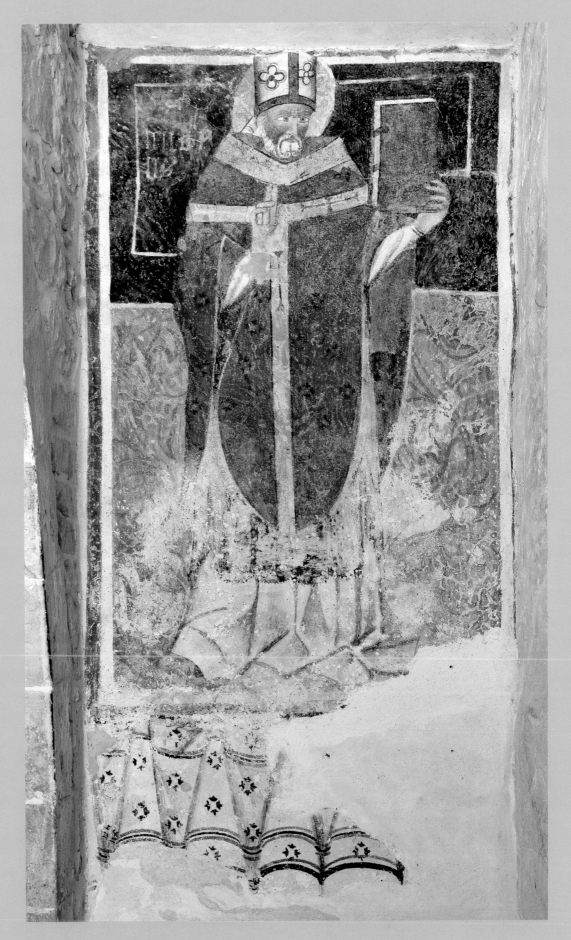

Opposite: The great polyptych depicting the life of St Paul was the main altarpiece of the medieval cathedral in Mdina (now at the Mdina Cathedral Museum).

Right: 15th-century fresco of St Leonard, Church of Ħal Millieri, Żurrieq.

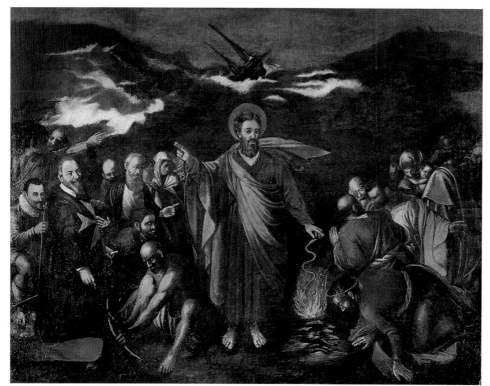

embellished, and a college built nearby. Wignacourt did not stop there. At St Paul's Bay, a new chapel was built near the place where the saint and his shipwrecked companions first came ashore. The chapel is still known as *Tal-Ħuġġieġa* sanctuary, after the bonfire that was lit to warm them after their unexpected winter swim. In the main painting over the altar [*left*], Paul stands in the centre, after having cast off a poisonous viper that had come out of some brushwood that he had collected, an incident that is described by his fellow-traveller Luke in the Acts of the Apostles. The incident of the viper entered Maltese popular lore as the moment when the venom of Maltese vipers ceased to be lethally poisonous. To the right of the same painting, some native Maltese figures are shown kindling the fire. To the left, Grand Master Wignacourt has inserted himself and his retinue into the Maltese landscape of 60 AD, to assist personally in the momentous occasion.

The native population fervently believed that one of the first great apostles of Christianity had been shipwrecked on the island and that he had converted the entire population to Christianity. Now the very same island had become the new home of the Knights of St John, Christendom's border warriors who considered themselves no less zealous than Paul in the safeguarding of their faith. Grand Master Alof de Wignacourt was among the first to realize the power of the Pauline narrative to raise Malta's international profile and to further legitimate the Order's *raison d'être* and its role as a bulwark of Christendom. He invested heavily in the consolidation and promotion of the Pauline cult which drew pilgrims from across Europe. In Rabat, the sanctuary overlying the cave where Paul was reputedly kept prisoner was enlarged and

Below: The serpent and the sword have become symbols of Paul's encounter with Malta. Detail from one of the wooden library cupboards at the old Mdina Cathedral library.

Opposite: The rock-cut sanctuary of St Paul in Rabat. The marble statue carved in Rome by the Maltese sculptor Melchiorre Cafà, was commissioned by Grand Master Nicolas Cotoner in 1666.

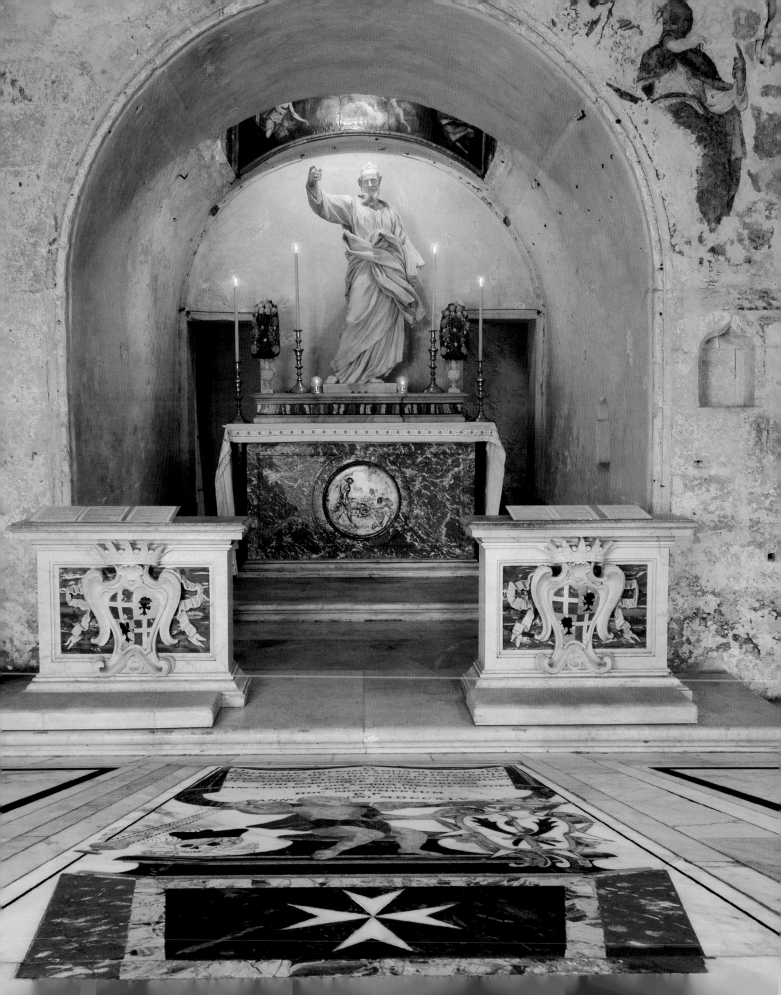

The shipwreck acquired immense significance for the inhabitants of this small island on the edge of the Christian world. The story of Paul's stay in Malta has indeed been so treasured by the Maltese for so many centuries that it is inscribed into the very landscape, particularly in the north of Malta. Every place where some incident tied to the saint is reputed to have taken place is marked in some way. We have already mentioned the spring of Għajn Rasul where he was said to have struck the rock to bring forth a spring of fresh water. A chapel dedicated to the saint was built over the ruins of a Roman farmstead, which was reputedly the place where the governor of the island hosted Paul. It is still known as San Pawl Milqi (popularly rendered as St Paul welcomed). The most colossal example [*left*], however, stands on the islet of Selmunett, one of the locations that have been put forward as the

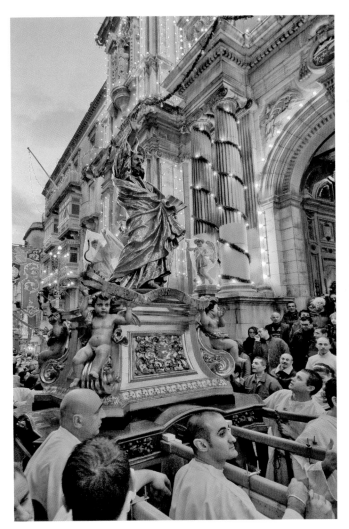

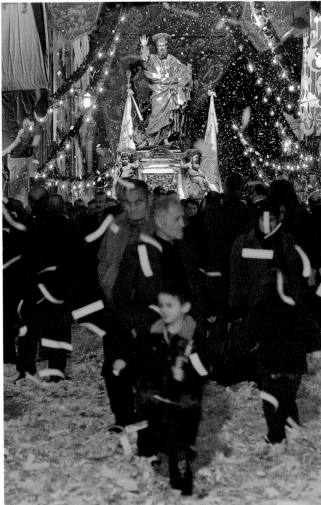

actual site of the shipwreck. In Mellieħa, the northernmost village on Malta, another statue of Paul stands over the courtyard of the sanctuary of Our Lady, an important focus of devotion and pilgrimage, which, according to popular tradition, was founded by the apostle. Just across the valley, overlooking the bay, yet another statue of the preacher was erected in the most impossible of locations, on a pinnacle of rock beneath a cliff-edge, defiantly overlooking the sweep of Mellieħa Bay, the scene of frequent raids by Barbary corsairs [*opposite top left*]. At San Pawl tat-Targa, a chapel marks the point where he is said to have preached across the water to the inhabitants of Gozo. A statue of the saint still stands there, hand upraised in the middle of a petrified sermon [*opposite top right*]. Similar statues may be found in other places.

The most treasured of all the statues of Paul, however, must surely be the wooden sculpture of the saint held in the church of St Paul

Shipwrecked, in – wait for it – St Paul's Street, Valletta, which incidentally is the only street in the capital that has never changed its name since the founding of the city in the sixteenth century. The statue is the creation of the master sculptor Melchiorre Cafà. On 10 February each year, when the shipwreck is commemorated, the statue comes to life as it is carried in solemn procession through the streets of Valletta [*top*]. The rhythmic movement of the carriers creates the illusion that the saint is ambling through the streets of the city, stopping to acknowledge devotees at various points along the way, and even performing a final dance before reentering the church to return to a niche in the wall until the following year. Here, perhaps, we have the inverse of what Wignacourt did with a painting to insert himself into the scene of the shipwreck in AD 60. The Maltese have used statues to bring Paul into the present-day landscape, and even to let him continue to tread their streets today.

continues on page 222

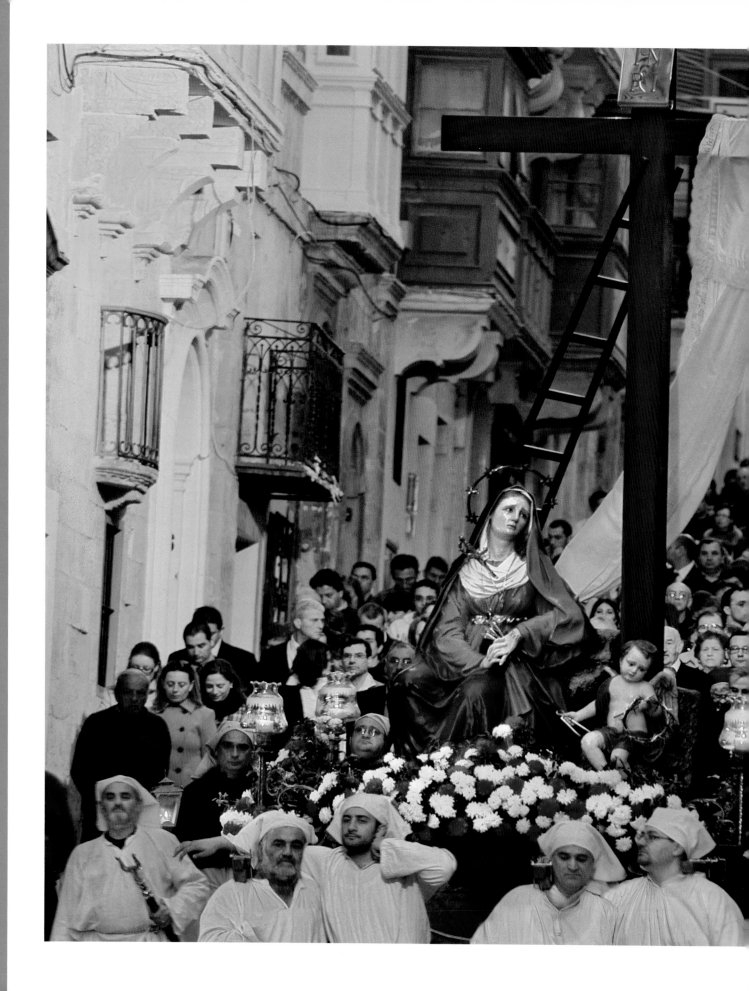

Our Lady of Sorrows is carried in procession in Valletta, a week before Good Friday

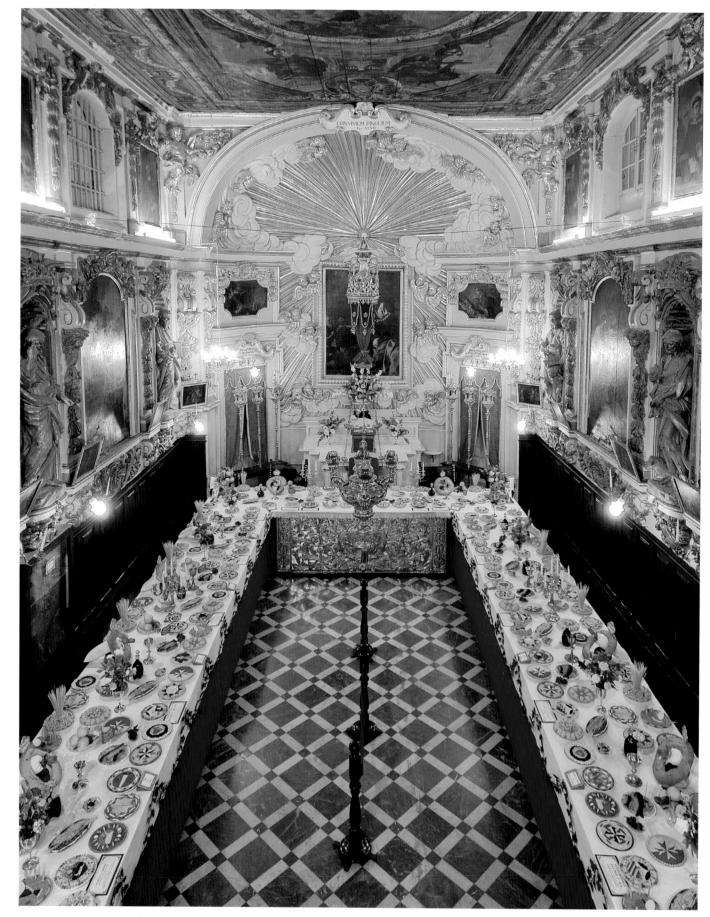

Traditional Last Supper Table. Maundy Thursday, Oratory of the Blessed Sacrament, St Dominic's Priory, Valletta

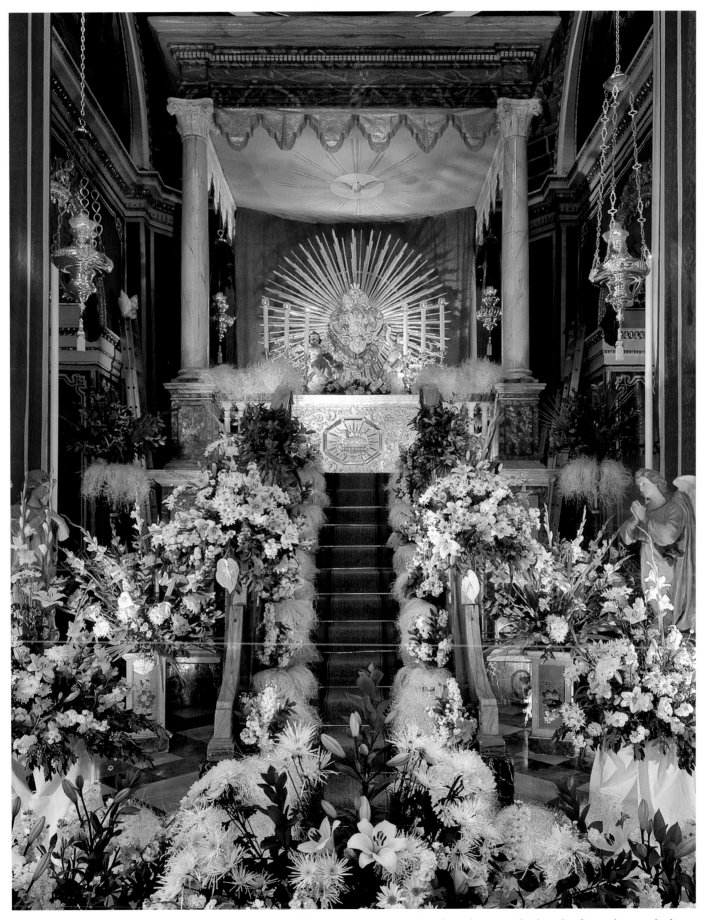

Altar of repose. Maundy Thursday, parish church of St Helen, Birkirkara

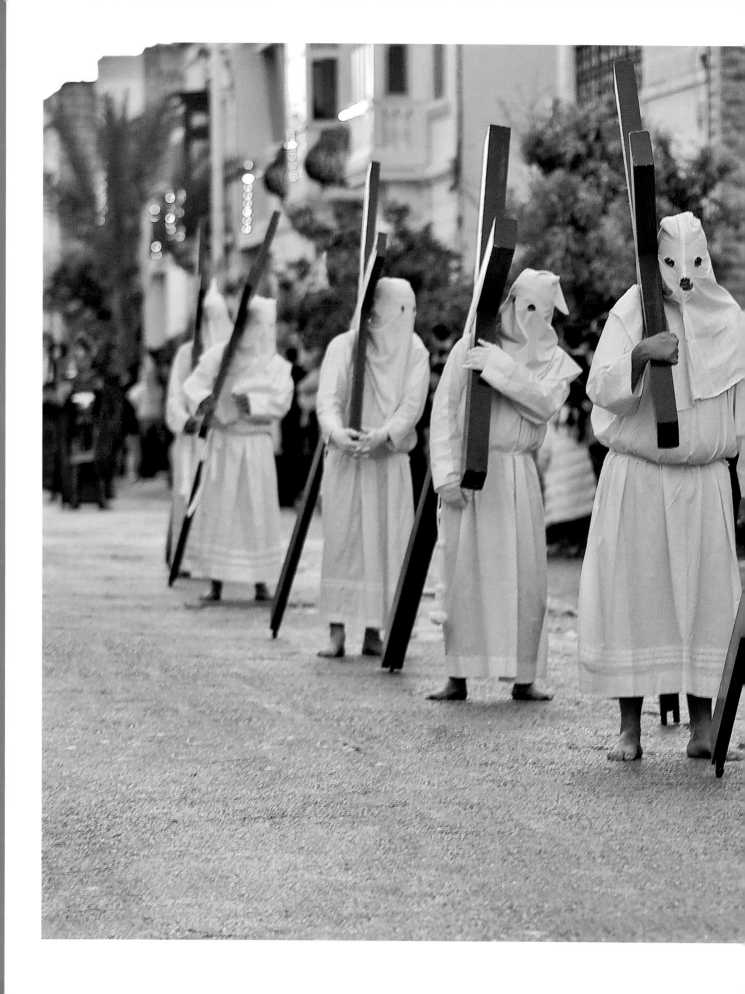

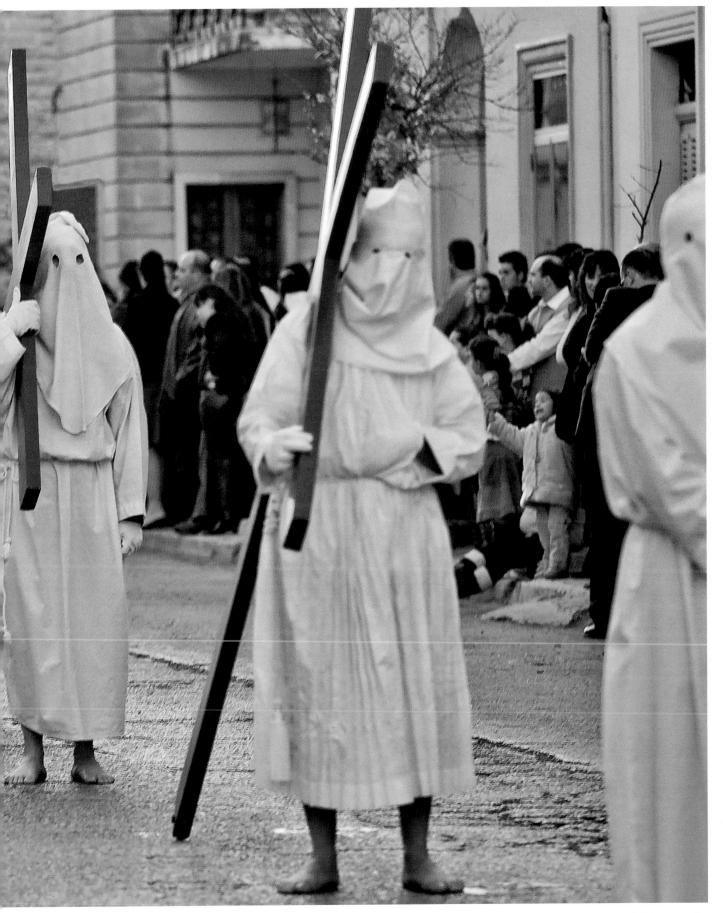

Private penitence in a public arena. Good Friday, Ħaż-Żebbuġ, Malta

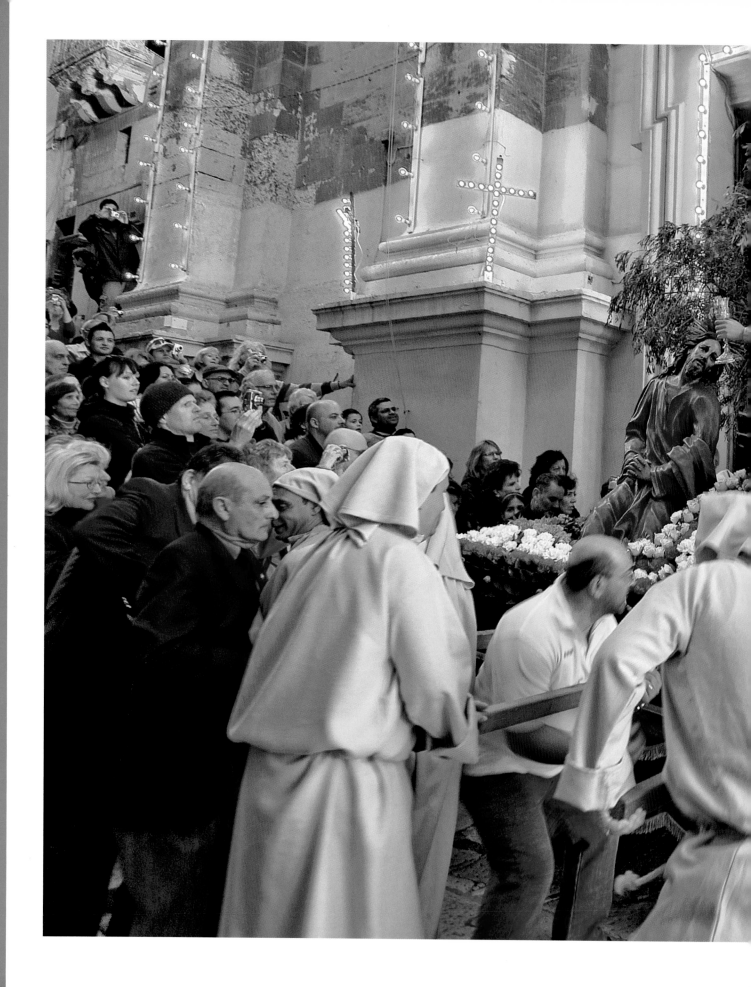

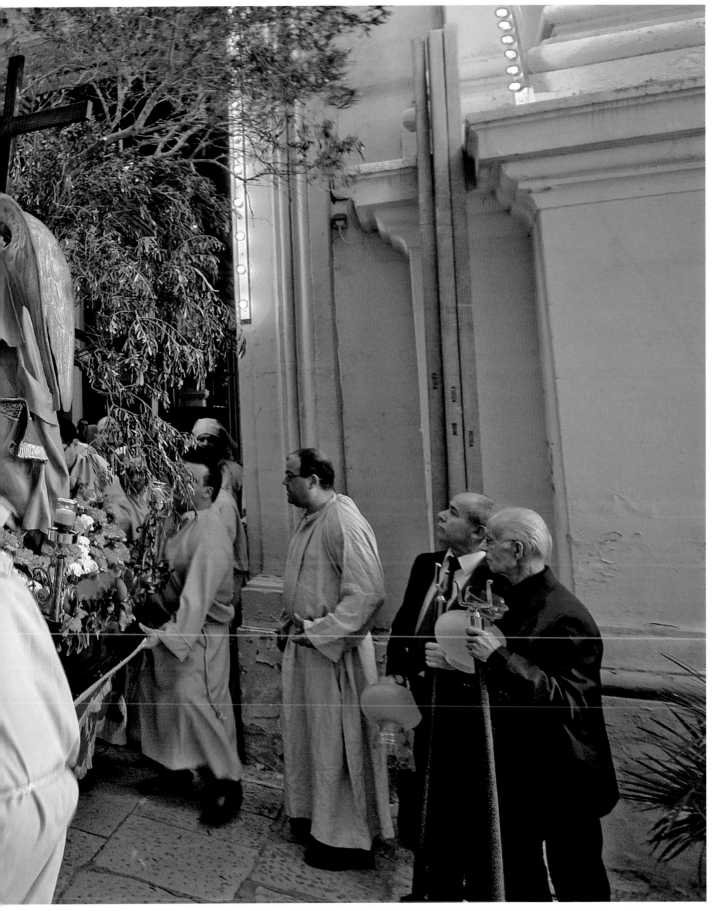

Carrying a vara through the church door is a tricky manoeuvre. Good Friday, Ta' Ġieżu, Valletta

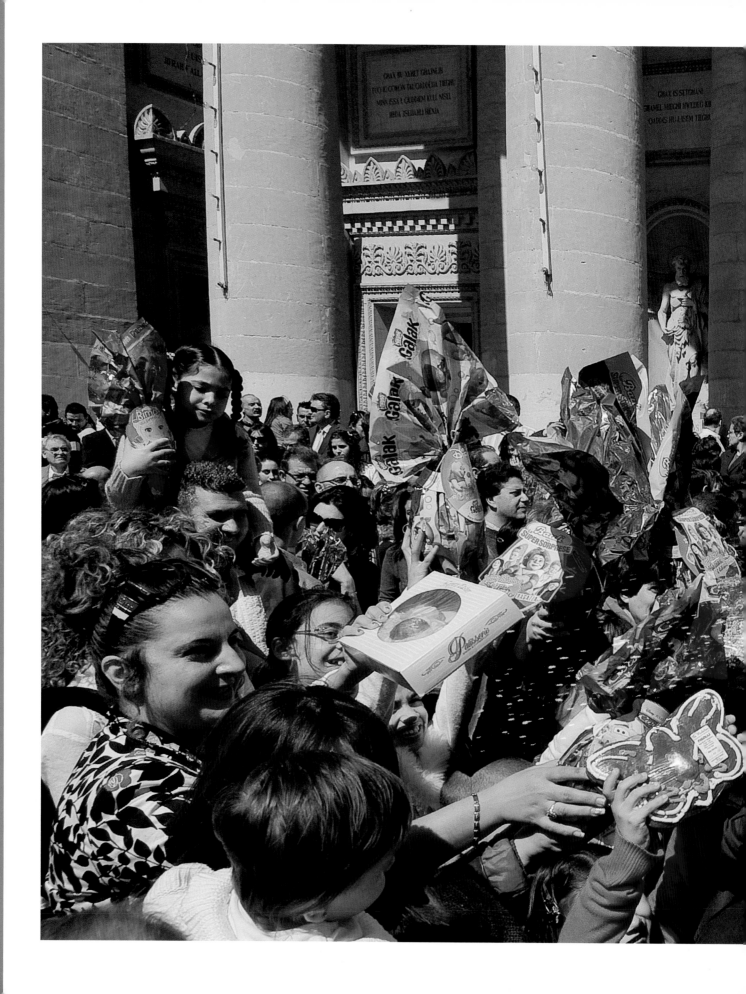

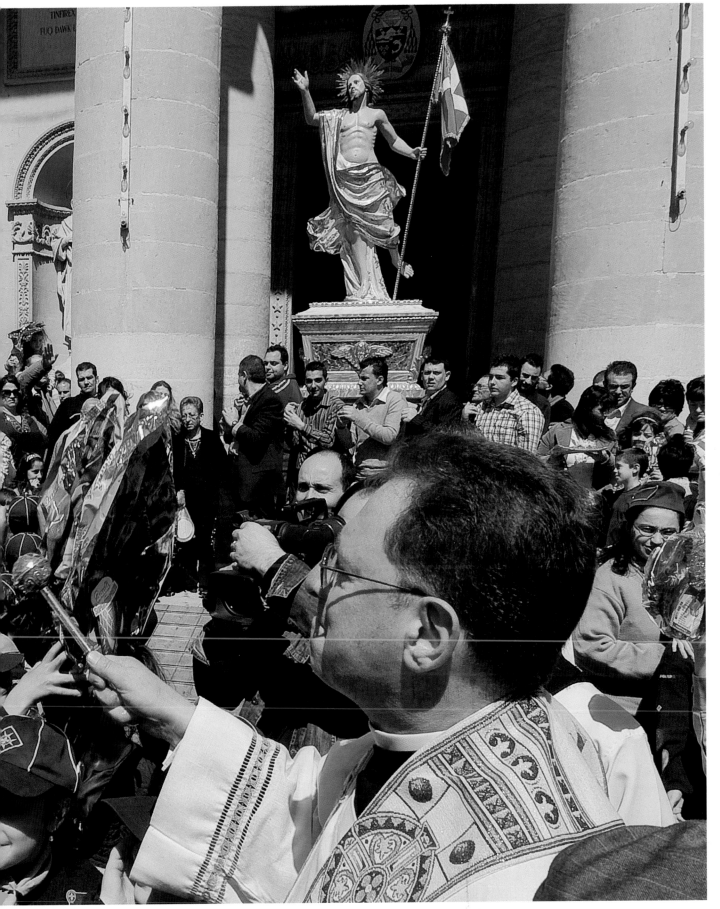

The blessing of the figolli *and, the more recently introduced Easter eggs, on Easter Sunday morning at Mosta*

A procession at Msida commemorating the apparitions of Our Lady at Lourdes

© 2007 Daniel Cilia

Feast of St Helen, held in Birkirkara in mid-August. This is the only parish feast procession to be held in the morning

Blessing of motorcyclists as they pass through Ħaż-Żabbar during the pilgrimage of their patron, Our Lady of Graces

continues from page 205

The feast of St Paul's Shipwreck is but one of the many that mark the liturgical calendar, particularly during the summer months. Apart from the feasts of the patron saints of different villages, the period of most intense religious commemoration is Eastertide, which mobilizes the entire nation in an annual cycle of procession and prayer. The Friday before Good Friday is dedicated to Our Lady of Sorrows. The day is marked by penance and prayer, which in many localities across Malta culminates in a solemn procession with the statue of a grieving Mary at the foot of an empty cross. The most elaborate mobilisation takes place a week later, on Good Friday. In the early evening, following a church service to commemorate the passion and death of Jesus, solemn processions take place in nearly a score of towns and villages across the archipelago. This time, in a local variation of a tradition that is also widespread in Spain, Sicily, Latin America and the Philippines, a series of *vari*, or life-size scenes with figures, representing different scenes from the passion are carried through the streets, accompanied by hundreds of adults and children dressed in costumes to represent different characters from the scriptures. Accompanied by a band playing funeral marches and sombre music,

The archpriests and bishops of Malta walk up the nave of St John's co-Cathedral to celebrate high mass commemorating the start of the liturgical year.

the processions wind their way slowly through the streets of the locality, only returning to the church after nightfall.

In Malta, the tradition of the Good Friday procession dates back at least to the seventeenth century. The procession centred on the church of Ta' Ġieżu in Valletta boasts some of the earliest Good Friday procession statues on the island, several of which date back to the eighteenth century. The statues representing the passion are a bloodily graphic display of the mangled body of Christ under torture. To the modern viewer, they may appear alien, horrifying and distasteful. To the audience of the seventeenth or eighteenth century, however, for whom the statues were first created, the public, almost theatrical, display of torture was a familiar sight. The infliction of ridicule, pain, mutilation and dismemberment was a routine and accepted form of punishment for offenders, conducted in public to inspire others to virtue. The graphic representation

In mid-April, the parish of Floriana celebrates the first of the summer festas. Every year, the Archbishop and the President (4th and 5th from left) meet at the Vilhena Band Club to inaugurate the festa season.

of the torture and execution of Christ was perhaps not intended to make its hardened audience flinch at the sight of the gore, but rather at the thought of the innocence of who suffered it.

The culmination of the Easter celebrations is Easter Sunday, which once again is marked by processions through the streets, this time with the statue of *l-Irxoxt*, the triumphant risen Christ. In several localities, the statue is carried at a run for several stretches along the route of the procession, usually without mishap. The annual cycle of processions through the streets, and the colossal mobilisation of volunteer energy that it requires, binds parish and community together. The permanent focus of worship, that is the church, is allowed to spill over and take possession of the streets for the appointed period, renewing the bonds that hold the inhabitants together for another year. A related tradition is for the clergy of the parish to visit every household shortly after Easter, to bless the house

and its dwellers. Other occasions extend the comfort and security of a ceremoniously administered blessing to fishing boats, motorbikes, and most endearingly, to pet animals brought to the ceremony by their young owners.

Christmas also has its own Maltese traditions. One of the most cherished is the *presepju*, or crib, which dates back at least to the eighteenth century, and is also popular in southern Italy and Sicily. Miniature figures are used to recreate the scene of Jesus' birth in a manger, in what may range from a simple representation of the cave or hut where it happened, to reconstructions of the entire landscape of Bethlehem, populated with mechanized and moving figures.

In all these expressions of faith, the use of statues and material objects plays a central role, focussing the attention of an audience, allowing it to share a spectacle with the rest of the community. This graphic characteristic is partly an inheritance from the Catholic policies reaffirmed at the Council of Trent, to deploy imagery in order to galvanize the faith of people in different walks of life, including the simple and illiterate. If the persistence of these traditions today is anything to go by, in Malta they had certainly struck a winning formula.

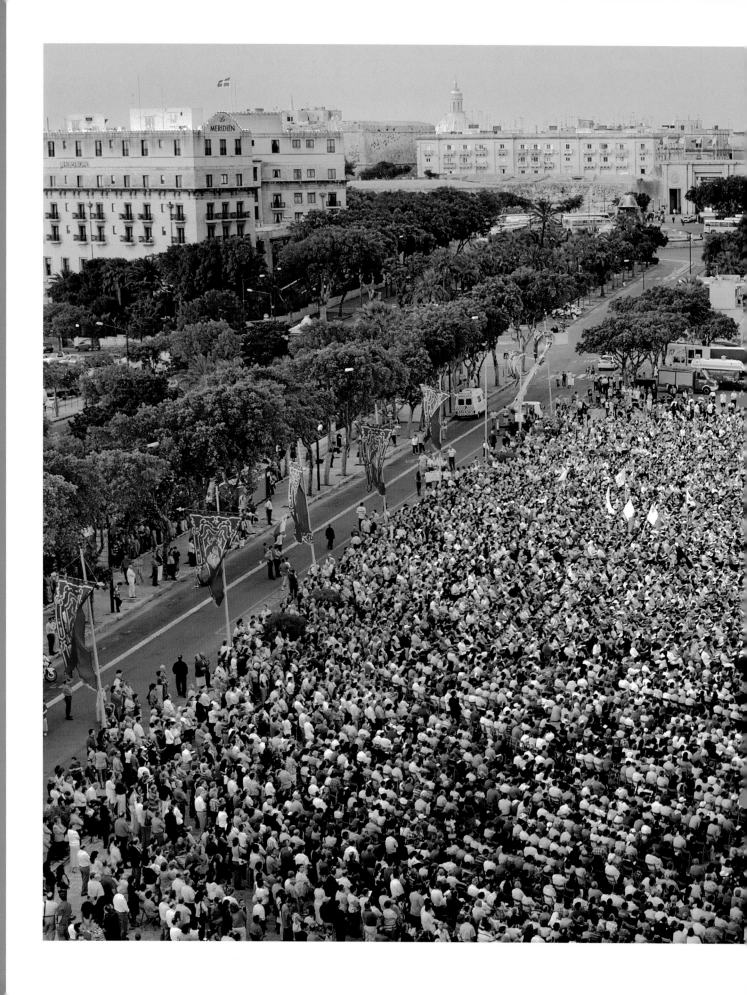

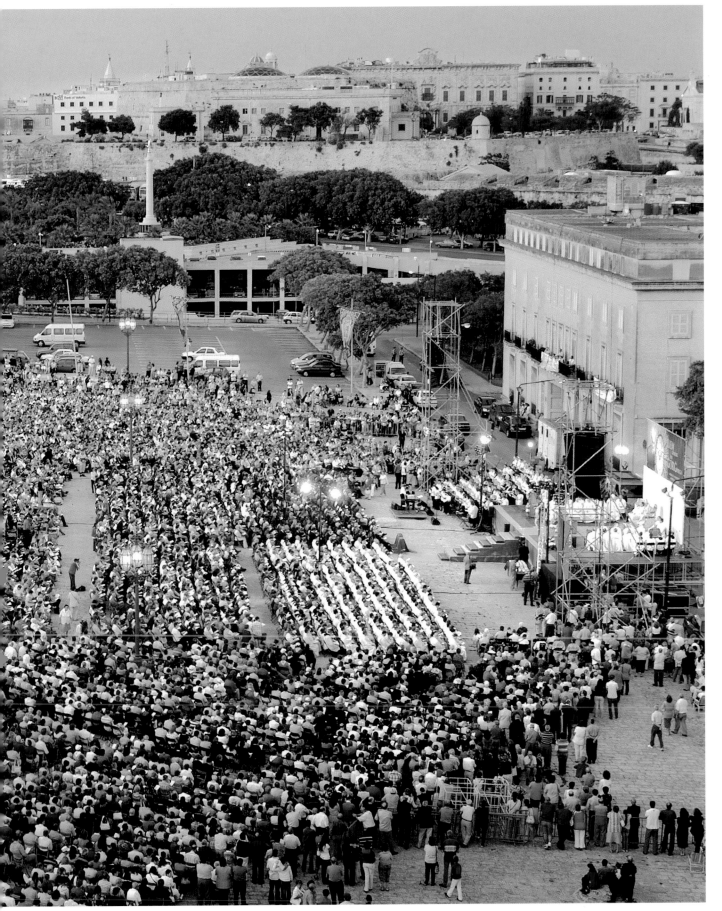

Thanksgiving mass held at the Floriana Granaries, on the occasion of the canonization of of the first Maltese saint, Dun Ġorġ Preca, in 2007.

The interior of the national shrine of the Blessed Virgin of Ta' Pinu, Gozo, built between 1920 and 1935

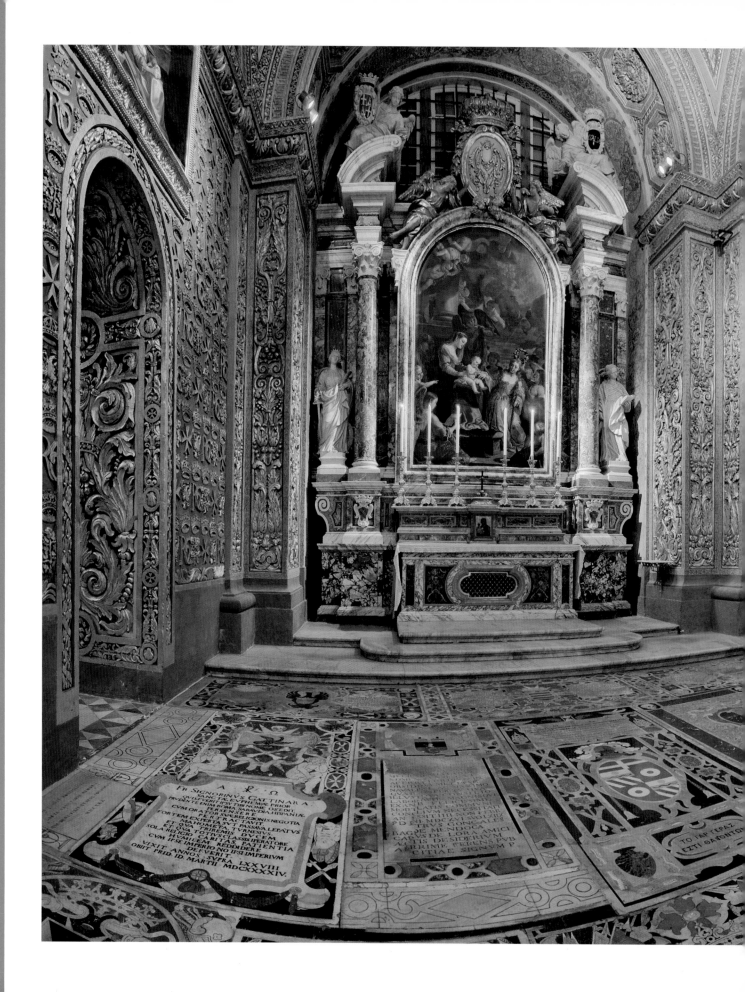

The dazzlingly restored Chapel of the Language of Italy at St John's co-Cathedral, Valletta

Traditional crib showing the Nativity in miniature. Strait Street, Valletta

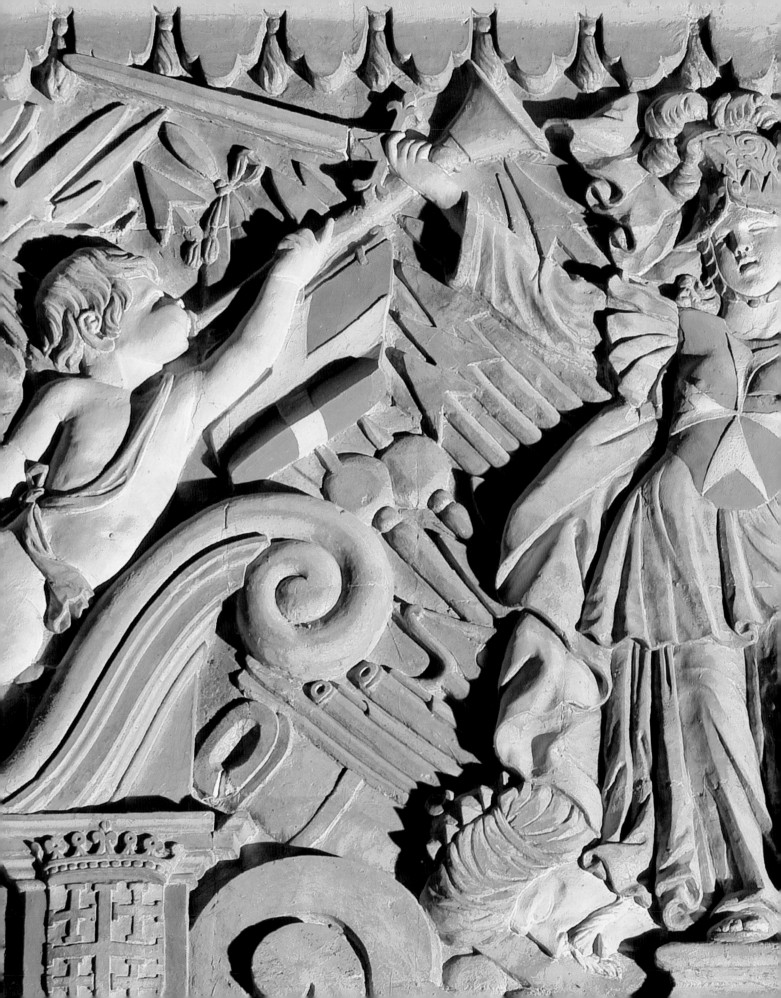

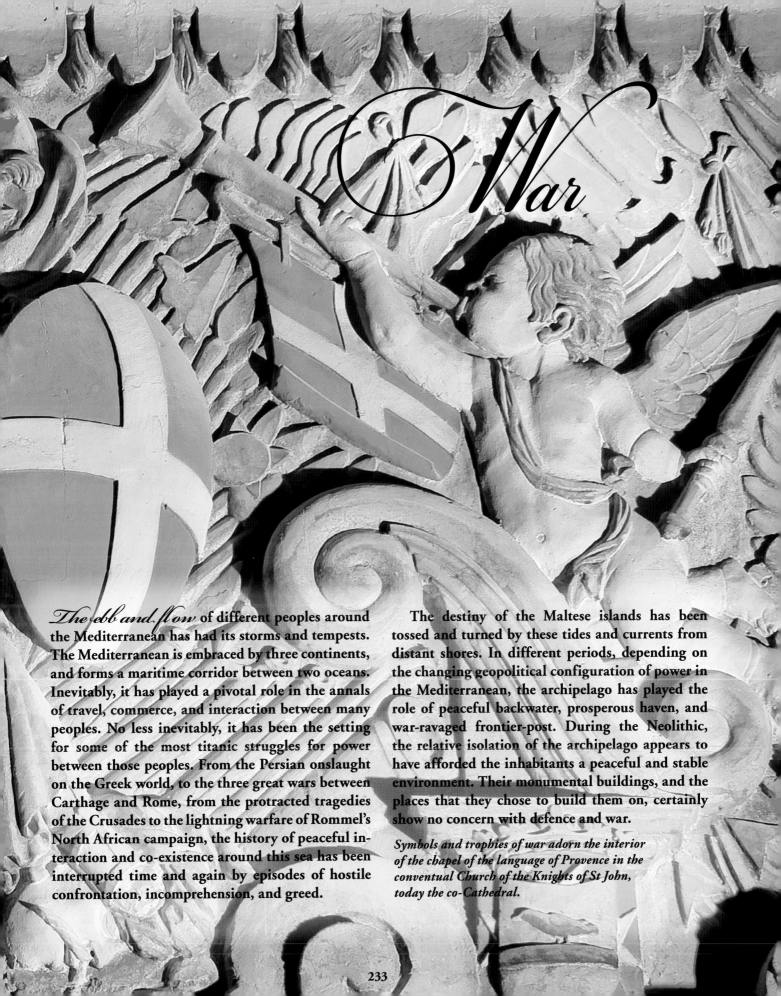

War

The ebb and flow of different peoples around the Mediterranean has had its storms and tempests. The Mediterranean is embraced by three continents, and forms a maritime corridor between two oceans. Inevitably, it has played a pivotal role in the annals of travel, commerce, and interaction between many peoples. No less inevitably, it has been the setting for some of the most titanic struggles for power between those peoples. From the Persian onslaught on the Greek world, to the three great wars between Carthage and Rome, from the protracted tragedies of the Crusades to the lightning warfare of Rommel's North African campaign, the history of peaceful interaction and co-existence around this sea has been interrupted time and again by episodes of hostile confrontation, incomprehension, and greed.

The destiny of the Maltese islands has been tossed and turned by these tides and currents from distant shores. In different periods, depending on the changing geopolitical configuration of power in the Mediterranean, the archipelago has played the role of peaceful backwater, prosperous haven, and war-ravaged frontier-post. During the Neolithic, the relative isolation of the archipelago appears to have afforded the inhabitants a peaceful and stable environment. Their monumental buildings, and the places that they chose to build them on, certainly show no concern with defence and war.

Symbols and trophies of war adorn the interior of the chapel of the language of Provence in the conventual Church of the Knights of St John, today the co-Cathedral.

233

By the third millennium BC, new winds had begun to blow. The discovery of metals and the spread of metal-working technology were to change the world for ever. Gold and silver made it possible for chiefs to accumulate wealth and power as never before. Copper, lead, and tin could be fashioned into weapons that were far more deadly than their stone predecessors. The demand for metals drove people on increasingly long journeys across the Mediterranean world, in quest for new sources of copper, tin, lead, silver, and gold. The development of sails and sailing technology harnessed the wind, and helped power these journeys. Boat-building technology also churned ahead, creating larger seacraft that could venture on longer journeys.

These developments gradually transformed many societies to become more hierarchic and more warlike, with powerful leaders and specialized warriors and seafarers.

The same developments also networked the Mediterranean into an economic system that was becoming more closely integrated and interdependent than ever before. It also created new incentives and opportunities for the conquest of neighbours, and for the pillage of the accumulated wealth of others. From one end of the Mediterranean to the other, defence now became a major preoccupation. Naturally

Ħaġar Qim Temples, Qrendi. The location of monumental buildings during the Temple Period does not suggest that defence was a great concern.

defensible sites were chosen for settlements which were further protected by ingenious and increasingly elaborate fortifications.

These new tides and currents transformed life on the Maltese islands. Around the middle of the third millennium BC, the megalithic buildings that we call temples, which the inhabitants had been building and using for a thousand years, were suddenly abandoned or destroyed. Archaeologists are still debating what may have happened to the inhabitants. Did this culture collapse as a result of disease, famine, or invasion, or owing to a combination of different reasons? Were the islands completely abandoned for a time, or did the survivors of the crisis become a part of the new population? What we know for certain is that from around the middle of the third millennium, people started doing things very differently in Malta. The transformation is so far-reaching, that this is accepted as the moment when Malta moved from the Neolithic (New Stone Age) into the Bronze Age.

continues on page 238

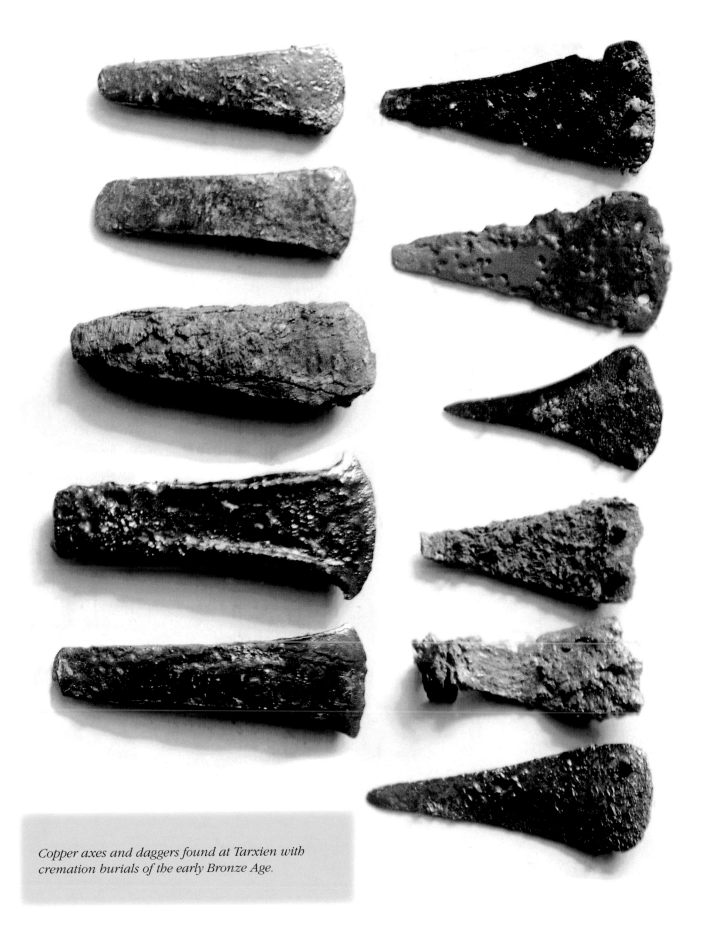

Copper axes and daggers found at Tarxien with cremation burials of the early Bronze Age.

A dolmen found at Ta' Fuq Wied Filep, Mosta. The Coralline Limestone capstone is 4m long

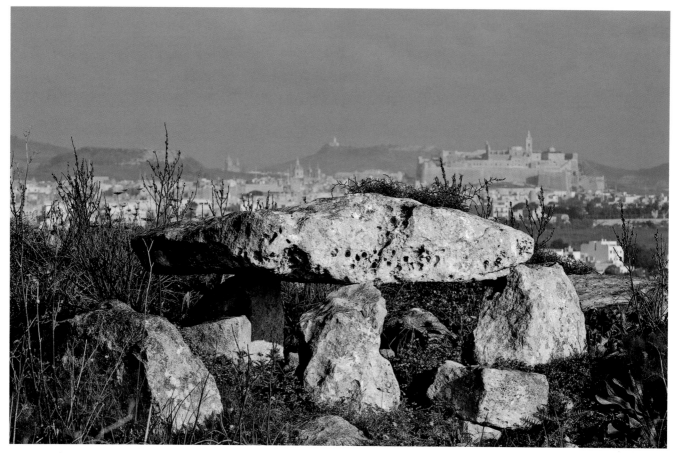

continues from page 234

The pottery styles were now very different. Geometric patterns [*below*] replaced the curvilinear designs of the Temple Period. The burial rite for the dead also underwent radical changes, with cremation replacing the mass inhumation that the temple builders had practised. Another conspicuous difference was the kind of monuments that people built. The massive and sophisticated megalithic complexes of the Neolithic were allowed to fall into disrepair and, in some cases used as cremation cemeteries. A new kind of monument appeared, with a very different purpose. This was the dolmen, a huge horizontal slab of rock raised on boulders at either end, to mark the

A Bronze Age dolmen on the heights of Ta' Ċenċ, Gozo, with the medieval stronghold of the Citadel in the background.

site of a cremation burial. The Maltese landscape is dotted with these monuments, which are also known in southern Italy.

Another transformation that became increasingly evident as the Bronze Age progressed was the preoccupation with defence. By the middle of the second millennium BC, there is a marked shift in the places that people chose for their settlements. In contrast to the megalithic temples, the settlements of the Borġ in-Nadur Phase (1500-700 BC) are located in or near places that could easily be defended. Craggy hilltops that were difficult to scale now became the preferred locations. Outcrops of Upper Coralline Limestone proved ideal for this purpose, as they tend to provide a level surface, together with vertical sides resembling a natural bastion. At Borġ in-Nadur, the natural defences of the site were complemented with a man-made defensive wall, which seems designed more to defend its inhabitants from an attack by land rather than by sea.

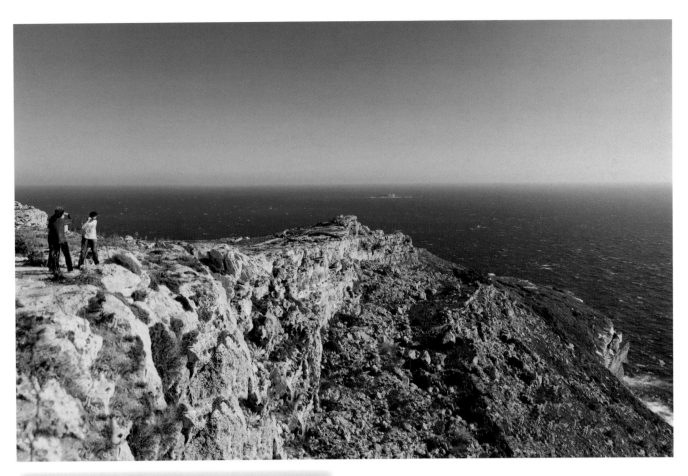

During the latter part of the Bronze Age, the inhabitants made use of craggy outcrops that afforded natural defences. Wardija ta' San Ġorġ.

Phoenician traders established themselves on Malta before the close of the eighth century BC. We do not know if their encounter with the native population was a hostile one, though, in all likelihood, the Phoenicians would have used their famous bartering skills and their stock of trinkets to seduce the natives into a peaceful trading relationship. The location that was chosen for the principal Phoenician settlement was the area of present-day Rabat, which enjoyed an abundant water supply, as well as the security of a hilltop location that was as far inland as one could ever be on such a small island. For the next 2,000 years, this was to remain the principal town of Malta. By around the fifth century BC, Malta is believed to have come within the sphere of influence of Carthage. The latter stood near the site where Tunis stands today, was the Phoenician's greatest colony in the west, eclipsing even the great cities of the Phoenician homeland, on the seaboard of Lebanon. [*right, an unusual Punic vessel found in Malta*].

With the emergence of Rome as the foremost power in Italy, a stand-off between the two cities became inevitable. The economic interests in controlling Mediterranean resources and trade were too great, and the cultures of the two powers too different. Three great wars had to be fought before the struggle for supremacy was settled. The Romans were the final victors, and consequently we know the wars by the name in Roman history books, the 'Punic Wars'. We have no history books from the side that lost, and even the script that Phoenicians wrote in was eventually completely forgotten. Their script was only deciphered in the late eighteenth century, largely thanks to the bilingual inscriptions in Phoenician and Greek, which as mentioned earlier were discovered in Malta.

continues on page 246

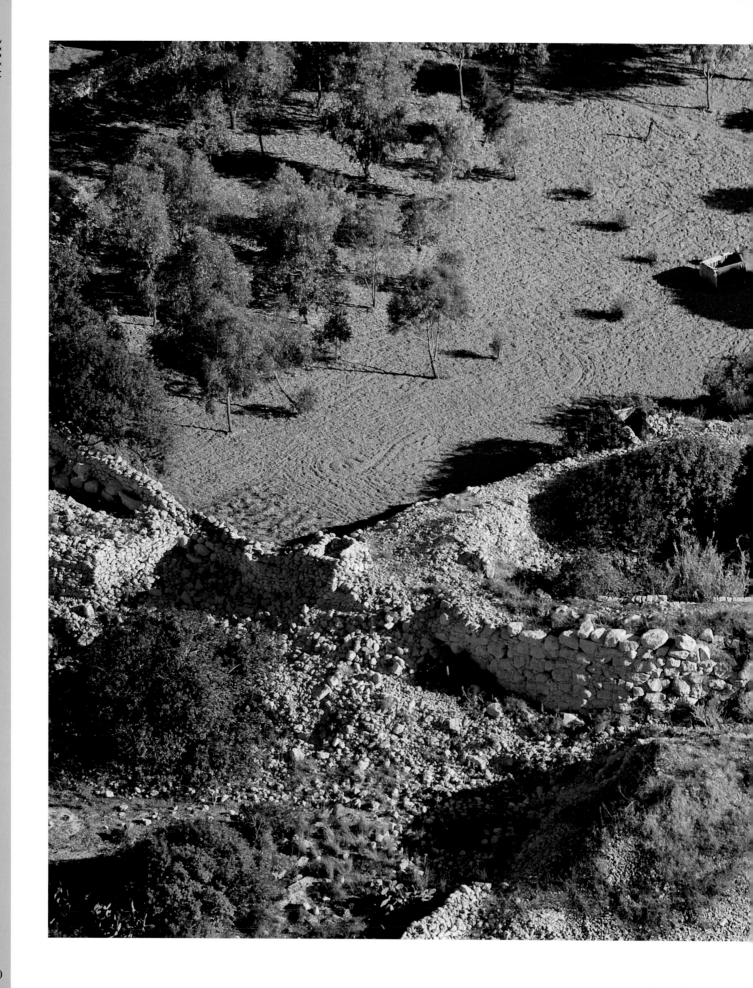

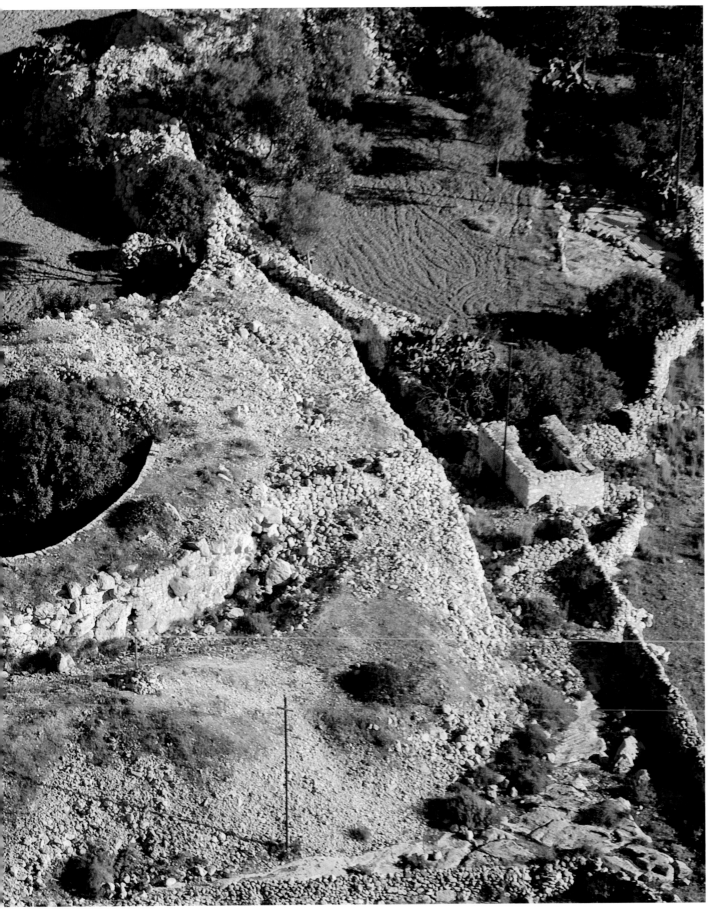

The Borġ in-Nadur ridge is protected by a massive wall with a D-shaped projection

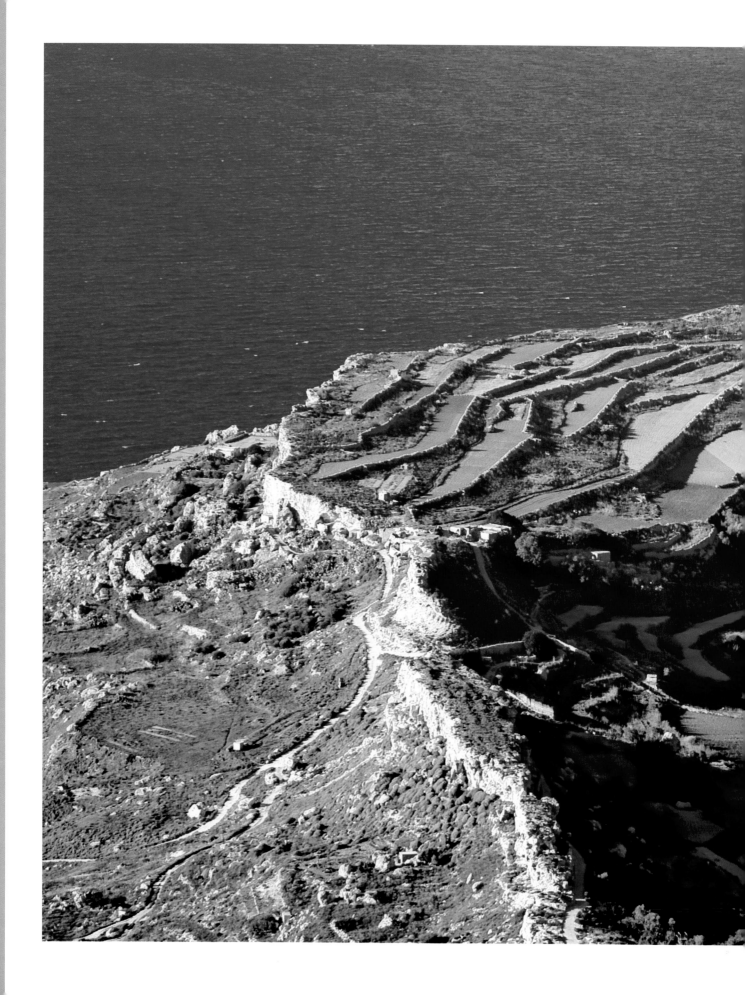

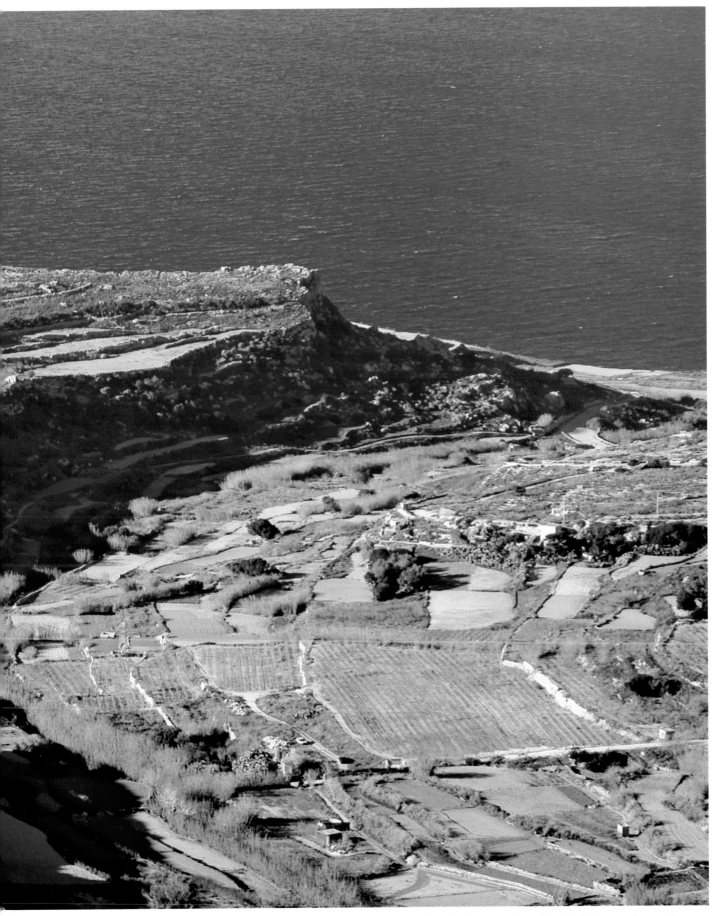

Baħrija Ridge provided the ideal setting for a fortified Bronze Age settlement

Torri ta' Wilġa. Several such structures were in use during the Roman period, but their purpose is unclear

continues from page 239

The three Punic Wars all had direct repercussions for Malta. In the first war, Rome wrested western Sicily from Carthage and was soon in control of the whole island, which it coveted as an important source of grain. Malta now became an even more isolated Carthaginian outpost, and its harbours must have continued to provide shelter to shipping travelling between Carthage and the eastern Mediterranean. This came to an end in 218 BC, when Malta was seized by Rome at the start of the Second Punic War. By the end of that war, Rome had also displaced Carthage in the Iberian peninsula. The Third Punic War culminated in the total destruction of Carthage itself.

Having finally conquered its most serious competitor, Rome went on to take control of the entire seaboard around the Mediterranean by the end of the first century BC. Piracy was eradicated, and for the only time in its history, the entire Mediterranean was ruled as a single political system. As a result, the sea now enjoyed one of the most peaceful periods it has ever known. Malta was now a comfortable backwater, far from the frontiers, and close to the shipping routes that fed the great metropolis of Rome. Luxurious villas with baths were built on the archipelago and commercial activity prospered.

The peace lasted for centuries, but could not last forever. By the third century AD, the empire was in crisis. Having extended itself over a vast geographical area, it was now proving difficult to maintain. The nomadic peoples who had been disrupted or displaced by Rome's advance now started making inroads into Roman occupied territory. In 410 BC Rome itself was sacked and pillaged by

The Greek trireme was the archetypal fighting vessel of the ancient world. Model at the Maritime Museum, Birgu.

the Visigoths. The western half of the empire disintegrated into kingdoms controlled by the invaders, while the eastern half, controlled from Constantinople, was to survive for another thousand years.

Events in Malta during this turbulent period are far from clear, and we depend on ongoing work by archaeologists to shed more light on the question. As Constantinople struggled to maintain its influence in the western Mediterranean, Malta may have once again become a strategic military base located close to the front line. Around 870, however, the island was lost to the Arabs, who had already swept through a large part of Sicily. The Arabs held the Maltese islands for more than two hundred years, during which the islands appear to have been thoroughly islamicized. In 1091, the islands changed hands yet again, this time being taken by the Normans, who were also establishing themselves in Sicily. The initial raid by Count Roger in 1091 has been mythologised into a Christian liberation that continues to be commemorated [*opposite: Effigy of Roger set up for a parish feast in Rabat*]. During the centuries that followed, the destiny of the Maltese islands continued to follow that of its much larger neighbour. Then in 1530, an event took place that was to place Malta on a very different historical trajectory to that of Sicily.

In that year, Emperor Charles V of Spain decided to entrust Malta to an order of knights who had recently lost their home in Rhodes. The arrival of the Knights of St John of Jerusalem allowed them to resume their increasingly anachronistic role as crusaders. In practice, this meant that they started harassing Muslim shipping with their galleys. The Turkish Sultan, Suleiman the Magnificent, who as a young man had magnanimously allowed the knights to leave Rhodes with their followers and with their possessions, watched with mounting concern and anger.

continues on page 252

Deed of Donation of the Maltese Islands to the Order of Saint John of Jerusalem by the Emperor Charles V in 1530, held at the National Library, Valletta.

We Charles V, by the clemency of the Divine Favour ever Augustus, Emperor of the Romans; Joanna his mother, and the same Charles being, by the Grace of God Monarchs of Castile, Aragon, the Two Sicilies, Jerusalem, Hungary, Dalmatia, Croatia, Leòn, Navarre, Granada, Toledo, Valencia, Gallicia, Majorca, Seville, Sardinia, Cordoba, Corsica, Murcia, Algarve, Algeria, Gibraltar, the Canary Islands; also the Islands and Continent of India and of the Oceans; Archduke of Austria, Duke of Burgundy and of Brabant; Count of Barcelona, of Flanders and of Tyrol, Lord of Biscay and of Molina, Duke of Athens and of Neopatria; Count of Rousillon and of Catalonia, Marquis of La Mancha and of Ghent:

With the restoration and establishment of the Convent, Order and Religion of the Hospital of Saint John of Jerusalem; and so that the Very Reverend and Venerable, and much beloved, the Grand Master, the Priors, Bailiffs, Preceptors and Knights of the said Order, who, having been expelled from the island of Rhodes by the Turks, who occupied that island following a protracted and violent siege, have wandered for several years, should at length obtain a fixed Residence, and there should once more return to those duties for the benefit of Christendom which appertain to their Religion; and should diligently exert their strength and their arms against the perfidious enemies of the Christian religion; moved by the devotion, and actuated by the same spirit which has allied us to the Order, we have determined upon granting a fixed home to the above mentioned Grand Master and Order, that they should no longer be compelled to wander about the world; by the tenor of this our present Charter, firmly valid for all future times; through our certain knowledge, and royal authority and deliberation; and with special design for ourselves, our heirs and successors who ascend the throne; we grant, and of our liberality we bountifully bestow upon the aforesaid Very Reverend Grand Master of the Religion and Order of Saint John of Jerusalem, in feudal perpetuity, noble, free and unencumbered, our cities, castles, places and islands of Tripoli, Malta and Gozo, with all their cities, castles, places and island territories; with pure and mixed jurisdiction, right, and property of useful government; with power of life and death over males and females residing within their limits, and with the laws, constitutions, and rights now existing amongst the inhabitants; together with all other laws and rights, exemptions, privileges, revenues and other immunities whatsoever; so that they may hereafter hold them in feudal tenure from us, as Kings of both Sicilies, and from our successors in the same kingdom, reigning at the time, under the sole payment of a falcon; which every year, on the Feast of All Saints, shall be presented by the person or persons duly authorised for that purpose, into the hands of the Viceroy

or President, who may at that time be administering the government, in sign and recognition of feudal tenure; and having made that payment, they shall remain exempt and free from all other service claimable by law, and by custom performed by feudal vassals.

The investiture of which feudal tenure, however, shall be renewed in every case of a new succession, and completed according to the dispositions of common law, and the Grand Master pro tempore, for himself and the above mentioned Order generally in this recognition and investiture, shall be bound to pledge that from the said cities, castles, or places, and islands, he will not permit loss, or prejudice, or injury, to be perpetrated against us, or our kingdoms and lordships above named, or those of our successors in the said kingdoms, either by sea or by land, nor will offer assistance or favour to those inflicting such injuries, or desirous of inflicting them; but rather shall strive to avert the same with all their power.

If anyone arraigned of a capital crime, or accused of any similar offence, shall escape from the Kingdom of Sicily, and shall take refuge in these islands, and their allied feudatories, if they shall be requested on the part of the Viceroy, or of the Governor, or the Ministers of Justice of the said Kingdom, they shall be bound to expel such fugitive or fugitives, and to deport them far away from their island, with the exception of those accused of treason or of heresy, whom they shall not eject but, at the requisition of the Viceroy or his lieutenant, shall take prisoners and remand them to custody of the Viceroy or Governor.

To ensure that nomination to the episcopal see of Malta remain as it is presently, in our gift and presentation, and in that of our successors as Kings of Sicily, we therefore decree that after the death of our Reverend and Beloved Councillor, Balthasar de Vualtkirk, our Imperial Vice-Chancellor, of late nominated by us to that diocese, as likewise in the case of every subsequent vacancy occurring hereafter, the Grand Master and the Convent of the Order shall nominate to the Viceroy of Sicily three persons of the Order, of whom at least one shall be our subject, or of our successors in the Kingdom, and who shall all be fit and proper persons for the exercise of that pastoral dignity. Of which three persons thus to be nominated, we, and our successors in the Kingdom, will present, and shall be bound to present, the one whom we or they may judge to be the most worthy for the post. The Grand Master shall be bound to grant the dignity of Grand Cross to whosoever may be appointed to the said bishopric, and shall give him admission into the Council of the Order, together with the Priors and Bailiffs.

As the Admiral of the Order is bound to be of the langue and nation of Italy, it is deemed advisable that, for he who is to exercise his authority, when absence or other impediments occur, if a suitable person can be found in the same langue and nation, the position shall be given to him; it is therefore reasonable that under like parity of suitability, that person should the rather be elected to exercise II that office who may be judged the most eligible from amongst that langue and nation, who shall exercise his office and be deemed suspected of none.

Furthermore, let statutes and firm decrees be made of everything contained in the three preceding articles, according to the style and manner used in the said Order, with the approbation of our Holy Lord and of the Holy Apostolic See; and let the Grand Master of the Order, who now is, or hereafter may be, bound to swear solemnly to the faithful observation of the said statutes, and to preserve them in perpetuity inviolate.

Furthermore, if the Order should succeed in re-conquering the island of Rhodes, and for that reason, or from any other cause, shall depart from these Islands and their local feudatories, and shall establish their Home and Convent elsewhere, it shall not be lawful for them to transfer the possession of these islands to any other person without the express sanction of their feudal lord; but if they shall presume to alienate them without our sanction and licence, they shall, in that event, revert to us and to our successors in full sovereignty.

Whatever artillery or engines of war now exist within the castle and city of Tripoli, as shall be specified in a proper inventory, they may retain the same for three years for the protection of the town and citadel; the obligation, however, remaining valid to restore said artillery and machines after the lapse of three years, unless at that time our grace may, owing to the necessities of the case, see fit to prolong the time, so that the town and citadel may have its defence more securely provided for.

Be it noted that whatever rewards or gratuities, temporary or permanent, may have been granted to certain persons in these territories, which have been given them, either on account of their merits or from some other obligation, in whatever state they may now stand, they shall not be deprived of without proper recompense, but shall remain in full force until the Grand Master and Convent shall see fit to provide them elsewhere with equal and similar property.

In the valuation of this recompense all difference of opinion which might arise, and all annoyance and expense of legal proceedings shall be obviated thus: When it shall seem fit to the Grand Master and Convent to grant to anyone such recompense, two judges shall be nominated; one, in our name, by the Viceroy of Sicily pro tempore, the other by the Grand Master and Convent who, summarily and precisely, shall define the concession of privileges to be transferred, with the arguments on both sides, without any other form or process of law; and if any recompense is to be given, they shall decree how much it should be by right. But if the two judges should, by chance, be of different and

opposing opinions, by the consent of both litigating parties let a third judge be named, and whilst the question is being adjudicated or inquired into, and the recompense fixed, the possessors shall remain in the enjoyment of their rights, and shall receive the produce of their privileges, until compensation shall have been made to them.

Under which conditions, as contained and described above, and in no other manner, conceding to the aforesaid Grand Master and Convent one and all of the said articles in feudal tenure, as have been described, as can best and most usefully be stated and written for their convenience and benefit, and good, sound and favourable understanding, we offer and transfer the same to the rule of the Grand Master, Convent and Order, in useful and firm dominion irrevocably, in full right, to have and to hold, to govern, to exercise in full jurisdiction, and to retain in peace and in perpetuity.

On account of this concession, and otherwise, according as it can best be made available and held by law, we give, concede and bestow to the said Grand Master, Convent and Order all rights and all property, real and personal, of every description whatever, which appertain to us, and which can and ought to belong to us in those Islands, which we grant to them by feudal tenure, under the said conditions as have been recited, and in other matters according to the circumstances of the case; which rights and privileges, so that these may be perpetual and actionable and maintained, and that each and every right might be enjoyed and freely exercised by law, and whatever else we ourselves may perform in any manner, either now or in future, placing the said Grand Master, Convent and Order in every respect in our place; we constitute them true lords, duly authorised agents and administrators in their own affairs;no rights or privileges which we have conceded them, as above, beyond what we have already received, shall be retained or received by us or by our Council.

Committing, henceforth, to the charge of the said Grand Master, Convent and Order of Saint John of Jerusalem, with the same authority as we have heretofore exercised, each and every one, male and female, who may now be dwelling, or who shall hereafter dwell, in the said Islands, cities, lands, places and castles, or in their territories, under whatsoever laws or conditions they may have resided there, that they should receive and consider the said Grand Master as their true and feudal lord, and the rightful holder of the aforesaid territories, and shall perform and obey his behests, as good and faithful vassals should always obey their lord.

They shall also make and offer fidelity and homage to the said Grand Master and Convent, with all the oaths usually entailed in such cases; we also ourselves, from the moment that they take those oaths and tender that homage, absolve and free them from all oaths and homage which they may have formerly made and taken to us, or to any of our predecessors, or to any other persons in our name, and by which they have been heretofore bound.

To the illustrious Philip, Prince of the Asturias etc. our well-beloved first-born son who, following our long and prosperous reign, we nominate and appoint, under the support of our paternal benediction, to be, by the grace of God, our immediate heir and legitimate successor, in all our kingdoms and dominions; to all the most illustrious lords our beloved Councillors, and to our faithful Viceroy and Captain General in our Kingdom of the Two Sicilies, to the Chief Justice, or whosoever may be acting in his place, to the Judges and Magistrates of our courts, to the Magistrates of the Portulan and the Secretary, to the Treasurer and Conservator of our royal patrimonies, to the Patrons of our Treasury, to the Castellans of our fortresses, to our Prefects and Guards, portulans and master portulans, secretaries, and to all and sundry officials, and of subjects in our said Kingdom of the Two Sicilies, especially of the said Islands, and of the city and castle of Tripoli, now and hereafter, by the same authority we command and direct, under pain of our indignation and anger; and under a penalty of ten thousand crowns, to be otherwise levied upon their property, and paid into our treasury, that they hold, and support, and observe, and shall cause to be inviolably held and observed by others, these our concessions and grants, one and all, as contained above. Our aforesaid Viceroy himself, or by means of a commissioner or commissioners whom he may choose to nominate in our name for that purpose, shall cause to be handed over and transferred, in actual and tangible possession, as vacant and free, all, as is aforesaid, which we have conceded to the said Grand Master and Convent, to himself, or to a procurator named in his stead, to whom in every way, so that for their part they complete and execute the stipulation with the said Grand Master and Convent, we confer power and commit our plenary authority. After possession shall have been duly transmitted they shall support the said Grand Master and Convent in that authority, and shall protect them powerfully against every one, nor shall they cease to be paid rents, import or export duties, or any other taxes or rights, by either of the aforesaid, to whom we have granted this feudal tenure.

We also, to give effect to this deed, in the event it shall be necessary, provide all defects, nullities, faults or omissions, should any chance to be included, or shall arise, or be in any manner alleged from which in the plenitude of our royal authority, we grant a dispensation.

For which purpose we have ordered the present deed to be drafted, with our official seal for the affairs of Sicily attached to it.

Given at Castel Franco the 23rd day of the month of March, Third Indiction, in the Year of Our Lord 1530; in the 10th year of our reign as Emperor, the 27th as King of Castile, Granada etc., the 16th of Navarre, the 15th of Aragon, the Two Sicilies, Jerusalem and all our other realms.

CHARLES

(Translation: Porter 1858, adapted by Mendola n.d.)

continues from page 246

In 1565, the long awaited happened. A Turkish armada appeared over the horizon, carrying a larger force than the islands had ever seen before. A bloody siege followed. The Maltese and the knights were holed up behind fortifications of Birgu and Isla in the Grand Harbour, Mdina, and the *Castello* on Gozo. The siege catapulted Malta into the modern world. Before that moment, the islands had hardly seen the use of artillery. Now they were witnessing a full-scale artillery bombardment that lasted a whole summer. Against all odds, a series of blunders by the invaders, combined with the legendary tenacity of the defenders, resulted in the lifting of the siege. The occasion was celebrated across Europe, and the date of the Turkish withdrawal, 8 September, is still commemorated every year by a national holiday, Victory Day.

The lifting of the siege was certainly an important turning point in the destiny of the Maltese archipelago. Its new role was now to be a bulwark of Christian Europe. In order to fulfil this role, a new transformation of the Maltese islandscape was required, and the knights of St John devoted more than 200 years to achieving it. The islands required modern fortifications designed to resist artillery bombardment. They also needed a new cosmopolitan capital to house the Order and its institutions. Only a year after the siege, the foundations of a new fortified city were laid. Valletta is still the country's capital today. The city was laid out on a grid plan, very similar to the Spanish colonial cities that were being established in the New World during the same period. The building of Valletta was only the core of the knights' building project. During the course of the seventeenth century, the fortified suburb of Floriana was laid out, while across the harbour, two successive rings of fortifications were built to safeguard the landfront of the harbour cities of Birgu, Isla, and Bormla. Birgu remained the home of the Order's fleet. Its western waterfront was completely taken up by the fleet's facilities, that included stores, the palace of the captain of the galleys, and an enormous arsenal where the galleys could be hauled up slipways for shelter and maintenance.

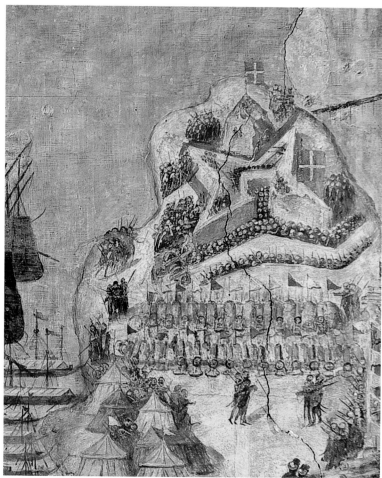

Fort St Elmo (top) and Isla (opposite) under siege in 1565. Details from the d'Aleccio frescoes in the Grand Master's Palace.

More fortifications were projected and built across the archipelago. Much of the coastline was already naturally defended by precipitous cliffs. Creeks and bays, however, represented a chink in this natural armour, and the knights vigorously set about correcting it. Fortresses, towers, gun batteries, and defensive walls were thrown up all along the more vulnerable parts of the coastline. Several examples of a gigantic rock-cut gun, known as a *fougasse*, were cut into the living rock to guard bays from mass landings. The archipelago was turned into a veritable fortress. Perhaps the most telling indicator of their success is that they were never put to the test by the Turkish Sultan. Although the islands were constantly preparing for the eventuality of a fresh full-scale invasion, such an invasion never materialized. The reputation of the islands' impregnable defences must have played a critical role in deterring such an attempt.

continues on page 264

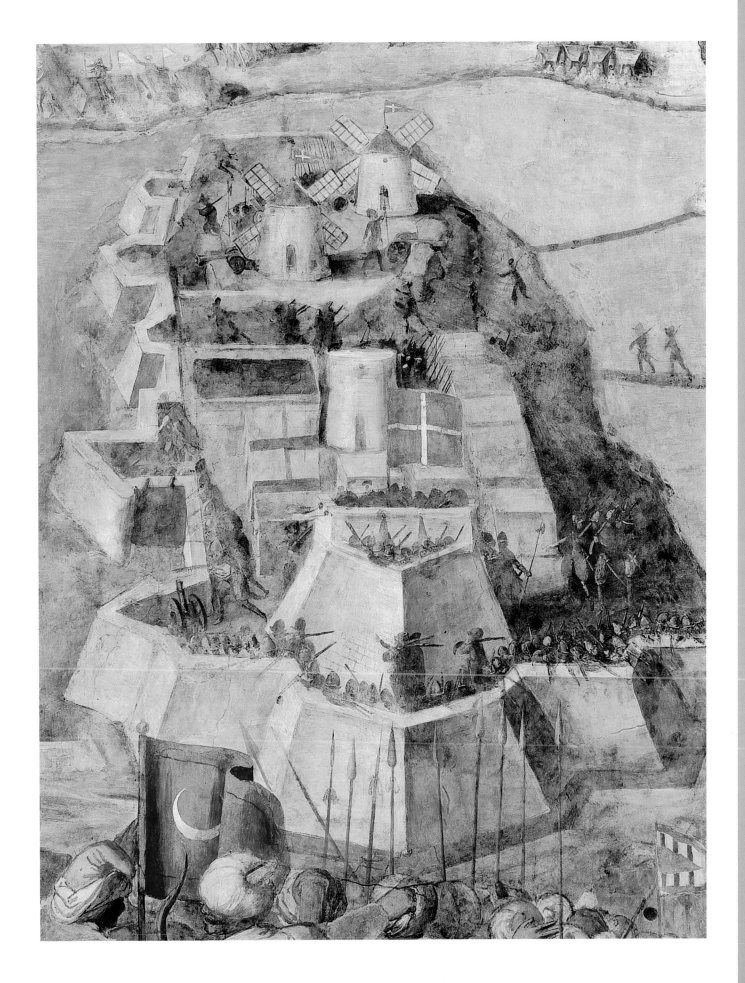

Numerous maps of the siege of Malta, such as the example shown here, were published and distributed across Europe to provide updated information on how the siege was progressing

Il Porto di Malta di nuovo da molti errori emendato et con diligenza ristampato con l'Assedio, Batterie et Assalti nuovamente dati da Infedeli.
Dom. Zenoi, Venetiano fece MDLXV

(The Harbour of Malta corrected anew and carefully reprinted, showing, the Siege, Batteries and fresh Infidel Attacks. By Dom. Zenoi, Venetian, 1565)

1. *Marsa Miseto* (Marsamxett Harbour)
2. *San Giorgio* (St George's Chapel)
3-4. *Forte dei Turchi* (Turkish strongholds)
5. *San Paolo* (St Paul's Chapel)
6. *Turchi amalati da flusso* (Turkish infirmary for the sick)
7. *Osterie* (Taverns)
8. *Gianiceri* (Janissaries)
9. *Vivandieri che portan da mangiare ai soldati* (Provision merchants supplying food to the soldiers)
10. *Guardia della Vettovaglie* (Provisions sentry)
11. *Forte della Munition* (Ammunition blockhouse)
12. *Allogio de Generale della Munition et Vettovaglia* (Quarters of the commander of ammunition and supplies)
13. *La Marsa* (Marsa basin)
14. *Fonte* (Fountain)
15. *Giardino della Marsa* (Marsa Garden)
16. *Mori* (Moors)
17. *Arabi* (Arabs)
18. *Persiani* (Persians)
19. *Alloggio del Colonello del Campo* (Quarters of the Field Colonel)
20. *Loco dei Feriti* (Infirmary for the wounded)
21. *Dragut Ferito* (Dragut one of the invaders' leaders, after being fatally wounded)
22. *Il Colonello del Campo* (Field Colonel)
23. *Marsa Sirocco* (Marsaxlokk Bay)
24. *Sengiachi* (Signal unit)
25. *Colle di Santa Margarita* (Santa Margherita Hieght)
26. *Borgo dirupato per D. Garzia* (Defensive outwork)
27. *Giardino* (Garden)
28. *Turchi iiii Compagnie* (Turkish four companies)
29-31. *Forte dei Turchi* (Turkish strongholds)
32. *Loco di Giusticia* (Place of execution)
33. *San Salvatore* (Chapel of Our Saviour)
34. *Sant Elmo* (Fort St Elmo)
35. *Castel Sant Angelo* (Fort St Angelo)
36. *Borgo Sant Angelo* (Borough of St Angelo)
37. *Borgo San Michele* (Borough of St Michael)
38. *Ponte fatto per Soccorer San Michele* (St Michael relief bridge)
39. *Arsenale* (Arsenal)
40. *Giardino di Monsignor* (The Monsignor's Garden)
41. *Molino* (Windmill)
42. *San Michele* (Fort St Michael)
43. *Fosso* (Ditch)
44. *Li Turchi si calo nel fosso et miser le scalle alle mura* (The Turks in the ditch setting ladders against the walls)
45. *Galeotte di Spagna con l'Armata Cattolicha* (The Catholic fleet)
46. *Armata di D. Garzia* (Don Garzia's relief force)

Print held in the sacristy of the parish church, Isla. Red numbers added here for clarity.

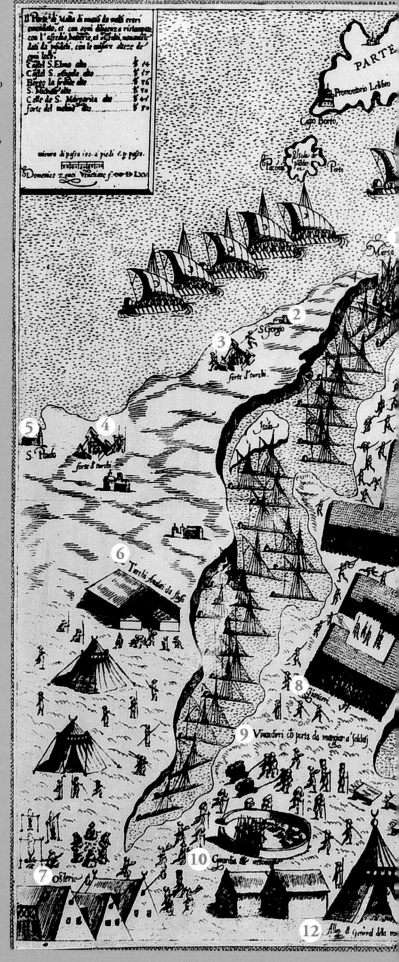

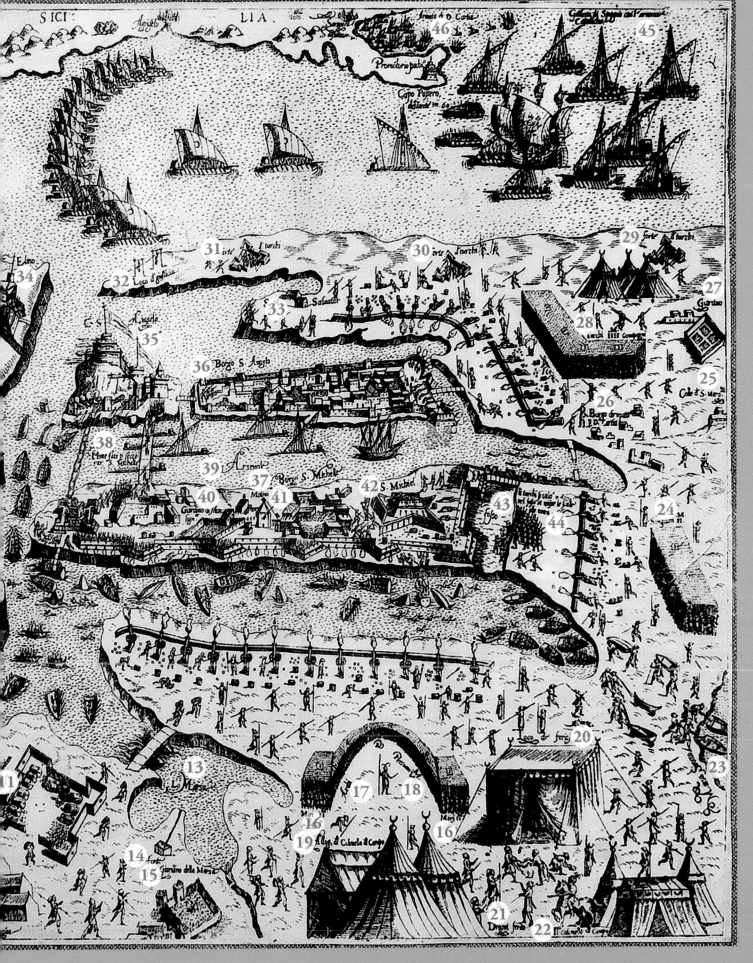

The besiegers came from every direction. An ill-fated seaborne attack on Isla …

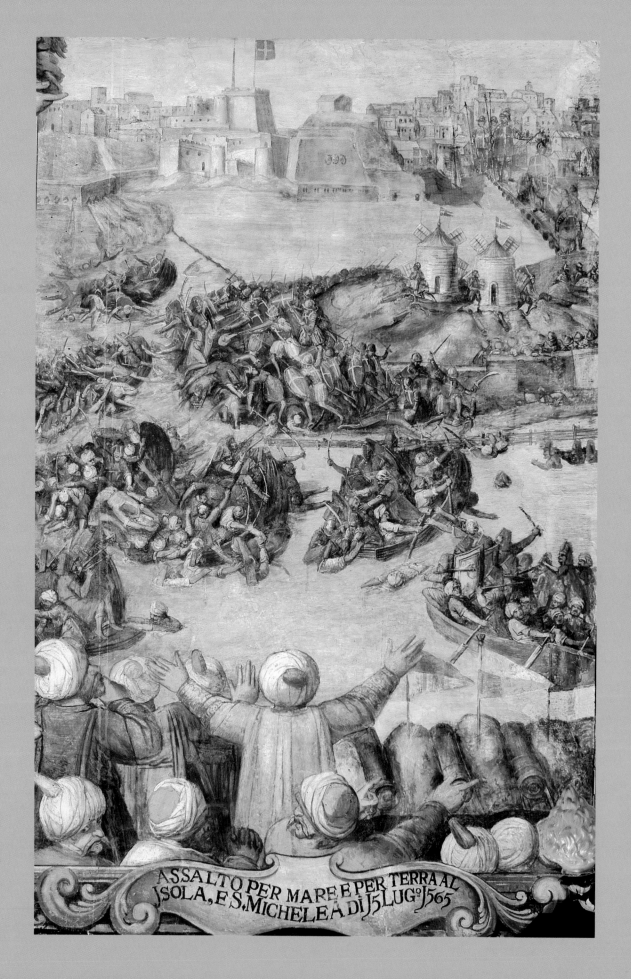

ASSALTO PER MARE E PER TERRA AL ISOLA, E S. MICHELE A DI 15 LUG.º 1565

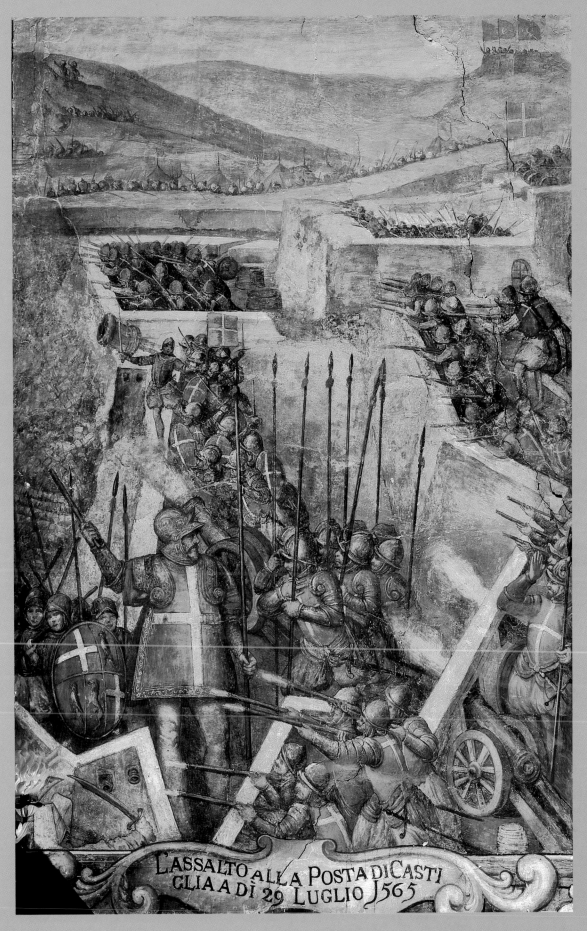

… and the defence of the land-front of Birgu being rallied by the Grand Master. D'Aleccio frescoes.

L'ASSALTO ALLA POSTA DI CASTIGLIA A DÌ 29 LUGLIO 1565

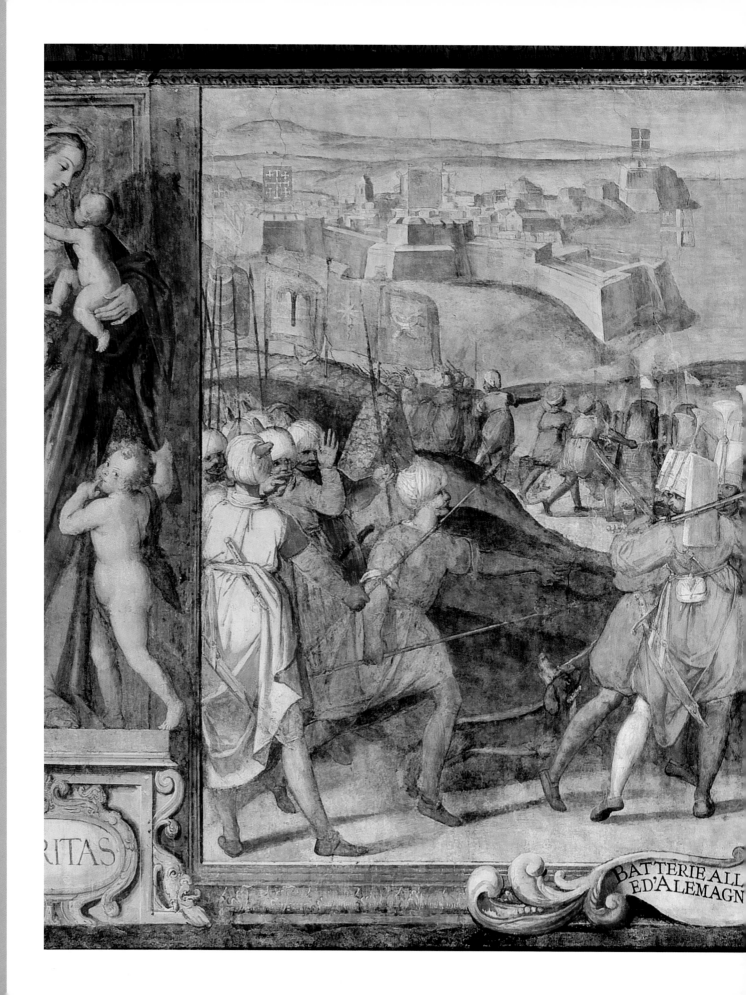

RITAS

BATTERIE ALL
ED'ALEMAGN

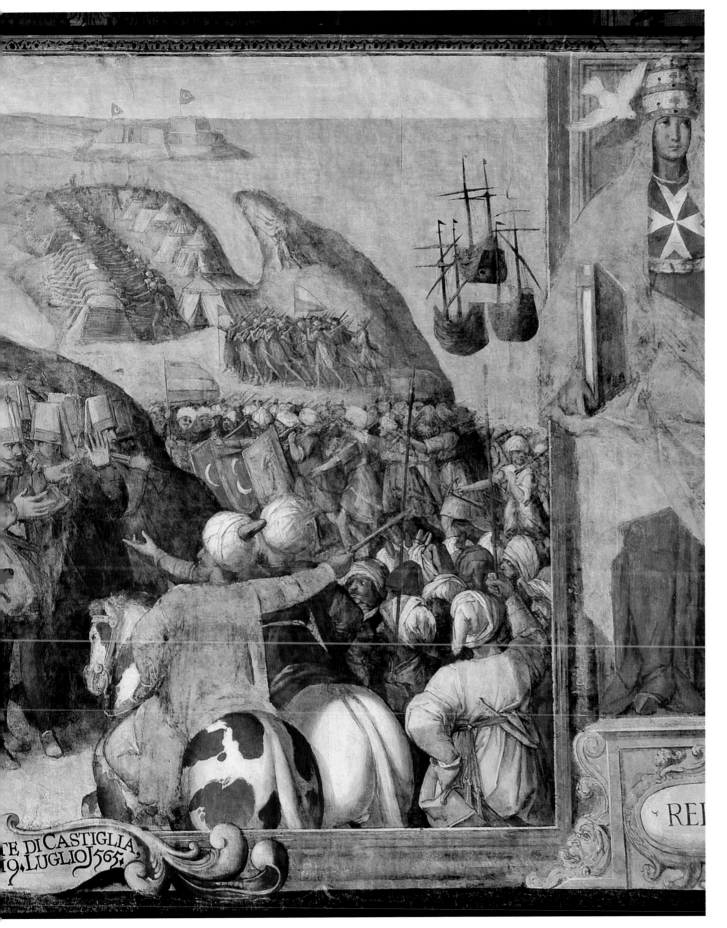

TE DI CASTIGLIA,
19.LUGLIO 1565.

REL

The sheer numbers of the Turkish army presented a grim prospect to the defenders

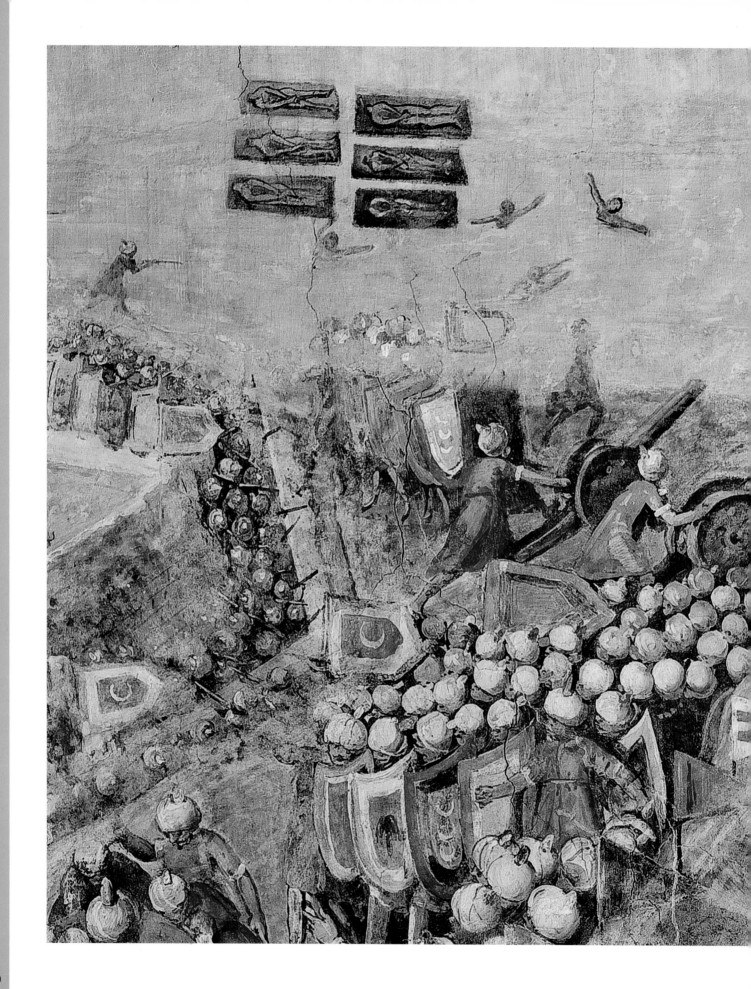

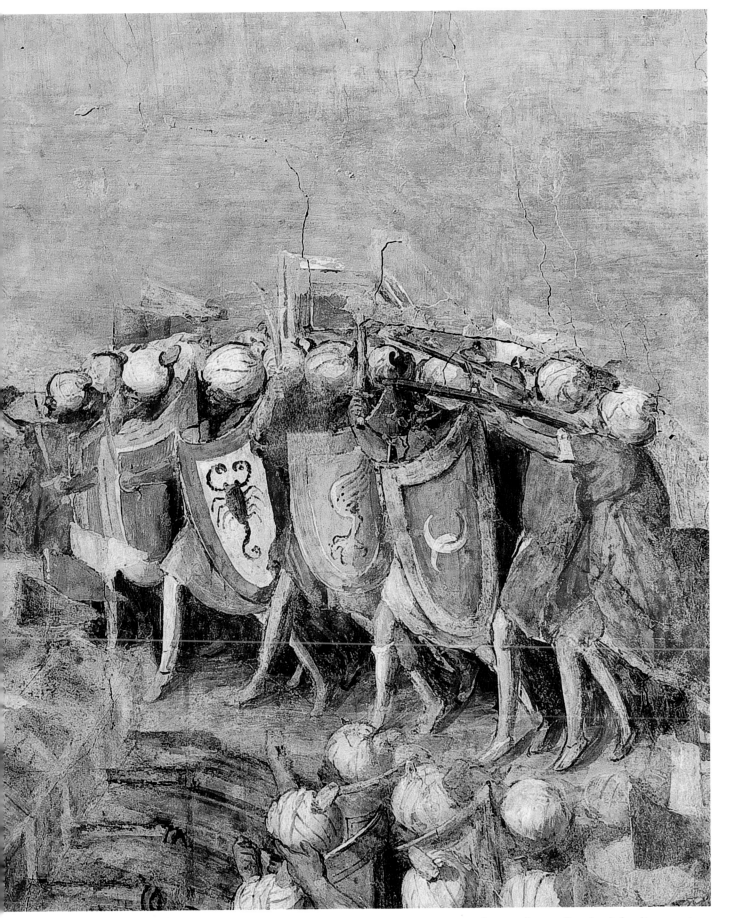

Decapitated bodies of defenders captured at St Elmo were set afloat to demoralize the defending garrison

An 18th-century fougasse, or rock-cut gun, guarding Ramla Bay, Gozo

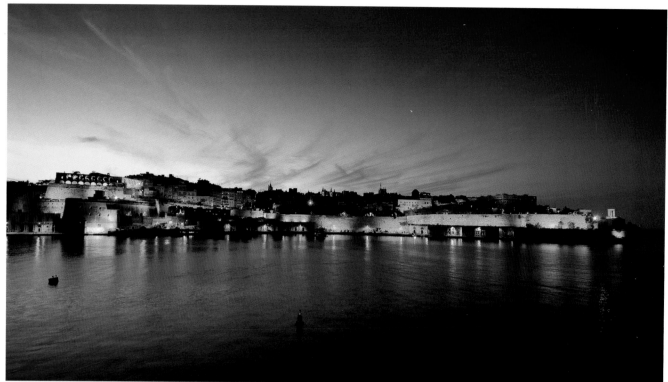

continues from page 252

When the islands were eventually prised from the hands of the Order, it was not by the Turkish sultan. Following the French Revolution, the Order was weakened by the loss of revenues from France, divided political allegiances among its members, and popular disquiet. In 1798, Napoleon's fleet appeared on the horizon, bound for Egypt [*below: Bonaparte's arrival to Malta*]. In a matter of hours, the Order had capitulated to the French, rather than attempt a bloody defence against the superior forces of a European power. The period that the French held Malta was brief but eventful. Within months, the new regime had made itself even more unpopular than the one it replaced. A full-scale uprising by the Maltese drove the French garrison behind the walls of the fortified cities. In one of the cruellest ironies of

Valletta's defences created a stronghold that was in theory impregnable. A twilight view of the floodlit bastions as seen from Fort St Angelo.

Maltese history, the defences that the inhabitants had toiled for centuries to build were now used for the first time … against them. The Maltese were constrained to ask for Britain's help to blockade the French. The Royal Navy prevented supplies and reinforcements from reaching the French garrison. On the brink of starvation, the French surrendered. By the end of the Napoleonic wars, the British presence, which had started as a temporary military campaign, had turned into permanent possession of the archipelago. The reasons why the British were keen to maintain their foothold

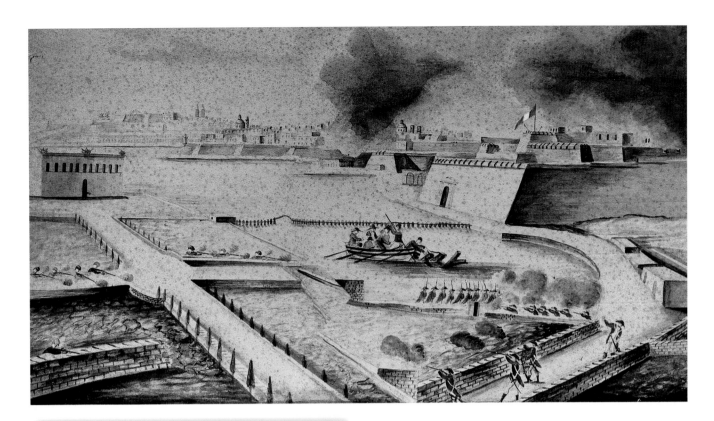

Maltese insurgents blockading French troops behind the city walls. Watercolour held at the Maritime Museum, Birgu.

here are not difficult to see. Napoleon's Egyptian adventure had brought home the vulnerability of Britain's trade routes to India. It now became a tenet of British policy to safeguard its 'Mediterranean corridor' to India. Gibraltar. Malta, and Alexandria became important staging posts along this corridor. With the opening of the Suez Canal in 1869, the volume of shipping passing through the Mediterranean increased dramatically. As Malta was pressed into serving the new needs of these changed circumstances, yet another transformation of its landscape was required. Naturally enough,

the transformation was focused on the harbours of Valletta. In the 1830s, a naval hospital [*below*] was built on a promontory in the Grand Harbour, where direct access from the sea allowed the rapid disembarkation of those wounded in battle. In the 1840s, a naval bakery was built on the waterfront of Birgu, on the site of the knights' arsenal. The bakery was housed in a colossal building, designed to serve the needs of the entire Mediterranean fleet. In preparation for the opening of the Suez Canal, the marshy inner end of the Grand Harbour was dredged and transformed into basins equipped with modern quays and warehouses to serve the needs of commercial shipping. Meanwhile a vast complex of dry docks was developed for Royal Navy's maintenance needs.

continues on page 276

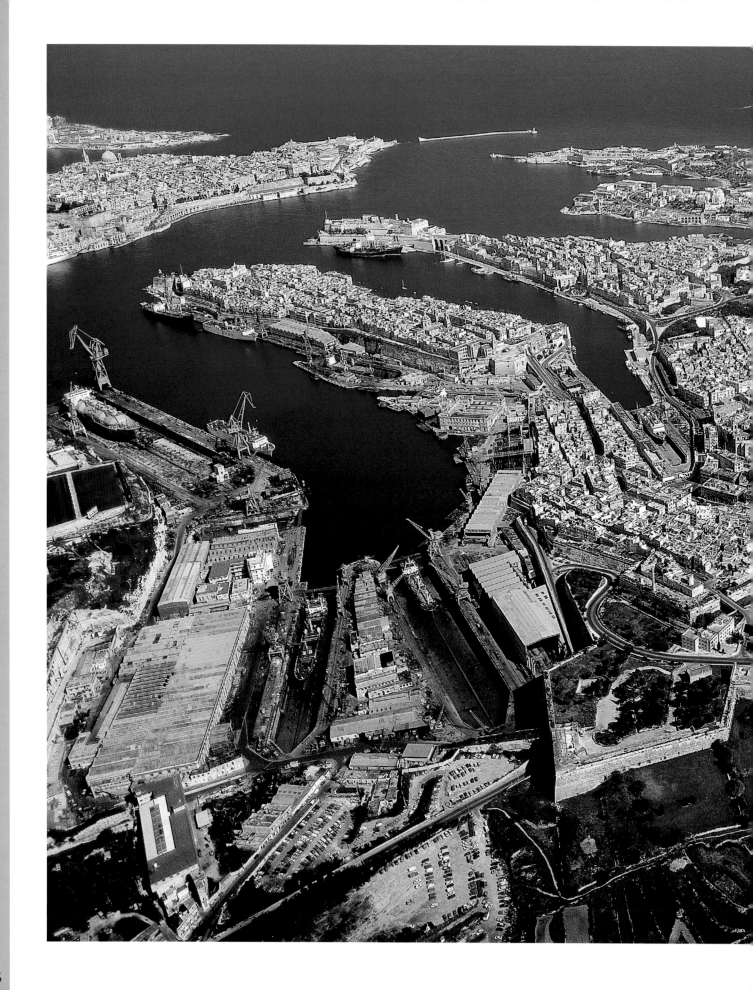

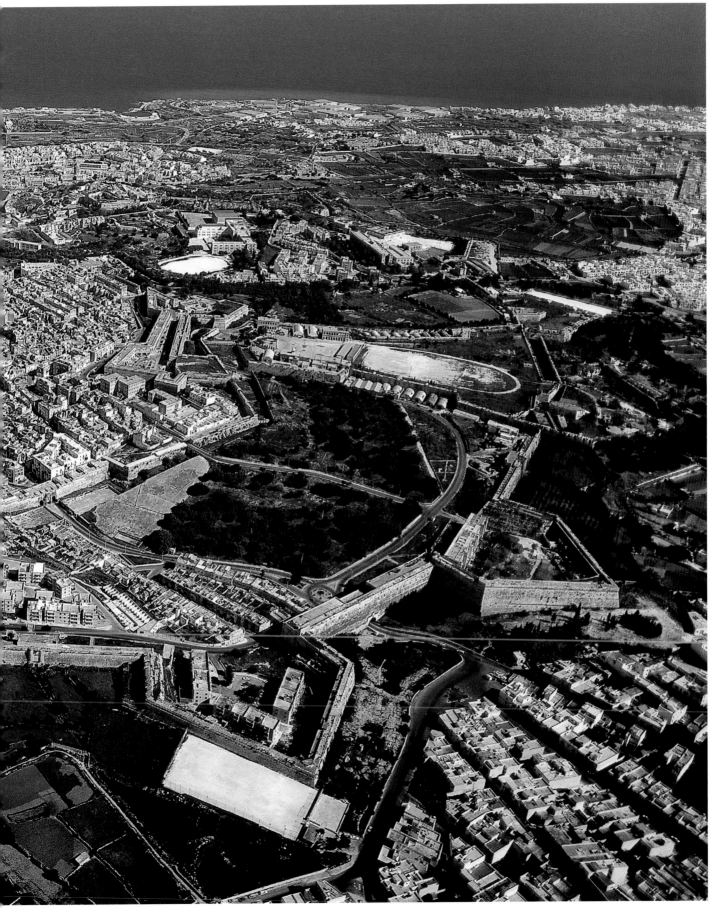

The formidable Cottonera Lines protected the south-east flank of the harbour area

Scesa della truppa Francese dal Gran
Inglese guidata dal Comandan
Il dì 30 Ottob

astello accompagnata dalla truppa.

"Sir Alexander Ball"

"798"

Surrender of the French garrison of the Citadel, Gozo. Watercolour, private collection

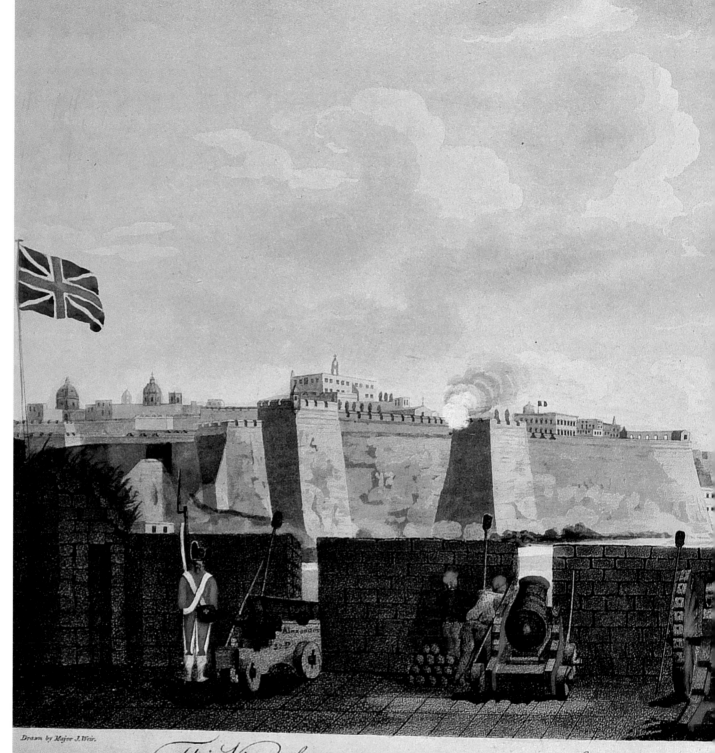

Drawn by Major J. Weir.

This View of LA VALLETTA, *taken from the*
is most humbly Inscribed by Permission, to
then Commanding the ALLIED FORCES *in* MALTA;

Published as the

Engraved by F. Chesham.

MARSA BATTERY *during the* SIEGE *in 1800.*
Brigadier GENERAL THOMAS GRAHAM,
by his humble Serv. *Major Ja.* *Weir,* *Commandant of the Maltese Battallion.*

by J. Weir, 25. *Jan. 1803.*

One of the batteries from where the Maltese, aided by British troops, blockaded the French. Maritime Museum, Birgu

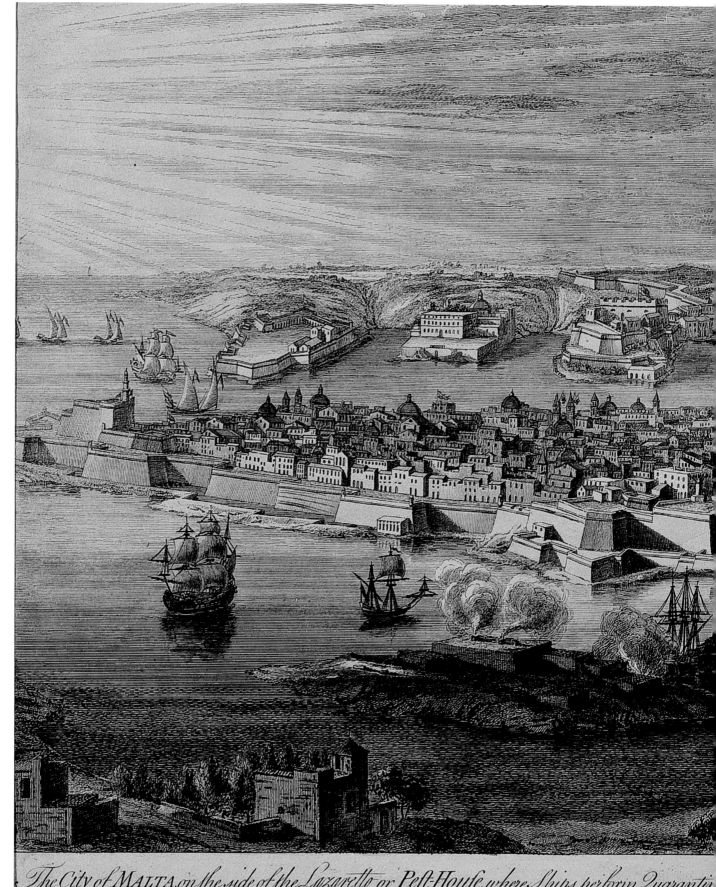

The City of MALTA, on the side of the Lazaretto or Peft-Houfe, where Ships perform Quarantin...

Published 24th June 1818 by Jas. WHI...

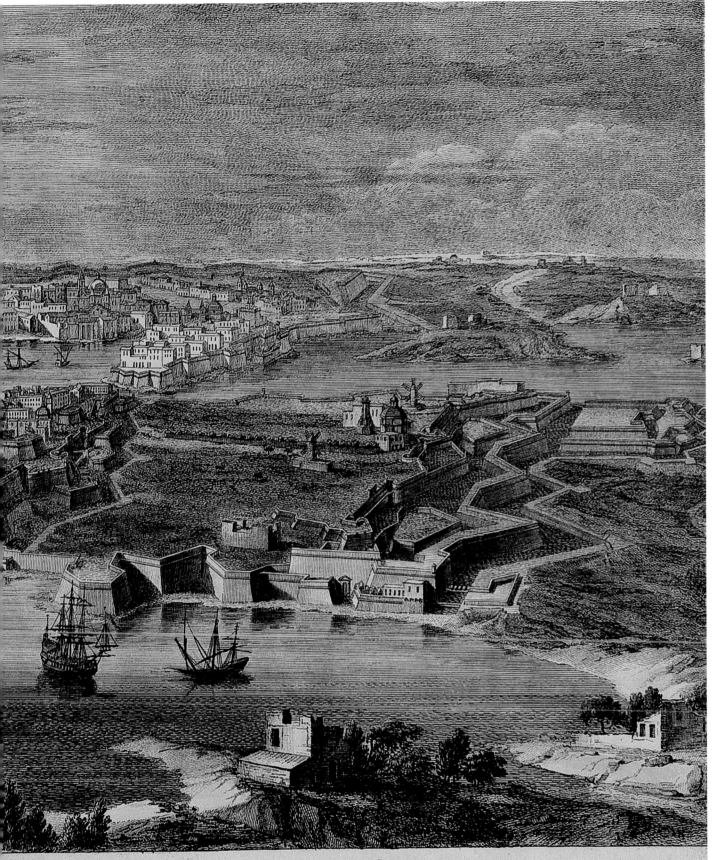

Vuë de la Ville de MALTHE, du côté du Lazaret, où les Vaisseaux font la Quarantaine

R.H. LAURIE, Nº 53, Fleet Street, London

Early 19th-century view of the Valletta peninsula from the west. Maritime Museum, Birgu.

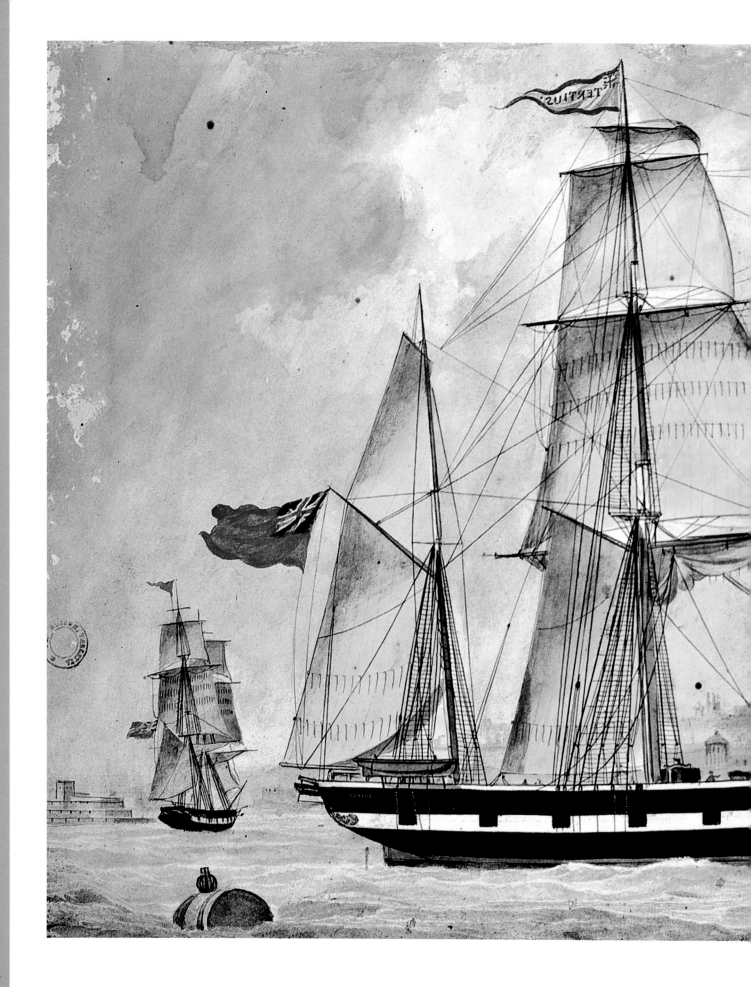

Merchantmen flying the Red Ensign became a common sight in Valletta's harbours in the early 19th-century.
Maritime Museum, Birgu.

continues from page 265

The growing military and economic importance of the Valletta Harbours also meant that they were jealously guarded. Following the unification of Italy in 1861, British strategists became increasingly nervous about the vulnerability of their island fortress to the coveting eyes of this new Mediterranean power. When the Italian fleet ordered a consignment of the newly-developed 100-ton guns to be installed on its battleships, two similar guns were installed in Malta, one on either side of the entrances to the Valletta

harbours. Today, the one at Fort Rinella is one of the only two surviving examples of these steel giants, the other example being in Gibraltar. During the first decade of the twentieth century, another colossal project was undertaken, this time to improve the Grand Harbour's defences against the elements. A breakwater was built at the entrance to the harbour, using well-fitted blocks of Lower Coralline Limestone to resist the sea's fury.

All this activity had important implications for Malta's economy. The Royal Navy's facilities employed thousands of Maltese workers. The building projects required by Britain's military machine employed hundreds more. Projects were, however, driven by imperial needs, not those of the welfare of the local population. Booms created by a building project, such as the building of the breakwater, would be followed by periods of unemployment and hardship when the project was completed. This is poignantly recorded in the register of workers that was held during the building of Bighi Hospital, which is now kept at the Public Records Office in London. Workers were literally employed day by day, and could be summarily dismissed with no notice. As a result, Malta's economic well-being became heavily dependent on British strategy and imperial policy.

Top: The 100-ton gun at Fort Rinella. Re-enactments are held by Fondazzjoni Wirt Artna - *the Malta Heritage Trust - which has restored the fort and gun.*

Opposite: Building the east arm of the Grand Harbour breakwater. Maritime Museum, Birgu.

Paradoxically, periods when Britain was engaged in hostilities in the Mediterranean often proved to be periods of prosperity for Malta. During the Crimean War, Malta's role as staging post, supply station, and hospital generated an upturn of activity and employment, without direct exposure to the grim realities of the warfront. The same happened during World War One. Many Maltese serving with the British services lost their lives, but the islands themselves were unscathed.

World War Two, however, could not have been more different, and was to become one of the most indelible chapters in the islands' history.

The Mediterranean in 1940 presented a grim picture to Britain and its allies. The forces of the axis formed by Germany and Italy had swept through France, Greece, and North Africa. Between Gibraltar at one end of the Mediterranean and Alexandria at the other, there was only one stronghold in the hands of the Allies – Malta.

continues on page 280

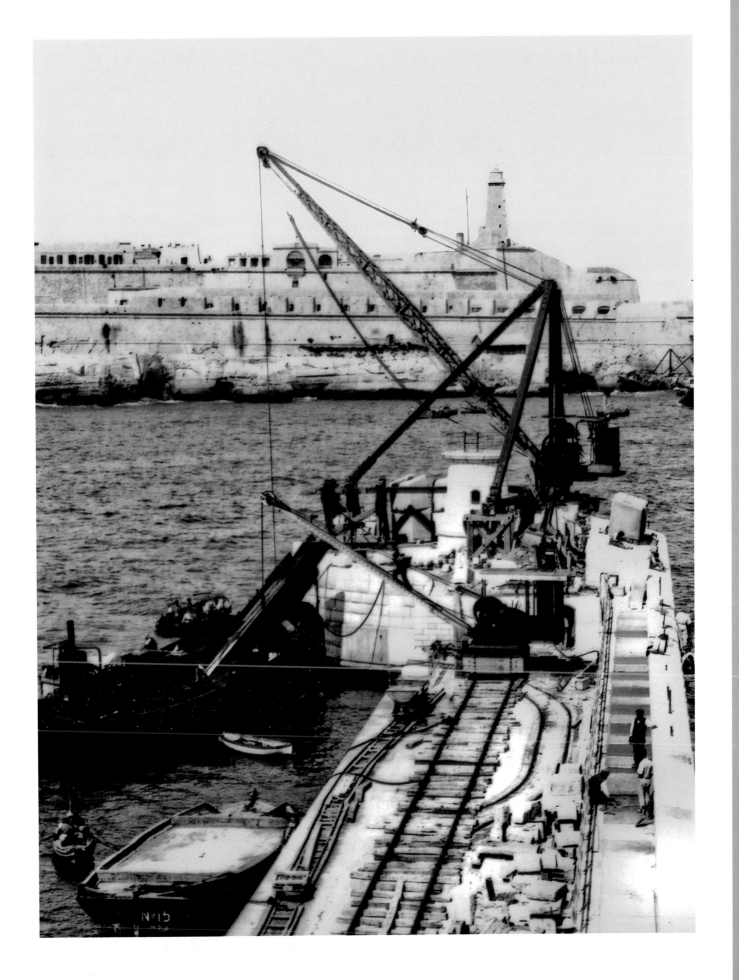

THE CEREMONY OF LAYING THE FOUN

N-STONE OF A NEW DOCK AT MALTA.

Laying the foundation stone of a new dock. Maritime Museum, Birgu.

continues from page 276

Much has been written about the island's strategic value. Major Francis Gerard's contemporary account has noted that, firstly, it provided a vital base for air reconnaissance, permitting the gathering and relaying of vital information about enemy movements, crucial for allied strategy across the Mediterranean theatre. A second factor in Malta's strategic importance was the fact that, as long as it held out, it held down large numbers of enemy aircraft and resources, diverting them from other theatres of war where they were sorely needed. A third factor was that attacks on the enemy could be launched from the island. According to Gerard, more than a thousand enemy aircraft were lost in the battle for the island, while submarines operating from tiny Malta sank more than half a million tons of enemy shipping, maintaining a stranglehold on supplies to Rommel in North Africa, which was to prove decisive in his defeat. For all these reasons, it was a declared priority of the Axis forces to wipe out the island fortress.

Malta had never found itself so surrounded by hostile forces, not even during the Punic Wars. Furthermore, the hostile forces that now surrounded it

The long hall of the Holy Infirmary became a hospital once again during the First World War.
National Museum of Archaeology, Valletta.

possessed fighting machines far more terrifying and devastating than anything that the world had seen before. Airplanes based in nearby Sicily could now bombard the islands from the air. Fleets of submarines preyed on the ships trying to reach Malta with the precious supplies that it needed to survive.

This was a war that gave no quarter and made no distinction between soldiers and civilians. Month after month, steel rained from the sky, pounding whole streets of buildings into the ground, in what was fast becoming one of the most heavily-bombed spots on Earth.

At the darkest hour, in April 1942, with air raids continuing almost round the clock, a small token of recognition of the population's resilience and courage came in the form of the award of the George Cross to the entire people of Malta. The George Cross, which is still the highest civilian decoration that may be awarded in the British Commonwealth,

continues on page 295

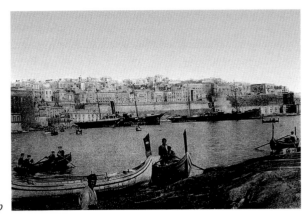

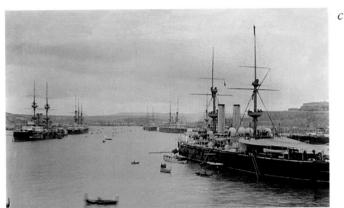

a. *Valletta Marina c.1890*
b. *View of Valletta from Isla c.1890*
c. *British battleships at Malta, c.1899*
d. *Two Royal Sovereign class British battleships in the Grand Harbour c.1900*
e. *Invalids recovering in a hospital on Malta during World War One*
f. *RAF planes over Manoel Island 1929*
g. *RAF planes over Isla 1932*

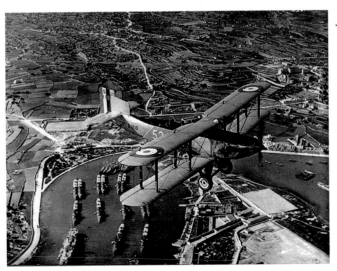

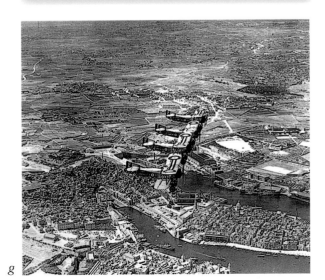

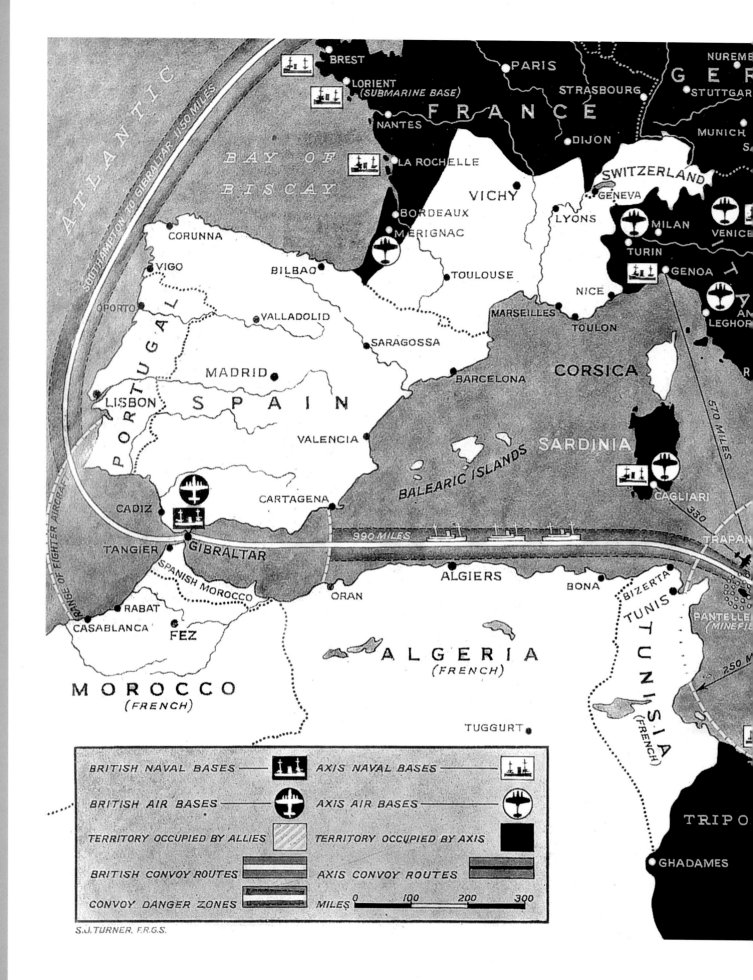

BREST
LORIENT
(SUBMARINE BASE)
NANTES
PARIS
STRASBOURG
NUREMB
GER
STUTTGAR
MUNICH

FRANCE
DIJON

BAY OF
BISCAY

LA ROCHELLE

BORDEAUX
MERIGNAC

VICHY
LYONS
SWITZERLAND
GENEVA

MILAN
VENICE

ATLANTIC

SOUTHAMPTON TO GIBRALTAR 1150 MILES

CORUNNA
VIGO
OPORTO

BILBAO
VALLADOLID

TOULOUSE

TURIN
NICE

TOULON

GENOA
ITA

AN
LEGHOR

PORTUGAL

MADRID

SARAGOSSA

MARSEILLES

CORSICA

LISBON
SPAIN

BARCELONA

SARDINIA

VALENCIA

BALEARIC ISLANDS

570 MILES

RANGE OF FIGHTER AIRCRAFT

CADIZ

CARTAGENA

CAGLIARI

330

TANGIER
GIBRALTAR
SPANISH MOROCCO

990 MILES

ORAN

ALGIERS

BONA

BIZERTA

TRAPAN

RABAT
CASABLANCA
FEZ

TUNIS

PANTELLE
(MINEFI

ALGERIA
(FRENCH)

250 M

MOROCCO
(FRENCH)

TUGGURT

TUNISIA
(FRENCH)

TRIPO

GHADAMES

BRITISH NAVAL BASES ——— | AXIS NAVAL BASES ———
BRITISH AIR BASES ——— | AXIS AIR BASES ———
TERRITORY OCCUPIED BY ALLIES | TERRITORY OCCUPIED BY AXIS
BRITISH CONVOY ROUTES | AXIS CONVOY ROUTES
CONVOY DANGER ZONES | MILES 0 100 200 300

S.J. TURNER, F.R.G.S.

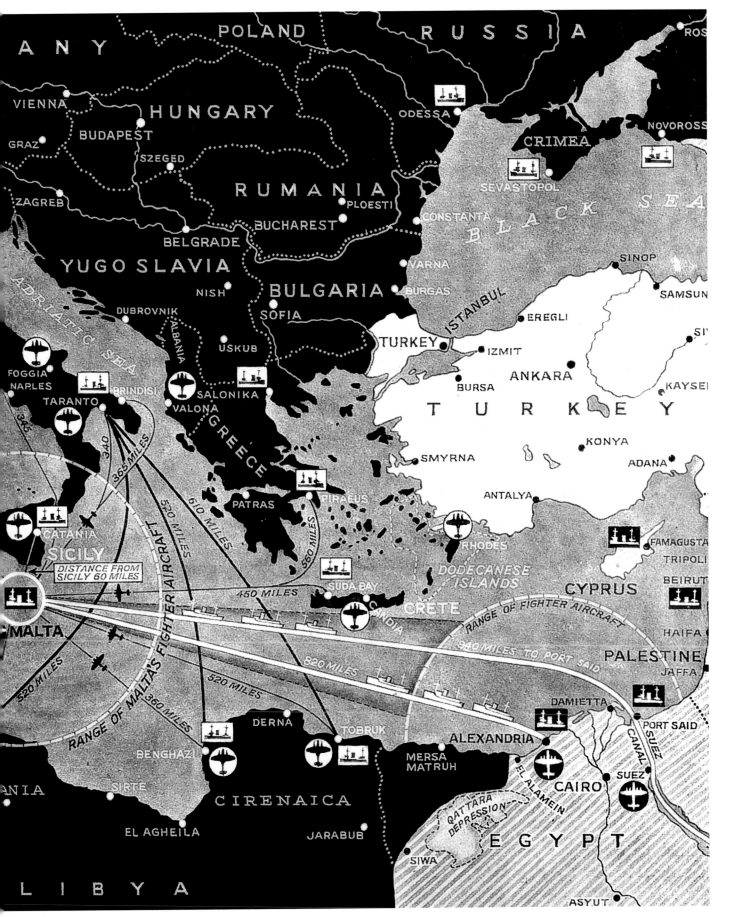

Malta's position during World War Two was extremely isolated. (*Source:* The Epic of Malta)

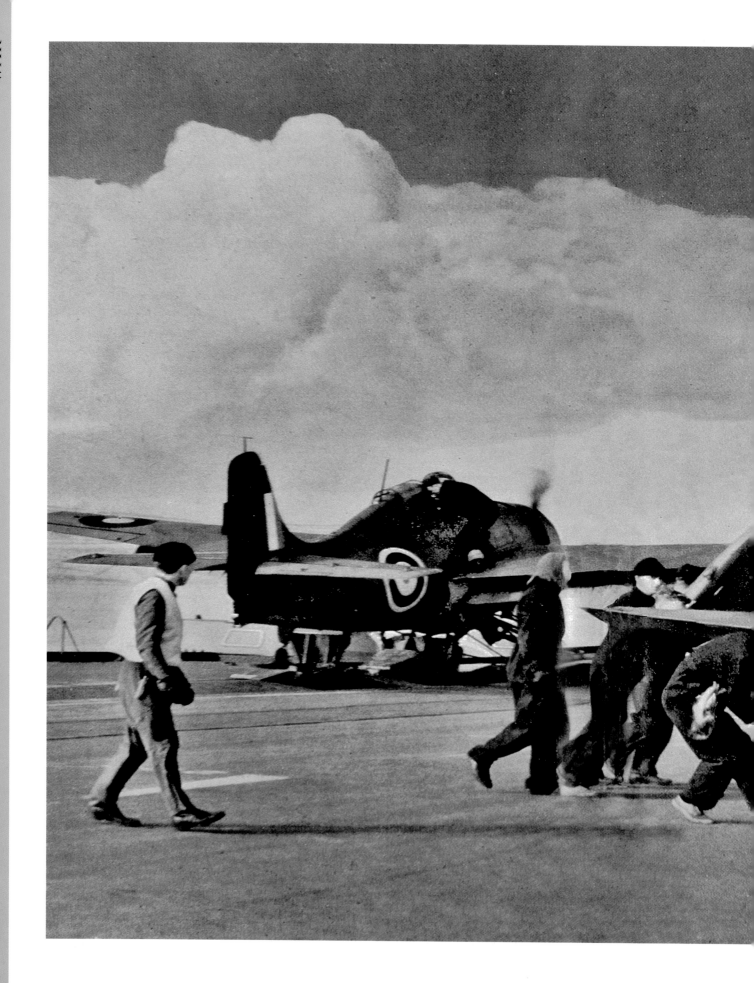

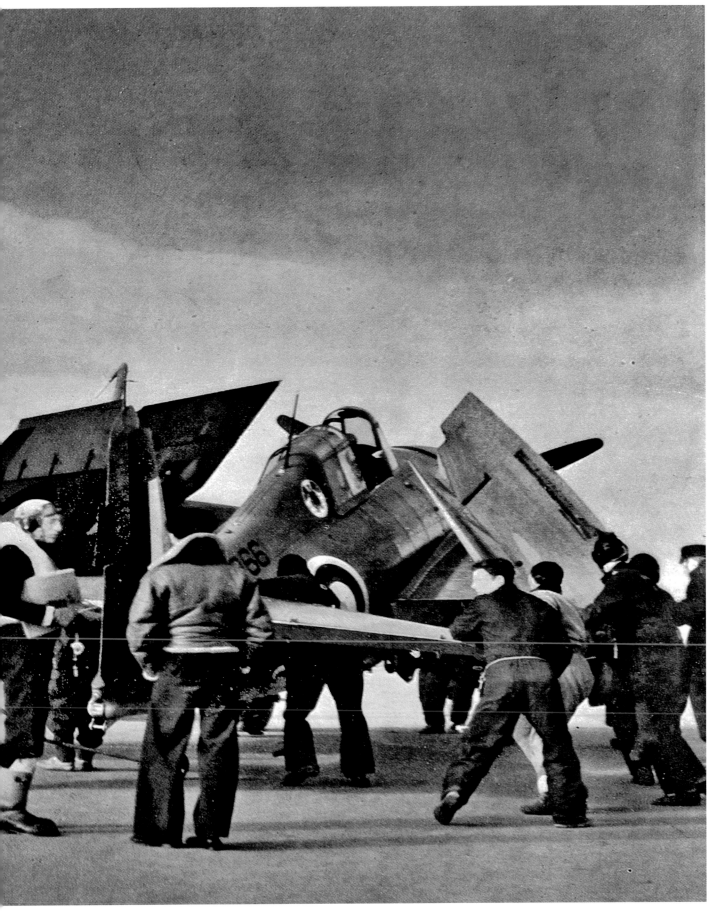

Preparing for take-off from an aircraft carrier at sea

A merchant vessel safely reaches harbour with its precious cargo

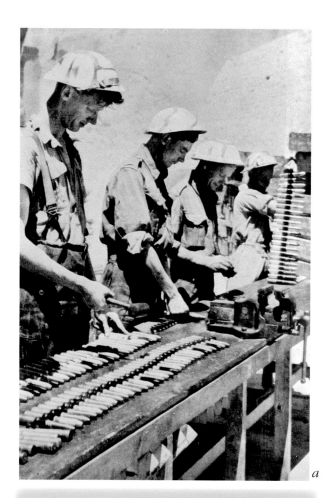

b

a

a. Preparing cartridge belts the Spitfires
b. Loading the guns on a Spitfire
c. Loading a torpedo onto a bomber
d. Unloading supplies from a ship

(All World War Two photographs reproduced from The Epic of Malta.*)*

c

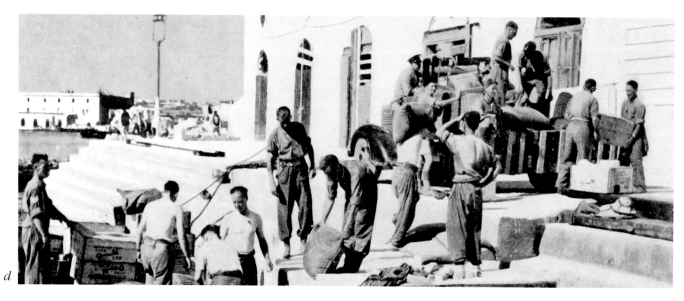

d

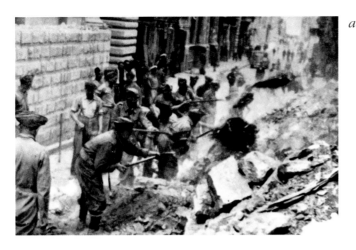

a

b

c

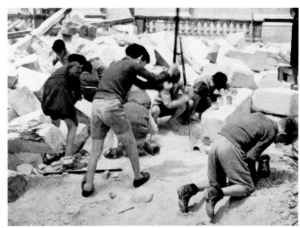

d

a. Clearing debris after an air-raid in Valletta
b. Maintaining normality through the chaos
c. Salvaging belongings from the devastation
d. Children playing in the ruins
e. A railway tunnel converted to a communal shelter

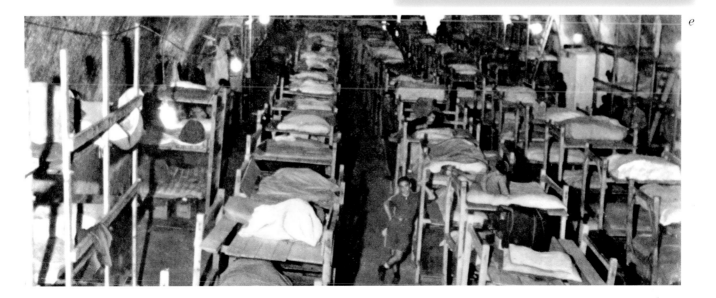

e

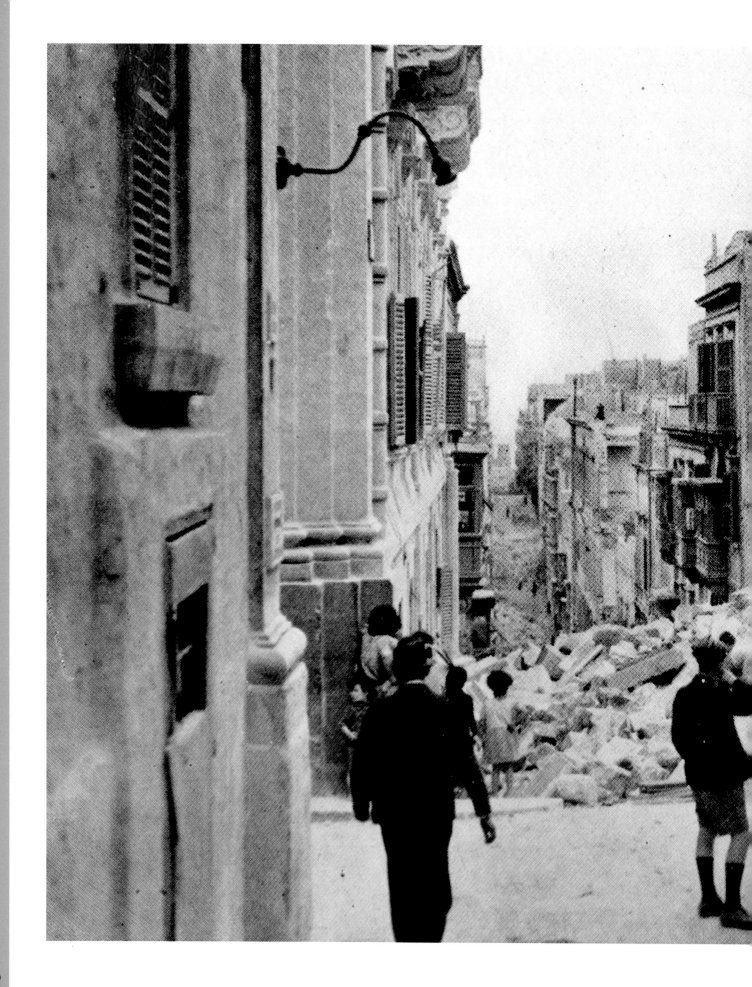

The ruins of the Auberge de France. The General Workers Union building stands on the same site today

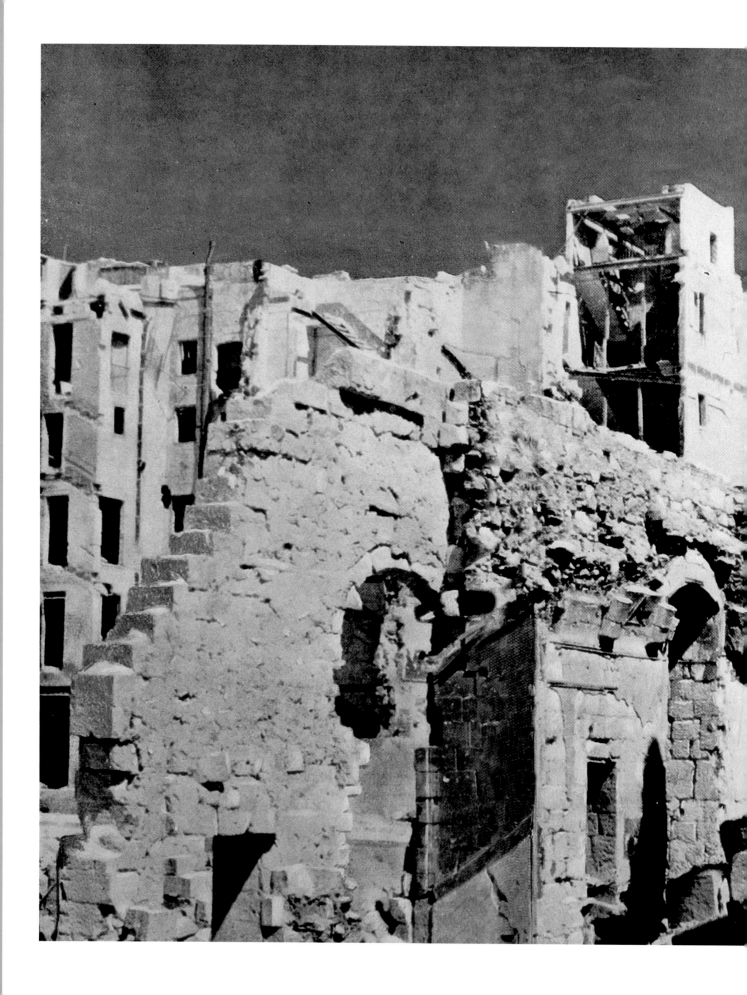

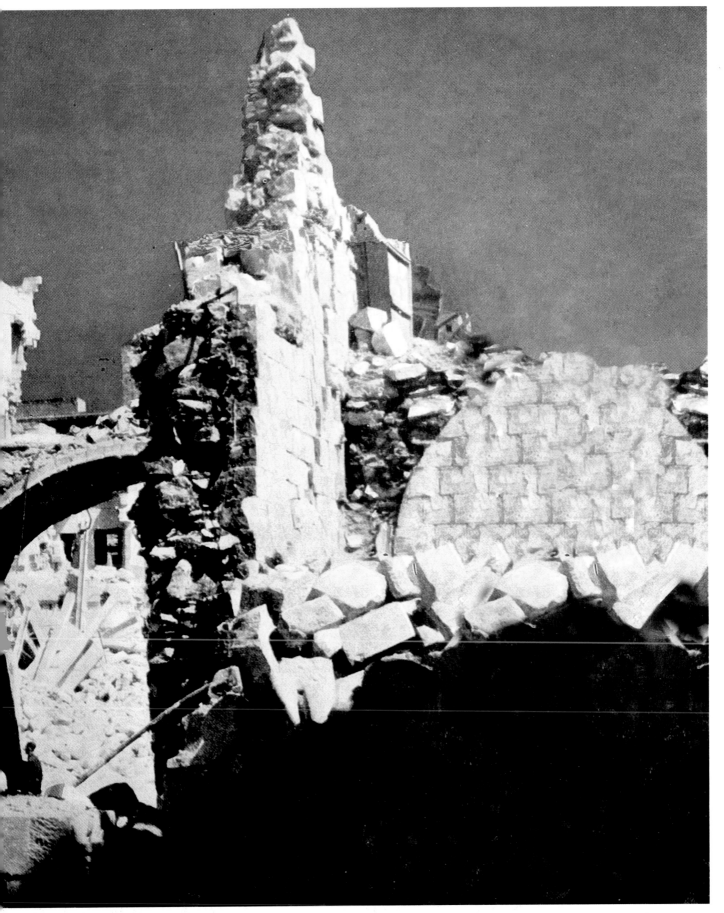

The ruins of the Auberge d'Auvergne which served as the law courts. The new law courts were built on the same site

293

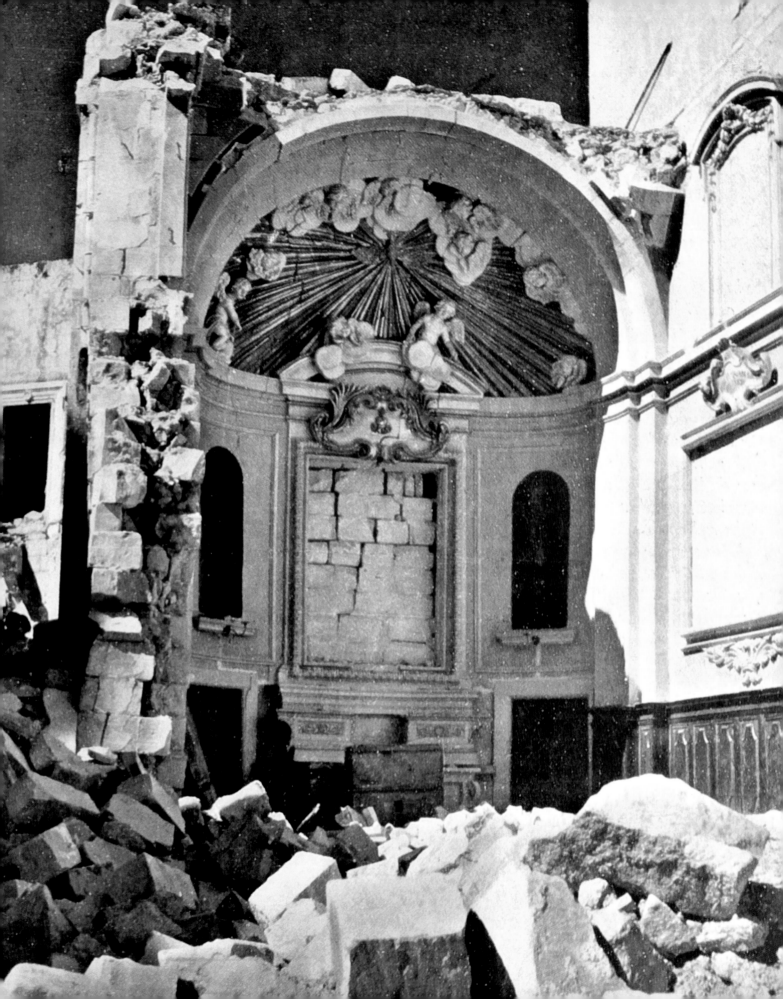

continues from page 280

has since formed part of the Maltese national flag.

Once again, the islanders sought refuge in the rock beneath their feet, hewing deep shelters into the Globigerina Limestone [*right*]. Whole convoys of ships laden with supplies were practically wiped out by enemy submarines. Starvation looming, the civilian population continued to bear the siege with rare stoicism.

When a convoy finally broke through to Malta on the feast of Santa Marija, 15 August 1942, it saved the island from the brink of starvation. The story of the siege and the convoy is no less epic than that of the siege of 1565, or the insurgency of 1798. Its influence on the Maltese nation was equally formative, setting the stage for self-determination and full independence on 21 September 1964.

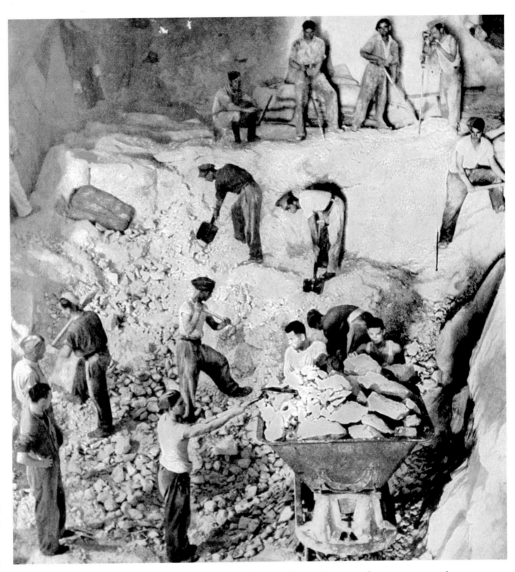

At the close of hostilities, the Grand Harbour area was a scene of devastation, and Malta's infrastructure lay in ruins [*opposite: the ruins of the Oratory of St Philip, Isla*]. As reconstruction programmes and funding were mobilized, the islanders rolled up their sleeves for yet another remarkable battle, this time to rebuild their world. In the space of a short decade, the lost housing stock had been replaced with apartment blocks, while many of the partially damaged historic buildings had been consolidated and restored. Entire streetscapes in the historic urban cores had however been erased for ever, and countless remarkable monuments live on only in photographs.

The material losses and transformations brought about by the war are only a pale reflection of the social upheaval and transformations that came hand in hand. The exodus from the harbour area for the safety of the countryside brought about an unprecedented level of interaction and familiarity between urban dwellers and village communities, and between members of different social classes. The distinctions between these worlds, so sharply demarcated until the war, would never be the same again.

Since the World War Two, Malta has not been on the front line of hostilities again. During the Cold War however, it continued to serve the role of advanced listening post and military base. The military infrastructure continued to be updated to keep abreast of the ever-accelerating pace of development of weapon technology. The entire military machine was kept in a constant state of readiness to respond to attack at a moment's notice.

continues on page 298

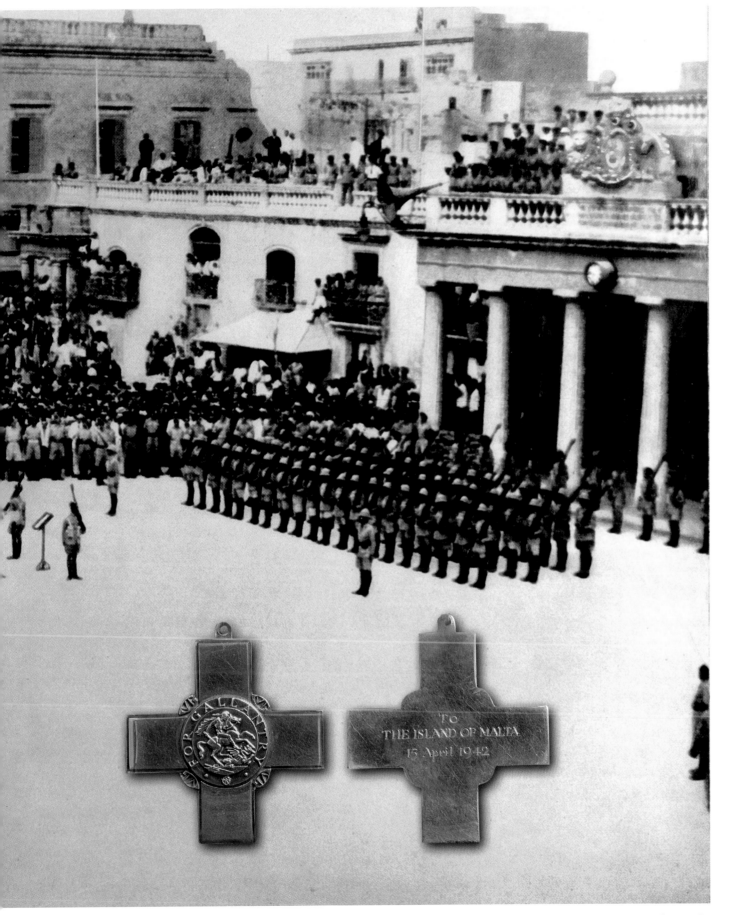

The presentation ceremony of the George Cross [inset] on Palace Square, 13 September 1942

continues from page 295

In preparation for the nightmare scenario, a series of flour-mills were created in rock-cut nuclear bunkers across the islands, some examples of which are now being opened for visitors.

In a poetic twist of history, one of the events that have come to symbolize the end of the Cold War took place in Malta. In December 1989, even as a storm raged, the President of the Soviet Union Mikhail Gorbachev met US President George Bush on board a ship in the shelter of Marsaxlokk Harbour [*right*].

The last British forces left Malta on 31 March 1979. Since then, one of the country's biggest challenges has been how best to manage and use the vast military infrastructure that had been assembled over the centuries. Today, many of the military facilities have been converted into schools, old people's homes, and residential complexes. Appropriately enough, the building of the Naval Bakery has now become the Maritime Museum. The Bighi

Top: The tunnel leading into the flour-mill at Xlendi, Gozo, one of seven created during the Cold War, in the 1950s.

Royal Naval Hospital now houses a Malta's council for science and technology, conservation laboratories, and a centre for creative thinking. In Valletta, Fort St Elmo houses the Police Academy, St John's Cavalier is the embassy of the knights of St John, and St James Cavalier is a centre for creativity and the arts. Across the water, Fort St Angelo has been once again entrusted to the knights of St John, in acknowledgement of the enduring bond between the people of Malta and the Order.

And so, once more, a wide-ranging transformation of the Maltese islandscape is unfolding. From serving the needs of a world empire, a vast military infrastructure is now being transformed to serve the needs of a resourceful people, keen to build a peaceful future.

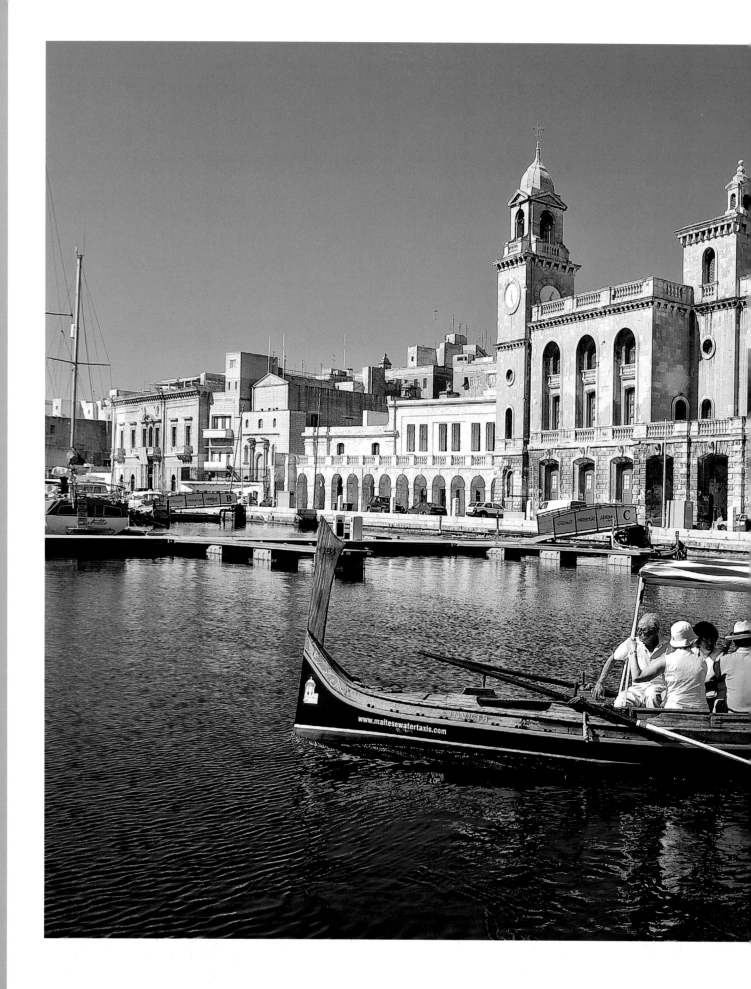

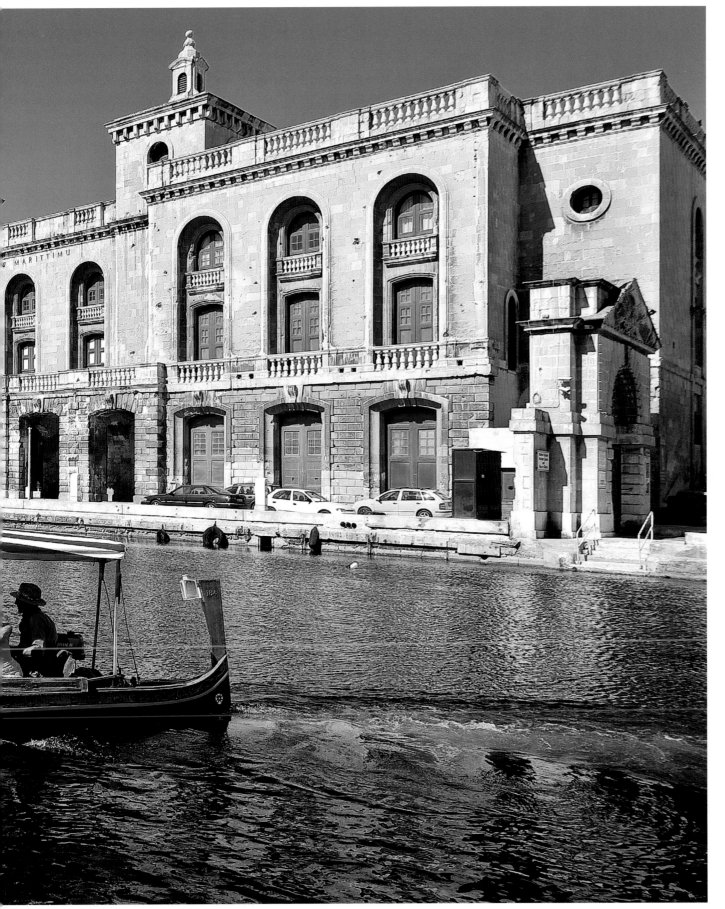

*Today leisure boats have taken the place of warships in Dockyard Creek,
while the Naval Bakery building houses Malta's Maritime Museum.*

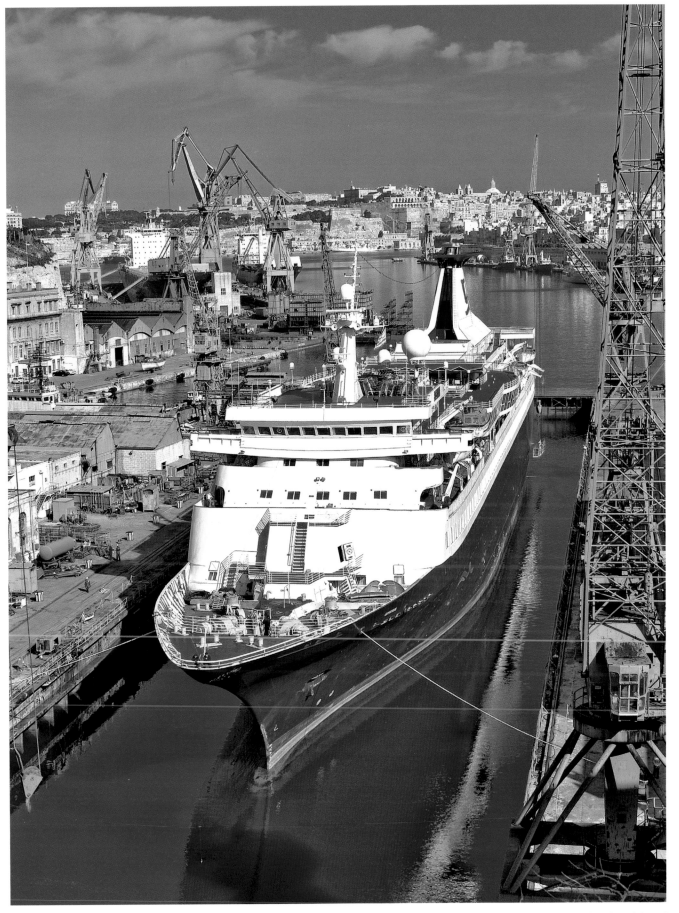

Dock N° 4 at the Malta Shipyard, during the World War Two (left) and today (above)

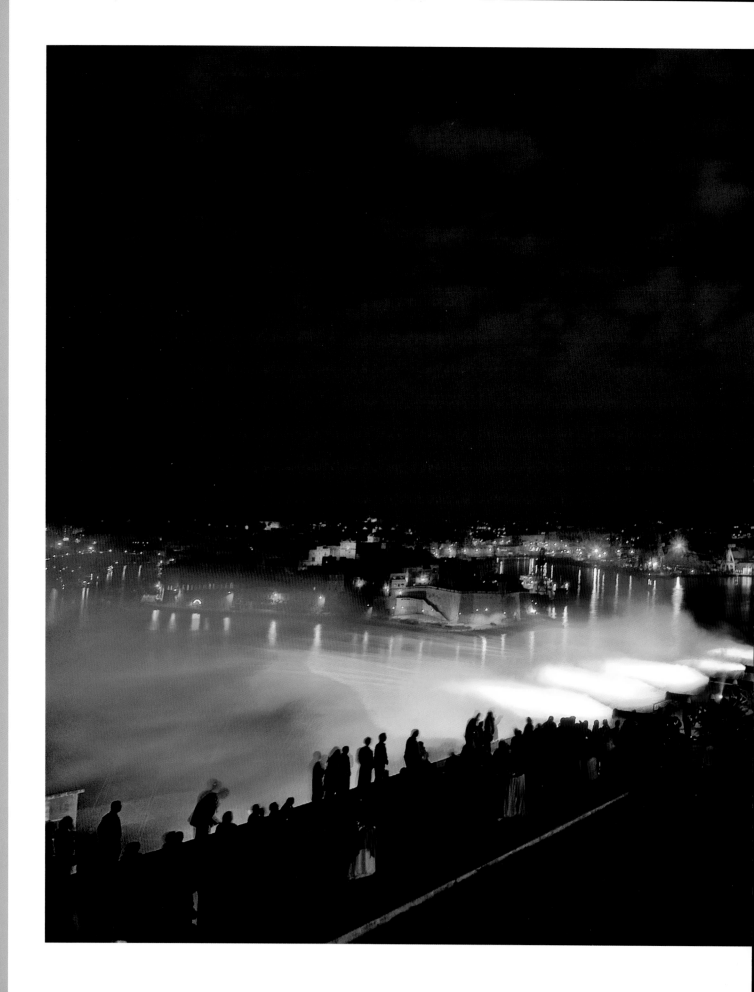

The only guns that are heard in Valletta today are the blanks of saluting batteries during a re-enactment by Fondazzjoni Wirt Artna - *the Malta Heritage Trust.*

Celebration

Life on the Maltese islands is characterized by hard work, punctuated by big parties. Like many communities that traditionally relied on agriculture and fishing, the Maltese have been accustomed to periods of intense work during the sowing, harvesting, or fishing months, interrupted by periods when attention could focus elsewhere. These lulls are times to bring together family, friends, and community, and to recollect memories and celebrate the successes of yet another season. Although the archipelago is becoming less and less dependent on agriculture, the tradition of seasonal celebration is as strong as ever.

Perhaps the best known and most characteristic community celebrations are the parish *festas*. Every parish has its principal patron saint, and sometimes a secondary one for good measure. Each year, the whole community is mobilized to celebrate the feast-day of its saint. A few of the *festas* are celebrated in winter, such as St Paul's Shipwreck in Valletta, marked on 10 February, or the Immaculate Conception that is marked in Bormla on 8 December. In summer, the *festas* come thick and fast, with at least one, sometimes more, village celebrating a *festa* practically every week. In the days running up to each *festa*, fireworks light up the sky, announcing the celebrations to neighbouring villages in a way that is difficult to ignore. Rivalries between different parishes often run high. Where more than one *festa* is celebrated in the same parish, the community is playfully divided according to allegiance.

continues on page 310

Playing with fire. Celebrants holding suffarelli *during a* festa *band march at Birkirkara.*

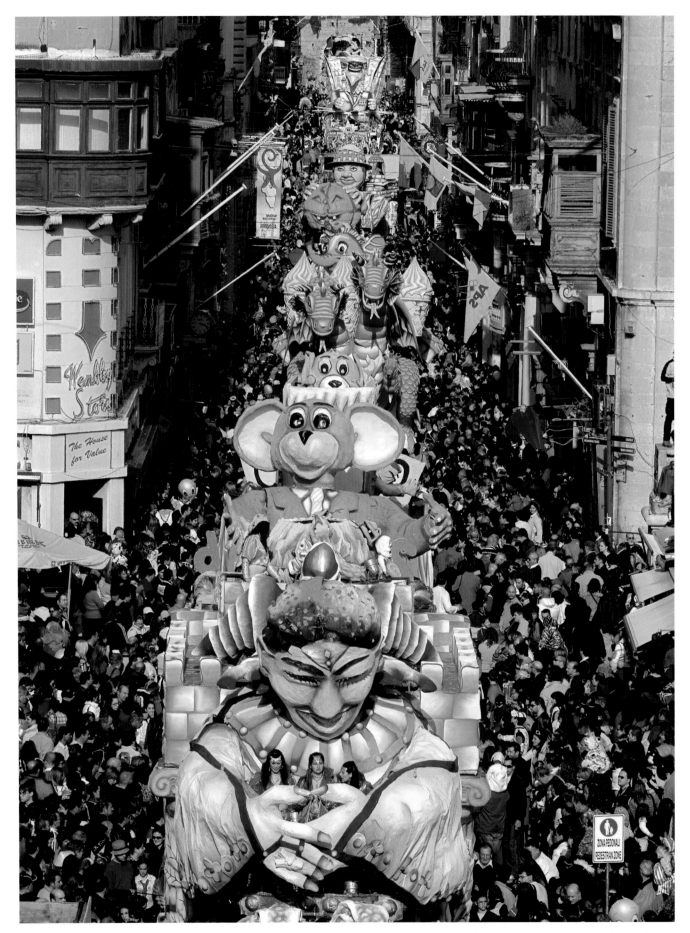

Papier-mâché floats along Republic Street during carnival in Valletta

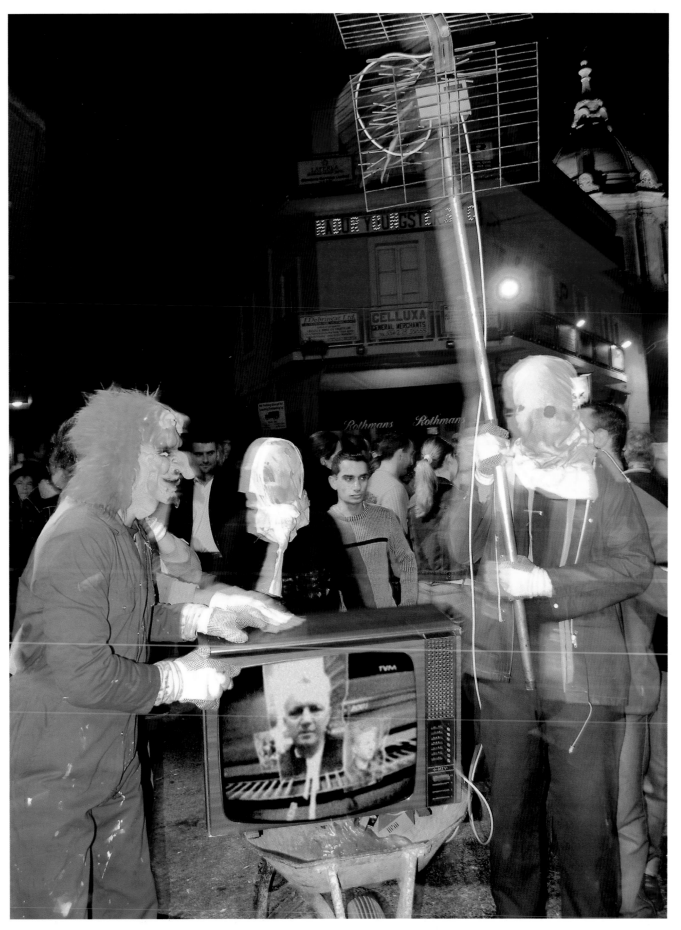

Home-made satirical tableaux characterize carnival in Nadur, Gozo

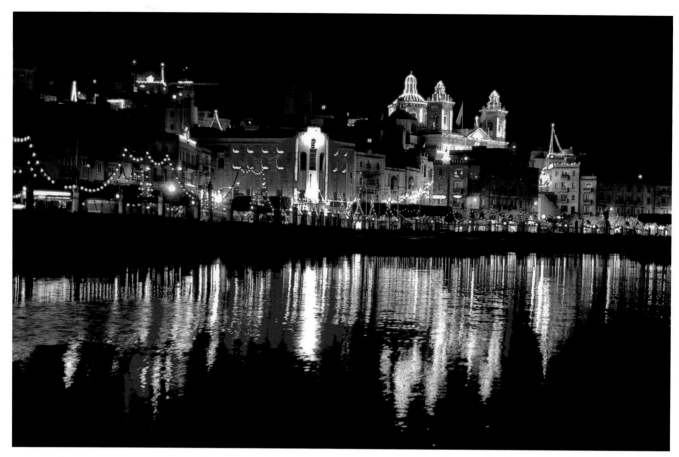

continues from page 307

The sense of competition and rivalry continues to fuel ever more extravagant celebrations and machinations. The main streets and square of every village is transformed with decorations for the occasion. Damask hangings, coloured lights, and *papier-mâché* statues on *faux-marbre* pedestals turn the streetscape into a vast, open-air stage-set for the celebrations. Every *festa* culminates in the procession of the patron saint around the streets, escorted by bands and the village dignitaries. The *festa* season peaks on 15 August, when the Assumption of Our Lady is celebrated in seven different parishes across the archipelago.

Summer is also the time for picnics and barbecues by the seaside. Entire extended families, with everyone from the great-grandparents to the toddlers, may be seen all along the shoreline on summer evenings, particularly over weekends. Gas lamps, portable tables, and vast quantities of food are obligatory paraphernalia for the Maltese family outing. On a still August evening, a picnic by the sea offers some respite from the stifling heat inland, and more importantly, a moment when the whole family may gather and celebrate

Top: Bormla lit up for the festa *of the Immaculate Conception on 8 December.*

Opposite: The vara *of Our Lady of Mount Carmel, during the secondary feast of Żurrieq.*

the moment. Seaside gatherings of teenagers are no less common, the barbecue and nocturnal swim an almost indispensable rite of passage.

In wintertime, the most traditional way to meet up with friends is the *fenkata*, a dish of fried or stewed rabbit served in many taverns. Rabbit is considered a national dish and is the most traditional fare at the popular Mnarja festival celebrated through the night in the woods of Buskett every 29 June. It appears that rabbit may have acquired greater symbolic significance as a result of an incident that took place in the eighteenth century, when Grand Master Francesco Ximenes prohibited rabbit-hunting by the Maltese. The prohibition was defied, and the chain of events that followed brought the population dangerously close to open revolt.

continues on page 322

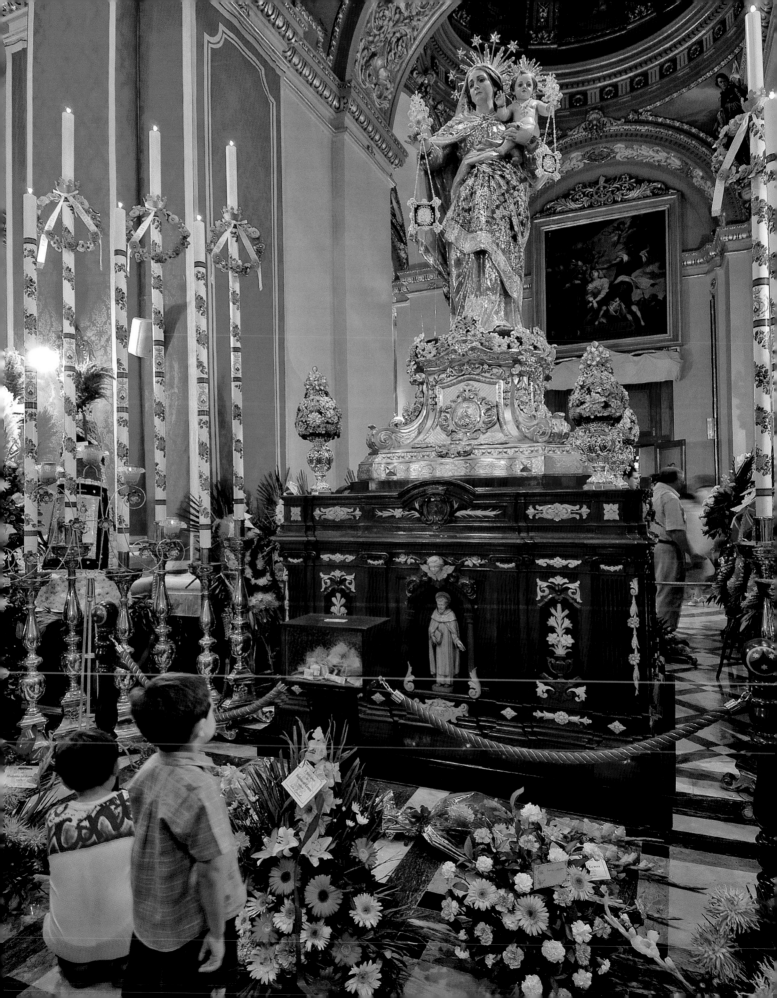

a: Feast of the Assumption, 15 August, in Mosta

b: Revellers during a morning band march, at Rabat, Gozo

c: Church of the Assumption at Mqabba bedecked for its festa

d: The band march sets the pace of the festa in Mosta

a

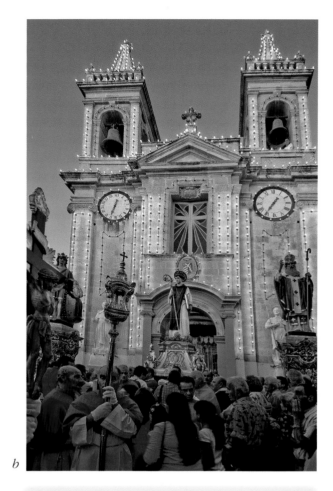

b

c

a: Horse races in Rabat Gozo, during the feast of Santa Marija
b: Start of the procession with St Leonard at Hal Kirkop
c: A consecrated host carried in a monstrance during the feast of Corpus Christi, Valletta
d: The Fireworks Festival held yearly on the Floriana granaries during the parish feast

d

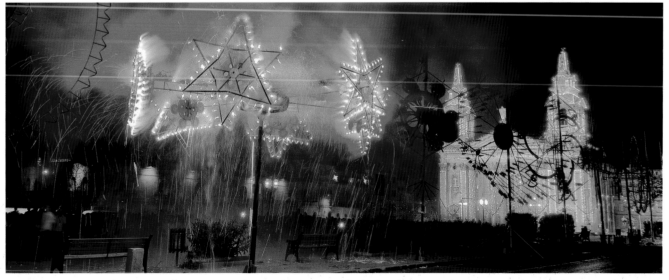

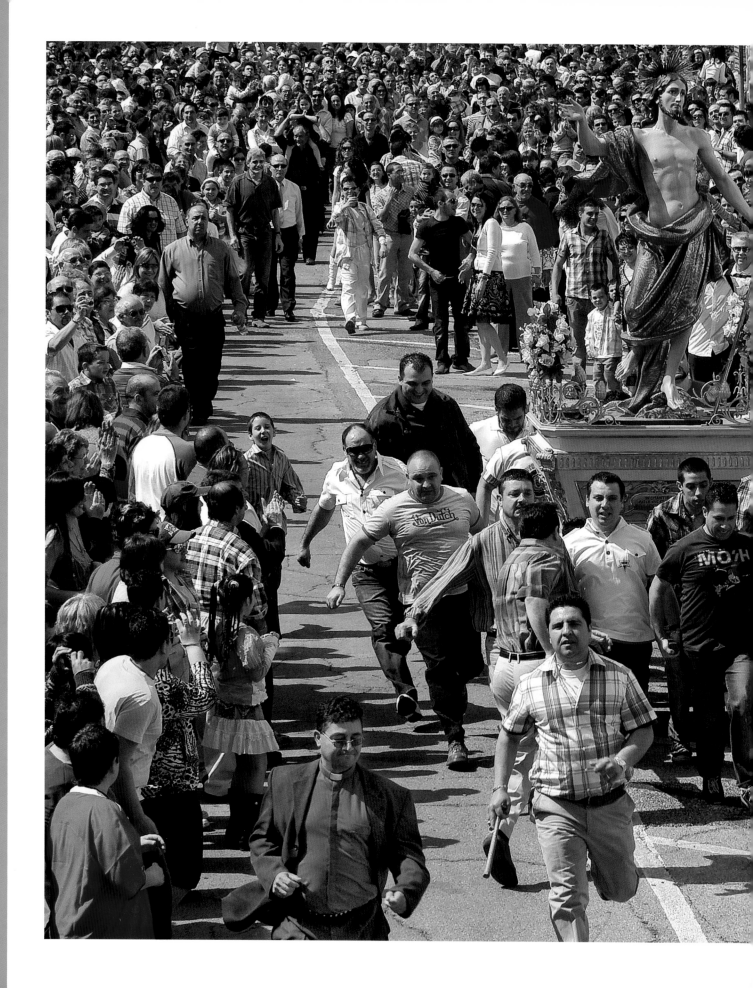

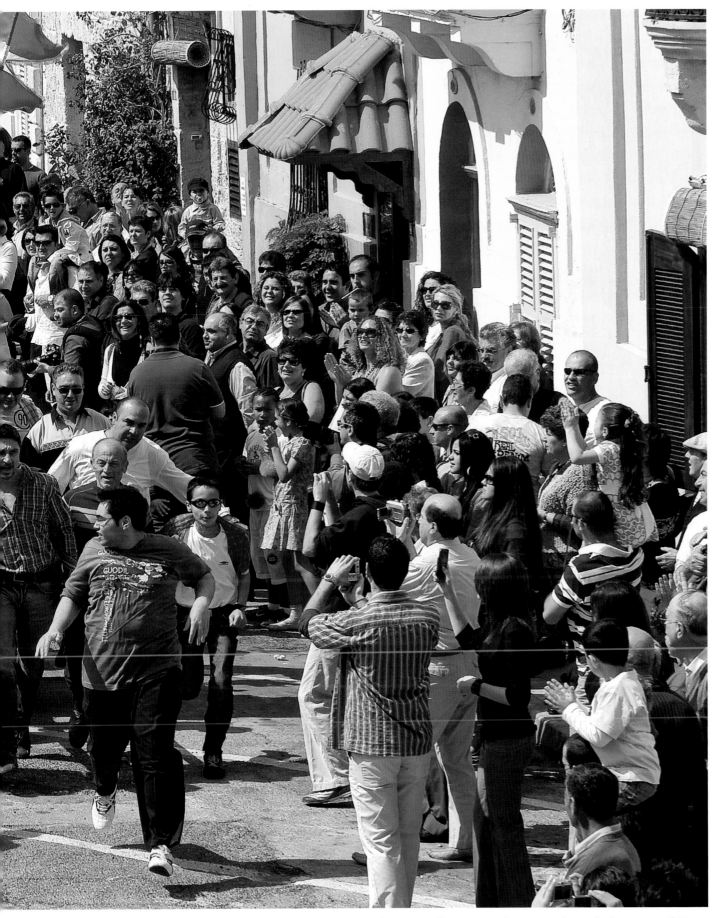

The Risen Christ carried at a run through the streets of Birgu

Traditional costumes and agricultural shows during the Mnarja celebration on 29 June

A prize-winning horse during the Mnarja celebration on 29 June

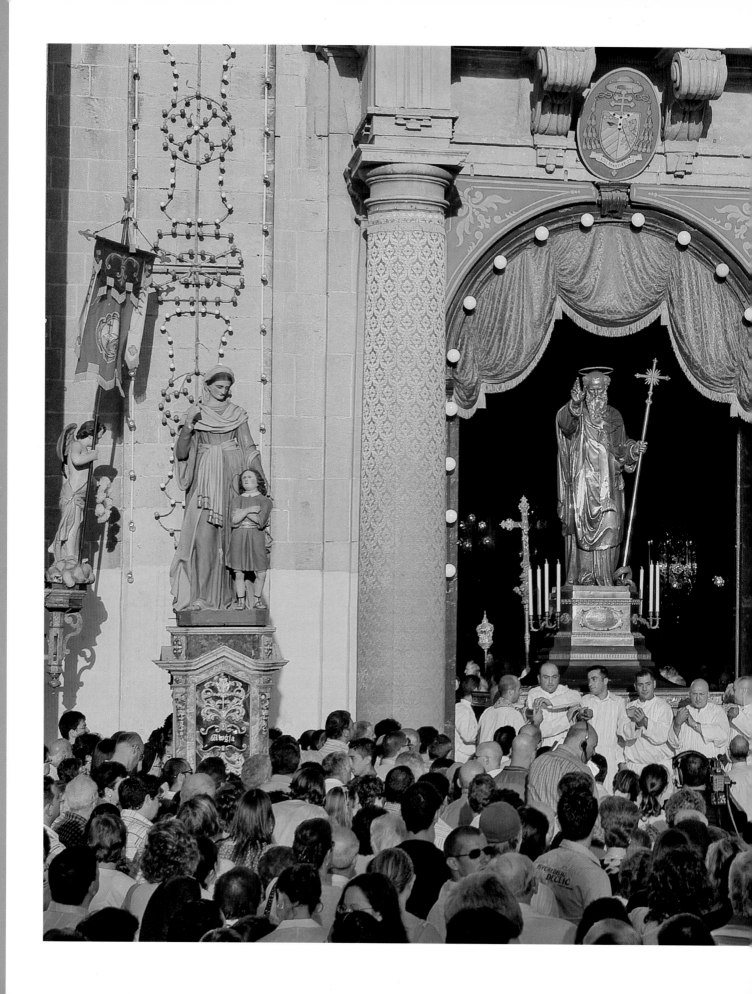

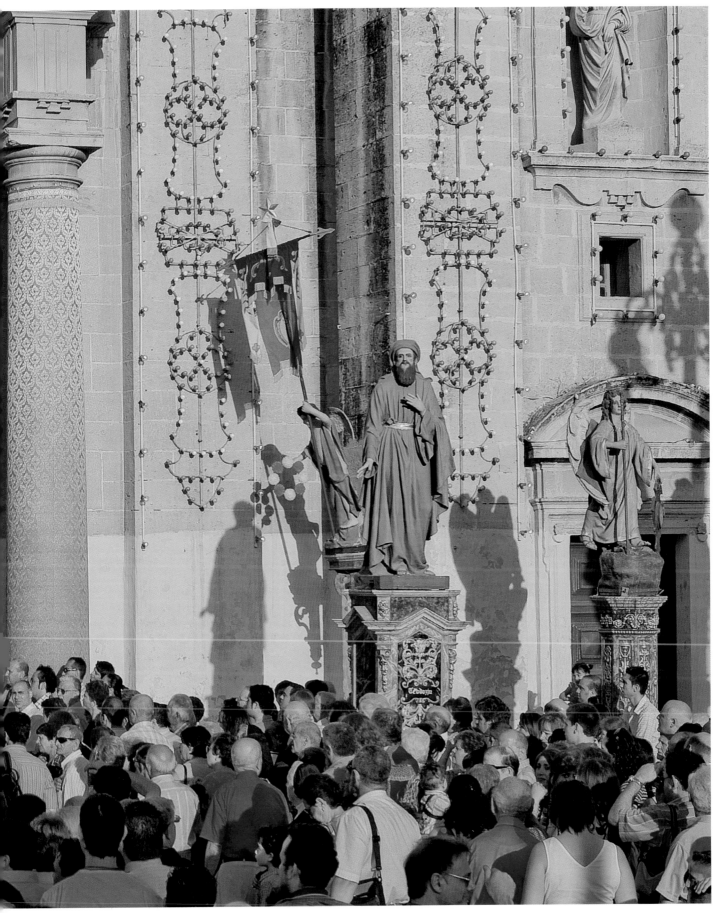

St Philip of Aggira being carried out of the parish church of Ħaż-Żebbuġ

Fireworks over Paola during the feast of Christ the King

321

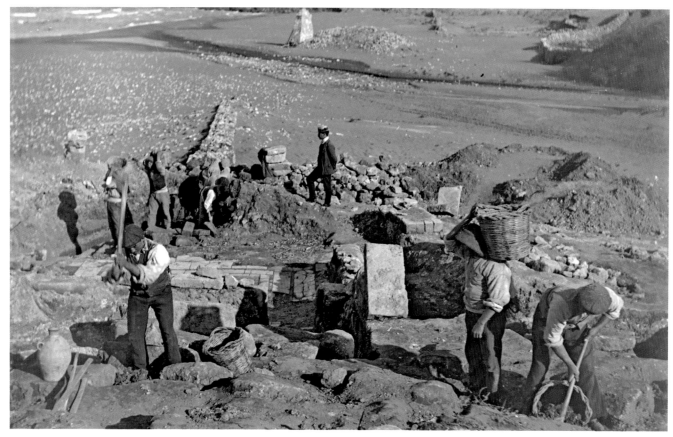

continues from page 310

It has been suggested that, as a result, the *fenkata* [*below*] became a symbol of national identity and defiance. Though most people today have forgotten the historic reasons, rabbit cultivation and consumption per capita is perhaps the highest anywhere in the world.

It is difficult to write about celebration without writing of leisure, and to write of leisure, we should probe back thousands of years. Beneath the sandy beach of ir-Ramla l-Ħamra,

The excavation of the Roman seaside villa at Ramla l-Ħamra, Gozo

on the North coast of Gozo, lie the remains of a Roman villa complete with a system of heated baths and a cold plunge. This was once the idyllic holiday home of some wealthy patrician, enviably located a stone's throw from the shore, with a steady supply of fresh water coming down from the springs in the hills to feed the baths. Another Roman bathing complex overlooks Għajn Tuffieħa Bay. The very modest size of the baths suggests that such leisurely luxuries were the preserve of a privileged few.

If we fast forward to the seventeenth or eighteenth centuries, we find that little had changed in this respect. Seaside villas and country retreats were still the preserve of the small minority that

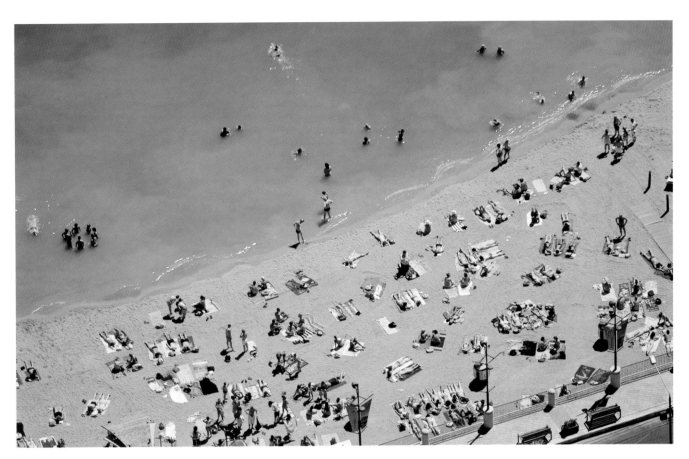

Crowds flock to sandy beaches through the summer months. St George's Bay, St Julian's.

could afford them. Wealthier families typically kept a house in the capital, as well as a country residence, perhaps set among the orange groves of Lija, Attard or Balzan, or along the bays and inlets near Valletta. It was only during the course of the nineteenth and twentieth centuries that leisure activity was commoditized and popularized for the enjoyment of the population at large.

During the late nineteenth century, the coast to the north of Valletta, which until then had been the preserve of palatial summer retreats, was developed into the modern suburb of Sliema. In the early decades of the twentieth century, several public baths were cut into the shoreline of Valletta, Sliema, and St Paul's Bay, as crowds began to throng the beaches to enjoy the newly discovered delights of bathing in the sea and sun. Leisure and relaxation were not the only motive. During the nineteenth century, it was widely believed that swimming and

the sea air were the cure for many ailments. Many invalids were dispatched to the Mediterranean from more northern climes in the hope of restoring their health. While eighteenth century travellers on the Grand Tour had come to the Mediterranean to explore and discover the remains of past cultures, from the nineteenth century onwards tourists have come in ever-growing numbers to seek health and leisure.

The trend has continued unabated. With the advent of cheap air travel during the latter part of the twentieth century, Malta became a popular holiday destination. Whole towns have been developed along many of the bays and beaches of the archipelago in order to receive this influx. These coastal holiday towns are also the leading nightspots, where every evening the young and not so young throng through a maze of nightclubs, bars and restaurants.

Tourism has played a vital role in the country's economy. Malta gained independence from Britain in 1964, and the last British troops left in 1979. The run-down of military activity required an economic transformation, which was achieved with remarkable success.

continues on page 338

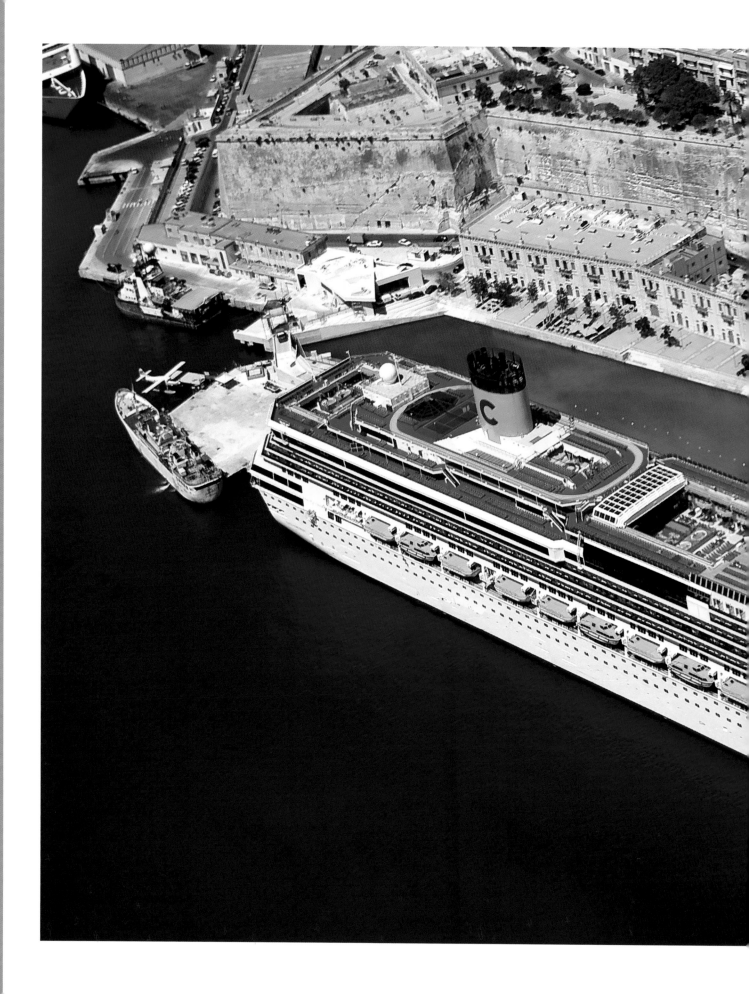

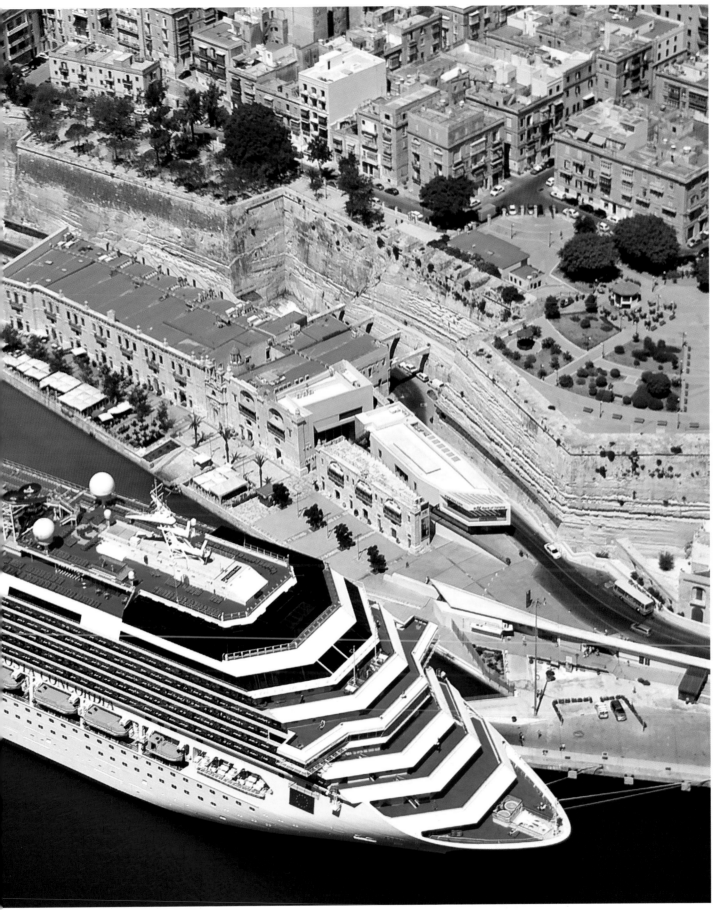

The proliferation of cruise liners has popularized sea travel for leisure

Walter Micallef, a leading Maltese singer and songwriter, performing during a concert at the Valletta Waterfront

Flamenco dancing in the courtyard of the Grand Master's Palace, Valletta

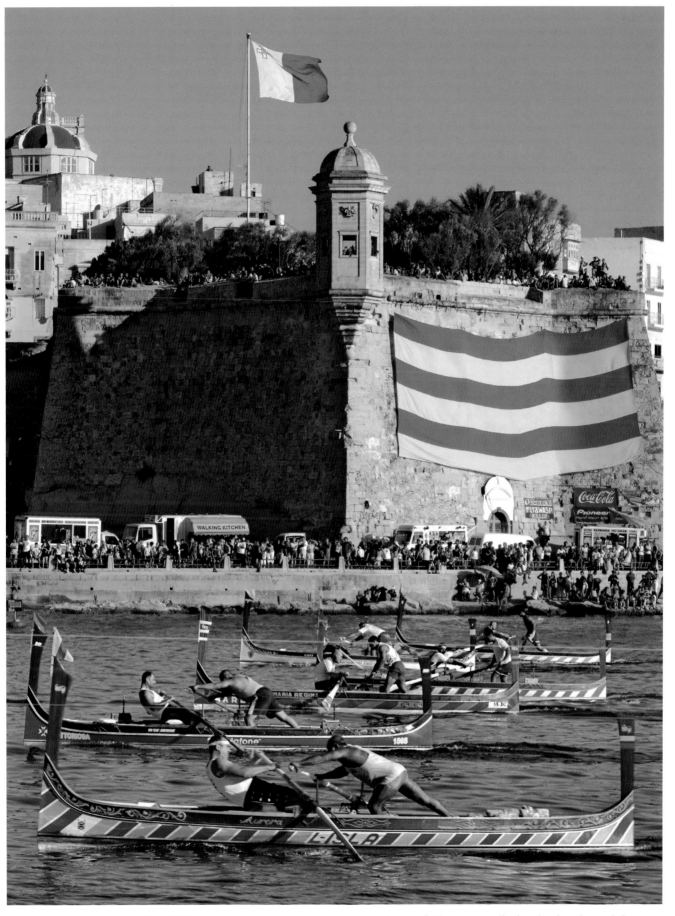

The 1565 victory commemorated with races beneath the very walls that had withstood the siege

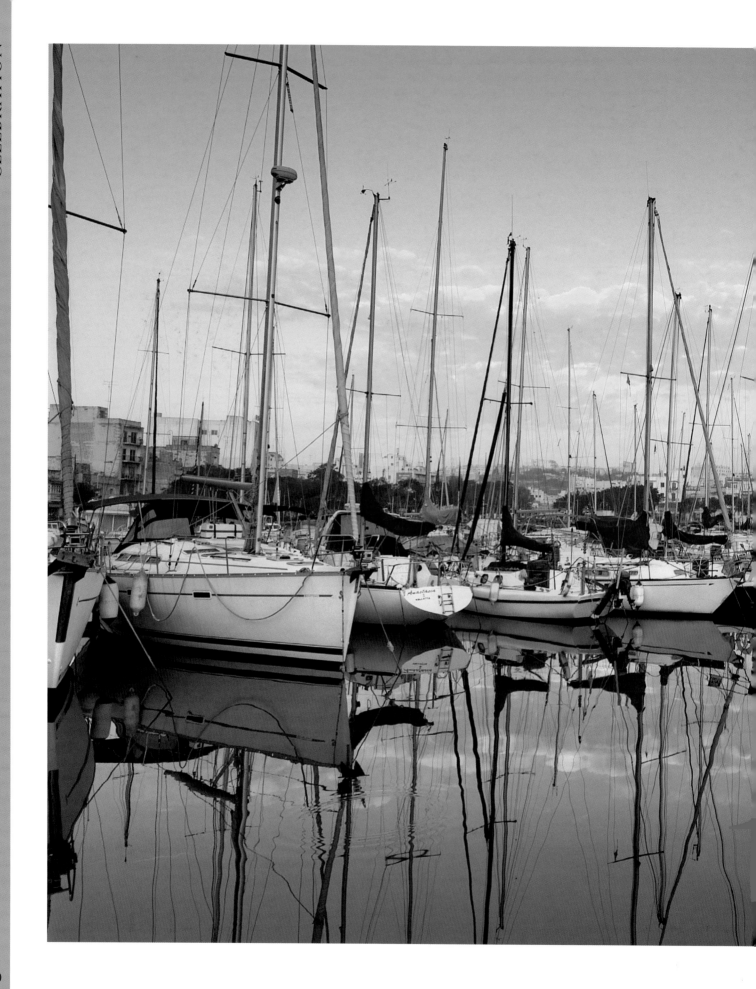

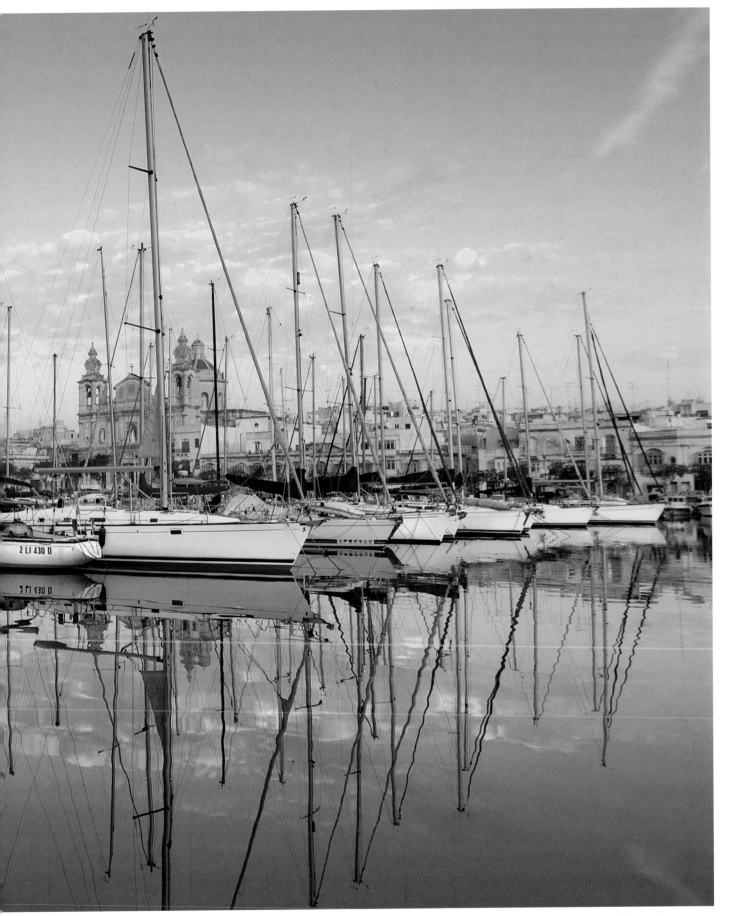

Leisure boats at their moorings at the Msida Marina

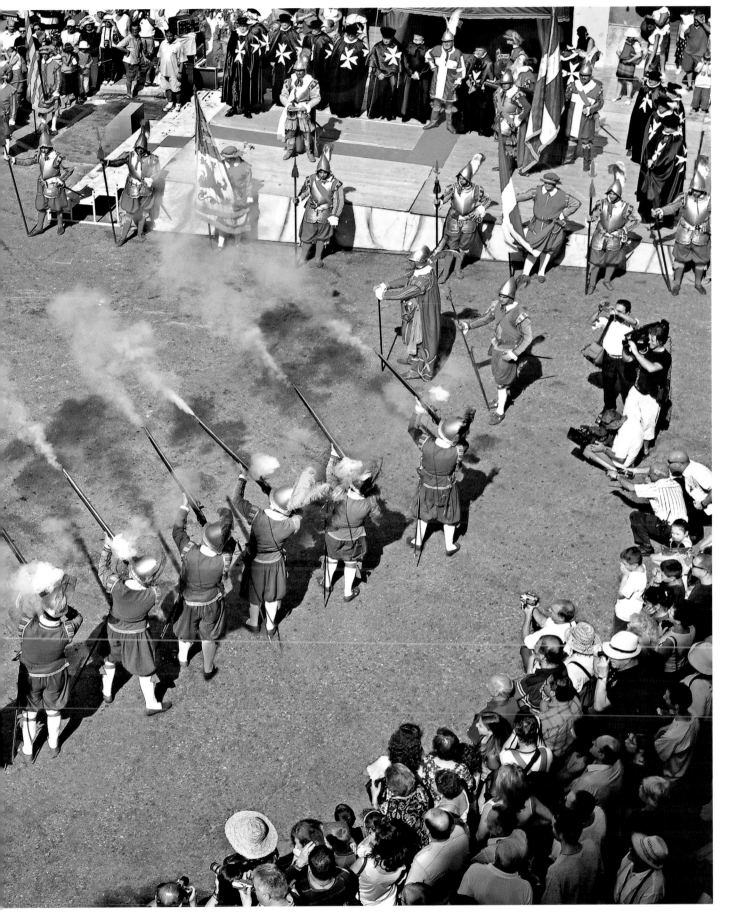

Historical enactments are re-inventing the past to entertain tourists and locals. Birgu

Fireworks over the Grand Harbour during the annual Aerial Fireworks Festival

a. A nativity scene at a band club in Mosta
b. The façade of a band club in Paola decorated
* for the Christmas season*
c. The carrying of the infant Jesus accompanied
* with Christmas carols in San Ġwann*
d. Santa blazes across the façade of a hotel
* in Qawra*
Opposite: A Christmas concert in Valletta

continues from page 323

Tourism was a key ingredient in this success story, which must rank as the greatest achievement of Malta since World War Two.

At the stroke of midnight on the first of May 2004, Malta passed another historic milestone when it joined the European Union. Less than four years later, on the first of January 2008 Malta entred the Eurozone.

The celebrations that marked these milestones are still as fresh in the mind of the entire population. And yet even as those celebrations ended, another celebration was beginning. This is the celebration of a people that has forged an identity and a destiny for itself, proud of its distinctive culture, yet keen to strengthen ties with its neighbours.

This book is also a celebration of life on the Maltese islands. And indeed there is much to celebrate as the archipelago

Top: Low-cost airlines are bringing a fresh influx of travellers to Malta.

Left: Malta's Euro coins introduced in 2008

embarks on yet another millennium of human endeavours and adventures. Over the centuries, the islanders have had to overcome one threat after another. Famine and drought, piracy and war, plague and cholera have all been terribly familiar visitors to the islands. In spite of these ravages, the islanders have created for themselves an independent state with a thriving population and a vibrant economy. No less significantly, they even speak a language of their own, shaped by more than a thousand years of the islands' curious history.

Yet, as old threats recede into the history books, new ones crowd into the newspapers. On closer inspection, some new threats are only variations of old problems that have perplexed the islanders in the past. The delicate relationship between the economy of the islands and the outside world is no less a matter of preoccupation today than it has

Model of Smart City, planned to become an international centre of excellence and innovation in the information and communication sector.

been for thousands of years. The interdependence of the islands' economy with that of the region continues to present risks and opportunities. Success or failure continues to depend on the acumen with which the inhabitants guard against the risks, and seize the opportunities.

The possibilities presented by tourism, real estate, and shipping have brought with them a new challenge. There is a danger that the islands become a victim of their own success, and suffer irreversible damage as a result of over-development. And yet this threat is also a variation of a familiar problem. The meagre resources of a small island have always needed careful nursing. The most successful chapters in the islands' history books are those about people who recognized the fragility of the islands, turning it into resilience through far-sighted policies and practices. To recall just

one, very simple, example, the deadly dryness of the Maltese summer prompted many generations of islanders to sweat and toil in the creation of water storage and management systems that are truly colossal. By the late eighteenth century, such cisterns permitted the irrigation of gardens and orchards on a grand scale, permitting Maltese blood-oranges to become one of the island's most famous and sought-after exports, alongside Maltese cotton. Today, the same venerable water cisterns are being bulldozed out of existence at a rate that should alarm us with its wantonness and short-sightedness.

In recent years, an encouraging reaction against such miscalculations is becoming increasingly evident, particularly among the young. Public interest in the history, archaeology, and environment of the archipelago is reaching unprecedented heights, while policy-makers are increasingly recognizing that the islands' past is one of their richest assets for the future, and that it will continue to be so for future generations. As we close this little journey, we must leave the unwritten chapters in their hands.

Concert at the Mediterranean Conference Centre with Mro Riccardo Muti directing the Orchestra Giovanile Luigi Cherubini

A family picnic on the edge of Buskett

a

b

c

*Opposite: 'Boċċi' (bowls) is a very popular
pastime*
*a. The trotters' races at the Marsa horse racing
course*
b. Golfing at the Marsa Sports Club
c. Windsurfing at Mellieħa
d. The National Stadium at Ta' Qali

d

Paragliding at Għajn Tuffieħa

Celebrations in the Grand Harbour as Malta joined the European Union. 1 May 2004

Index

Sources and further reading

The narrow compass of a volume like the present one may only give an introductory, fragmented and rather opinionated account of Maltese culture. The following is an equally fragmentary and opinionated list of useful sources and further reading, which should in turn lead the more interested reader to the wider literature that is available.

A thorough and up-to-date but very readable multi-volume introduction to Maltese history is being created in the form of the *Malta's Living Heritage* series, of which the first three volumes, each written by a specialist on the respective period, had appeared at the time of writing (Trump 2002; Bonanno 2005; Dalli 2006). For those looking for a quicker read, there are some excellent single-volume accounts of Maltese history and culture (Blouet 1967; Cassar 2000), as well as an archaeological field-guide (Trump 1972).

In recent years, a number of very accessible, informative and lavishly illustrated books have appeared on the subject of Maltese prehistory (Cilia 2004; Vella Gregory 2005). The broader Mediterranean context is attracting much study (Broodbank 2000; Horden & Purcell 2000), as is the question of Malta's island setting in prehistory (Robb 2001) as well as in the Roman and Byzantine world (Bruno 2004).

A very accessible and well-illustrated introduction to Maltese geology is now available (Pedley *et al.* 2002). The changing landscape and environment since prehistory is the subject of a recent study (Fenech 2007). An ever-growing number of books is available on the exploitation of Malta's stone for architecture (Hughes 1956; Mahoney 1996) and fortifications (Spiteri 1994; Spiteri 1996).

The subject of food in Malta has been approached from historic (Cassar 1994; Gambin & Buttigieg 2003) as well as culinary (Mattei 2003; Caruana Galizia & Caruana Galizia 2006) perspectives.

The profuse documentation and literature on the siege of 1565 is magisterially reconsidered in a recent study (Spiteri 2005). Malta's second siege, which peaked in 1942, continues to attract scholarly debate, yet the contemporary first-hand accounts published during the war (Gerard 1943; Ritchie 1943) remain the most hauntingly vivid.

Ritchie's *Epic of Malta* contains an extraordinary pictorial record of the war, and is the source of the World War Two photographs reproduced here. These remarkable photographs were originally supplied by Photochrom Co. Ltd, London. Unfortunately the names of the photographers could not be traced.

Blouet,B.W. 1967. *The Story of Malta*. London: Faber and Faber.

Bonanno,A. 2005. *Malta, Phoenician, Punic and Roman*. Malta: Midsea.

Broodbank,C. 2000. *An Island Archaeology of the Early Cyclades*. Cambridge: Cambridge University Press.

Bruno,B. 2004. *L'Arcipelago Maltese in Eta' Romana e Bizantina: Attivita' Economiche e Scambi Al Centro Del Mediterraneo*. Bari: Edipuglia.

Caruana Galizia,A. & Caruana Galizia,H. 2006. *The Food and Cookery of Malta*. Malta: Pax Books.

Cassar,C. 1994. *Fenkata: an Emblem of Maltese Peasant Resistance?* Malta: Minsitry for Youth and the Arts.

Cassar,C. 2000. *A Concise History of Malta*. Malta: Mireva.

Cilia,D. (ed.) 2004. *Malta Before History*. Malta: Miranda.

Dalli,C. 2006. *Malta, the Medieval Millennium*. Malta: Midsea.

Fenech,K. 2007. *Human-Induced Changes in the Environment and Landscape of the Maltese Islands From the Neolithic to the 15th Century AD As Inferred From a Scientific Study of Sediments From Marsa*, Malta. Oxford: BAR International Series 1682.

Gambin,K. & Buttigieg,N. 2003. *Storja Tal-Kultura Ta' l-Ikel F'Malta*. Malta: PIN.

Ganado,A. & Agius-Vadala,M. 1994. *A Study in Depth of 143 Maps Representing the Great Siege of Malta of 1565*. Malta: PEG.

Gerard,F.W. 1943. *Malta Magnificent*. London: Whittlesey House.

Horden,P. & Purcell,N. 2000. *The Corrupting Sea: A Study of Mediterranean History*. Oxford: Blackwell.

Hughes,Q. 1956. *The Building of Malta* 1530-1795. London: Alec Tiranti Ltd.

Luttrell,A. T. 1975. Approaches to Medieval Malta. In A.T. Luttrell (ed), *Medieval Malta: Studies on Malta before the Knights*. London: British School at Rome.

Mahoney,L. 1996. *5000 Years of Architecture in Malta*. Malta: Valletta publishing.

Mattei,P. 2003. *25 Years in a Maltese Kitchen. Malta*: Miranda.

Mendola,L. n.d. *Translation of the Deed of Donation of the Maltese Islands to the Order of Saint John of Jerusalem by the Holy Roman Emperor Charles V*. Published online at http://www.regalis.com/malta/deedCharles.pdf.

Pedley,H.M., Hughes Clarke,M. & Galea,P. 2002. *Limestone Isles in a Crystal Sea. The Geology of the Maltese Islands*. Malta: PEG.

Porter,W. 1858. A History of the Knights of Malta. London.

Ritchie,L. 1943. *The Epic of Malta*. London: Odham's Press.

Robb,J. 2001. Island identities: Ritual, travel and the creation of difference in Neolithic Malta. *European Journal of Archaeology 4*, 175-202.

Spiteri,S.C. 1994. *Fortresses of the Cross: Hospitaller Military Architecture*, 1136-1798. Valletta: Heritage Interpretation Services.

Spiteri,S.C. 1996. *British Military Architecture in Malta*. Valletta: The author.

Spiteri,S.C. 2005. *The Great Siege. Knights Vs Turks 1565: Anatomy of a Hospitaller Victory*. Malta: The author.

Trump,D.H. 1972. *Malta, an Archaeological Guide*. London: Faber.

Trump,D.H. 2002. *Malta, Prehistory and Temples*. Malta: Midsea.

Vella Gregory,I. 2005. *The Human Form in Neolithic Malta*. Malta: Midsea.

Wettinger,G. 2000. *Place-Names of the Maltese Islands* Ca. 1300-1800. Malta: PEG